SIDNEY NOLAN

LANDSCAPES & LEGENDS

Jane Clark
Curator, National Gallery of Victoria
with an essay by Patrick McCaughey

Cambridge University Press
Cambridge
New York New Rochelle Melbourne Sydney

Published by the Press Syndicate of the University of Cambridge
The Pitt Building, Trumpington Street, Cambridge CB2 1RP
32 East 57th Street, New York, NY 10022, USA
10 Stamford Road, Oakleigh, Melbourne 3166, Australia

First published 1987
by International Cultural Corporation of Australia Limited
This edition copublished by Cambridge University Press
with International Cultural Corporation of Australia Limited 1987

Printed in Australia by Southbank Printing Services

National Library of Australia Cataloguing-in-Publication data
Clark, Jane, 1955–
Sidney Nolan, landscapes and legends.
Bibliography.
Includes index,

1. Nolan, Sir Sidney, 1917- - Exhibitions. 2. Painting, Modern - 20th century -
Australia - Exhibitions. I. Nolan, Sir Sidney, 1917- . II. McCaughey, Patrick,
1943- . III. Title.
759.994'074'0994

ISBN 0 521 35301 7

CONTENTS

Preface 6

Sidney Nolan: experience, memory and the emphatic present 9
by Patrick McCaughey

Maps 14

Sir Sidney Nolan: a biographical outline 15

Nolan becomes a painter 30

War and the Wimmera 42

Post-War in Melbourne 58

Nolan's Ned Kelly 71

Travelling north 89

Outback 95

Inland Australia 109

Europe and America 115

The world 138

A living legend ? 160

Selected bibliography 173

Index of works 175

PREFACE

This book celebrates fifty years of painting by Sir Sidney Nolan, O.M., Kt, C.B.E. He has by no means finished. And so, whilst my aims have been 'scholarship', 'objectivity' and 'a comprehensive overview' (as demanded by various art critics in recent years), I make no claim to be definitive. The book was written to reflect and illustrate the contents of the full-scale retrospective exhibition *Landscapes and legends* touring four Australian state capitals in 1987–88. Organized by the National Gallery of Victoria, this exhibition was a major undertaking made possible by grants from News Limited and Clemenger Australia, with assistance from Qantas Airways Limited. It was managed by International Cultural Corporation of Australia Limited, and indemnified by the Australian Government through the Department of Arts, Heritage and Environment.

Nolan's London retrospective in 1957 had covered only ten years of his career. The well-presented exhibition for his fiftieth birthday, in 1967, was likewise not fully representative: the Kelly paintings of 1946–47 being a major omission. No exhibition could show every aspect of this extraordinarily vast and wide-ranging oeuvre. I have nevertheless included paintings from 1936–37 (his earliest dated works) to the present, as well as some examples of his work for ballet and opera, and records of involvements with film, printmaking, poetry and book illustration. By a most felicitous coincidence, the recent appearance of Brian Adams' *Sidney Nolan: such is life, a biography* (Hutchinson) has enabled me to concentrate on Nolan's art and confine biographical data to summary form.

Nolan has been called a 'strange chick from an Irish hatchery'; also 'the first modern Australian painter'—perhaps the first to work coherently within a post-Cubist idiom without compromising his own original, poetic vision. Internationally, he has become an intrinsic part of everything that 'Australian' means. And he is the most honoured Australian artist of his generation. The book is arranged chronologically and thematically to reflect Nolan's development as a painter from his student years in Melbourne to his great and continuing successes overseas. Historical and legendary figures such as Ned Kelly, Mrs Fraser, Rimbaud, Burke and Wills appear and reappear within ever-changing landscapes over half a century; perpetually catching up the artist's past into the present. 'I'm not very didactic and I don't wish to impart information very much', he has said, 'I'm very random in what I read and in what I know. I'm not very co-ordinated but what I latch on to I stick at.'

Information about each work is provided in the following order: title and date (any attributed dates are in square parentheses), medium, dimensions (height before width), exact inscriptions recto and verso, present ownership. Original titles given by Nolan when the paintings were first exhibited are used whenever possible; any subsequent changes of title have generally been made at his request. Provenance, exhibition history and contemporary critical response are documented as fully as possible.

A project such as this is possible only through the diverse contributions of many people. First I must thank the Director of the National Gallery of Victoria, Patrick McCaughey, for initiating the exhibition and Nancy Staub, for unflagging enthusiasm and support during the past year as Acting Director. Many colleagues at the Gallery have rendered special assistance: Curators Jan Minchin and Robert Lindsay for advice and expertise in Twentieth Century Australian Art, Irena Zdanowicz in Prints and Drawings and Geoffrey Edwards in Decorative Arts; the Conservation and Framing team, led by Tom Dixon and John Payne; as well as Gordon Morrison, Danny McOwan and Garth McLean; the Gallery Library and Photographic, Education, Installation and Secretarial staff. Jennie Moloney has assembled the illustrations with utmost efficiency. Judy Shelverton has speedily and willingly unravelled my chaotic manuscripts and prepared the typescript for typesetting. Judy Ryan, the Gallery's Editor, has given invaluable advice and assistance. Kathy Richards, Graphic Designer, has worked fantastically hard on this book. I would like to thank colleagues from all those Galleries which participated in the exhibition's tour: especially Barry Pearce, Deborah Edwards and Susan Schmocker in Sydney, Jane Hylton in Adelaide and Erica Persak in Perth. All private and institutional lenders have been unfailingly generous with their time and knowledge: in particular I am grateful to John McPhee, Mary Eagle, Andrew Sayers, Tim Fisher, Andrew Durham, Jane Hyden and library staff at the Australian National Gallery, Anne Gray at the Australian War Memorial, David Dolan, Joan Scott and Pam Swaffield at 'Lanyon', Bettina MacAulay at the Queensland Art

Gallery, Francesca Franchi, archivist of the Royal Opera House, Covent Garden, Barrie Reid, Nancy Underhill, Tony and Dosha Reichardt and The Lord McAlpine of West Green. Many librarians at the State Library of Victoria have assisted with research. I am indebted to Mr Elwyn Lynn both for advice and information and as author of numerous books, articles and catalogues on Nolan's work; also to Brian Adams and Elizabeth Douglas, formerly of Hutchinson, for allowing me to read *Such is life* before publication. In London, Mr Ronald Alley very kindly gave me access to the artist's press-clipping books; John Hull gave essential physical and moral support in examining literally hundreds of works in the artist's own collection. Management of the exhibition's interstate tour was ably undertaken by International Cultural Corporation of Australia Limited, with Carol Henry and Lisa Purser heading the Project Team. And listed below are other individuals who have helped in many different ways: Richard Adams, William Akers, David Albrecht, Michele Anderson, Roderick Anderson, Peggy Armstrong, The Lady Avebury, Paul Bentley, Doria Block, Mr Kym Bonython, Dr Joseph Brown, Elaine and Penelope Clark, Heather Clifford, Alannah Coleman, Lauraine Diggins, Neil Douglas, Miss Sonia Downing, Cecilia Dutkiewicz, Dinah Dysart, Christine France, Julie and Klaus Friedeberger, Maggie Gilchrist, Joan Gough, Sir Andrew and Lady Grimwade, Richard Haese, Paul Hammond, Piers Hipwell, Gordon House, Ann Jones, Philip Jones, Stefan Jordanoff, Alex Kidson, Jean Langley, Cherry and Len Lewis, Rebecca Llewellyn, John Lockhart, Mr John Longstaff, Mary Mácha, Tony Marshall, Sarah Nichols, Annegreth Nill, Charles Osborne, Maudie Palmer, Nicholas Paspaley, Mr R.E. Pepprell, Roslyn Poignant, Mrs Ann Purves and Stuart Purves, Bryan Robertson, Mr William Rubin, Mrs Gisella Scheinberg, Miss Constance Sheares, Petronilla Silver, Mr John Sinclair, Linda Slutzkin, Barry Stern, Joe Studholme, Mr Harry Tatlock Miller, Mr Gordon Thomson, Maggie Thornton, Mr Albert Tucker, Mr Patrick White, Katharine Wilkinson, Mrs Judith Wright-MacKinney and Dick Wynveen.

Special thanks are due to the owners of the works for permission to show them at the exhibition and to include them in the resulting publication: Sir Sidney and Lady Nolan, Arts Council of Great Britain, the Trustees of the Tate Gallery, London, Walker Art Gallery (National Museums and Art Galleries on Merseyside), Liverpool, Mr William Akers, Alcoa of Australia Limited, Art Gallery of New South Wales, Sydney, Art Gallery of South Australia, Adelaide, Art Gallery of Western Australia, Perth, Australian National Gallery, Canberra, The Australian Opera, Australian War Memorial, Canberra, Ms Lauraine Diggins, Mr James O. Fairfax, Mr Derek R. Gascoigne, Heide Park and Art Gallery, Ms Jill L.N. Hickson, The Robert Holmes à Court Collection, ICI Australia Limited, Mr Philip Jones, The Lord McAlpine of West Green, National Gallery of Victoria, Melbourne, The News Corporation Collection, Nolan Gallery of the Department of Territories, A.C.T., Queensland Art Gallery, Brisbane, Mr Tony Reichardt, Mr Barrett Reid, Reserve Bank of Australia, Mr Alexander Slutzkin, Mr John Sumner, The Sussan Corporation Collection, Sydney College of Advanced Education, University Art Museum of the University of Queensland, University of Western Australia, Dr von Clemm, Dr and Mrs Norman Wettenhall, Woolloomooloo Gallery Collection, Mr and Mrs E. Zweig, and those private collectors who wished to remain anonymous.

Photography for this book was by Brian Adams, Prudence Cuming Associates Limited, Victor France, Henry Jolles, Axel Poignant Archive, David Reid, Helen Skuse, Garry Sommerfeld and Ann Williams.

Finally—and most importantly—I am grateful to Sir Sidney and Lady Nolan for hospitality, enthusiasm, and patient answers to my many questions. Sir Sidney kindly allowed me to read and quote from his Wimmera and Queensland letters, normally unavailable to the public. He is, of course, the *raison d'être* of this whole enterprise— one of the most exciting and challenging projects with which I have ever been involved. I wish him many many happy years of painting 'landscapes and legends' in the future.

Jane Clark

ABBREVIATIONS USED IN BIOGRAPHY AND DOCUMENTATION

A.G.D.C. – Art Gallery Directors' Council
A.G.N.S.W. — Art Gallery of New South Wales
A.G.S.A. — Art Gallery of South Australia
A.G.W.A. — Art Gallery of Western Australia
A.N.G. — Australian National Gallery, Canberra
A.N.U. — Australian National University, Canberra
C.A.S. – Contemporary Art Society—various
 Australian state branches
C.A.S. London — Contemporary Art Society, based at
 the Tate Gallery; (unrelated to the
 Australian C.A.S.)

Heide – Heide Park and Art Gallery, Bulleen
I.C.A. – Institute of Contemporary Art, London
Lanyon — The Nolan Gallery at 'Lanyon', A.C.T.
M.O.M.A. —Museum of Modern Art and Design
 of Australia 1958–65 (called 'Museum
 of Modern Art of Australia' 1958–63)
N.G.V. –National Gallery of Victoria, Melbourne
Q.A.G.— Queensland Art Gallery

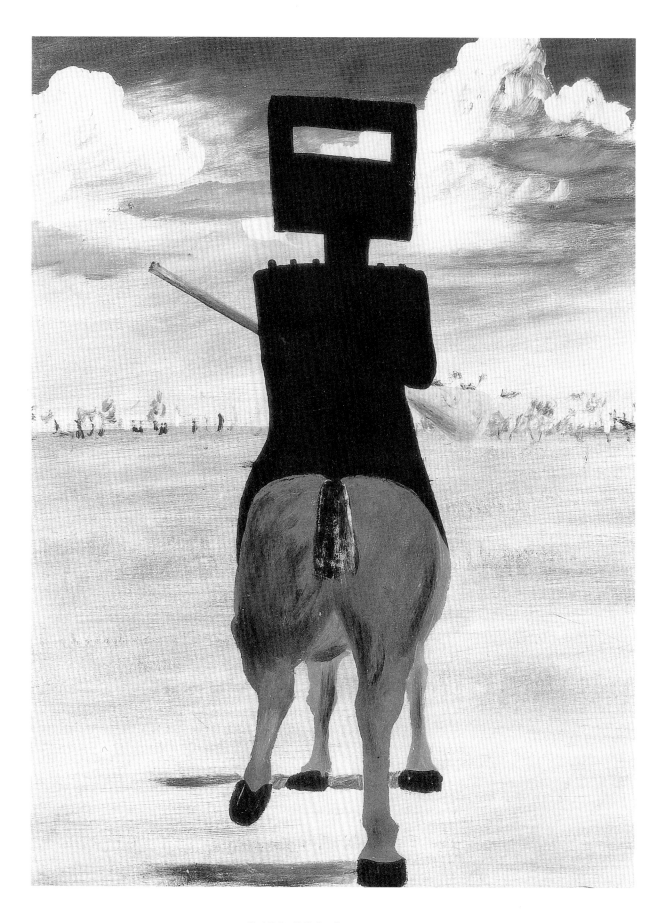

Ned Kelly *1946 (detail)*
Ripolin enamel on hardboard
Photograph: Australian National Gallery

SIDNEY NOLAN: EXPERIENCE, MEMORY AND THE EMPHATIC PRESENT

THE SHARP FOCUS IMAGE: EARLY WORKS

Of all Sidney Nolan's memorable earlier images, surely that of Ned Kelly, centaur-like riding into the landscape from the first Kelly series of 1946–47 remains the most vivid. This was Kelly alone in the landscape, become a creature of the wide sun-filled world he dominates, known by the black helmet against the sky, a pill-box slit for his eyes. Outcast and hero, menacing and estranged, abrupt and ironic, here was a new identity in the landscape of Australian painting.

This Kelly has a strange and ambiguous relationship to the beckoning landscape. He stands out so clearly he looks like a target; the wide plain neither absorbs nor camouflages his approach. He is man against the landscape. He doesn't really fit in at all. Yet where else could Kelly exist but in the sun-drenched landscape of north-eastern Victoria? There is no mistaking this landscape for 'a country of the mind': it is too well observed, too actual. The security of the space and the truthfulness of the tone attest to the reality of the world Kelly imprints himself upon. Kelly's dramatic separation from this environment and its actuality create one of the most striking resonances between the figure and landscape in modern Australian art.

Here and elsewhere in early Nolan a new contract was drawn up between the human and the natural. There are many explanations for this new contract. Nolan had begun as a reluctant landscape painter three or four years earlier when he was conscripted and banished to the Wimmera. There he had wrestled with the problem of being both a modern painter with an instinctive sense of the power and immediacy of painting on the flat and yet giving a truthful account of a vast and vacant landscape, featureless and monotonous. The Kelly series was a way of inserting the figure into the landscape in the thoroughly modernist way. Kelly was the perfect surrogate for Nolan's mind and imagination: an Irish rebel against society, an intrusive presence in the landscape, an inescapable blot on the horizon of Australian painting.

Kelly also answered Nolan's primitivism, that well-spring of modernism which served the rebels and precursors of the 1940s in Melbourne so well. By painting the legend so literally with levitating figures and policemen falling headlong from their horses, Nolan clearly engaged folkish and primitive elements and delivered a snub to conventional taste and propriety. He forced the truth of the incident upon the resisting eye. The power of Nolan's images is greater, however, than just a well planned strategy of deliberately interrupting landscape painting with primitive, literal and irrational images of Kelly, his gang and the comic opera police who pursue them. For all the deployment of low-life imagery, the paintings never descend to genre. There remains an instaneity to early Nolan which is thoroughly modern.

The chief cause of that instaneity is the sharp focused images of the 1940s which have the precision and force of observed experience behind them. The Kelly helmet head gathers to itself the compelling presence of reality equal to that of the landscape. Such images, for all their oddity or quaintness, are the carriers of experience, the bearers of consciousness and by their presence the landscape is redeemed from sun-filled vacancy.

Throughout the 1940s Nolan gravitated towards the outsider as the representative figure in the landscape. The outlaw Kelly gives way to the doomed explorers Burke and Wills. Their absurd, tragic story is one of men who start as the exemplary heroes of society but win lasting identity in history and myth as outsiders, dying and disintegrating in the landscape and becoming part of it. The romantic hero although destroyed is not defeated: such is the powerful iconography Nolan develops around these explorers over the course of thirty years or more.

Most strikingly from our point of view, Nolan's first encounter with this subject in the 1940s has the air of a documentary. He paints the explorers' portraits, their departure, their journey as though his models and sources were nineteenth-century colonial

photographs. The painter adopts the viewpoint of the neutral observer who simply records what he sees. Yet, Nolan's stance is one of grim irony because he knows, and we share his knowledge of what actually happens. The faces of his explorers are of burnt sienna. The invulnerable desert flows into the heart of Melbourne, dooming them even as they depart.

The third classic outsider images of the 1940s are those of Mrs Fraser and her rescuer, the escaped convict Bracefell. These images carry a heavier burden than the earlier Kelly or Burke and Wills paintings. Mrs Fraser is the literal outcast, neither compelled there by an alien society as with Kelly nor voluntarily and foolhardily there as with Burke and Wills. She is estranged involuntarily and accidentally, at the mercy of the world in which she finds herself. One of the most devastating images in early Nolan is that of Mrs Fraser on all fours like a female Nebuchadnezzar exiled and forced to eat grass. Her bestial posture, faceless and degraded, once again is no bland image, melting into the landscape, but stays in sharp focus, stamped against the lush rainforest. Thus even in an intense moment of mythical experience, the transformation of the human into animal, Nolan holds on to the image of absolute clarity and directness. Such sharp focus images have their pictorial origins in Nolan's non-legendary figure paintings of the early 1940s. Two of the most striking of these, from the crucial Wimmera series (1942–43), are *Flour lumper* and *Railway guard*. Stamped out against the landscape in sharp, close focus, both images fill the frame so that the landscape is pushed to the edges. The hard outline of the figures locks them into the landscape in a peculiarly tight and airless way. Both lumper and guard overwhelm the eye with a sense of presentness and immediacy. They are the pictorial models for the later mythical figures, not so much figures *in* the landscape as figures set *against* it. The important point here is that the inspired eccentricity and plasticity of the Wimmera figures and their legendary successors arose out of Nolan's effort to get experience into pictorial form.

The contemporaneous St Kilda bathers bear out the factual origins of Nolan's early sharp focused images. The figures are so flatly composed that they anticipate the cut-out quality of Kelly's helmet and armour. In these St Kilda pictures of light, heat and atmosphere, there is no mistaking the elements of air and water in which bathers bathe or sunbake.

If the Wimmera and St Kilda sharp focus figures are the origins of Nolan's mythic-legendary figures, the apotheosis of the sharp focus images comes at the close of the decade with the long running Central Australia landscape series of 1949–50. Snap shots of the sublime, they combine Nolan's documentary observations and his visionary capacity. The landscape is limitless, inhuman in its scale and indifference, remote from intrusion or settlement. It can be seen safely only from the modern aerial viewpoint and yet that vantage point only increases our sense of its infinity. The sharp focus image is here *the* agent of experience; Nolan's hand and eye function as impersonally as the landscape depicted. The paintings have an extraordinary transparency of experience as though nothing intervened between their observation and its faithful record in paint.

Such pellucidity is deceptive, however. The landscape is so impersonal and Nolan's gaze so unflinching that it becomes a landscape through which the mind alone can pass. We cannot project the human figure into it. There is a strangeness to these landscapes which familiarity can never quite dispel. For all their vivid objectivity and immediacy, they evoke a profound inward shudder at the desolation and the waste. They close out Nolan's first full decade. He had never looked so keenly or painted the world in such sharp focus. Small wonder they were to be the means of his passage from Australia to Europe.

THE IMAGE OF MEMORY: THE 1950S AND 1960S

Australia has been in the past unkind and defensive about expatriates. Nolan has suffered personally and professionally from both reactions. Yet when Nolan left Australia to settle 'semi-permanently' in England in 1952, what choices did he have? The Melbourne scene which had nourished him for a decade from 1937–47, had been

alien to him for some years before his departure and had itself fallen into the doldrums. He had sustained throughout the 1940s a tumultuous succession of series and innovations. Acknowledgement, let alone rewards, had come grudgingly, only towards the end of the decade and more frequently from outside observers like Sir Kenneth Clark in 1949 or the then recently arrived Joseph Burke, Herald Professor of Fine Arts at the University of Melbourne from 1947 until 1978. Nolan was thirty-five in 1952, at the height of his powers and his confidence as an artist. Knowing both what he had achieved over the previous decade and sensing his capacity to be at the flood, Nolan did what any Australian artist then or now would do; find the larger arena and the more stimulating ambience to chance arm and fortune.

Nolan's poetic widened and flourished steadily throughout the 1950s and 60s. His success in England, so rapid and complete compared with the lean years of struggle and anonymity in Australia owes itself both to the quality of the paintings and the nature of his sensibility. Nolan, it should be stressed, was already established before the Australian wave gently washed the shores of the London art world around 1960–61. If anything, Nolan contributed to the wave rather than was borne along by it. It was not a simple case of Nolan's Australianness propelling him to a seat of critical honour and regard.

Nolan, almost by accident, met some of the most fundamental characteristics of the best in English art. These can be summarily described as non-academic, narrative painting where the absence or ignorance of the academic virtues lends the work an eccentricity of vision. Blake and his followers are the pre-eminent examples. Stanley Spencer and his followers exemplify the tendency in the early twentieth century. And Francis Bacon and David Hockney, like their predecessors look wonderfully independent of, if not blind to, the contemporary European or American current. Each in his own way sustained narrative painting on a level of intelligence and intensity which transcends the anecdotal quality of genre painting.

Nolan's recurrent and ever-changing trope of the figure against the landscape was a particularly potent means of renewing narrative painting; and he tackled the Ned Kelly theme for a second time as his first narrative series in England. One picture which directly echoes one from the earlier series is the centaur-like Kelly riding alone into the landscape. The brilliant light and heat of the earlier image gives way to a chilly, even overcast atmosphere in the later version, for all the blue sky and high cloud. The impress of place unconsciously stole across Nolan's sensibility; no longer the piercing light of experience, it was recalled and filtered through the chillier, northern lights of London. Moving move away from the primitivism of the first series, Nolan now models the figure of Kelly in an impressively sculptural way. The jaunty bushranger becomes a universal figure of stoic endurance. The modelling of the figure and the creation of a more self-conscious surrounding landscape may have cost Nolan something in spontaneity and brio but they also enabled him to develop his constructive power.

Of course Sidney Nolan has drawn directly from experience throughout the 1950s and 60s alongside these narratives of memory. His visits to Africa, Antarctica, America and to Australia all brought forth remarkable works. Nolan's nomadic character as an artist is atuned to the fatal voyages of his imagination. Africa and Antarctica—polar opposites of environment— are equally his for the taking: vivid and adroit, they elicit the lyric and dramatic poet in him. They only occasionally, however, touch the deeper impulses of his art as when he scents the trail of Arthur Rimbaud, lost and damned in the African inferno or shadows the lost explorers against the white and windy wastes of Antarctica.

Where one finds the truest poet in the Nolan of the 1950s and 60s is when experience triggers memory and the desire to recall it. The Leda and the Swan series of the mid 1950s led him through the Aegean to meditations on Gallipoli and Troy, one of the richest veins in Nolan's mid-career. The antique in the present landscape, myth and the actors of history intertwine in Nolan's mind and art.

The loosening up of his pictorial style was the direct result of this habit of imagination. The painterliness was there from the beginning but constrained by the press to fashion the experience into the sharp and memorable image. Now, in such paintings

as the later Mrs Fraser series of the 1950s, Nolan's painterly touch evoked a myste-rious, shadowed world. The ruthless heat and light of his first essays on the theme ten years earlier gave way to a sombre, darkened world of pools and impenetrable, sunless rainforests. Mrs Fraser and her convict lover were either diminished to a tiny scale or found wraith-like and bodiless against the profusions of nature. Evocation and illusion, the murky and the indeterminant, the ambivalence of past and present, these became the character of Nolan's imagery. The tour de force of Nolan's painterliness came with the epic, multi-panelled sequences of the 1960s—*Riverbend*, 1964–65, *Desert storm*, 1966 and *Inferno*, 1966. All of them bear the stamp of sustained inspira-tion: their formal unity and pictorial tensions bear testament to Nolan's impassioned bravura.

Desert storm brings Nolan back to the world of the outback Australian landscapes of 1949–50. There is the same sense of being present and observing with unflinching gaze the scale and power of nature. Once again there is that unsettling transaction in Nolan between documentary realism and its transcendence into the storm as meta-phor. The storm is not just a moment's experience but is shown as the heart of the landscape: an inferno where power and action dwarfs even the physical might of the land, let alone the human presence within it. Nothing can withstand the wind, matter hurled at matter. This is Nolan's first world: the world of direct experience enacted out, remorselessly panel after panel.

Riverbend, the earliest of the great polyptychs, is one of Nolan's most comprehen-sive accounts of the figure in the landscape and the power of memory. Less readily spectacular than either *Desert storm* or *Inferno*, it takes the horizonless landscape of the bush, familiar to the Heidelberg School. The idea of nature as sublime spectacle is cast aside: here is landscape as enclosing environment. Although wild and dense, it admits, conceals and disguises the human 'the intruder in the bush'. The landscape is beheld intently by Nolan who knits over and under surfaces so tightly that we are made aware of the microforms of the bush—the layered groves, its vegetable past—as well as the larger interchange of gum tree and undergrowth, dry bush and muddy river. *Riverbend* invites a dramatic reading: the viewer paces through the panels and is slowly enveloped by their heat-filled imagery where nothing moves and everything is held in expectation of a brief and bloody climax and then returns to the primal world of the bush. No work of Nolan makes us feel the action of time so explicitly as *River-bend*. The landscape is licked by fire; there is something stifling about the heat. The river gives no relief and the bush no shade.

Inferno is a mighty climax to the epics of the 1960s. Completely abandoning the conventions of the landscape, Nolan's damned swim and oscillate in fire and cold. The dramatic or lyrical narrative painter gives way here to an artist prepared to invoke the non-ethical energies of the imagination; the hateful powers of suffering and pain are here hypothesized. The giddiness of the figural style without limb to support, shield or guide the sufferers, is wholly without irony. Here at last Nolan's fiery, inferno-like vision of the landscape and its testing of the human is explicitly revealed. Where Burke and Wills swim mirage-like in the landscape and become part of it, transcend their literal names and are transfigured into myth, the damned of the *Inferno* enjoy no such release into legend. No work of Nolans is more relentless, proceeds so much from inward volition and is so apallingly removed from the world of observation or memory.

THE EMPHATIC PRESENT: RECENT WORK

Sidney Nolan presented his Ern Malley series of paintings to the Art Gallery of South Australia in 1974. The series consists of portraits of the leading figures associated with *Angry Penguins* of the 1940s and a group of then recent paintings painted during 1972–73 based on lines and images from the Ern Malley poems. The bridge between the two groups was *Inferno*. The exhibition was an arresting event. The portraits had not been seen for many years and aroused both interest and curiosity.

The new Ern Malley paintings were greeted with puzzled silence on the most part. The images looked so bizarre that they did not admit an easy reading and seemed only explicable if one consulted the text of the Ern Malley poems themselves. But that was only half the trouble. They looked so flat, abrasive, graphic, without the painterly richness and flux Nolan had cultivated through the later 1950s into the 1960s. The new Ern Malley paintings were angular and unaccommodating. They were over-emphatic to most eyes and taste in 1974. Therein lay their quality and their interest. Nolan had returned to an earlier theme but in a new and vigorous manner. There was no homage to memory and absolutely no attempt to revive an earlier style. The paintings were emphatically of the present: they took nothing but their titles from the past.

As such, they are key paintings to understanding the Nolan of recent years. Far from reworking his own earlier successful modes, the Nolan of the 1970s and 80s has become an increasingly bewildering figure to his audience as he pushes his art around, looking for the new way and the new range of motifs. The Nolan of the past is the wish of his audience. There is on Nolan's part a strenuous effort to bring the present back into his art, to move away from the images of memory. When he turns to long-cherished motifs—inland Australia, for example—the new way is frequently, even perversely at times, at odds with his own earlier, well established manner. Such a path necessarily involves the artist in risks and in unevenness of success. The work of the last decade and more has gone without proper evaluation largely because of its strangeness and its abandonment of his earlier canons of narrative landscape painting. General taste wishes him to be as he once was.

What has persisted into the best of the recent works is the inferno vision of the landscape or the wider environment as the arena of punishment and travail. The catastrophic still haunts Nolan's imagination. And he does not flinch from the fact that hatred and lust may be the goads of human action and the motifs of art. He has for so long been regarded and accepted as lyricist or ironist that it has obscured the harsher, less accommodating side of his art. It was there at the beginning in those sharp focus images which allow no escape from the experience. In the long march of his art from the sun-filled landscapes and legends of the 1940s to the present cloudy and smoky apparitions, Nolan has never relinquished a sense of the human as victim, vulnerable to the world in which he lives.

Patrick McCaughey
Director
National Gallery of Victoria

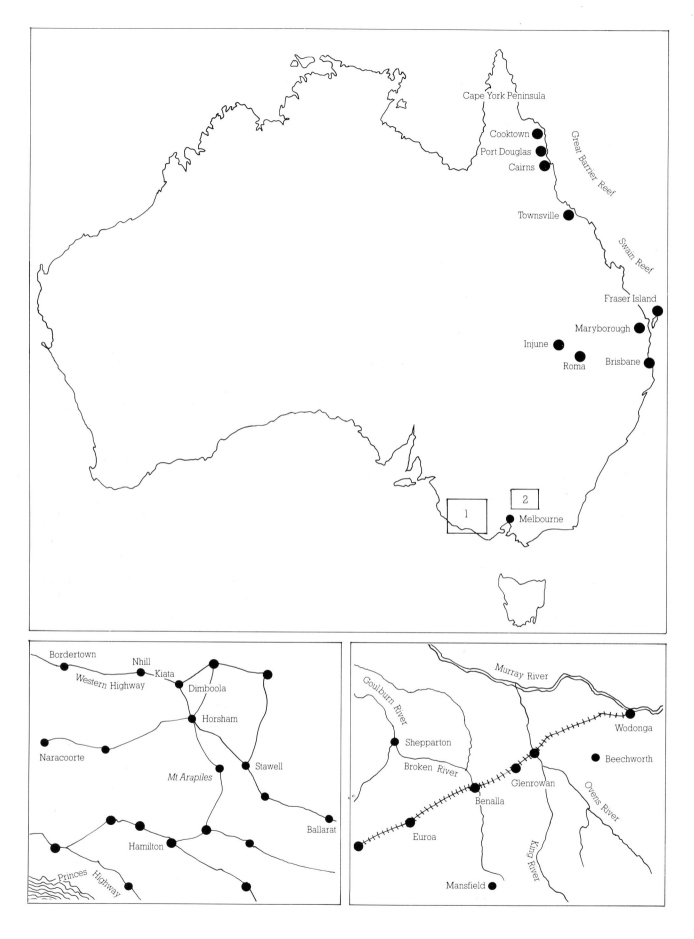

Cape York Peninsula

Cooktown
Port Douglas
Cairns

Great Barrier Reef

Townsville

Swain Reef

Fraser Island

Maryborough

Injune

Roma

Brisbane

1

2

Melbourne

Bordertown
Nhill
Kiata
Western Highway
Dimboola
Horsham
Naracoorte
Mt Arapiles
Stawell
Ballarat
Hamilton
Princes Highway

Murray River
Goulburn River
Wodonga
Shepparton
Broken River
Beechworth
Glenrowan
Benalla
Ovens River
Euroa
King River
Mansfield

1 THE WIMMERA

2 KELLY COUNTRY, NORTH-EASTERN VICTORIA

14

SIR SIDNEY NOLAN

My own history is involved in what I can probably call with truth a working class background. My father was a tram driver & of necessity my education was what could be provided by a tram driver. After school it took place in a factory. None of this process provides a classical education in painting. I learnt to paint in precisely the same way as any other worker would have to do. Look around him, use his eyes, fight for the opportunity to strengthen his vision.

- Sidney Nolan, 14 July [1944] to Malcolm Good

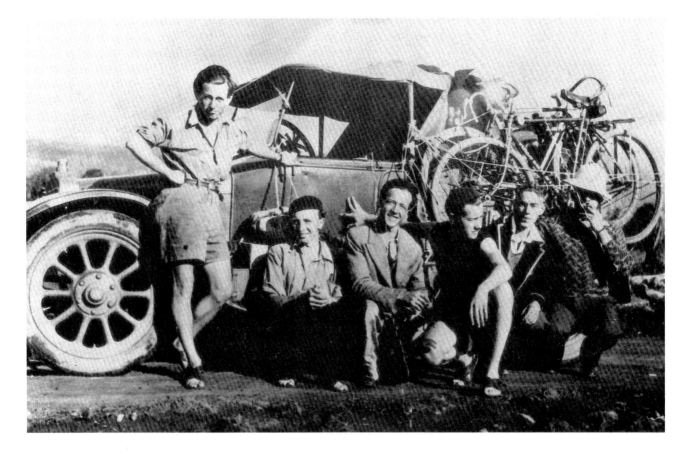

1917
Born 22 April, in the inner Melbourne suburb of Carlton—although his parents have been living on a farm at Nagambie; eldest of four children of Dora Irene Sutherland (d. 1975) and Sidney Henry Nolan (tramways employee and later a publican, d. 1965); sixth generation Australian, of Irish origin.

1917–31
The family soon move to bayside St Kilda; young Nolan attends the Brighton Road State School and then Brighton Technical School.

1932
Nolan leaves school, aged fourteen; enrols at Prahran Technical College, department of design and crafts, in a course which he has already commenced part-time by correspondence; diverse employment includes making commercial illuminated signs with glass, transparent enamels and tinfoil.

1933
Begins almost six years at Fayrfield Hats, Abbotsford, producing advertising and display stands with spray paints and dyes; spare-time reading according to the Melbourne University syllabus; non-artistic activities include athletics, swimming and bicycle racing.

1934
Nolan attends night classes sporadically at the N.G.V.'s art school under Charles Wheeler and William Beckwith McInnes; voracious reading, encouraged particularly by fellow student Howard Matthews, includes Blake, Baudelaire, Rimbaud, Verlaine and the French Symbolists, Proust, D.H. Lawrence, James Joyce, Dostoevsky, Kierkegaard, Nietzsche, Marx and the Bible.

Spends less time at the Gallery School than next door in the Public Library reading room; becomes familiar with works by van Gogh, Seurat, Picasso and other modern artists through reproductions in library books and journals.

'Bicycle racers'
John Sinclair, Gordon Daniels, Laurence Pendlebury, Sidney Nolan and friends outside the Tawonga pub in the Kiewa valley, 1936–37
Photograph by courtesy of Charles Osborne

1935–36
Returning to Melbourne after end-of-year summer holidays in Sydney (cycling some two hundred miles per day), he meets Gallery School students John Sinclair and Clifford Bayliss (b. 1916); decides to re-enrol with them for 1936.

1936
Moves from home to share a city studio with Sinclair, Laurence Pendlebury (b. 1914) and Arthur Daniels (architecture student), above a shop at the corner of Russell and Lonsdale Streets; friendship with Francis Brabazon—poet, mystic, 'primitive painter', N.G.V. attendant and owner of a substantial philosophical library; begins to write poetry.

1937

Nolan produces a few *plein air* landscapes on a painting expedition to Mount Hotham with Sinclair.

Spends some weeks with Howard Matthews at Selby, near Ferntree Gully, in a cottage owned by one of his aunts—living on pickled tripe, raw cabbage and madeira; weekend visitors include flamboyant fellow student, Noel Blaubaum, and seventy-three year old Rupert Bunny.

Nolan attempts, with Matthews, to stow away by sea to Europe but they are detected and returned ignominiously by pilot boat to Queenscliff.

More conventionally, he works desperately to save for a trip overseas: briefly in the office of a goldmining company at Ballarat; leaves Fayrfield Hats for Hamburger Bill's in Swanston Street; then returns to the felt-making section of the hat factory—'all of my teeth seemed to ache in the steam and I never forgot it'.

Constant and passionate artistic experimentation and exploration in any available free time.

1938

Sharing a studio with Sinclair and Gordon Thomson at 237 Exhibition Street, Melbourne; decides on painting as a full-time career.

Visits Sir Keith Murdoch, a trustee at the National Gallery of Victoria and Managing Director of *The Herald*, with a folio of abstract drawings and monotypes on tissue and blotting paper; meets *Herald* art critic, Basil Burdett (1897–1942).

Meets John and Sunday Reed.

Nolan becomes a foundation member of the Contemporary Art Society, instigated by John Reed in July 1938 with a letter addressed 'To Art Lovers' in opposition to the reactionary spirit of R.G. Menzies's Australian Academy of Art.

Marries Elizabeth Paterson, another Gallery School student and granddaughter of 'Heidelberg School' painter John Ford Paterson (1851–1912); the couple move to seaside Ocean Grove where Nolan works on an asparagus farm: 'a decent house and a studio upstairs, plenty of room to sleep (guests) ...Started work on red, yellow and blue paintings. This is a wonderful spot, quite a distinct character about the fields and the ocean. Thanks a lot for all you have done, all this quiet counts a lot', he writes to the Reeds, who visit regularly from Melbourne.

1939

Contributes *Head of Rimbaud* to the *Contemporary Art Society Inaugural Exhibition*, N.G.V., 6–25 June 1939.

Returns to live in Melbourne—having seen the epoch-making *Herald Exhibition of English and European Contemporary Art* in October at the Town Hall (organized by Basil Burdett, with 215 paintings including nine by Picasso, seven by Cézanne, six by Bonnard, plus Ernst, Redon, Dali, Chagall, de Chirico, Braque, Dufy etc.) and having decided that Ocean Grove was too far from the centre of things.

With Elizabeth, he takes on a pie shop in Lonsdale Street, but spends as much time as possible with the Reeds out at Heidelberg; the Nolans travel to Sydney over summer.

1940

Designs décor for Serge Lifar's *Ballet Russe* production of *Icare*, opening at the Theatre Royal, Sydney, 16 February 1940.

Moves into a condemned tenement opposite the Melbourne Museum, in Russell Street— a studio previously occupied by Howard Matthews and Noel Blaubaum who had painted the walls 'shocking' pink: first one-man show there, *Exhibition of Paintings and Drawings by Sidney Nolan at his Studio*, opened by John Reed, 11 June 1940—small abstracts, collages, etc.—dismissed by Burdett as 'highly esoteric'.

'To me it is something new, something which this individual artist—whose extreme sensitivity never ceases to astonish and thrill me—is doing, creating purely and simply out of his own unique reactions to the world he lives in. In this finally resides the value of the work of art. By no other standards will it ultimately be judged; and in this country in particular, where practically without exception our art is derived almost exclusively from the works of European masters, is work of this nature of inestimable value... What I would say to you, however, is that in the last analysis it is the artist who makes the rules and the spectator who revises his accepted theories to make them conform with those rules.'
- John Reed's opening speech, 11 June 1940

Nolan meets Arthur Boyd (b. 1920 and still a very close friend) for the first time: 'I remember him coming up to the exhibition in the old studio & saying he was a painter. Not as modern as this, he said looking around. He had leggings on I think & was very gentle indeed ... He just about promises as much as anyone' (letter written two years later from Dimboola, 5 November 1942).

Sharing studio premises once again with Sinclair, at 5 Smith Street, St Kilda

Contemporary Art Society Annual Exhibition, N.G.V., 9 August–1 September 1940: six paintings

Contemporary Art Society Annual Exhibition, David Jones' Gallery, Sydney, 24 September–24 October 1940: five paintings

Nolan's daughter is born.

He meets John Reed's sister, Cynthia Hansen (née Reed) for the first time.

1941

Studio at 325 Russell Street, Melbourne

Contemporary Art Society Third Annual Exhibition, Sydney, 9 September–4 October 1941: four paintings

Contemporary Art Society Annual Exhibition , Hotel Australia, Collins Street, Melbourne, 14–31 October 1941: five paintings, one sculpture

Nolan separates from his wife and moves to 'Heide'.

1942

Nolan is conscripted into the Army.
15 April 1942: reports to Caulfield induction camp before transfer to training

Private Nolan (No. V206 559), c.1942
Photograph by courtesy of Charles Osborne

Nolan's exhibition at Sheffield's Newsagency, Heidelberg, opened 18 July 1942.
Photograph: Australian National Gallery archives

camp near Seymour, Victoria, with the 3rd Supply and Personnel Company (Private Nolan, no. V206 559).

Stationed in the Wimmera.
4 May: arrives at Dimboola for labouring and guard duties, billeted with a local family; guarding a requisitioned garage full of biscuits, jam, tins of pineapple and bully beef—stored to feed Australia if the Japanese were ever to reach to notorious 'Brisbane Line' of defence. 'Feel a bit like a little boy left on my own here', he writes, 'Cold too. Surrounded by enough jam to make me feel like an apricot'.

Nolan moves to Horsham in July.
One-man exhibition at Sheffield's newsagency in Heidelberg village, organized by Sunday Reed, opens 18 July 1942. 'It is practical to show pictures in windows. Our equivalent of a market place', he

writes from Horsham, 'I wish I was there in it all'. Unfortunately there are no sales.

Transferred to Ballarat in August: 'stillness and sunshine', he writes one day, 'The wheel turned a full circle this morning ... Painting bridge classification signs. In bright yellow like the moonboy'! To training camp near Hurstbridge in September: 'shorn sheep that look like goats and very aesthetic latrines against the sky'. Spends some time at Nhill before returning to Dimboola in October; billeted in a hotel; promoted to Lance Corporal, 17 October 1942, in charge of stores; applies, unsuccessfully, to become an official war artist.

First Exposition, Royal S.A. Society of Arts Associate Contemporary Group, Society of Arts Gallery, Adelaide, 9 July 1942: two paintings

The Contemporary Art Society Exhibition, Athenaeum Gallery, Melbourne, 4–15 August 1942: three paintings, one drawing, one sculpture

Contemporary Art Society Fourth Annual Exhibition, Education Department Gallery, Sydney, 8 September 1942: four paintings

The Contemporary Art Society of Australia Anti-Fascist Exhibition, Athenaeum Gallery, Melbourne, 8–18 December 1942: three paintings

1943
From mid-January to June, Nolan is stationed mainly at Nhill—with 'a door on a couple of boxes for a studio'; then briefly in Horsham and on to Ballarat for five months from July. In August he suffers a serious accident to his left hand, losing parts of two fingers.

Contemporary Art Society Fifth Annual Exhibition, Education Building, Loftus Street, Sydney, 29 June–19 July 1943: five paintings

Exhibition of Paintings by Sidney Nolan, The Contemporary Art Society Studio, 527 Collins Street, Melbourne, 3 August 1943: seventeen Wimmera paintings, chalk drawings, painted slates; catalogue by John Reed

Contemporary Art Society Exhibition, Velasquez Gallery, Tye's Furniture Store, Bourke Street, Melbourne, 24 August–4 September 1943: five paintings

C.A.S. Adelaide 1943, Institute Building, North Terrace, Adelaide, 25 October–15 November 1943: five paintings (one substituted since the Melbourne showing)

The Vegetative Eye, modernist novel by Max Harris: colour frontispiece and cover from chalk drawing of a head by Nolan, published by Reed & Harris, Melbourne and Adelaide, 1943

A Second Summary, by American poet Harry Roskolenko: jacket illustration, Reed & Harris, Melbourne and Adelaide, 1943

Returning from leave at 'Heide', Nolan is sent to Horsham in November; paints the *Arabian Tree* there in December 1943, inspired by a poem by 'Ern Malley'.

1944
11 January 1944: Nolan returns again to Dimboola.

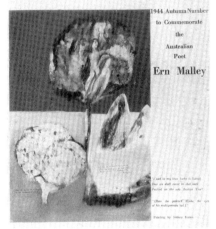

Photograph: State Library of Victoria

3 February: his unit leaves the Wimmera, transferred to Watsonia Barracks not far from Heidelberg.

Sixteen poems by 'Ern Malley' are published in the autumn number of *Angry Penguins* with Nolan's painting *Arabian Tree* on the cover; the poems are also issued as a booklet, *Australian Poet Ern Malley, The Darkening Ecliptic*, Reed & Harris, Melbourne and Adelaide, 1944.

5 June: the 'Ern Malley hoax' is revealed by 'Fact' in the Sydney *Sunday Sun*.

Nolan is hospitalized, ill and feverish, at the end of June; and a week later, in July, faced with the possibility of front-line duty in New Guinea he goes absent without leave. 'My conduct as an artist and as a soldier have finally proved incompatible', he writes. John Reed arranges false papers in the name of 'Robin Murray'; Nolan lives variously at 'Heide' and with John Sinclair, Max Harris and Douglas Cairns at 32 Gatehouse Street, Parkville—a converted stable

'Heide', the old farmhouse in Templestowe Road, Bulleen, purchased by Sunday and John Reed in 1934: hub of a creative community in the 1940s. Photograph by courtesy of Barrett Reid

known as 'The Loft' and furnished with a Bechstein piano.

Contemporary Art Society Sixth Annual Exhibition, Education Building, Loftus Street, Sydney, 26 June–14 July 1944: five paintings

Contemporary Art Society Exhibition, Velasquez Gallery, Melbourne, September 1944: six paintings

Night Flight and Sunrise: Poems, by Geoffrey Dutton: book jacket design by Nolan, published by Reed & Harris, Melbourne, 1944

1945
Nolan works with Reed & Harris—publishers of *Angry Penguins* and modern Australian literature; living at 'Heide', he embarks on his first Ned Kelly paintings and drawings (the earliest known is dated 'March 14th 45'). His younger brother, Raymond John Nolan, drowns at Cooktown, Queensland—just before the war ends in August.

Contemporary Art Society Exhibition Catalogue, Myer Gallery, Melbourne, 21–31 August 1945: six paintings (one ex-catalogue)

Contemporary Art Society, Sydney, November 1945

Psychiatric Aspects of Modern Warfare, by Reginald Spencer Ellery: book cover illustration, Reed & Harris, Melbourne, 1945

1946
Nolan and Max Harris travel together through the 'Kelly country' of north-eastern Victoria. The well-known series of Ned Kelly paintings (now in A.N.G.)—probably the most carefully planned and considered works of Nolan's career—are produced at this time, inscribed with dates from 1 March 1946 to 18 May 1947.

Archibald, Wynne and Sulman Competitions for 1945, A.G.N.S.W., January 1946:

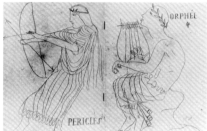

portrait of Albert Tucker submitted for Archibald Prize

Three Members of the Contemporary Art Society, Rowden White Library, University of Melbourne, 23 July 1946: exhibition with Albert Tucker and Arthur Boyd

Contemporary Art Society 4th Annual Exhibition, Institute Building, North Terrace, Adelaide, 23 July–August 1946: one painting

Contemporary Art Society Eighth Annual Interstate Exhibition, Education Galleries, Loftus Street, Sydney, 12–28 November 1946: two paintings

Contemporary Art Society Catalogue, Melbourne (exact location and dates unspecified): four paintings

Living mainly at 'Heide'; about two months 'caretaking' Vassilieff's house, 'Stonygrad', at Warrandyte at the end of the year

1947

Nolan departs for Queensland, via Sydney, early in July 1947; he exhibits in Brisbane at the Miya Studio and the Ballad Bookshop, run by Charles Osborne and Barrie Reid; spends a nomadic six months travelling to Bundaberg, Tamborine, Maryborough and out to Fraser Island in August, back to Brisbane and again to Fraser Island in October; then to the far north—Green Island, Cairns, Port Douglas and Cape York peninsula at the end of the year—new landscapes which affect his imagination for many years to come.

Returning to Sydney, be borrows Alannah Coleman's studio at 151 Dowling Street, Woolloomooloo.

Notes from a Journey: poems, by Harry Roskolenko: book jacket design, Meanjin Press, Melbourne, 1947

Christmas at 'Heide', c.1945:
Nolan, Sunday Reed (1905–81), John Sinclair and John Reed (1901–81). Nolan's relationship with the Reeds was based on both intimate friendship and a deeply felt sense of common endeavour. Photograph by courtesy of Barrett Reid

1948

Nolan settles in Sydney with novelist Cynthia Hansen, née Reed, and her daughter Jinx, at 8 Woniora Avenue, Wahroonga; they marry on 25 March 1948; taking advantage of a Government amnesty, he obtains a dishonourable discharge from the army. From June to September Nolan and family travel in Central, far north and Western Australia.

Paintings by Sidney Nolan, Moreton Galleries, Brisbane, 17–28 February 1948: twelve Fraser Island paintings

Easter Exhibition, Macquarie Galleries, Sydney, 17 March–5 April 1948: one work

The "Kelly" Paintings of Sidney Nolan 1946–47, Velasquez Gallery, Tye's Furniture Store, Bourke Street, Melbourne, April 1948: twenty-six paintings lent by Sunday Reed and one lent by Clive Turnbull; organized by Sunday and John Reed

The Sydney Group: Paintings and Drawings, David Jones' Art Gallery, Sydney, April–May 1948: five paintings

Studio of Realist Art, 3rd Annual Exhibition, David Jones' Art Gallery, Sydney, 18–31 August 1948: four works

Miya Studio, Fourth Annual Exhibition, Finney's Art Gallery, Brisbane, 23–28 August 1948: three works, no catalogue

Orphée, play by Jean Cocteau, produced by Sam Hughes for the Sydney University

Dramatic Society, September 1948: Nolan designs the décor and a programme illustrated with transfer drawings; paints the sets in collaboration with Margaret Olley.

Contemporary Art Society tenth annual interstate exhibition, Education Department Galleries, Sydney, 6–24 November 1948: three paintings

Christmas Exhibition, Macquarie Galleries, Sydney, 1–24 December 1948: one work

1949

Archibald, Wynne and Sulman Competitions for 1948, A.G.N.S.W., 22 January–7 March 1949: one landscape submitted for Wynne Prize

Contemporary Art Society Fifth State Exhibition, Education Department Galleries, Sydney, 5–16 March 1949: two paintings

Sidney Nolan Exhibition of Queensland Outback Paintings, David Jones' Art Gallery, Sydney, 8 March 1949: twenty-seven paintings and ten graphic works

Easter Exhibition of paintings and sculpture, Macquarie Galleries, Sydney, 6–23 April 1949

Sidney Nolan paintings of the Eureka Stockade, Macquarie Galleries, Sydney, 20 June–July 1949: sixty-six paintings on glass

Contemporary Art Society eleventh annual interstate exhibition, Education Department Galleries, Sydney, 15 October–2 November 1949: two paintings on glass

Exhibition of paintings 1937–47 by five Australian artists, Macquarie Galleries, Sydney, 2–24 November 1949: two paintings

Gallery Acquisitions for 1949, A.G.N.S.W., December 1949: two paintings

Un group d'oeuvres du peintre Australien Sidney Nolan, Maison de l'Unesco, 19 Avenue Kléber, Paris, December 1949: twenty-seven Kelly paintings of 1946–47; organized by the Reeds who were then living in Paris; catalogue introduction by

Jean Cassou, Curator-in-chief of the Musée national d'art moderne

1950

Archibald, Wynne and Sulman Competitions for 1949, A.G.N.S.W., 21 January–5 March 1950: one landscape submitted for Wynne Prize

Show of Sixes: Exhibition of Paintings, Macquarie Galleries, Sydney, 1–20 February 1950: one work

Sydney Art Today, Exhibition of Paintings, Macquarie Galleries, Sydney, 28 February–10 March 1950: two paintings

Sidney Nolan Exhibition of Central Australian Landscapes, David Jones' Art Gallery, Sydney, 31 March 1950: forty-seven paintings

Australian Art Contest—Dunlop Rubber Australia Ltd, Melbourne and interstate tour, 5 June 1950: first prize £250 for no. 463 'Inland Australia'

Exhibition of Paintings—Sidney Nolan, Macquarie Galleries, Sydney, 28 June–10 July 1950: twenty-six works

Sidney Nolan: Central Australian Landscapes, Stanley Coe Gallery, Melbourne, 3–13 July 1950: sixteen paintings

Contemporary Art Society Exhibition, Royal South Australian Society of Arts Gallery, Adelaide, 25 July–5 August 1950: two paintings (one lent by Max Harris)

110 Years of Australian Art: an exhibition of the art of Australia—Drawings, Paintings, Sculpture—since 1840, Farmer's Blaxland Gallery, Sydney, September 1950: one painting

Una serie di quadri ad olio del pittore Australiano Sidney Nolan gentilmente concessi da Mrs e Mr John Reed di Melbourne, Libreria Ai Quattro Venti, Largo Giuseppe Toniolo, Rome, 17–31 October 1950: the Kelly paintings, with introductions by Jean Cassou and Gino Nibbi

Exhibition of paintings (Christmas exhibition), Macquarie Galleries, Sydney, 6–21 December 1950: one work

Nolan travels in Central Australia again; and, at the end of the year, he journeys overseas for the first time.

1951

Living in Cambridge, England; Nolan visits France, Spain, Portugal and Italy; first one-man show in London.

Sidney Nolan; Sylvia Gosse; Vera Cunningham; French Paintings, Redfern Gallery, London, January–February 1951: thirty-nine works

Archibald, Wynne, Sulman—Competitions for 1950, A.G.N.S.W., 20 January–4 March 1951: one landscape for Wynne Prize

Exhibition of Paintings, Sydney Art Today presented by the Macquarie Galleries, Sydney, Royal South Australian Society of Arts, Adelaide, 3–14 July 1951: one painting

Nolan and family return to Australia.

Sidney Nolan European Paintings, Macquarie Galleries, Sydney, 10 October 1951: forty-two paintings

Jubilee Exhibition of Australian Art, organized by Laurie Thomas for the Plastic Arts Committee, Commonwealth Jubilee Celebrations, A.G.N.S.W., 28 June–23 July 1951 and tour to all states: one painting

1952

Archibald, Wynne and Sulman Competitions for 1951, A.G.N.S.W., 26 January–24 February 1952: one landscape submitted for Wynne Prize

Show of Sixes, Annual exhibition, Macquarie Galleries, Sydney, 6–18 February 1952: one work

Blake Prize, Mark Foy's Art Gallery, Sydney, 12–29 March 1952: two paintings; awarded third prize for *Flight into Egypt*

Sidney Nolan European Paintings, Stanley Coe Gallery, Melbourne, March 1952

Easter Exhibition of Paintings, Macquarie Galleries, Sydney, 2–21 April 1952: one work

Inland Australia: Ayer's Rock as illustrated in Walkabout *magazine*
Photograph: The artist

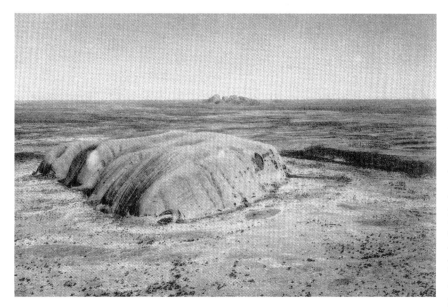

Sidney Nolan, Royal South Australian Society of Arts, Adelaide, 6–17 May 1952: eighteen works

Society of Artists, Autumn Exhibition, David Jones' Art Gallery, Sydney, 9–24 May 1952: one painting

M-G-M's "American in Paris" Art Exhibition, David Jones' Art Gallery, Sydney, 27 May–7 June 1952: one work

Macquarie Galleries Exhibition, Sydney Painting 1952, Victorian Artists' Society, Melbourne, 11–21 June 1952: two works

Sydney Group, Macquarie Galleries, July–August 1952: two paintings

Commissioned by the Brisbane *Courier-Mail* to make drawings of devastated outback droughtlands, Nolan makes an extensive tour of desert areas by diesel truck and light aircraft—departing from Darwin in August.

Sidney Nolan, Johnstone Gallery, Brisbane, 9 September 1952: drought paintings and European subjects

Two exhibitions of drawings: Donald Friend, Sidney Nolan, Macquarie Galleries, Sydney, October 1952: twenty-four drawings

D. Khayatt; Maurice Utrillo; Michael Ayreton; Sidney Nolan, Redfern Gallery, London, 2 October 1952: thirty-three paintings

The 1952 Pittsburgh International Exhibition of Contemporary Painting, Department of Fine Arts, Carnegie Institute, Pittsburgh, 16 October–14 December 1952: one Burke and Wills painting; along with Dobell, Drysdale and Friend

1953

Nolan visits remote inland Australia and the Birdsville Track—'the loneliest mail run in the world'— with John Heyer, director of the film *The Back of Beyond* sponsored by the Shell Company.

Society of Artists, Autumn Exhibition, David Jones' Art Gallery, Sydney, 1–16 April 1953: four sketches

Blake Prize, Mark Foy's Gallery, Sydney, 9–30 April 1953: one painting

Loan Paintings from Brisbane Private Collections, Queensland Art Gallery, Brisbane, 20 May–21 June 1953: two paintings

Drought Paintings by Sidney Nolan, Peter Bray Gallery, Melbourne, June 1953: thirty-one works

Twelve Australian Artists, Arts Council of Great Britain, New Burlington Galleries, Burlington House, London, 24 July 1953; thence to Bath, Bradford, Derby, Bristol, Belfast and the Venice Biennale of 1954: ten paintings. The London *Times* considers 'Mr Sidney Nolan the strongest and most curious of these artists'.

Sidney Nolan Exhibition of Paintings, David Jones' Art Gallery, Sydney, 29 July–15 August 1953: twenty-seven works

Sidney Nolan, Johnstone Gallery, Brisbane, 15 September 1953: twenty-four Australian paintings

A restrospective exhibition of Australian Painting, A.G.N.S.W., 25 September–25 October 1953: two paintings

Sydney Group: Paintings, David Jones' Art Gallery, Sydney, 1–15 October 1953: two paintings

Christmas Exhibition of Paintings, Macquarie Galleries, Sydney, 9–22 December 1953: one painting

International Exhibition, New Delhi

Nolan and family return to Europe—where he has based his career ever since.

1954
Show of Sixes, Macquarie Galleries, Sydney, 27 January–12 February 1954: one painting

Visit to southern Italy

Sidney Nolan and Albert Tucker, International Press Club, Rome, May 1954: drought paintings

XXVII Biennale internazionale d'arte, Venice, summer 1954: includes the ten paintings by Nolan which toured Britain in 1953–54; Nolan serves as Australian commissioner.

Back of Beyond, exhibition of drawings by Nolan relating to the film by John Heyer which won the Film Festival *grand prix*, Venice Lido, 1954

The Redfern Gallery Summer Exhibition, Redfern Gallery, London, July–August 1954: two paintings

1955
The Nolans settle in London—a small flat near Paddington Station.

Sidney Nolan, Macquarie Galleries, Sydney, 2 March 1955: thirty-seven Italian drawings

The Redfern Gallery presents Sidney Nolan: Paintings, Drawings, Redfern Gallery, London, 3 May 1955: sixty-six works

Contemporary Australian Paintings, an exhibition of Australian paintings, recently purchased by the State Galleries, A.G.N.S.W., 11–29 May 1955: one painting

The Redfern Gallery Summer Exhibition, Redfern Gallery, London, July–August 1955: one painting

First Loan Exhibition, National Gallery Society of New South Wales, Sydney, 28 September–19 October 1955: five paintings

The 1955 Pittsburgh International Exhibition of Contemporary Painting, Department of Fine Arts, Carnegie Institute, Pittsburgh, 13 October–18 December 1955: one Kelly painting

To Greece in November, urged to visit by George Johnston and Charmian Clift

1956
Spends some months on Hydra; visits the Gallipoli peninsula in spring; to Italy on British Council/Italian Government Scholarship, with a studio in the British School at Rome; returns to London; then to Australia and back via Greece, Turkey, India, Cambodia—commissioned to produce a series of paintings for Qantas offices; first one-man show in New York.

Sidney Nolan, Durlacher Bros, New York, March–April 1956: eighteen paintings

Sidney Nolan, Johnstone Gallery, Brisbane, 21 March 1956: Italian subjects

Small studio exhibition, British School at Rome, May–June 1956

Contemporary British Painting and Sculpture, Arthur Jeffress, London, May–June 1956

The "Kelly" paintings 1946–47, Sidney Nolan, The Gallery of Contemporary Art, Tavistock Place, Melbourne, June 1956: paintings lent by Sunday Reed

Sidney Nolan, Macquarie Galleries, Sydney, 8 August 1956: thirty-six Greek drawings

Ned Kelly, play by Douglas Stewart, produced by John Sumner: designs for stage cloths and theatre programme, Australian Elizabethan Theatre Trust, Elizabethan Theatre, Newtown, Sydney, 3 October 1956

Contemporary Australian Painting. Pacific Loan Exhibition, s.s. *Orcades* at Auckland, Honolulu, Vancouver, San Francisco, October 1956; and A.G.N.S.W., Sydney, November 1956: three paintings

Arts Festival of the Olympic Games, Melbourne, 1956: one painting

1957
The Nolans travel to Japan and Mexico; visit America for the first time; and move from Paddington to a house overlooking the Thames at Putney. A very good year for Australians in London, with Ray Lawlor's *Summer of the Seventeenth Doll* in the west end, Patrick White's *Voss* a literary hit and Nolan's first retrospective at the Whitechapel Gallery through the summer.

Contemporary Australian Paintings, Auckland City Art Gallery, February 1957: three paintings

Sidney Nolan, Johnstone Gallery, Brisbane, 13 March 1957: Greek paintings

Famous Paintings from Australian Homes, David Jones' Art Gallery, Sydney, May 1957: one painting

Sidney Nolan: Catalogue of an exhibition of paintings from 1947 to 1957, Whitechapel Art Gallery, London, 13 June–July 1957: retrospective of 153 works, organized by Bryan Robertson; selections from this exhibition toured by the Arts Council of Great Britain to Brighton, Nottingham, Barnsley, Exeter, Southampton and Cambridge, September 1957–February 1958

Fifty paintings from Members' Collections, National Gallery Society of Queensland, Q.A.G., 16 July–18 August 1957: three paintings

Summer Exhibition, Redfern Gallery, London, July–August 1957: one painting

Contemporary Australian Painters, tour to eight Canadian cities, July 1957–May 1958: two paintings

Strangers and Brothers, novel by C.P. Snow: book jacket design for uniform edition of the 'Lewis Elliot' novels, Macmillan, London, 1957—first of numerous designs at special request of this author (Sir Charles Snow) and first for an English publisher

Voss, novel by Patrick White: book jacket design, Eyre & Spottiswoode, London, 1957—first of many designs for this author

Nolan studies engraving and lithography at Stanley Hayter's *Atelier 17* in Paris, one of the most influential and innovative European print-making studios.

1958
Nolan is awarded a two-year Commonwealth Fund Harkness Fellowship to 'record the American scene': departs for New York with his family in June; extensive journeys are described in Cynthia Nolan's *Open Negative*, published by Macmillan, 1967.

A.I.A. 25: An Exhibition to celebrate the 25th Anniversary of the Foundation in 1933 of the Artists International Association, R.B.A. Galleries, London, March–April 1958: one work (along with Picasso, Piper, Braque, Chagall, Hepworth, etc.)

The Christian Vision, Redfern Gallery, London, April 1958

Transferences, Zwemmer Gallery, London, June–July 1958; thence to Dublin, Belfast, Washington and other U.S.A. venues; thirteen artists from Australia, Canada, Ceylon, India and South Africa: one painting

The Religious Theme, Tate Gallery, London, July–August 1958

Modern Australian Art. A Melbourne Collection of Paintings and Drawings, first exhibition of the 'permanent collection' of the Museum of Modern Art of Australia, September–October 1958: forty-six works, including the 'Kelly' paintings; catalogue by Barrie Reid

Sidney Nolan, Durlacher Bros, New York, October–November 1958: fifteen paintings

50 Years of Modern Art, Brussels World Exhibition, 1958

Portraiture, the Dying Art, Roland, Browse and Delbanco, London, 1958

The Aunt's Story, novel by Patrick White: book jacket design, republished by Eyre & Spottiswoode, London, 1958 (1st edn 1948)

The Light and the Dark and *The Conscience of the Rich*, by C.P. Snow: book jacket designs, Macmillan, London, 1958

1959
The Nolans visit Washington and Chicago in spring, then on to Nebraska; returning for summer to New York where Cynthia is hospitalized with tuberculosis.

The Museum of Modern Art of Australia: a Melbourne Collection, David Jones' Art Gallery, Sydney, 18 February 1959: including 'Kelly' paintings of 1946–47

Contemporary Art Society Recent Acquisitions, Tate Gallery, London, 25 February–26 March 1959: one painting

Nolan. Paintings of Australia. Landscapes and Legends, Mount Holyoke Friends of Art, Dwight Art Memorial, South Hadley, Massachusetts, 13 April 1959: sixteen paintings lent by Durlacher Bros, New York

Redfern Summer 1959, Redfern Gallery, London, July–September 1959: one painting

The Private Collection of Robert Shaw, Challerton Gallery, 78 Castlereagh Street, Sydney, September 1959: two works

Critic's Choice, Arthur Tooth and Sons, London, October 1959: selected by Terence Mullaly.

II Documenta '59, Kassel, Germany, 1959: international survey of contemporary art

1960
The Nolans return to London.

Cynthia and Sidney Nolan at home in London, 1961
Photograph: Axel Poignant, London

Exhibits at Phoenix Art Museum, Phoenix, Arizona, February 1960

The Mervyn Horton Collection, Museum of Modern Art, 23 Roslyn Gardens, King's Cross, Sydney, February 1960: three paintings

Collectors' Exhibition, Challerton Gallery, 78 Castlereagh Street, Sydney, 16 March 1960: one painting

Festival Prize Exhibition, Royal South Australian Society of Arts, Adelaide, 15–26 March 1960: one painting

50th Anniversary Exhibition. Contemporary Art Society 1910–1960, Tate Gallery, London, April–May 1960

Contemporary Australian Art, Auckland City Art Gallery, May 1960: two paintings

Sidney Nolan—Leda and the Swan, and other recent work, Matthiesen Gallery, London, 16 June–16 July 1960: forty-four paintings; catalogue introduction by Stephen Spender

Australian Paintings, National Art Gallery, Kuala Lumpur, November 1960: one painting

The Affair and *Time of Hope*, novels by C.P. Snow (a character in *The Affair* collects Nolan's work): book jacket designs, Macmillan, London, 1960

Mr Love and Justice, by Colin MacInnes: book jacket design, MacGibbon & Kee, London, 1960

Voss, by Patrick White: new jacket design for paperback edn by Penguin Books, Harmondsworth, 1960

Man in a Landscape, the art of Sidney Nolan, Australian painter, film directed by Peter Newington for 'Monitor', narrated by Huw Wheldon, B.B.C. London, 1 December 1960; forty minutes

Ned Kelly, Australian Paintings by Sidney Nolan, film directed by Tim Burstall, Eltham Films, Melbourne, 1960; six minutes

1961

Nolan visits Egypt, as part of a proposal by Huw Wheldon for a television series entitled 'The Painter's Eye'.

The Guide, play by Harvey Breit and

Patricia Rinehart from the novel by R.K. Navayan, produced by Frank Hauser, Meadow Players Ltd in association with the Arts Council of Great Britain: set designs, Cambridge Arts Theatre, February–March 1961; Oxford Playhouse, March 1961; and London (very well reviewed)

Sidney Nolan, retrospective exhibition, Hatton Gallery, University of Newcastle-upon-Tyne, March 1961; thence to Sheffield, Leeds, Hull, Bristol, Liverpool, Edinburgh, Wakefield: works since 1937, organized by Prof. Kenneth Rowntree; catalogue introduction by John Russell

Recent Australian Painting, Whitechapel Art Gallery, London, June–July 1961; then selections toured by Arts Council of Great Britain to Cambridge, Hull, Liverpool and Southampton during 1962: two paintings; catalogue introduction by Robert Hughes, preface by Bryan Robertson

Summer Exhibition 1961, Redfern Gallery, London, June–August 1961

Sidney Nolan, Bonython Art Gallery, Adelaide, 11 September 1961: thirty-four recent paintings

American sketches at U.S.I.S., United States Embassy, London, September 1961

Sidney Nolan at Australian Galleries, Derby Street, Collingwood, 31 October–17 November 1961: twenty-nine paintings, plus prints, exhibition to aid the National Gallery and 'Cultural Centre' building appeal

1940–1945: Paintings by Arthur Boyd, Sidney Nolan, John Perceval, Albert Tucker, Museum of Modern Art of Australia, Melbourne, 17 October–14 November 1961: twelve paintings

Australian Artists, Raymond Burr Galleries, Beverley Hills, California, 30 November 1961

The Australian Vision, touring exhibition organized by Council of Adult Education and N.G.V., 1961: one painting

Drawing towards painting, Arts Council of Great Britain touring exhibition, U.K., 1961–62

Leda Suite, eight lithographs from stone, edn of 125; printed by John Watson, published by Ganymede Press, London, November 1961—15 gns each

Riders in the Chariot, new novel by Patrick White: book jacket design, Eyre & Spottiswoode, London, 1961

Tree of Man, novel by Patrick White: cover for paperback edn, Penguin Books, Harmondsworth, 1961

Homecomings, by C.P. Snow: book jacket design, Macmillan, London, 1961

Sidney Nolan, monograph by Sir Kenneth Clark, Colin MacInnes and Bryan Robertson: with cover illustration by Nolan, Thames & Hudson, London, 1961

1962

Exhibition of Paintings, Royal South Australian Society of Arts, Adelaide, February 1962: one painting

Sidney Nolan, Durlacher Bros, New York, March–April 1962

Australian Painting. Colonial, Impressionist, Contemporary, A.G.S.A., Ade-

laide Festival, March 1962; thence to Perth, London (Tate Gallery), Ottawa, Vancouver, until June 1963: six paintings

Nolan '37–'47, Institute of Contemporary Art, London, 15 May 1962: approximately forty paintings and many works on paper

Rite of Spring: décor and costumes for a new production of Stravinsky's ballet by Kenneth MacMillan, the Royal Ballet, Covent Garden, London, May 1962 and Metropolitan Opera House, New York, April 1963

Rebels and Precursors, Aspects of Australian Painting in Melbourne 1937–1947, N.G.V., August–September and A.G.N.S.W., September–October 1962: organized by Eric Westbrook and Albert Tucker; Nolan's selections of own work—thirty-four paintings and drawings

Commonwealth Art Today, Commonwealth Institute, London, 7 November 1962

International Exhibition and Sale of Contemporary Art, O'Hara Gallery, London, November 1962

Nolan travels to Africa in the autumn. He also returns briefly to Australia in November, his first visit in five years—'to charge my batteries', he tells the local press.

Recent Paintings by Sidney Nolan, Skinner Galleries, Perth, 26 November–December 1962: twenty-nine paintings; opened in the presence of H.R.H. Duke of Edinburgh, to assist the Music Bursary of Western Australia

Four Arts in Australia, touring exhibition to Malaysia, Thailand, Laos, Cambodia, Vietnam, Philippines and Indonesia, during 1962: one painting

An Australian Story 1837–1907, by Maie Casey: book jacket illustration, Michael Joseph, London, 1962

Outback, by Cynthia Nolan: cover from a painting of 1948 plus illustrations, Methuen, London, 1962; Danish edn, *Bag Australiens ryg*, published Copenhagen, 1963

Outrider. Poems 1956–1962, by Randolph Stow: book jacket and seven illustrations, Macdonald & Co., London, October 1962

The Living and the Dead, novel by Patrick White (1st edn 1941): new jacket design, Eyre & Spottiswoode, London, November 1962

Sidney Nolan: film directed by Dahl and Geoffrey Collings for Qantas, Sydney, commentary by Laurie Thomas, spoken by Rod Milgate; twenty-one minutes, using 120 works of art

1963

Nolan is created Commander of the Order of the British Empire in the New Year's Honours list, for services to art in Britain.

He spends some time in Greece.

Australian Painting and Sculpture in Europe Today, New Metropole Arts Centre, Folkestone, 20 April 1963 and Stadel'sches Kunstinstitut, Frankfurt-am-Main, 4 July 1963: organized by Australian expatriate artist, Alannah Coleman; with Boyd, Blackman, French, Whiteley, Delafield Cook, etc.

Stravinsky and the Theatre, a catalogue of décor and costume designs for stage productions of his works 1910–1962, The New York Public Library, New York, 1963: ten designs

Sidney Nolan, African Journey, Marlborough Fine Art, London, May–June 1963: thirty-four paintings and eleven drawings

British Painting in the Sixties, organized by the Contemporary Art Society, Tate Gallery, London, 1–30 June 1963; selections to Manchester, Glasgow, Hull, Zurich, until September 1963: three paintings

The Ned Kelly Paintings 1946–47, Sidney Nolan, Museum of Modern Art and Design of Australia, Georges Art Gallery, Melbourne, 25 June–13 July 1963: twenty-five paintings, 'cleaned and revarnished ... and ... reframed for this exhibition'

Paintings from the Kym Bonython Collection of Modern Australian Art, Museum of Modern Art and Design of Australia, Ball and Welch Ltd, Melbourne, 8–31 October 1963: three paintings

The World's 100 Leading Painters, Dunn International, Beaverbrook Art Gallery, Fredericton, New Brunswick, Canada, September 1963; and Arts Council of Great Britain, Tate Gallery, London, 15 November–December 1963: one painting

Sydney Harbour, A.G.N.S.W., 30 October–19 November 1963: one work, not catalogued

Viscount Collection: 'The Australian Scene', paintings by seven artists from the collection of Godfrey Phillips International Pty Ltd, touring six states 1963–64; organized by Australian Galleries

Australian Painting Today, touring exhibition to six state Galleries, 19 September 1963–5 July 1964: four paintings; thence to Hotel de Ville, Brussels, 23 October 1964; Galerie Creuze, Paris, 19 November; Cultureel Centrum de Beijerd, Breda, 24 January 1965; Folkwang Museum, Essen, 26 February; Town Hall, Lyngby, Copenhagen, 30 April; Town Hall, Aarhus, 20 May; Art Hall, Gothenburg, 14 June; Munich, 9 August; Parma, 21 October; Belgrade, 6 December 1965: three paintings; organized by Laurie Thomas and the Commonwealth Art Advisory Board

Tourmaline, by Randolph Stow: book jacket illustration, Macdonald & Co., London, 1963

Cooper's Creek, the story of Burke and Wills by Alan Moorehead, written at Nolan's suggestion: cover illustration from a painting of 1948, Hamish Hamilton, London, 1963

The Aunt's Story, by Patrick White: cover for paperback edn, Penguin Books, Harmondsworth, 1963

1964

Nolan arrives in Sydney, January 1964, to join a U.S. Navy expedition to Antarctica with writer Alan Moorehead.

The Display: décor and lyrebird costume for ballet by Robert Helpmann, The Australian Ballet, Adelaide Festival of Arts, March 1964; subsequent interstate tour; thence to London, Liverpool, Glasgow and elsewhere overseas

Photograph by courtesy of William Akers, The Australian Ballet

Sidney Nolan: an exhibition of Recent African Paintings, Bonython Art Gallery, Adelaide, 8 March 1964: thirty-four paintings

'54–64' Painting and Sculpture of a Decade, Calouste Gulbenkian Foundation, Tate Gallery, London, 22 April 1964: two paintings

The Sidney Nolan 'Ned Kelly' Paintings 1946–47, Qantas Gallery, London, June 1964; thence to David Hume Tower, University of Edinburgh, Edinburgh Festival 1964; Qantas Gallery, Paris; Qantas Gallery, Sydney, September 1964: twenty-five paintings lent by Sunday Reed

Australian Painting. XIX and XX Century, Auckland City Art Gallery, March 1964 and tour to nine other New Zealand venues during 1964: two paintings

Sidney Nolan. A series of studies based on the Shakespearian Sonnets, Guildhall, City of London Festival, July 1964; Aldeburgh Festival; Hatton Gallery, University of Newcastle-upon-Tyne, December 1964; organized by Marlborough Fine Art

Nieu Realisten, Gemeentmuseum, The Hague, Netherlands, 1964

Marlborough: Opening of the Print Department, Marlborough Fine Art, London, 1964: two Kelly lithographs, edn of sixty-five

"You-Beaut Country": Australian Landscape Painting 1837–1964, N.G.V. and Museum of Modern Art and Design of Australia, Melbourne, 29 October–19 December 1964

The 1964 Pittsburgh International Exhibition of Contemporary Painting and Sculpture, Museum of Art, Carnegie Institute, Pittsburgh, 30 October 1964–10 January 1965: one Gallipoli painting

Sidney Nolan, The Arts Club of Chicago, December 1964–January 1965

Minotaur, lithographs published by Ganymede Press, London, edn of seventy-five

My Brother Jack, semi-autobiographical novel by George Johnston: book jacket illustration, Collins, London, 1964

The Burnt Ones, short stories by Patrick White: jacket illustration, Eyre & Spottiswoode, London, 1964

Riders in the Chariot, by Patrick White: cover for paperback edn, Penguin Books, Harmondsworth, 1964

The Corridors of Power, by C.P. Snow: book jacket illustration, Macmillan, London, 1964

1965
Nolan is awarded the second Creative Arts Fellowship (succeeding Perceval) at the A.N.U., Canberra; travels to Queensland, New Guinea, Indonesia, Pakistan, Afganistan, Nepal; first visit to China, including Canton, Shanghai, Peking and the ancient city of Sochow; 'seeking a whole new colour range', he says, 'Some artists invent their colour relationships and others go to look for them. I'm the latter kind' (Port Moresby, January 1965). Moves to New York at the end of the year.

Pop Art, Nouveau Realism etc., Palais des Beaux Arts, Brussels, Belgium, 1964

Sidney Nolan, Marlborough-Gerson Gallery, New York, January 1965: forty-three paintings plus works on paper; catalogue by Robert Melville and Alan Moorehead

Time Magazine, 16 April 1965: portrait of Rudolf Nureyev as first of numerous cover illustrations for *Time*

Sidney Nolan: Recent Works, Marlborough Fine Art, London, May 1965: forty-seven works

Nolan, David Jones' Art Gallery, Sydney, 5–22 May 1965: twenty-four paintings

Antarctic paintings at the R.G. Menzies Library, A.N.U., Canberra, 16 June 1965, no catalogue

Recent Paintings, A.N.U. and Dept of the Interior, Albert Hall, Canberra, 2 August–September 1965: introduction by Donald Brooks

Commonwealth Arts Festival: Treasures from the Commonwealth, Royal Academy, London, 17 September–November 1965: four paintings

Sidney Nolan, Australian Galleries, Collingwood, 21 September–October 1965: twenty-six Antarctic paintings

Sidney Nolan, an exhibition of paintings at the home of Dr and Mrs Keith Anderson, 'Yamba', 33 Chapel Street, St Kilda, 3 October 1965: fifty-five paintings; organized by Brian Finemore, for the A.E.H. Nickson Travelling Scholarship Fund, University of Melbourne

Sidney Nolan, Terry Clune Galleries, Sydney, 1965: prints and lithographs

The English Eye, Marlborough-Gerson Gallery, New York, November 1965: catalogue by Robert Melville and Bryan Robertson

Antarctic Paintings by Sidney Nolan, Bonython Gallery, Adelaide, 15 November–2 December 1965

Marlborough Prints, screenprints published by Marlborough Fine Art, London: seven Ned Kelly (edn of sixty-five); illustrations to Baudelaire, Rilke and Mentale

Eureka Stockade mural for the Reserve Bank of Australia, Melbourne: sixty-six enamelled copper panels, designed by Nolan and produced in collaboration with artists Miss Robin Banks and Patrick Furze, London

Toehold in History film of Nolan's 'Gallipoli' directed by Dahl and Geoffrey Collings for Qantas, twenty-one minutes; premiere in Canberra, March 1965

In Excited Reverie: A Centenary Tribute to William Butler Yeats 1865–1935, eds A. Norman Jeffares & K.G.W. Cross: book jacket illustration, Macmillan, London, Melbourne, Toronto and St Martin's Press, New York, 1965

1966
In New York for the first six months of 1966, Nolan rents a penthouse and studio at the celebrated Chelsea Hotel; works with the poet Robert Lowell.

Exhibition of Paintings by Sidney Nolan, City of Shepparton Art Gallery, February 1966: mainly pictures loaned by the artist's family

Birds in Contemporary Art—a loan exhibition, The Phillips Collection, Washington D.C., February–March 1966: one Antarctic painting

The Mertz Collection of Contemporary Australian Painting, A.G.S.A., Adelaide Festival of Arts, March 1966: four paintings

13 Screenprints by Sidney Nolan, Australian Galleries, Collingwood, 8 March 1966: 'Kelly', 'Convict', 'Warrior' and others

Nolan, Piper, Richards, Marlborough New London Gallery, Old Bond Street, London, April–May 1965: seven paintings

Gallipoli studies, Qantas Gallery, Sydney, 20 April 1966: 145 works; organized by Hal Missingham

An exhibition of recent paintings, drawings and sculpture 1958–1966 by the Harkness Fellows, Leicester Galleries, London, June–July 1966: four paintings

Australian Prints Today, Division of Graphic Arts, Smithsonian Institution, Washington D.C., 15 July 1966: five works

Aspects of Australian Painting, Auckland City Art Gallery, October 1966

Paintings from the Collection of Mr and Mrs Douglas Carnegie, N.G.V., 27 October–30 November 1966: five paintings

Animal Painting: Van Dyck to Nolan, The Queen's Gallery, Buckingham Palace, London, 1966–67: one painting

Sidney Nolan, Court Gallery, Copenhagen, 11–22 December 1966: graphic works

Exhibition of prints with Arthur Boyd, Moreton Galleries, Brisbane, 1966

1967
Visits Morocco; in Australia for the opening of his retrospective exhibition

in September; returns to London via Mexico, October 1967; in Paris to produce a set of lithographs on the 'Jerilderie Letter' at Mourlot Studios.

Sidney Nolan, San Antonio Art League, Witte Memorial Museum, San Antonio, Texas, January–February 1967

The Australian Painters 1964–1966: Contemporary Australian Painting from the Mertz Collection, Port Washington, New York, Corcoran Gallery, Washington D.C., March 1967 and U.S. tour

Easter Exhibition, Kym Bonython's Hungry Horse Art Gallery, Sydney, March 1967

Paintings for Expo/67, Australian Pavilion, Universal and International Exhibitions— 'Man and his World', Montreal, Canada, April-October 1967: two paintings

Sidney Nolan Retrospective Exhibition, Paintings from 1937 to 1967, A.G.N.S.W., 12 September–2 October 1967; N.G.V., 22 November–17 December 1967; A.G.W.A., 9 January–4 February 1968: 143 paintings; organized by Hal Missingham and Daniel Thomas

Exhibition of drawings by Sidney Nolan, Kym Bonython's Hungry Horse Art Gallery, Sydney, 18–29 September 1967: 'Jerilderie Letter', 'Paradise Lost', 'Near the Ocean'.

Nolan—Recent Paintings 1966–67, David Jones' Art Gallery, Sydney, 20 September–14 October 1967: twenty-four works

26 ballet and theatre designs, Qantas House, Sydney, 19 September–9 October 1967: thirty-five works

Sidney Nolan, Shakespeare Sonnets, Macquarie Galleries, Sydney, 20 September–14 October 1967: forty works

Sidney Nolan Asian and Promethean Studies, R.G. Menzies Library, A.N.U., Canberra, September–October 1967

Brighton Historical Society present an Exhibition of Paintings by Sidney Nolan, Brighton Town Hall, October 1967: loans from the artist and his mother

Ned Kelly, the paintings of 1946–47 at Tolarno Galleries, St Kilda, on loan from Sunday Reed; and a selection of early works at Strines Gallery, Carlton, November 1967

Octave Landuyt and Sidney Nolan, Kunstkring Tilburg, University of Tilburg, Netherlands, 25 November–20 December 1967: prints

Sidney Nolan—Landscapes, Drawings and Shakespeare Sonnet paintings, Australian Galleries, Collingwood, 28 November–22 December 1967

Paintings and Sculpture from the London Galleries of Marlborough Fine Art Ltd, London, Rome, New York, Bonython Galleries, Paddington and North Adelaide; Australian Galleries, Collingwood, during 1967: one painting

1967 Pittsburgh International Exhibition of Contemporary Painting and Sculpture, Museum of Art, Carnegie Institute, Pittsburgh, 27 October 1967–7 January 1968: *Drought* triptych

This Dreaming, Spinning Thing: film produced by Storry Walton for the A.B.C.,

script by George Johnston; sixty minutes (premiere 6 January 1970)

Prometheus Bound, prose play by Robert Lowell (from Aeschylus), first produced June 1967 at the Yale School of Drama: four illustrations and book cover by Nolan for publication 1967

Near the Ocean, poems by Robert Lowell: illustrations, Farrar, Straus & Giroux, New York, 1967

Open Negative, Cynthia Nolan's account of their experiences in America: book jacket and illustrations, Macmillan, London, 1967

1968
A long sojourn in Australia this year

Nolan, Recent Paintings, Skinner Galleries, Perth, 14 January–2 February 1968: twenty-five works

The 1946–47 Ned Kelly Paintings by Sidney Nolan, Auckland City Art Gallery, 15 March–10 April; Canterbury Art Society Gallery, Christchurch, 18 April–12 May; National Gallery, Wellington, 20 May–2 June 1968: lent by Sunday Reed

Australian Artists working in Britain, Bear Lane Gallery, Oxford, March–April 1968

Sidney Nolan Recent Work, Marlborough Fine Art, London, May 1968: forty-seven works; introduction by Robert Melville

Sidney Nolan—An Exhibition of Paintings, Aldeburgh Festival, June 1968: 150 'Paradise Garden' paintings

An exhibition of paintings by Sidney Nolan touring the Victorian Public Galleries group, Mildura Arts Centre, August 1968; thence to Geelong, Ballarat, Sale, Swan Hill, Bendigo and Castlemaine, until March 1969: thirty-three works lent by the artist's mother

Honorary Doctorate of Law, A.N.U., Canberra, 6 September 1968

Swansong: poems, by Charles Osborne: illustrations for limited edn of 500, Shenval Press, London, 1968

'The Voyage' and other versions of poems by Baudelaire, by Robert Lowell: illustrations, Faber, London, 1968

1969
Arthur Boyd—Sidney Nolan, Joseph Brown Gallery, 5 Collins Street, Melbourne, 20 February–13 March 1969: eleven paintings and 'Leda' lithographs

The Aubrey Gibson Collection, N.G.V., 28 July–17 September 1969: two paintings

Spring Exhibition 1969, Joseph Brown Gallery, Melbourne, 15 September–8 October 1969: one painting

Arthur Boyd—Sidney Nolan, Villiers Fine Art, Double Bay, Sydney, 14–27 October 1969: seven paintings, plus lithographs

Drought, series of five lithographs published 1969

Britannica Australia Award for contributions to arts, science and humanities, October 1969

A Sight of China, by Cynthia Nolan: drawings by Nolan, Macmillan, London, 1969

1970
Sidney Nolan recent paintings, Skinner Galleries, Perth, 3 February 1970; as part of the eighteenth Festival of Perth

Sidney Nolan Retrospective Exhibition, The Arts Centre, New Metropole, Folkestone, February–April 1970; thence to Hayworth Gallery, Accrington; Laing Art Gallery, Newcastle-upon-Tyne; Ferens Art Gallery, Hull; University of East Anglia Library

Autumn Exhibition 1970, Joseph Brown Gallery, Melbourne, 2–23 March 1970: two paintings

Wimmera Paintings of Sidney Nolan, Adelaide Festival of Arts Exhibition, David Jones' Art Gallery, Adelaide, March 1970: twenty-three paintings; catalogue introduction by Max Harris

Sidney Nolan: Paradise Garden, N.G.V., 2–28 April 1970: 220 frames of six paintings, as part of 'Landfall'—Captain Cook bi-centenary exhibition

Flower paintings at Aldeburgh Festival, June 1970

Screenprints at Richard De Marco Gallery, Edinburgh, July–August 1970

Helpra Prints at the Hayward Gallery, London

Spring Exhibition 1970—Recent Acquisitions of Paintings and Sculpture, Joseph Brown Gallery, Melbourne, 14 September–5 October 1970: one painting

The 1970 Pittsburgh International Exhibition of Contemporary Art, Museum of Art, Carnegie Institute, Pittsburgh, 30 October 1970–10 January 1971: *Glenrowan* polyptych and *Central Park* triptych

1971
Honorary Doctorate of Literature, University of London

Honorary Fellow of York University

Fellow of the Bavarian Academy

Nolan visits Australia for the Adelaide Festival, with Benjamin Britten and Peter Pears; they travel to Alice Springs and the Olgas.

In Germany during the summer—to Darmstadt for a small retrospective and Nuremburg, with Sir Kenneth Clark to see an exhibition of Dürer's work; also visits Ireland, France and Portugal.

Sidney Nolan Paintings '40–'70, Skinner Galleries, Perth, 19 January 1971; also through the agency of Mrs Rose Skinner, sixty panels from *Paradise Garden* are installed in the Perth Concert Hall at this time for the Festival of Perth.

Autumn Exhibition—1971 (Recent Acquisitions), Joseph Brown Gallery, Melbourne, 3–21 March 1971: two paintings

Paintings: Shakespeare's Sonnets, Paradise Garden, Bats, Ashmolean Museum, Oxford, April–May 1971

Sidney Nolan: Gemälde und Druckgraphik, Kunsthalle, Darmstadt, May–June 1971: ninety-one works

Snake (120 panels), Aldeburgh Festival, June 1971; and thence to Heslington Hall, York University

Winter Exhibition 1971—Recent Acquisitions of Paintings and Sculpture, Joseph Brown Gallery, Melbourne, 10–30 June 1971: one painting

'Dust' by Sidney Nolan, Johnstone Gallery, Bowen Hills, Brisbane, 9–31 July 1971: twenty-five etchings in edn of sixty

Beaux Livres, The Artist and the Book, Maltzahn Gallery, London, December 1971

Other exhibitions at Anglesea Hall, Brighton, Victoria; Bladon Gallery, Hurstbourne Tarrant, Hampshire; work included in A.G.W.A. south-western touring exhibition

Ned Kelly, sixteen screenprints based on paintings of 1946–47, published by Marlborough Graphics, London: exhibited at Power Institute of Contemporary Art, Bonython Art Gallery, Sydney; and Mayoral Suite, St Kilda Town Hall

Paradise Garden, A Book of Paintings: poems and paintings by Nolan published by R. Alistair McAlpine Publishing Ltd, London, April 1971; deluxe edn of 110 and twenty copies with original signed drawings

Paradise, and yet, by Cynthia Nolan: an account of their travels in New Guinea with dust jacket by Nolan, Macmillan, London, 1971

1972
Second visit to China; travel to Cologne, Dusseldorf, Paris, Africa and Australia

The Australian Landscape, travelling exhibition, A.G.S.A., Adelaide Festival, 3 March–3 April 1972; thence to Perth, Melbourne, Hobart, Canberra, Sydney, Newcastle and Brisbane, until 1 April 1973: one painting

Sidney Nolan—Paradise Garden, installed at the Tate Gallery, London, November–December 1972; also at the Institute of Contemporary Art, London

Snake, installed at B.B.C. Television Centre, London, as part of the arts programme 'Open House', November 1972

Kelly Country, the paintings of Sidney Nolan: film produced by Nolan and Stewart Cooper, directed by Cooper and narrated by Orson Welles, for B.B.C. 'Omnibus', November 1972; sixty minutes

A Time Remembered, Johnstone Gallery, Brisbane, 12–30 November 1972

Sidney Nolan Paintings, Marlborough Fine Art, London, December 1972: fifty works—miners and other subjects

Marlborough Graphics including 'Kelly' screenprints, 1971–72, and other subjects, exhibited at Bonython Gallery, Sydney; Bonython Gallery, Adelaide; and Hambledon Gallery

Exhibition at the Mutual Permanent Building Society, Bendigo

1973
Extensive travels again: to Ireland, Zurich, Sweden, Japan, China, Australia

Sidney Nolan's Riverbend, Farmer's Blaxland Gallery, Sydney, 1–14 March 1973

Autumn Exhibition 1973—Recent Acquisitions, Joseph Brown Gallery, Melbourne, 26 March–11 April 1973: one painting

The Collectors, a personal choice, Fremantle Arts Centre, 4–30 April 1973

Sidney Nolan, Fuji Television Gallery, Tokyo, 10–28 April 1973: twenty-six paintings plus screenprints of 1971; assisted by Marlborough Fine Art and the Australian Embassy, Tokyo

Sidney Nolan, Ilkley Manor House, April 1973: forty works from the artist's collection

Sidney Nolan Retrospective Exhibition, Royal Society, Ballsbridge, Dublin, 19 June–5 July 1973: 168 works plus 'Oceania'—comprising the 4,000 units of *Paradise Garden*, *Snake* and *Shark*; organized by the Irish Arts Council and the Australian Dept of External Affairs; opened by the Prime Minister of Ireland, Mr Liam Cosgrave; introduction by Sir Kenneth Clark

Snake I installed on the western wall of the Great Hall, University of Sydney, 1973–74

Snake II installed in the Concert Hall, Adelaide

Shark II or '*Little Shark*' installed in the Playhouse foyer, Sydney Opera House: 240 paintings, presented by the artist on long term loan (the Playhouse was then called the 'music room'; one panel now hangs in the General Manager's office)

Winter Exhibition 1973—Recent Acquisitions, Joseph Brown Gallery, Melbourne, 18 July–2 August 1973: two paintings

The Cairnmiller Institute Exhibition of Contemporary Art by Australian Painters and Sculptors, sponsored by Alcoa of Australia Ltd, Georges Gallery, Melbourne, 7–11 August 1973

Eight Commonwealth Artists: Peter Daglish, Maqbul Husain, John Hutton, Emmanuel Jegede, Sidney Nolan, Senaka Senanayake, Stelios Votsis, Aubrey Williams, Laing Art Gallery, Newcastle-upon-Tyne, and Commonwealth Art Gallery, London, September 1973–February 1974: screenprints

Paintings and Prints by Sidney Nolan, Bonython Gallery, Adelaide, 6–20 October 1973

Sidney Nolan—Paradise Garden, Bonython Gallery, Sydney, October 1973

Sidney Nolan, Marlborough Galerie AG, Zurich, October–November 1973: fifty works

Paintings and Tapestries by Sidney Nolan, David Jones' Art Gallery, Sydney, 6–24 November 1973: twelve paintings and four tapestries

15 Floral Images, screenprints published by Marlborough Graphics from *Paradise Garden*; each 66.7 x 51.1 cm, edn of seventy

Children's Crusade—kinderkreuzzug op.82. A Ballad for children's voices and orchestra, music by Benjamin Britten, words by Bertolt Brecht, illustrations by Sidney Nolan: a limited edition of the composer's MS, Faber Music Ltd in association with Faber & Faber, London, 22 November 1973

1974
Honorary Doctorate, Leeds University

Sidney Nolan, Skinner Galleries, Perth, 12 March–5 April 1974: African paintings and other subjects

Autumn Exhibition 1974—Recent Acquisitions, Joseph Brown Gallery, Melbourne, 18 March–1 April 1974: one painting

'74' Acquisitions, Sweeney Reed Gallery, 266 Brunswick Street, Fitzroy, 18 March–7 April 1974: three works

Ern Malley and Paradise Garden, The Art Gallery of South Australia Festival Exhibitions, Adelaide, March 1974, opened by the Prime Minister, Mr Whitlam: paintings and drawings subsequently presented to the people of South Australia

Australian Artists in England, Matthew Flinders Bicentenary Celebrations, Usher Gallery, Lincoln, 4 May–9 June and Commonwealth Institute, London, 10 July–4 August 1974: four works

The Boxer Collection, University Art Gallery, University of Melbourne, 1–30 August 1974: one painting

Spring Exhibition 1974—Recent Acquisitions, Joseph Brown Gallery, Melbourne, 7–23 October 1974: one painting

Sidney Nolan Paintings and Prints, Playhouse Gallery, Harlow, Essex, October–November 1974

Gifts from Patrick White, A.G.N.S.W., 6–22 December 1974: eight works

The Darkening Ecliptic, poems by Ern Malley, drawings by Nolan: R. Alistair McAlpine Publishing Ltd, London, 1974

Beyond is Anything, film directed by Paula Nagel: A.B.C., Adelaide, 1974; fifty minutes

1975
Nolan visits Australia; travels in America; and twice to Africa.

5 Tapestries by Sidney Nolan, David Jones' Art Gallery, Sydney, 4–23 March 1975

Autumn Exhibition 1975—Recent Acquisitions, Joseph Brown Gallery, Melbourne, 2–17 April 1975: one painting

The Cynthia Nolan Collection of Paintings by Sidney Nolan, David Jones' Art Gallery, Sydney, 7–26 July 1975: forty-two paintings

The Australian Landscape 1802–1975, Cultural Palace of the Nationalities, Peking, 2–17 September; Kiangsu Art Gallery, Nanking, 23 September–7 October; A.G.N.S.W., 14–30 November 1975: three paintings; a cultural exchange exhibition with China organized by Daniel Thomas for the Visual Arts Board of the Australia Council and the Department of Foreign Affairs

Sidney Nolan—The Bush, Australian Galleries, Collingwood, 15–30 September 1975

Notes for Oedipus, Marlborough Fine Art, London, November 1975: twenty-three paintings

Nolan at Lanyon—an exhibition of the Sidney Nolan gift of twenty-four paintings to the Australian people, 'Lanyon' homestead, south of Canberra, A.C.T.: first exhibition of the permanent collection presented 1974; catalogue by Maureen Gilchrist, Australian Government Publishing Service, Canberra, 1975 and subsequent editions

1976
Travel destinations include Venice, Spitzberger, Switzerland, Germany and Australia.

Sidney Nolan, Moderna Museet, Stockholm, January–March 1976: seventy-four paintings plus works on paper

Sidney Nolan Paintings, Pieter Wenning Gallery, Johannesburg, April 1976: thirty-three works

Sidney Nolan, Fantasia Galleries, Scullin, A.C.T., 24 April–7 May 1976: including '*Dust*' etchings

The Bather Paintings, Rudy Komon Art Gallery, Sydney, 1–26 May 1976

Winter Exhibition 1976—Recent Acquisitions, Joseph Brown Gallery, Melbourne, 7–18 June 1976: two paintings

Notes for Oedipus, Realities Gallery, Melbourne, 3–19 June and Institute of Modern Art, Brisbane, 8–23 July 1976

Aspects of Australian Surrealism, Naracoorte Art Gallery, South Australia, 15 April–10 September 1976

A Fringe of Leaves, historical novel by Patrick White, based on the Mrs Fraser story: cover painting by Nolan, Jonathan Cape, London, 1976 (Penguin edn 1979, French translation 1981 and German 1982)

Death of Cynthia Nolan, 23 November 1976

1977
Nolan is awarded an Honorary Doctorate of Letters by the University of Sydney on his birthday, April 22. Travels extensively in making the film *Nolan at Sixty*; announces the gift of 252 'Gallipoli' paintings to the nation through the Australian War Memorial. Sunday Reed presents her twenty-five 'Ned Kelly' paintings of 1946–47 to the A.N.G.

Art Treasures from Adelaide, A.G.N.S.W., 1 January–6 February 1977

The Heroic Years of Australian Painting 1940–45, Lower Town Hall, Melbourne, 2–20 April 1977; thence to Sale, Ballarat, Warrnambool, Shepparton, Hamilton, Bendigo, Mildura, Benalla, Mornington, Ararat, Geelong, Latrobe Valley, McClelland Gallery (Langwarrin), Castlemaine, Horsham, Swan Hill, until 4 August 1978: four paintings; organized by Alan McCulloch and sponsored by *The Herald*

Sidney Nolan, Naracoorte Art Gallery, South Australia, April–May 1977

Sidney Nolan, Institute of Modern Art, Brisbane, 27 April–14 May 1977

Sidney Nolan: Baptism and Flowers, Rudy Komon Art Gallery, Sydney, 30 April–25 May 1977

Sidney Nolan: An artist's response to the music of Benjamin Britten, 30th Aldeburgh Festival, June 1977

Collectors' Pride, A.G.W.A., Perth, June 1977

Spring Exhibition 1977—Recent Acquisitions, Joseph Brown Gallery, 74 Caroline Street, South Yarra, 19 October–3 November 1977: two works

Sidney Nolan, 10 recent drawings, Tolarno Galleries, St Kilda, 9–26 November 1977

Nolan at Sixty: film produced by Brian Adams for A.B.C. Australia, B.B.C. Television and RM Productions, Munich; script by Elwyn Lynn, commentary by Lord Clark, 1977; fifty minutes

1978
Nolan marries Mary Boyd at the Euston Road Registry Office, London, February 1978; they visit Mexico, America, Tahiti and Australia; and tour southern China in April, *en route* back to Europe.

Sidney Nolan—Bush and Flowers, Rudy Komon Art Gallery, Sydney, 1–27 April 1978

Autumn Exhibition 1978—Recent Acquisitions, Joseph Brown Gallery, South Yarra, 7–20 April 1978: one painting

Sidney Nolan Recent Drawings, 'Samuel Beckett' themes, Institute of Modern Art, Brisbane, 7–29 April 1978

Nolan's Gallipoli, Australian War Memorial, Canberra, 13 April 1978: 105 paintings from the artist's gift to the Australian nation through the War Memorial in memory of his younger brother Raymond John Nolan (d. 1945), catalogue by Judith McKay; opened in Canberra by the Prime Minister, Mr Malcolm Fraser, thence to Sydney, Melbourne, Adelaide and Perth through sponsorship of Myer

Sidney Nolan, Australian Galleries, Collingwood, 18 April–2 May 1978: twelve paintings of outback subjects, etc.

Sidney Nolan: Oeuvres d'un grand peintre Australien à l'ambassade d'Australie, Paris, 16 June–28 July 1978: fifty-nine works

Spring Exhibition 1978, Joseph Brown Gallery, South Yarra, 25 September–9 October 1978: four paintings

Also exhibits in *Contemporary Australian drawing*, tour of capital cities; with Stuart Devlin and Henry Moore at Whitby, Yorkshire, for celebration of birth of Captain Cook; *Landscape and Image*, Indonesia

Ned Kelly II, set of ten screenprints published by Marlborough Fine Art, London 1978–79, from 'Ned Kelly' paintings of 1946–47; printed by Kelpra Studio Ltd, edn of seventy-five

1979
Nolan, The Fine Arts Gallery, Perth, 31 January–18 February 1979: twelve paintings, 'Miner' subjects etc.

Autumn Exhibition 1979, Joseph Brown Gallery, South Yarra, 5–20 April 1979: four paintings

Sidney Nolan Selected Works, Marlborough Fine Art, London, May–June 1979: thirty-two works

Sidney Nolan: 1939 to 1979, Arts Centre, New Metropole, The Leas, Folkestone, May–June 1979: seventy-two paintings

Screenprints at Chapman Gallery, Canberra, July 1979

Sidney Nolan: 102 works from the first fifteen years (1939–53), Joseph Brown Gallery, South Yarra, July–August 1979

Spring Exhibition 1979, Joseph Brown Gallery, South Yarra, 17–30 October 1979: two paintings

Sidney Nolan. Paintings 1957, Rex Irwin, Woollahra, 20 November–8 December 1979

Sidney Nolan—Australia, monograph by Elwyn Lynn and Sidney Nolan: Bay Books, Sydney and London, 1979

1980
Nolan visits Australia for the opening of the new Nolan Gallery in the grounds of 'Lanyon' homestead, near Canberra, in March.

Sidney Nolan, Rudy Komon Art Gallery, Sydney, 1–22 March 1980: landscapes and 'Ned Kelly' paintings of 1979

Sidney Nolan works on paper retrospective, Nolan Gallery, 'Lanyon', March 1980; thence to Mornington, Geelong, Benalla, Wollongong, Sydney, Launceston, Devonport, Hobart and Ararat until February 1981: 139 works; catalogue by John Buckley

'Dust' etchings at McClelland Gallery, Langwarrin, 27 April–25 May 1980

Two lithographs to commemorate death of Ned Kelly, distributed through Hogarth Galleries, Paddington, May 1980

Spring Exhibition 1980, Joseph Brown Gallery, South Yarra, 1–10 September 1980: three paintings

Selected Australian Works of Art, Lauraine Diggins, North Caulfield, 28 October–7 November 1980: one painting

The Joseph Brown Collection, exhibition to aid Austcare, N.G.V., 31 October–7 December 1980: three paintings

Australian Drawings of the Thirties and Forties in the National Gallery of Victoria, N.G.V., 1980: one work; catalogue by Bridget Whitelaw

1981
Nolan is created Knight Bachelor for service to the art, in the Queen's Birthday Honours, 13 July 1981. He visits the novelist Xavier Herbert in north Queensland.

Sidney Nolan, Rudy Komon Art Gallery, Sydney, 9 March—1 April 1981: 'Ned Kelly' and Chinese subjects

Sidney Nolan in China, A.G.N.S.W., 21 March–10 April 1981: including nine paintings from his Kuei River journey of 1979; to accompany the 'blockbuster' touring exhibition *Chinese Paintings of the Ming and Qing Dynasties* from the People's Republic of China

For the Term of His Natural Life, 31 Drawings, Nolan Gallery, 'Lanyon', 25 March–31 May 1981: inspired by Marcus Clarke's epic novel of the convict era; subsequently presented to the permanent collection; catalogue by John Buckley

Joseph Brown Gallery, South Yarra, 10–14 September 1981: four paintings

Samson et Dalila, opera by Camille Saint-Saëns, libretto by Ferdinand Lemaire, produced by Elijah Moshinsky: designs for décor and costume for The Royal Opera, Royal Opera House, Covent Garden, London, 18 September 1981

The Boxer Collection: Modernism, Murrumbeena and Angry Penguins, Nolan Gallery, 'Lanyon', November 1981: one painting

Inaugural exhibition, The Ned Kelly Paintings 1946–47 by Sidney Nolan, Heide Park and Art Gallery, 7 Templestowe Road, Bulleen, 13 November 1981–19 February 1982: on loan from the A.N.G.

Heide Park and Art Gallery, catalogue of the core collection, November 1981: nine paintings

Stringybark Creek, by Sidney Nolan, film directed by David Muir for Film Australia's Australian Eye series, 1981

1982
Nolan's *Paradise Garden*, series I of 136 frames, is installed in the Concert Hall stalls foyer, Victorian Arts Centre, Melbourne: formally presented by the artist in January 1982. With Lady Nolan he tours Consolidated Gold Fields operations in Australia and New Guinea, accompanied by Robert Melville.

Riverbend II and nine *River Kuei* paintings published as limited edition photographic lithographs, January 1982

Sydney Harbour Bridge, anniversary exhibition at Hogarth Galleries, Paddington, January 1983: five works on paper; organized by Clive Evatt

Sir Sidney Nolan: 3 exhibitions at the 1982 Festival of Perth: 'Kangaroo' [1979–81], 'Ern Malley' [1944–74] and 'For the Term of His Natural Life' [1978], A.G.W.A. and Undercroft Gallery, University of Western Australia, Perth, February 1982: catalogue by Elwyn Lynn

Sidney Nolan Graphics 1961–1982, Hawks Hill Gallery, Kingsley, Western Australia, 21 February–10 March 1982

Selected Works from the Heide Collection 1930–80, Heide Park and Art Gallery, Bulleen, 1 March–16 May 1982: thirteen paintings, checklist only

Sir Sidney Nolan C.B.E. Australian paintings and prints of the River Kuei—China, Singapore National Museum Art Gallery, 20–31 March 1982: thirty-four works; organized by Wagner Art Gallery, Sydney

Sidney Nolan, paintings, drawings and prints, Milburn Galleries, Woolloongabba, Queensland, 17 April–5 May 1982

Sir Sidney Nolan, "Lasciate ogni speranza voi che 'entrate!", Dante's Inferno drawings, Rex Irwin, Woollahra, 27 April–22 May 1982: thirty oil pastels

Dante Inferno drawings, Solander Gallery, Yarralumla, A.C.T., July–August 1982: twenty-two oil pastels

Salome painting published as limited edition lithograph by The Australian Opera, September 1982

Glimpses of the Forties, Melbourne, Heide Park and Art Gallery, Bulleen, 17 September–7 November 1982: sixteen works

Western Australian Landscapes by Sir Sidney Nolan, Quentin Gallery, Claremont, Western Australia, 23 September–10 October 1982

Nolan—Rimbaud/Cézanne, Nolan Gallery, 'Lanyon', 1982: based on poetry by Rimbaud and Nolan's study mid-1977 of Cézanne's sketchbooks as reproduced in *The Drawings of Paul Cézanne: A catalogue raisonné* by Adrien Chappuis, New York Graphic Society, Greenwich, Conn., 1973; thirty-seven crayon-pastel drawings dated 1978, subsequently presented to the Nolan Gallery collection; catalogue by John Buckley

Sir Sidney Nolan, paintings, drawings and lithographs, Hogarth Galleries, Paddington, 25 September–13 October 1982

Sidney Nolan Chinese Journey, Thos. Agnew and Sons Ltd, London, 6–27 October 1982: eighteen paintings in acrylic and lacquer on canvas

The Painter as Potter, Decorated Ceramics of the Murrumbeena Circle, N.G.V., 9 December 1982–6 March 1983: one object; catalogue by Geoffrey Edwards

Ned Kelly: first of a series of films directed by Ted Bennetts on Australian identity for A.B.C. 'Summer Spectrum', using many paintings by Nolan

Sidney Nolan: An Australian Dream, film directed by Don Bennetts; Don Bennetts and A.B.C., Sydney, 1982: seventy-five minutes

1983

Life Member, National Gallery of Victoria, October 1983

Order of Merit, awarded by H.M. Queen Elizabeth II, 12 November 1983

Travel in Spain; to Australia; to China once again, visits the ancient Buddhist caves at Dun Huang in Gansu province.

Paintings and Prints by Sir Sidney Nolan, Christopher Day, Paddington, 12–29 January 1983

Heide II—as it was, Heide Park and Art Gallery, Bulleen, 19 February–20 March 1983: six paintings

Illuminations, an exhibition of paintings by Sir Sidney Nolan, Nolan Gallery, 'Lanyon', April 1983: thirty-one large synthetic spray on canvas paintings in homage to Rimbaud's life and work, featured in the film *It is of Eden I was Dreaming* (see below)

Moderns Exhibition, Lauraine Diggins Gallery, North Caulfield, June 1983: nine works

Il trovatore, opera by Giuseppe Verdi, produced by Elijah Moshinsky: décor for The Australian Opera, first performed at the Sydney Opera House, 25 June 1983

For Il trovatore: Arrighi costumes, Nolan sets, Rex Irwin, Woollahra, 12–30 July 1983

'*Aspects of the Unreal': Australian Surrealism 1930s–1950s*, Geelong Art Gallery, 8–31 July 1983

Sidney Nolan: Paintings, drawings and theatre design, Grosvenor Museum, Chester, July–September 1983: seventy-one works; catalogue introduction by Charles Osborne

'*Kate Kelly's Roadshow*', musical by Edward Cowie: designed by Nolan for the Chester Summer Music Festival 1983

Tenth Anniversary Exhibition, Hogarth Galleries, Paddington, 24 September–12 October 1983

Sidney Nolan, an exhibition of paintings from Australia's North-West, Holdsworth Galleries, Woollahra, 8 October–2 November 1983

Sidney Nolan: the city and the plain, N.G.V., 12 October–27 November 1983: seventy-seven works including a group of paintings and drawings presented to the N.G.V. by Sir Sidney and Lady Nolan; catalogue by Jan Minchin and Richard Haese

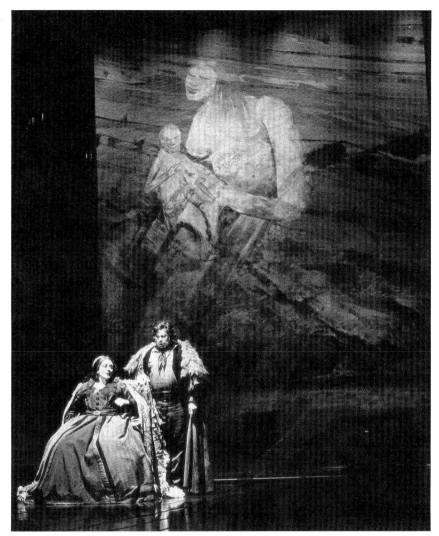

Il trovatore at the Sydney Opera House, 1983
Photograph by courtesy of The Australian Opera

Sydney Opera House Tenth Anniversary Exhibition, New South Wales House Gallery, London, 20 October–30 December 1983: six designs for *Il trovatore*

Sir Sidney Nolan—Paintings, Broome Art Gallery, 29 July–12 August 1983: seventeen paintings; organized by the Broome 1983 Centenary Committee

It is of Eden I was dreaming: film produced by Malcolm Otton, directed by David Muir, with a script by Lois Hunter narrated by Zoe Caldwell and Matthew O'Sullivan; a co-production of Film Australia and Total Holdings, using many of Nolan's paintings from the *Illuminations* series of 1982; twenty-five minutes; released June 1983

Sidney Nolan—an Australian Dream: second in a series of films directed by Ted Bennetts on Australian identity for A.B.C. 'Summer Spectrum'

Sir Sidney and Lady Nolan purchase 'The Rodd', on the Welsh border of Herefordshire.

1984

During a visit to Australia, Nolan's *Paradise Garden* Series II, presented to the people of Victoria in 1982, is installed in the new Victorian Arts Centre theatres complex. He also spends time in Ireland—increasingly interested in his own Irish heritage.

Sir Sidney Nolan, Christopher Day Gallery, Paddington, 4–29 January 1986: thirty-three works

Spirits and Effigies: an exhibition of paintings and drawings by Sir Sidney Nolan, Nolan Gallery, 'Lanyon', 23 March–20 May 1984: twenty-four works; catalogue by Elwyn Lynn

Sidney Nolan: an exhibition of birds, The Windsor Community Arts Centre, Windsor, Surrey, April–May 1984: fifteen works

Australian Paintings—Colonial/Contemporary, Deutscher Fine Art, Carlton, 2–19 April 1984: one painting

Selected Australian Works of Art, Lauraine Diggins Gallery, North Caulfield, May 1984: one painting

Creation: Modern Art and Nature, Scottish National Gallery of Modern Art, Edinburgh, 15 August–14 October 1984: one painting

English Contrasts Peintres et Sculpteurs Anglais 1950–1960, Artcurial centre d'art plastique contemporain, Paris, September–November 1984: two paintings; catalogue by Bryan Robertson

Art and Social Commitment, an end of the city of dreams 1931–1948, A.G.N.S.W., September–October 1984; thence to A.G.S.A., N.G.V. (Banyule), and Q.A.G., until April 1985: three paintings

Mixed exhibition at Lauraine Diggins Gallery, North Caulfield, October 1984: one painting

Australian Paintings—Colonial/Impressionist/Early Modern, Deutscher Fine Art, Carlton, 30 October–16 November 1984: one painting

The Great Decades of Australian Art: selected masterpieces from the J.G.L. collection, N.G.V., November 1984: seven paintings

Exhibition of recent 'Kelly' paintings at Kilkenny, Ireland

Letter to W.H. Auden and other poems 1941–1984, by Charles Osborne: book jacket portrait by Nolan, John Calder, London and Riverrun Press, New York, 1984

1985

Nolan is elected Honorary Member of the American Academy of Arts and Letters, New York, in May 1985.

Rite of Spring and *Samson et Dalila* designs exhibited at Folkestone, Kent, January 1985

Early works by Sir Sidney Nolan, Christopher Day Gallery, Paddington, 16 January–3 February 1985

Recalling the Fifties—British painting and sculpture 1950–60, Arts Council of Great Britain, Serpentine Gallery, London, 2 February–3 March 1985: three paintings; organized by Bryan Robertson

Sir Sidney Nolan—Trio, Heide Park and Art Gallery, Bulleen, 2 April–19 May 1985: a selection from the 'Rimbaud/Cézanne' drawings, seventeen *'Illuminations'* paintings and five large paintings of outback Australian landscapes executed at Arthur Boyd's property on the Shoalhaven River late in 1984

Sidney Nolan, an exhibition of birds, Nolan Gallery, 'Lanyon', 23 April–23 June 1985

Selected Australian Works of Art, Lauraine Diggins Gallery, North Caulfield, June 1985: one painting

Renaissance references in Australian art, The University Gallery, University of Melbourne, 14 August–20 September 1985: one painting

Sir Sidney Nolan, Gerstman-Abdallah Fine Arts International (inaugural exhibition), Cologne, 6 September–4 October 1985

Sidney Nolan: Burke and Wills, S.H. Ervin Gallery, National Trust Centre, Sydney, 7 November 1985–26 January 1986: twenty-nine paintings, including the series inspired by filming of Hoyts-Edgley's *Burke and Wills* during 1984; selection exhibited at the Nolan Gallery, 'Lanyon', 6 February – 25 May 1986; catalogue by Dinah Dysart

Nolan acquires the five hundred acres of farmland surrounding 'The Rodd' and establishes The Sidney Nolan Trust; purchases 'Earie Park' jointly with Arthur Boyd—a property with fourteen kilometres of river frontage on the Shoalhaven in New South Wales.

1986

Nolan announces his gift of approximately fifty paintings to the people of Ireland, 26 March 1986; purchases land in County Clare.

Counterclaims: presenting Australian Art 1938–1941, S.H. Ervin Gallery, Sydney, 17 May–6 July 1986: four paintings from early Contemporary Art Society exhibitions; catalogue by Christine Dixon and Dinah Dysart

Selected Australian Works of Art, volume 9, Lauraine Diggins Gallery, North Caulfield, June 1966: six paintings

Sidney Nolan, Antarctic Series, Nolan Gallery, 'Lanyon', 4 June–7 September 1986: eighteen paintings from the artist's collection

Nolan's Wimmera, N.G.V. travelling exhibition sponsored by the State Bank, Horsham Art Gallery, 9 October 1986; thence to Hamilton, Ararat, Mildura, Swan Hill, Benalla, until 30 June 1987

Recent Work—Sidney Nolan, The Douglas Hyde Gallery, Trinity College, Dublin, 16 October–8 November 1986: including 'Silk Route' Chinese paintings and large new abstract canvases

Modern Australian Paintings, Charles Nodrum Gallery, Richmond, Victoria, 31 October–14 November 1986: two paintings

Sidney Nolan—African Journey, Nolan Gallery, 'Lanyon', 19 November 1986–1 February 1987: twelve paintings from 1963 plus works on paper, lent by the artist

1987

Two vast Chinese mountain landscapes commissioned in 1986, are installed in the foyer of the Hongkong Land Company building as part of the Hongkong Festival, January 1987.

Various seventieth birthday celebrations in Australia and overseas; Nolan is also working on a major suite of prints with Alecto Editions, London, for Australia's bi-centenary in 1988.

Friends and Relations, Heide Park and Art Gallery, Bulleen, 13 January–22 February 1987: two paintings from the permanent collection

Nolan—Fremantle, recent works, London House, 214 St George's Terrace, Perth, 4–12 February 1987: twenty paintings commissioned by the W.A. Development Corporation, opened by H.R.H. Princess Anne

The Jack Manton Prize, Recent works by fourteen Australian artists, Q.A.G., Brisbane, 13 February–29 March 1987: 'Burke and Wills' paintings of 1985; with Boyd, Tucker, Rees, Olsen, Whiteley, etc.; catalogue by Bettina MacAulay

Another Summer—the Australian landscape 1942–1987, Heide Park and Art Gallery, Bulleen, 28 February–12 April 1987: three paintings

Sidney Nolan—Such is life, a biography, by Brian Adams: Century Hutchinson, Melbourne, 1987; and a film of the same title, produced by Brian Adams for National Video Corporation, Arts International, London with U.K. Channel 4 and Irish Television; filmed in England, Ireland, Hongkong and Australia; sixty minutes

Sir Sidney Nolan—landscapes and legends: a retrospective exhibition 1937–1987, N.G.V., 2 June 1987–thence to Sydney, Perth and Adelaide, until April 1988: managed by the International Cultural Corporation of Australia Limited

Sir Sidney Nolan, Lauraine Diggins, North Caulfield, 10 June 1987

Seventieth Birthday Exhibition, Nolan Gallery, 'Lanyon', 11 June 1987: recent works

The Abduction from the Seraglio, opera by Mozart, directed by Elijah Moshinsky: designs for décor, to open at The Royal Opera House, Covent Garden in October 1987

The artist and his wife, Mary, at 'Heide', 1982
Photograph by courtesy of The Herald and
Weekly Times

NOLAN BECOMES A PAINTER

The only necessity in art is that it shall continue to express itself imperiously in the
words of Baudelaire:
'Plonger au sein du gouffre—enfer ou ciel, qu'importe!
Au fond de l'inconnu pour trouver du nouveau'
(To plunge into the depths of the abyss—heaven or hell. What does it matter?
Into the heart of the unknown, to seek the new!)
'One must be absolutely modern', adds Rimbaud. And the caprice of Franz Marc
is still heard in these prophetic words: 'In the twentieth century we will live
among strange men and faces, new images and unimaginable noises.
Originality, ever greater originality in art, ought to be sought as the supreme
antidote for the poison of the times in which we are living. In art, as Hegel has
said, 'Everything depends on the liberty with which the imagination succeeds in
bringing herself and herself alone, to the centre of the stage'. Even though all
external liberty were abolished, that inherent, fundamental liberty, which gives
its sole authenticity to liberty itself, will be concentrated, more directly than ever
before, on works of art, in order to take life by surprise.

- André Breton, 'Originality and liberty', *Art in Australia*, December 1941

When Sidney Nolan turned twenty-one and decided, in 1938, to pursue a career as a
full-time artist, he had already been painting for several years. 'At eighteen I was
really steamed up about modern art', he recalls. His mother, ever supportive, had
hoped he might become a school teacher. His father could not see the *point* of
painting, particularly as young Nolan was 'rabidly modern to begin with ... And so all
he saw were my rather terrifying pathological statements on canvas in which he was
often involved.'[1]

He had spent a couple of terms at the Gallery School but, in the words of fellow
student John Sinclair:

Nolan had rejected the Gallery's teaching before he even entered the door and
his real reason for going there was to meet and talk to artists and students and to
discover in his own way what art, and what he himself, was all about. His method
of working at this time was almost secretive. The folio he always carried, and
rarely opened in company, contained neatly cut sheets of tissue-paper filled with
abstract drawings, essays and short esoteric poems written in an incredibly neat
and disciplined script. In the adjoining Library he read poetry, philosophy, poli-
tics and art criticism and studied the work of every artist, ancient and modern, he
could lay hands on.

He did not even pretend to study in the approved manner.[2] When he produced a
series of Brancusi-like 'eggs' in the life drawing class the model objected because her
back was reputedly one of the most beautiful in Melbourne. George Bell called the
Gallery School 'an anachronism, a vestigal relic of the days when artists felt that they
had to enter into active competition with the camera'.[3]

Melbourne was Australia's art Establishment headquarters. The National Gallery
of Victoria had the best collection of European paintings in the country—an undeni-
ably fine collection by any standards; but, as *The Herald* art critic Basil Burdett
observed, it had 'the air of a cultural backwater—an air as chilling as those waxy
marbles of royalties which greet one in the vestibule and seem to sound the keynote of
the whole institution'. Nolan's generation, raised during the Depression and now faced
with the shock of war, not suprisingly rose in total revolt against local cultural ortho-
doxy. As the leading French Surrealist, André Breton, pointed out, 'Each one of us,
from Paris to Sydney, from New York to the very depths of Asia, has an actual physical
part in this world convulsion ... Whatever may happen, he knows that already whole
sections of the former world have crumbled'.[4] Burdett had written in 1938:

The general theories behind modern art—the refusal to accept appearances as final truths or nature herself, in any form, as absolute—are, at least, in touch with the general ideas of our day, of an epoch when even the sacrosanct forms of society itself are being challenged. No wonder the younger generation is disturbed and excited by what we loosely call modern art, by anything which challenges the accepted modes. It would be strange if they were not, since the validity of accepted ideas is being challenged in every other department of life and culture, science included.[5]

Nolan read omnivorously: his employer's copies of *The Studio* and *Apparel Arts* at Fayrfield Hats, illustrated art books, overseas magazines and a phenomenal range of poetry and literature at the Public Library which at that time shared premises with the Gallery. Discovering and exploring the modern movement for himself, he experimented widely in a ferment of intense involvement, passion and speed. Fellow artist Neil Douglas recalls no one who tried as many techniques, media and 'wondrous gimmicks' as did Nolan: 'Kaleidoscopes, microscopes, stereoscopes, horoscopes, these in luminous paint!—feathers printing on architect's blue paper like cirrus clouds, cut outs, blackouts, handouts, any and every conceivable approach of eye and mind that could conceive Painting was engaged in with the agility of an athlete!'[6]

In 1938 he boldly visited Sir Keith Murdoch, a trustee at the Public Library, Museum and National Gallery of Victoria and Managing Director of *The Herald*, carrying a folio of his abstract transfer drawings and monotypes on tissue and blotting paper and hoping to win a *Herald* bursary. Murdoch sent him to Burdett who in turn recommended he see George Bell and/or John Reed, a Melbourne solicitor much interested in modern art. Bell was not impressed. Knowing him to be then at loggerheads with Reed over various artistic and cultural principles, Nolan made his way to the latter's office in Temple Court. Reed invited him home that evening to 'Heide', about fifty minutes by train from the city, for dinner and to meet his wife Sunday (née Baillieu). This was the beginning of almost a decade's close friendship and fruitful collaboration when, in Reed's words, their three lives were 'inextricably interwoven in a pattern of complete mutuality and intimacy'. The Reeds felt immediately 'that Nolan was a rare and special person and a true artist'. He was convinced of his own genius but as yet perhaps of little else, certainly not of its direction; confident that the fates were on his side, John Reed wrote. He gave the 'sense of a man who had a very definite statement to make and nothing would prevent him making it'.

'Heide' was, according to one contemporary, a forum of creativity, 'great battles of opinions and wordy scenes'. Nolan often worked there; even following his marriage to Elizabeth Paterson. He became a founder member of the Contemporary Art Society, instigated by John Reed in opposition to the arch-conservative (and short-lived) Australian Academy, launched by R.G. Menzies the year before in 1937. As stated in its Constitution, the 'primary and paramount object' of the Contemporary Art Society was 'the encouraging and fostering of contemporary art. By the expression "contemporary art" is meant all contemporary painting, sculpture, drawing and other visual art forms which is or are original and creative or which strive to give expression to progressive contemporary thought and life as opposed to work which is reactionary or retrogressive including work which has no aim other than representation.'[7]

The advent of the second world war meant isolation from international contemporary art at precisely the moment when awareness of art was growing. The arrival of immigrant artists was a help: such as the Russian Danila Vassilieff and, in 1937, Austrian-Jewish refugee Yosl Bergner. Most significant, perhaps, was *The Herald Exhibition of British and European Contemporary Art* which opened at the Melbourne Town Hall in October 1939: more than two hundred *original* paintings, including works by the French 'modern masters'. The almost unbelievably reactionary director of the National Gallery, James MacDonald, considered the exhibition an 'insult to the intelligence ... There is no doubt that the great majority of the work called "modern" is the product of degenerates and perverts and that by the press the public has been forcibly fed with it'.[8] For young Melbourne artists, however, it was a revelation—which they devoured, needing no coercion whatever from the press.

The following year, in June 1940, Nolan mounted an exhibition of his own work. He decorated his Russell Street studio as an imaginary French *salon*—like a theatrical set—with books scattered about and scores of pictures, mostly small abstracts, calligraphic drawings and collages on the bright pink walls.[9] John Harcourt, from *The Age* was plainly baffled by the whole thing. Burdett 'failed to find any key' to Nolan's 'highly esoteric art'. Interestingly, the most appreciative review was Bell's, in *The Sun*:

> One sees the effort of a young artist to explore the possibilities of his medium. He is striving, as many are overseas, at an absolutely pure art—an art in which representation of objects has no place at all. In these examples, which are entirely abstract, he is seen experimenting with line, color, mass and surface texture, significant in themselves as elements of a design discarding all extraneous association of ideas. Preserving his flat surface, he uses arabesque rather than form, pattern rather than volume and color in its own right and different paint textures rather than imitative textural effects. His results are extremely interesting and stimulating, his line is intriguing and his color is rich and sometimes rare in quality. Whether or not this aim at the absolute in art will be found wanting eventually in its relation to life, these experiments in the basic elements of painting will lay a foundation for the future of this young artist which will be invaluable.[10]

Not long afterwards, Nolan wrote to Sunday Reed that the 'sources' for 'any learning to be done in painting' were Matisse, Picasso, Henri *'Le douanier'* Rousseau and William Blake.[11] His overriding aim, however, was to be original: not to depend upon the example of any European precursor. In many of his earliest works he sought, like the poet Rainer Maria Rilke, 'symbols and equivalents' to communicate the reality of another world—internal, invisible—of 'hidden relationships'. Rimbaud, whose *Illuminations* he called 'a book of miracles', was perhaps his greatest inspiration: abandoning all poetic conventions for direct experience of the senses, insisting that the whole world was in need of transformation. Henceforth, in the words of André Breton, the 'spirit of discovery, of invention' would be the basis of his art.

1. Quoted by Barber 1964, p.90.

2. Sinclair 1967, p.436.

3. *The Argus*, Melbourne, 21 January 1939. Bell's own alternative private art school had earned a reputation for 'forward-thinking' in its five years' operation.

4. *Art in Australia*, December 1941, p.12. The author of the first Surrealist Manifesto had been invited to write by Peter Bellew, under whose regrettably short editorship this beautiful magazine reproduced art works ranging from Medieval sculpture and manuscripts to the most contemporary painting, architecture and design.

5. 'Modern Art in Melbourne', *Art in Australia*, November 1938, p.19.

6. Manuscript held by the Department of Australian Art, A.G.N.S.W., dated May 1962. Douglas (b.1911), a keen ecologist, encouraged Nolan to look closely at Australian bush landscape.

7. Extract printed in the *Inaugural Exhibition* catalogue, June 1939. The Sydney branch was founded in 1940; one in Adelaide in 1942.

8. Report to the Trustees, 31 October 1939, rejecting out of hand the proposed acquisition of nine exhibits; 'and I believe that this Gallery shall win fame by having the pluck utterly to avoid it'. A smaller exhibition of overseas art in 1937 had included Picasso, van Gogh, Utrillo and Christopher Wood. The *Herald* exhibition, organized by Burdett and Bellew, opened 21 August 1939 in Adelaide; thence 16 October–1 November in Melbourne and to Sydney and Brisbane in 1940.

9. Adams 1987, p.50, opened by John Reed. There is some confusion as to whether the building was 230 (as printed on the invitation) or 320 Russell Street; it was immediately opposite the Museum.

10. *The Herald*, Melbourne, 10 June 1940: 'Mr Nolan suggests a cross between Picasso and Rouault', Burdett said, 'At times he almost abstracts himself out of existence'. *The Sun*, Melbourne, 11 June 1940, p.21.

11. Undated letter of 1942. He quotes D.H. Lawrence, 'our unfashionable fascist...', regarding Blake that he was the only English painter of the human body'; and mentions that John Reed had given him 'a little book with Rousseau's Tiger Hunt in it'—which he much admired.

KIEWA VALLEY 1936–37
Oil and white lead on cardboard
22.4 x 40.4 cm
Inscribed verso: 'Kiewa Valley/
1936/37/Nolan'
Private collection
Exhibitions: Newcastle etc., 1961,
no.1; I.C.A., London, May 1962, no.1;
A.G.N.S.W. etc., 1967, no.1

KIEWA VALLEY LANDSCAPE 1936–37 ▷
Oil and white lead on cardboard
29.5 x 40.6 cm
Inscribed verso: 'Kiewa Valley/Land-
scape/Nolan 1936–37?'
Private collection

'He never drew from life and to my know-
ledge the only painting he ever did
outdoors was a view of Mount Hotham
painted while we were there in 1937.'
- John Sinclair, Melbourne, September 1967

In fact Nolan seems to have painted a
small group of relatively conventional
landscapes *en plein air* during the
summer of 1936–37 in the Kiewa valley
area and during his stay with Howard
Matthews at Ferntree Gully in 1937. One
rather battered example, formerly in the
Reed collection, now in the Australian
National Gallery, is inscribed on the
back 'Nolan first painting'. Comparable
small-scale, high keyed landscape
studies, using a palette knife, were pro-
duced by the young Arthur Boyd
between 1936 and 1938.
 The delicate golden blond and blue-
green tonality suggests some familiarity
with the late landscape style of 'Heidel-
berg School' artist Tom Roberts. In *Kiewa
valley landscape*, however, the billowing
clouds and rolling hills also recall van
Gogh's more cheerful landscapes, which
Nolan would have known well in repro-
duction. He suggests a line of fencing
by the simple means of a few pencil
scratches or the wrong end of a paint-
brush. Like any young man, Nolan
enjoyed the Australian countryside for
itself—as his long bicycle rides attest—
but in the early stages of his career he
mistrusted it as a direct ingredient of art:
a reaction against prevailing traditionalist
tendencies of conservative Australian
painting at the time.

COLLAGE 1938 ▷
Cut and pasted steel engravings
25.5 x 30.2 cm (image 19.4 x 22.5 cm)
Inscribed l.r.: 'Nolan 1938'
original printed title below: 'A
MYTHOLOGICAL BATTLE'
verso: 'Look at from various/points of
view/and see different compositions
/ ⟷ /Nolan/1938'
National Gallery of Victoria
Presented by the artist 1982

Provenance: The artist

Exhibitions: Probably I.C.A., London,
May 1962, screen D; *Sidney Nolan works
on paper retrospective*, A.G.D.C., 1980–
81, no.3, illus.

Nolan's series of quilt-like collages of
nineteenth-century engravings were
created in the spirit of Rimbaud's poetry:
pictorial equivalents of the poet's 'system-
atic derangement of the senses' in order
to create a new reality. As Nolan explains,
he had 'no mercy on the figurative ele-
ments—in other words just cut 'em up
and ... used them as a means to an end';
and the end was 'the lucidity of the non-
figurative image'. Recognition of any one
element is almost immediately dest-
royed by those in neighbouring uneven
squares—'like a series of contrapuntal
somersaults'.[1] Since the engravings were
after paintings by famous Old Masters,

cut from *The Art Journal* and similar
weighty tomes, there was an element of
whimsical Dada-ist blasphemy in the
exercise. The Hungarian-American
László Moholy-Nagy (1895–1946) was
well known for his Surrealist collages in
the 1930s. In other works from the years
1938–40, Nolan combines dissected
printed pages of mechanical and geo-
logical diagrams with photographs and
even segments of clothing, in composi-
tions which recall Kurt Schwitters or
Ben Nicolson.[2]

1. Anderson 1967, p.1.
2. See Lynn 1967, pls 3–5, for further examples.

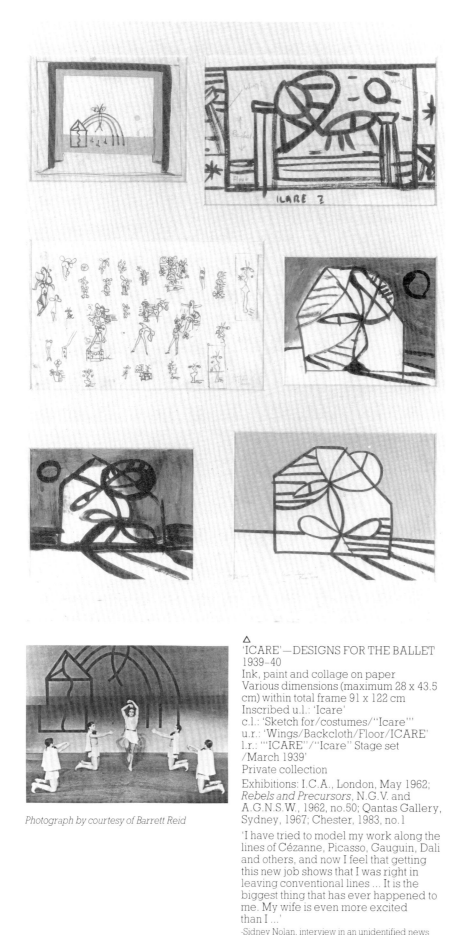

These were Nolan's first designs for the stage: first essays in an involvement which has continued throughout his long career. Colonel de Basil and his choreographer, Serge Lifar, brought a repertoire of thirty-four ballets for this second and final Australian tour when they were stranded by the outbreak of war.[1]

The *Ballets Russes* were a living exemplar of sophisticated *haut-bourgeois* French culture. As Nolan recalls, 'When de Basil came out with his Company I think this just stunned Melbourne. You see, I think it had certain fixed ideas about itself. It thought it was the centre of culture perhaps in the southern hemisphere ... Melbourne was just overwhelmed first of all by the beauty of the performances and then by the beauty of the people themselves.'[2] The dancers went out to 'Heide' for picnics.[3] *Art in Australia* published illustrated articles on ballet costume and décor by David Lichine, one of the dancers, and Harry Tatlock Miller, recently returned from Europe. Designs by such famous painters as Picasso, Derain and de Chirico were discussed.[4]

In Sydney, Lifar saw Nolan's painting *'The Eternals Closed the Tent...'* of 1939 and was immediately impressed. He sent a telegram to the artist's St Kilda flat commissioning sets and costumes for his controversial *Icare*, 'a choreographic legend in one act', danced only to percussion music.[5] Nolan's first designs were not accepted. They were too elaborate and therefore expensive: incorporating a painted floorcloth as well as backcloth and wings, and costumes made of silk with headdresses designed by Elizabeth Nolan. Arriving in Sydney himself, he attended the rehearsals to learn about the business of staging a ballet. He stayed in Peter Bellew's flat at Elizabeth Bay, 'working all day long ... going through the tremendous emotions' to revise his ambitious concept. Memories of St Kilda pier and Luna Park are distilled into a dramatically austere scheme of thick black bars—with none of the meretricious illusionism usually seen in theatre sets at that time.

Nolan aimed to convey the mood of the ballet as a whole. The imprisoning Blake-inspired tent recurs in several designs, the sun rising from its roofline. Icarus, the desperate escapee, is summarily indicated by a single line or stem with leaf-like waxen wings and a solitary eye. Opening night was Friday, 16 February 1940, at the Theatre Royal. 'Scenery and costumes by Sidney Nolan' read the printed programme; 'Rhythms by Lifar'.[6] Melbourne artist Alannah Coleman, visiting for the occasion, remembers sitting in the audience with Sunday and John Reed and Elizabeth. As reported by *The Sydney Morning Herald*, Lifar received 'an ovation which has not been parallelled, or even approached, during the past season'. Nolan joined him on the stage, confirmed in all his hopes and dreams of travelling to Europe. 'Cheers mingled with the clapping, and a pile of laurel wreaths was deposited in front of the dancer. There were fully twenty-five curtain calls.'[7]

Photograph by courtesy of Barrett Reid

△
'ICARE'—DESIGNS FOR THE BALLET
1939–40
Ink, paint and collage on paper
Various dimensions (maximum 28 x 43.5 cm) within total frame 91 x 122 cm
Inscribed u.l.: 'Icare'
c.l.: 'Sketch for/costumes/"Icare"'
u.r.: 'Wings/Backcloth/Floor/ICARE'
l.r.: '"ICARE"/"Icare" Stage set /March 1939'
Private collection

Exhibitions: I.C.A., London, May 1962; *Rebels and Precursors*, N.G.V. and A.G.N.S.W., 1962, no.50; Qantas Gallery, Sydney, 1967; Chester, 1983, no.1

'I have tried to model my work along the lines of Cézanne, Picasso, Gauguin, Dali and others, and now I feel that getting this new job shows that I was right in leaving conventional lines ... It is the biggest thing that has ever happened to me. My wife is even more excited than I ...'
-Sidney Nolan, interview in an unidentified news clipping 1939–40

1. Russian-born de Basil had founded his Monte Carlo Russian Ballet less than three years after the death of Sergei Diaghilev, founder and guiding force of the world famous *Ballets Russes*; by 1938 he had changed the name to the Covent Garden Russian Ballet. Lifar, now aged thirty-five, associate of Picasso and Jean Cocteau, had first attained international prominence as a dancer with Diaghilev in the early 1920s.
2. Nolan quoted in Haese 1981, p.96.
3. Wonderful film footage of their tour, by amateur cinematographer Dr J. Ringland Anderson, was included in Brian Adams's A.B.C. documentary *Another Beginning*, based on the Australian Ballet archives.
4. February 1939; February 1940. Miller had brought out an exhibition of European theatre designs which toured Australia during 1940. On the local front, Albert Tucker had designed a backdrop for the New Theatre in c.1938–39—an allegory of capitalist evils.
5. First produced in Paris in 1935, *Icare* was an unplanned addition to the Australian touring repertoire. Sydney artist Thea Proctor was first suggested to Lifar as designer; de Basil favoured Loudon Sainthill; but Peter Bellew, recently moved to Sydney, urged them to use a 'real artist' and recommended Nolan. The circumstances of the commission are documented by Gilchrist 1975, Adams 1987; and in an interview with Bellew, 1–2 October 1983, transcriptions of which were kindly lent to me by Mary Eagle.
6. A copy is held in the Mitchell Library, Sydney. Frank Hinder helped Nolan to paint the sets. There was no score for the controversial musical accompaniment; Lifar had composed it with assistance from Antal Dorati and merely instructed the conductor to 'clothe the rhythm of his dancing with music'.
7. 17 February 1940, p.19; see also 13 February 1940, p.5 for photographs of the dancers.

UNTITLED (WEEPING HEAD AND STARS) c.1940
Red transfer drawing on paper
44.6 x 57.5 cm
National Gallery of Victoria
Purchased through The Art Foundation of Victoria with the assistance of Unilever Australia Ltd 1982

Provenance: The artist

Exhibitions: Probably *Rebels and Precursors*, N.G.V. and A.G.N.S.W., 1962, no.52; *Sidney Nolan works on paper retrospective*, 'Lanyon' etc., 1980–81, no.24, illus.

△
UNTITLED (TENT, MOON, LADDER, WEEPING HEAD AND STARS) c.1940
Red transfer drawing on paper
44.4 x 57 cm
Private collection

Exhibitions: Probably *Rebels and Precursors*, N.G.V. and A.G.N.S.W., 1962, no.52

'Far too much encouragement is given to young artists these days to depict their personalities in their work. It is a pathological symptom, and not healthy.'
- Max Meldrum, *The Argus*, Melbourne, 16 December 1938

Although Nolan's very early works are often described as 'abstracts', many—such as these delicate transfer drawings—may be read as documents of a private world of elemental symbols.[1] This was a period of emotional turmoil and heart-searching in his personal life, with the birth of his daughter in 1940 and the breakdown of his first marriage. Much of the vocabulary is traceable to sources in European early modernist art. Tearful eyes, for example, appear in Picasso's weeping women. The ladder, a motif in other *Guernica* studies and a symbol of escape in several paintings by Joan Miro of 1940,[2] also suggests the Big Dipper scaffolding at Luna Park in St Kilda—where Nolan had grown up and was now living. The asterisks—which may be stars or kisses—appear in Miro's work; and the circular moon (or sun) in paintings by Paul Klee, such as *Pavilion with flags*, 1927 and *Gay mountain landscape*, 1929, both of which were reproduced in Nolan's copy of *Art Now* by Herbert Read. Like Klee, he was adept at 'taking a line for a walk'; although Burdett, reviewing Nolan's exhibition in 1940 considered his work lacked the German's whimsicality.[3] Bernard Smith remembers, too, how the supple line drawings of Gaudier-Brzeska excited the 1937 evening classes at the Melbourne Gallery School (notwithstanding the conservatism of the masters there).

Nolan might have echoed the words of Miro: 'For me a form is never something abstract, it is always a sign of something. It is always a man, a bird, or something else. For me painting is never form for form's sake.'[4] The tent image, which recurs in many of these drawings and in a sequence of small paintings at this time, relates closely to the poetry of William Blake. Indeed Nolan's title *'The Eternals Closed the Tent...'* (C.A.S. Annual Exhibition 1940) comes from the first book of Urizen, when Enitharmon is weeping just before the birth of Orc: the tent is perhaps a symbol of captivity. Such literary influences on Nolan are never exact in any illustrative sense. Poetry is, rather, a springboard for his own imagination. And, as Smith points out, 'The fact that he developed a highly personal manner of painting *en serie*, which has become a cardinal feature of his work, renders a close study of these early image-linked clusters highly relevant to an understanding of his later development'.[5]

1. Smith 1967, p.77. Nolan's works in this technique are sometimes catalogued as monotypes, but more correctly described as transfer drawings: a plate is inked, the paper laid upon it and the image drawn in pencil on the reverse of the sheet. I am grateful to Andrew Sayers of the Australian National Gallery for advice on this matter.
2. Gilchrist thesis 1975.
3. *The Herald*, Melbourne, 10 June 1940.
4. James Johnson Sweeney, 'Joan Miro: Comment and Interview', *Partisan Review* XV, 2 February 1948, p.208, quoted by Gilchrist, op.cit.
5. Smith, loc.cit.

△
FOUR RED, BLACK AND BLUE MONO-
TYPES [1940]
Monotypes in oil paint on tissue paper
each 28 x 40.5 cm and 28 x 35 cm (sight)
Private collection

Exhibitions: *Rebels and Precursors*,
N.G.V. and A.G.N.S.W., 1962, no.54

Abstract monotypes of this sort were
included in Nolan's first one-man exhibi-
tion in June 1940. Other examples suggest
more clearly motifs such as somewhat
anti-gravitational tents or boats.

RED AND BLACK MONOTYPE [1940]
Monotype on tissue paper
28 x 40.5 cm
Private collection

△
WOMAN AND TREE 1941
Enamel on three-layer plywood
38.2 x 25.5 cm
Inscribed l.r.: 'GARDEN OF EDEN/
NOLAN 41'
verso: 'No Price. Woman and
Tree. S. Nolan 325 Russell St/Melb'
Heide Park and Art Gallery
Bequest of Sunday and John Reed 1982

Provenance: Sunday and John Reed

Exhibitions: *C.A.S.*, Sydney, September–
October 1941, no.167: 'Woman and
Tree—N.F.S.'; *C.A.S.*, Melbourne,
October–November 1941, no.167;
Glimpses of the Forties, Heide, Sep-
tember–November 1982, no.35A; *Coun-
terclaims*, S.H. Ervin Galley, Sydney,
May–July 1986, no.44

You are not nearer God than we,
yet through your hands most wonderfully
his glory's manifest.
From woman's sleeves none ever grew
so ripe, so shimmeringly:
I am the day, I am the dew,
you, Lady, are the Tree.

Pardon, now my long journey's done,
I had forgot to say
what he who sat as in the sun,
grand in his gold array,
told me to tell you, pensive one
(space has bewildered me).
I, the beginner, have begun,
you, Lady, are the Tree.

I spread my wings out wide and rose,
the space around grew less;
your little house quite overflows
with my abundant dress.
But still you keep your solitude
and hardly notice me:
I'm but a breeze within the wood,
you, Lady, are the Tree.

The angels tremble in their choir,
grow pale, and separate:
never were longing and desire
so vague and yet so great.
Something perhaps is going to be
that you perceived in dream.
Hail to you! for my soul can see
that you are ripe and teem.
You lofty gate, that any day
may open for our good:
you ear my longing songs assay,
my word—I know now—lost its way
in you as in a wood.
And thus your last dream was designed
to be fulfilled by me.
God looked at me: he made me blind...
You, Lady, are the Tree.

Rainer Maria Rilke (1875–1926), 'Annunciation
(Words of the Angel)' from *The Picture Book*, 1903

'In Nolan's painting reproduced with this short statement, one is stirred by the simple harmony and fundamental human quality of the images presented. There is never any need for the artist to scream in order to make himself heard, and in this painting what has to be said is said quietly and with finality. The fact that there is perhaps conveyed some sense of an element of unreality does but accentuate the closeness of the artist's reaction to the world about him; but here again there is no over-laying of the accent. The harmony and lucidity of the whole is preserved in perfect balance and, as it were, suspended inevitably before us.'
- John Reed, 'Sidney Nolan's Woman and Tree', *Angry Penguins* 2, 1941

This extraordinarily haunting little image, inscribed 'Garden of Eden', was reproduced not only by *Angry Penguins*, but as the programme cover of the Contemporary Art Society's *First Concert of Contemporary Music* during its third annual exhibition, October 1941; and also by *Art in Australia* in December. Michael Keon, journalist, novelist and 'Heide' habitué, has called the exhibition of 1941 'undoubtedly the most celebrated and headily fruitful wartime exercise of the Contemporary Art Society (and, of course, the Reeds), ... held in the high profile salons of Melbourne's Hotel Australia'.[1] There were 310 works of art, 'a truly dazzling spectrum of wartime creative staying-power'. A concert of 'serious' modern music was held on the night of Tuesday, 21 October. And a week later Graeme Bell's jazz band performed below the paintings; as the Melbourne *Truth* reported: 'Long haired intellectuals, swing fiends, hot mommas and truckin' jazz boys rubbed shoulders on friendly terms. While swingsters hollered "Go to Town" and jittered in the aisles, the intelligentsia learnedly discussed differences between rhythms of hot jazz and pigments of Piccaso.'[2]

Nolan produced a number of related works at this time. Strange zoomorphic women like this 'Eve' figure with her silver enamel halo, or floating angels loosely inspired by Rilke's imagery, recur in the painted roof slates of 1941–42 and in several small pictures still in the artist's possession. Content and colour are not of this world; although perhaps the décor of Nolan's Russell Street studio, walls painted 'shocking' pink by Howard Matthews and Noel Blaubaum, had some small influence!

1. Catalogue introduction, *Glimpses of the Forties*, Heide Park and Art Gallery, 1982; the National Gallery of Victoria had refused hanging space for such modern art.
2. 'Art Jitterbugs Het-Up', *Truth*, 1 November 1941.

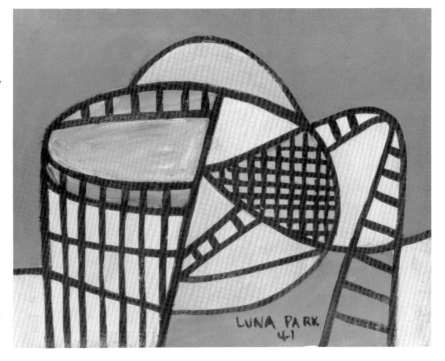

△
LUNA PARK 1941
Enamel on canvas mounted on cardboard
46 x 59 cm
Inscribed l.r.: 'LUNA PARK/41'
Private collection

The moon at St Kilda seems to have had a pervasive impact on Nolan's imagination: shining here through the iron grid of the 'Big Dipper' railway at Luna Park. He included a very similar painting in the C.A.S. exhibition of 1941, reproduced in *Truth* with the caption 'This ghastly effort is titled Luna Park!' (14 September 1941). The critic Dulcie Deamer asked, 'Why do our up-and-coming artists gibber, when they could draw straight sense?' Her objection to not-strictly-representational art seems to have been a moral one: 'This is not a time for drivelling. World conditions demand that we see straight and think straight.' For Nolan and his modernist contemporaries, of course, world conditions—the crises of war—were cause for a total revolution in social and aesthetic sensibilities.

△
GIRL AND HORSE [1941]
Enamel on canvas
58.5 x 54 cm
Private collection

Exhibitions: *C.A.S.*, Melbourne, October–November 1941, no.292: 'Girl and Horse—N.F.S.'; Sheffield's Newsagency, Heidelberg, July 1942; Newcastle etc., 1961, no.11; I.C.A., London, May 1962, no.5 (withdrawn from exhibition)

Both subject matter—the circus or fairground theme—and style of this work are strongly influenced by paintings of Picasso, Leger and Klee from the 1920s and 30s: with flat planes of bold colour separated by thick black lines. Local critics seem to have been particularly annoyed by such 'designs in the Picasso manner' at the C.A.S. shows.

Arthur Rimbaud (1854–91): revolutionary poet-prodigy, 'symbolist' pioneer and adventurer, photographed by Carjat in 1871. He wrote Le Bâteau ivre *that year; published* Une Saison en Enfer *in 1873; and 'disappeared' in 1875.* Les Illuminations *was published by Paul Verlaine in 1886, whilst Rimbaud was trading gold, ivory and firearms in north Africa.*
Photograph: State Library of Victoria

△
HEAD OF RIMBAUD [1938–39]
Pencil, oil and Kiwi boot polish
on cardboard
26.9 x 34.3 cm
Inscribed verso: 'Head of Rimbaud'
Heide Park and Art Gallery
Purchased 1980

Provenance: Sunday and John Reed,
until 1980

Exhibitions: *Contemporary Art Society Inaugural Exhibition*, N.G.V., June 1939, no.74: 'Rimbaud'; *Heide Park and Art Gallery*, November 1981, no.36; *Counterclaims*, S.H. Ervin Gallery, Sydney, May–July 1986, no.41

'Arthur Rimbaud, born in 1854, was a specialist from the beginning. Whether in his poetry, which established a legend less durable, more adorable than Shakespeare, or in his acts in Africa, he bears the birthmark of an angel, naked and possessed. The mob likes a crucifixion. Rimbaud gave them a crucifixion and resurrection all in one; upsetting at once their idea of a genius and the hand he should play ... Language is what counts.'
- Sidney Nolan, 'Faithful words', *Angry Penguins* 4, 1942

Nolan's 'portrait' *Head of Rimbaud* caused a minor storm at the Contemporary Art Society's inaugural exhibition in June 1939. Seemingly fairly unremarkable, it was rejected by the artist members of the selection committee—with George Bell as president and Rupert Bunny as artist vice-president; and eventually hung only when the lay members insisted on their right to reconsider any submission. John Reed was lay vice-president: other progressive members included Peter Bellew and art bookshop proprietor, Gino Nibbi. The producers of the catalogue called it simply 'Rimbaud';

against the wishes of Nolan, whose chosen title deliberately pointed to the relationship between his work and the famous photograph of the French poet taken by Carjat in 1871. (It is also reminiscent of Sam Atyeo's abstract *Organised Line to Yellow* of c.1933 which hung in the dining room at 'Heide'.)[1]

Adrian Lawlor, as C.A.S. honorary secretary and manager for the exhibition, asked scathingly, 'Tell me, Mr Nolan, what exactly is a rimbaud? A French cheese?' Needless to say, Lawlor knew perfectly well that Arthur Rimbaud was virtually a tutelary god in the eyes of many twentieth-century poets and painters. The *Illuminations* create a new world of dreams and childhood memories. His *Season in Hell* is a major text in the history of the modern spirit, with its explosive language, radical forms, and composition in pictures. Both Nolan and Reed realized 'when the Head of Rimbaud was hung, how it was like chamber music and didn't appear to work well in collected company'.[2] It was a purposeful affront to tradition: in the spirit of the Surrealist poets and painters who believed that acquired technique, 'formal training in the old sense', was unnecessary and irrelevant to art.[3] And, of course, it was in the spirit of the subject—Rimbaud himself.

1. Now in the A.N.G. collection; Haese 1981, p.20.
2. Letter from Nolan to Sunday Reed, 9 August [1943].
3. Jaynie Anderson quotes Nolan on this subject. At the age of about nineteen, he thought that 'art would first of all be socialist ... and accessible to everybody ... more or less everybody would be able to paint and that it would be a non-figurative art'. Moholy-Nagy's *New Vision* suggested explicitly that within every person there was latent artistic talent, submerged by the demands of a society which required specialized vocation. Anderson 1967, p.314.

△
BOY AND THE MOON [1940]
Oil on canvas, mounted on board
73.3 x 88.2 cm
Inscribed verso: 'Portrait of John Sinclair
at St Kilda/Sidney Nolan. 5 Smith Street
St Kilda/ 12 gns.'
Australian National Gallery
Purchased 1976
Also known as 'Moonboy' and 'Portrait of
John Sinclair'

Provenance: Sunday and John Reed;
Sweeney Reed Gallery 1976

Exhibitions: *C.A.S.*, N.G.V., August–
September 1940, no.109: 'Boy and the
Moon'; *C.A.S.*, David Jones' Art Gallery,
Sydney, September–October 1940,
no.126: 'Boy and the Moon—12 gns';
Aspects of Australian Art 1900–1940,
A.N.G., 1978, no.81; *Counterclaims*, S.H.
Ervin Gallery, Sydney, May–July
1986, no.42

'Few spectators ... will be able to take
seriously Sidney Nolan's "Boy in the
Moon" [*sic*], which consists of a flat disc
of yellow, with an oblong protuberance
at the bottom, set on a flat dark ground.
Given a little patience for the brushwork,
any layman could produce pictures like
this, without giving them the slightest
thought.'
- Kenneth Wilkinson, *The Sydney Morning Herald*,
24 September 1940

When Nolan submitted *Boy and the Moon*
for the 1940 C.A.S. exhibition in Mel-
bourne and Sydney he polarized artistic
and critical opinion alike. J.S. Mac-
Donald's reaction was not unexpected:
'It is all foreign to us and these depictive
mooncalves and nightmares fail to shock
or amuse us'.[1] Although there was now
no selection panel or jury, Adrian Lawlor
was reduced to a paroxysm of frustration
when asked by Nolan to demonstrate
exactly what was *not* a work of art.[2]
Burdett in the Melbourne *Herald*, called
it an 'embryonic canvas which seems
mere impertinence and posturing'.
Kenneth Wilkinson, whilst approving 'the
play of imagination' in the exhibition as a
whole, where 'everyone is hopeful and
high-spirited [and] the fancy of the spec-
tator, as well as of the artists, can soar
fast and free', classed *Boy and the Moon*
in 'the minority which fails to come up to
standard'. Sydney artist Frank Hinder
was 'one of several who wanted it thrown
out because we saw it as such a fraud'.[3]
Donald Friend included it in his cartoon
of 'The Australian Contemporary Tradi-
tion'.[4] Others called it a 'lavatory seat'.
 In fact, this most controversial of
works is simply a most minimal rendering
of reality. Abstract enough in itself, *Boy
and the Moon* is a conflation of two
images. Nolan has explained that shortly
after his one-man show, as he sat talking
with John Sinclair on a bench at St Kilda
beach, the full moon rose behind his
friend's head. He glimpsed the two
silhouettes as one and fashioned his
painting from the double sensation.[5]
Cryptic, uncompromising, certainly
impertinent, this was exactly the sort of
subversively revolutionary art called for
by André Breton when he wrote, 'Nothing
can appear in the artistic vision that does
not elaborate itself and gradually become
the phenomenon of the future'.[6] The

yellow disc on its stalk-like neck, a
distillation of sensory illusion, has since
become a basic and recurring form in
Nolan's oeuvre. For some months of 1941
a much larger version shone up from the
farmhouse roof of 'Heide'.[7] Two decades
later it rose thirty feet in diameter above
the stage of the Royal Opera House
in London, as a blackcloth for Igor
Stravinsky's *Rite of Spring* (see cata-
logue). The 'moonboy' motif reappeared
in Nolan's illustrations for *Near the Ocean*
by Robert Lowell, 1967, in Ern Malley
drawings of 1974 and *Samson et Dalila*
sets at Covent Garden in 1981.

1. Director's report to the National Gallery
Trustees, 28 August 1940 (declined); MacDonald
condemned the C.A.S. as 'local imitators of
(chiefly) French exhibitionists ... Not
recommended'.
2. Haese 1981, p.71.
3. Interview, 5 July 1974, quoted by Haese,
loc.cit. Hinder resigned in protest from the
C.A.S. Committee.
4. Donald Friend, *Painter's Journal*, Ure Smith,
Sydney 1946, p.45. *Boy and the Moon* also hangs
on the wall in a painting by Friend: *Ned Kelly
and family*, 1948, gold leaf and oil on board
(James O. Fairfax collection, Sydney).
5. Smith 1962, p.70. Sinclair himself says, 'I had
an open mind at that stage, and it is still open'.
6. *Art in Australia*, December 1941, p.12.
7. 'I was asked to take it off by Airforce Intelli-
gence because they thought it looked like the
rising sun of Japan and might be a signal for
Japanese bombers': it was too near a strategic
bridge over the Yarra. Quoted in Lynn
1979, p.20.

PAINTED SLATES

I had a boat and poet
with wings, and on his head
was red lead,
the river ran between his eyes;
and in his hands were trees.

I had a hill and night
with frost and on the moon
was mist,
the valley held an angel;
and in his hands were trees.

I had an air and water-
wheel and all beside
a waterfall,
the ferns were slim and tall;
and in his hands were trees.

Tell you sister, tell you
lovers three, the poet had
wings, the boat had wings,
singing ever of here and now;
and in his hands were trees.

- Sidney Nolan, 'Rime'

U.A.M. 322

U.A.M. 319

U.A.M. 313

UNTITLED (GIRL WITH FLOWERS) 1942
Enamel on slate
30 x 25.5 cm
Inscribed l.c.: 'JAN 22ND / 1942 N'
Private collection, Melbourne
For exhibition in Melbourne only
Provenance: Sunday and John Reed
Exhibitions: C.A.S. Studio, Melbourne,
August 1943: probably one of the 'Paint-
ings on Slate'

UNTITLED (BOAT AND FLOATING
FIGURE) 1941
Enamel, oil and inks on slate
25.8 x 51.5 cm
Inscribed l.c.: 'Dec 22nd/1941'
University Art Museum, University of
Queensland U.A.M. 324
Purchased with the assistance of the
Alumni Association and the Peter Stuyve-
sant Cultural Foundation 1977

UNTITLED (LOVERS AND FLOWERS)
1942
Enamel, oil and inks on slate
25.5 x 50.8 cm
verso: a landscape in oil and inks
University Art Museum, University of
Queensland U.A.M. 309
Purchased with the assistance of the
Alumni Association and the Peter Stuyve-
sant Cultural Foundation 1977

SHIP 1942
Enamel, oil and inks on slate
25.7 x 50.8 cm
Inscribed l.r.: 'Ship Jan. 13th./1942/
Nolan'
verso: painting of a bird and figure in oil
and inks inscribed l.c. 'DEC 11th 41'
University Art Museum, University of
Queensland U.A.M. 313
Purchased with the assistance of the
Alumni Association and the Peter Stuyve-
sant Cultural Foundation 1977

SHIP 1942
Oil and inks on slate
21.5 x 51.7 cm
Inscribed l.r.: 'SHIP JAN 13th/1942 N'
verso: a bird under a tree in oil and inks
inscribed c.r. 'Dec 17th/1941'
University Art Museum, University of
Queensland U.A.M. 323
Purchased with the assistance of the
Alumni Association and the Peter Stuyve-
sant Cultural Foundation 1977

UNTITLED (SHIP AND ANGEL) 1942
Oil and inks on slate
25.6 x 51.4 cm
Inscribed l.c.: 'Jan 13th/1942/N'
verso: pattern in brightly coloured oil
and ink
University Art Museum, University of
Queensland U.A.M. 322
Purchased with the assistance of the
Alumni Association and the Peter Stuyve-
sant Cultural Foundation 1977

FEET 1942
Enamel, oil and inks on slate
25.4 x 41.1 cm
Inscribed l.c.: 'Feet/Jan 27th N/1942'
verso: cloud-like image
University Art Museum, University of
Queensland U.A.M. 319
Purchased with the assistance of the
Alumni Association and the Peter Stuyve-
sant Cultural Foundation 1977
Provenance: The artist (through Elwyn
Lynn)
Exhibitions: C.A.S. Studio, Melbourne,
August 1943: 'Paintings on Slate, 1941';
Nineteen Early Paintings on Slate, Institute
of Modern Art, Brisbane, 1977

Living and working in very straitened
circumstances in his tenement studio
opposite the Museum, during the summer
of 1941–42 Nolan discovered that fallen
roof slates made an ideal semi-absorbent
surface for inks and enamel paint. He
often painted both sides. Eighteen exam-
ples are now in the Queensland Univer-
sity Art Museum; one in the Australian
National Gallery; others are in private
collections.

Swiftly executed, utterly—almost
naively—simple, several of them echo
the imagery of Rilke's poem 'Childhood':

...And hours on end by the grey pond-
side kneeling
with little sailing boat and elbows bare;
forgetting it, because one like it's stealing
below the ripples, but with sails more
fair;
and, having still to spare, to share some
feeling
with the small sinking face caught sight of
there:-
Childhood! Winged likeness half-
guessed at,
 wheeling,
oh, where, oh, where?

Sometimes Nolan's angels swing through
the air like acrobats; often there are
flowers, lovers' faces and 'gentle hands
this universal falling can't fall through'.[1]
Nolan recalls that Rilke's Fifth Elegy had
a special impact on his imagination at this
time—with images of lovers, angels,
hands picking flowers and tingling feet.
Like Rilke, he sought symbolic or
'external' visual equivalents for inward
experience. He does not *illustrate* Rilke's
poetry. Just as Rilke himself wrote the
Fifth Elegy as a generalized, deliberately
inexact response to Picasso's famous
The Family of Saltimbanques, so Nolan
appropriates the poetic imagery of angels
and acrobat-lovers as his own. The
floating angels probably owe as much to
Rimbaud, to Blake— and to images in
Nolan's own poems—as they do specifi-
cally to any words of Rilke.[2]

1. 'Autumn' from *The Picture Book (Buch der
Bilder)*, 1903.
2. In an undated letter of 1942 he reminded
Sunday Reed of 'a perfect watercolour of Blake's
... of an angel or likewise floating up over a
stream' which they had seen at the Public
Library. The watercolours of Dante's *Divine
Comedy* were acquired by the National Gallery
of Victoria in 1941; and eleven were published
in *Art in Australia*, March 1941, by the new
director, Daryl Lindsay, calling Blake the 'first
English Primitive'. Other 'floating angels' which
Nolan would have seen recently were a beautiful
fourteenth-century pair carved in bas relief on
Orvieto cathedral, also illustrated in *Art in
Australia*, December 1941.

Flowers, whose kinship with ordering hands we are able
to feel at last (girls' hands, of once, of today),
who often strewn all over the garden-table,
tired and tenderly injured, lay

waiting for water to come, yet again redeeming
from death already beginning,—you,
now lifting your heads in the vivifying current
 streaming
from feeling fingers, able to do

yet more in the way of kindness than ever you guessed,
light-headed ones, when you woke in the jug, to find
you were cooling and slowly exhaling the warmth of
 girls, like things confessed,

like tiring sins remembered in drowsy gloom,
which the gathering of you committed, to bind
you to them once more, who blend with you in their
 bloom.

- Rainer Maria Rilke (1875–1926)

WINDOW: GIRL AND FLOWERS
1942
Enamel on six glass panels in wooden frame—one panel restored
85 x 67.5 cm
Inscribed l.r.: 'GIRL & FLOWERS
Jan 10th 1942
NOLAN'
Private collection, Melbourne
For exhibition in Melbourne only

Provenance: Sunday Reed

Exhibitions: C.A.S. Studio, Melbourne, August 1943: 'Window 1941'; *1940–1945...*, M.O.M.A., Melbourne, October—November 1961, no.3: 'Girl with flowers, 1942 (six panels in an old cottage window) Collection, Sunday Reed'

Nolan was happy to experiment with almost any combination of media: a necessity imposed by impecunity and wartime stringencies and a legacy of his experience using enamel paints on glass to manufacture illuminated signs in the mid–1930s.

WAR AND THE WIMMERA

All things that you look at are cut off, hindered, altered in your mind later by things you don't actually remember having seen. Sooner or later they settle and are ready to come out. But not before they soak through you.

-Nolan to Sunday Reed, Nhill, 29 March 1943

His long immersion in radical modernism, prolific with magnificent trivialities, has paid dividends in the development of an individual perception of a very high order, and in the steady growth of a rare lyrical talent, maturing in his Nhill and Dimboola landscapes. Here ... we glimpse for the first time since Roberts, McCubbin and the early Streeton, the return of an authentic national vision on a higher and more independent level.

- Albert Tucker, *Angry Penguins* 5, 1943

These wartime years mark Nolan's first intense personal and artistic identification with the Australian landscape; a synthesis of his ideas about painting; and a period of development more concentrated, perhaps, than at any other time in his career. 'You were forced either to love it or hate it', he wrote of the Wimmera where he was stationed for almost two years, 'I loved it'. 'Being on one's own—or being in the army which is, in a sense, being on one's own—and being forced to stay in Australia, instead of going to Paris and paint as I'd hoped to, changed many things. I began to forget Paris and modern art. More and more I began to appreciate the reality of my situation... I was surrounded by Australian life...'[1]

The Wimmera district of Victoria is that flat golden wheat-growing country which unfolds north-west towards the Little Desert, beyond the grey granite and sandstone escarpments of the Grampians. Lacking in natural landscape features, the blacksoil plains stretch for miles, specked with stunted trees, punctuated only by railway lines and tall white silos. Nolan was compelled to paint the landscape by the very force of its presence.

'It was alright while we [were] in sight of the Grampians', he wrote to Sunday Reed after his first day spent in the back of an army transport, 'and then suddenly [there] was ... nothing of the earth except a thin line. And while I was thinking about all these things, it came simply that if you imagined the land going vertically into the sky it would work'.[2] The resultant paintings follow Cézanne's modernist dictum of 'representation not imitation'. Nolan aimed to convey 'the perennial sensation' of a given scene.[3] He seized upon the conceptual, map-like vision of primitive peoples', naive or children's art; but never followed such precedents slavishly. ('There is only one innocent to an age of painting', he wrote of Henri Rousseau.)[4] Some of the Wimmera pictures are 'impressionistic'—as though the landscape were enveloped in a heat haze. Others are more 'cubist' in style. With radical flatness, high horizons, virtual absence of conventional linear perspective and bright primary colours, they interpret the Australian landscape in an entirely new way.

Nolan's decision to tackle landscape painting was spurred to some extent by earlier discussions with the Reeds and fellow artists at 'Heide', discussions in which Sunday Reed's was the most outspoken voice. She calculated what the chances were of 're-doing Australian landscape', of recapturing the vitality which had been lost since the time of the 'Heidelberg School' artists in the 1880s. As *The Herald* critic Basil Burdett pointed out, 'most of our artistic history since then ... amounts to little more than successive imitations of Streeton impressionism, diminishing in force and value with each generation'.[5] At 'Heide' in the early 1940s, Nolan recalls, 'we were heavily involved in "abstract" painting and being avant-garde and going forward from that point; so going back to landscape was rather like treason. We did discuss it and I did start to change course as a result.'[6]

The mundane, day to day physical routine of army life rested his 'emotions and mental complexities'. He sketched extensively during 1942, producing page after page of vibrantly coloured small drawings in chalk which 'does keep me honest, I

think and helps bigger paintings when they come' (c.July 1942). By October, based at Dimboola, he had more free time: 'waiting here, walking, doing my share of dreaming & every now and again a painting'. He read incessantly (Sunday keeping him supplied with parcels of books from 'Heide'): the poetry of Rainer Maria Rilke in particular, his beloved Rimbaud and Stephen Spender; writers concerned in some way with myth—Kafka, Melville, T.S. Eliot, Yeats, Faulkner and Treece; as well as Gide, Saint-Exupery, Malraux, Spengler, Auden, Heppenstall, Freud, Lenin; 'reading Chekhov generally over dinner in the cafe'; and Karl Marx's *Capital* 'before going to sleep at night. Reading then you seem to be able to concentrate more'! This extraordinary range of intellectual interests is parallelled in the subject matter of his paintings at the time: landscapes—real and imaginary—portraits, local school children, aeroplanes, bathers and so on. 'Still a lot of different tracks, too many it feels sometimes', he said, 'but they have all got to march together & that's the way it is' (6 November 1942, Dimboola). He was also writing poetry. 'I am smitten with a desire to write poetry once on my own. This is terrible, bad for business, particularly as I must bend my energies to becoming prime minister', he quipped.

Bundles of paintings were regularly despatched by train to the Reeds in Melbourne, sometimes for exhibition with the Contemporary Art Society or elsewhere. Sunday sent him raw materials in exchange: sheets of 'Masonite' hardboard, canvases, fine linen or muslin laid down on boards and 'Ripolin'—the high grade enamel paint, manufactured for use on houses or boats, which Picasso called 'healthy paint' and Nolan had now been using for about a year. (Ripolin allowed far greater colour subtleties and formed less surface skin than local enamels.) Dulux would do at a pinch if Ripolin were unobtainable, he wrote; 'Still a hankering after oil-color but I really think it belongs with Rembrandt or Cézanne—or after the war. There must be a stock of Ripolin somewhere in the country, there was a Ripolin House in Sydney but Bert [Tucker] said they were no go.' And again:

> Dulux is probably the most durable lacquer or enamel on the market, so really it's the best angle to concentrate on. Their three best colors, strongest, brightest, are lemon yellow, cobalt blue & the red I've forgotten but you can tell it easily enough on the color card. Those three colors & black & white & thinner give a pretty complete range. 'Dynamel' is next best ... and the Duco firm also put out a 'Duco' white lacquer [enamel] undercoat which all serve as a base for strong color. If you are going to get a bit of a hoard together... it would be a good idea to see Deans [artists' supplies] about more aniline dye ... Ask if they have the three colors, red, blue & yellow again, soluble in spirit ... And black. But as strong as they have got.[7]

Although wonderfully fast-drying, Ripolin is an extremely fluid medium—'like quicksilver'—and must, therefore, be applied to a canvas or board lying flat. The effect of immediacy was thus implicit in Nolan's chosen working method. His fellow soldiers seem, in general, to have been interested in and tolerant of such eccentrically off-handed painting practice. He was nevertheless unable to convince his superiors that his talents might qualify him as an official war artist. On one occasion he was offered a job painting camouflage—and refused. Later he wrote with wry amusement that he was employed 'painting bridge classification signs. In bright yellow like the moonboy' (Ballarat, September 1943): just like the giant 'Boy and the Moon' image he had once painted on the roof at 'Heide'!

Nolan's Wimmera paintings rarely reflect the disturbances of the world at war—unlike contemporaries such as Tucker, with his 'Images of Modern Evil', or Perceval's grimly expressionist subject matter. Indeed Tucker considered that 'in these violent days', Nolan's work was 'frequently remote and esoteric'.[8] And Nolan himself admitted, 'Lyricism seems almost an irony now in these days'. Yet it 'becomes a centre to oppose what goes on', he explained in a letter to Sunday Reed.

Among his most lyrical works from this period is the *Arabian Tree*, painted in response to one of a group of new poems which Max Harris had recently sent up from Melbourne for his opinion. These sixteen poems, collectively entitled 'The Darkening Ecliptic', had been written by one Ernest Lalor Malley, a garage mechanic and insurance salesman recently deceased and hitherto unknown to the literary world. They

contained some startling and powerful images which Nolan felt had 'an explicit paint-erly instruction about them'. 'Been reading the Malley at most opportunities', he told John Reed, '& do find his images are ones which I am in harmony with, or visually practicable, put it that way... For the moment, as much as I can synthesize my thoughts on the import of his poetry, I think of a critic (probably Spender) saying the fact that Dante was able to use his poetry to enact a more coherent world than say Rimbaud did not alter the greatness of Rimbaud's poetry' (Horsham, 1 December 1943). The subse-quent history of the Ern Malley affair is, of course, well known. Doubt was raised about the poems' authenticity soon after they were published in *Angry Penguins* special 1944 Autumn Number, with Nolan's *Arabian Tree* reproduced on the cover. The truth finally came out on 5 June 1944, when the Sydney *Sun*'s supplement 'Fact' published a statement by two former Sydney University students, James McAuley and Harold Stewart:

> We produced the whole of Ern Malley's tragic life-work in one afternoon, with the aid of a chance collection of books which happened to be on our desk: the *Concise Oxford Dictionary*, a Collected Shakespeare, *Dictionary of Quotations*, etc. We opened books at random, choosing a word or phrase haphazardly. We made lists of these and wove them into nonsensical sentences. We misquoted and made false allusions. We deliberately perpetrated bad verse, and selected awkward rhymes from a Ripman's Rhyming Dictionary. In parts we even aban-doned metre altogether ... Then we elaborated the details of the alleged poet's life. This took more time than the composition of his *Works*.[9]

This 'Great Literary Leg-Pull' received enormous attention from both the local and overseas press. And the edition of *Angry Penguins* very quickly sold out.

Most local critics supported the anti-modernist hoaxers' 'serious literary experi-ment' in protest against 'the gradual decay of the meaning and craftsmanship in poetry'. Sir Herbert Read, however, defended 'The Darkening Ecliptic' as 'poetic and poetic on an unusual level of achievement' (Harris had called Read 'the best living art-critic'). Others, including the American poet Harry Roskolenko, said that McAuley and Stewart had been hoist with their own petard by writing poetry in spite of them-selves. As Nolan said to Malcolm Good, whatever the hoaxers' initial intention, the episode had a 'powerful, creative and constructive effect' in the long run. 'What has hoax got to do with it?' he asked, ' Poetry such as that deepens my insight, not the reverse'. He admired especially the imagery in 'Durer: Innsbruck, 1945', 'Documen-tary Film', 'Petit Testament' and 'Young Prince of Tyre'; saying, 'My reaction to Malley derives its acceptance [from] a quite genuine belief that the poems deal with experi-ences that are accessible to me, & many of them talking a more instinctively familiar language than I have yet found in Australia'.[10]

1. Barber 1964, p.92.

2. Letter of May 1942.

3. Interview in *The Studio*, October 1960, p.130.

4. Undated letter of 1942.

5. 'Modern Art in Melbourne', *Art in Australia*, November 1938, p.18.

6. 25 February 1983, interview with Richard Haese quoted in *Sidney Nolan: the city and the plain*, N.G.V., 1983, p.12: the best discussion of Nolan's Wimmera years; see also Haese 1984 and Adams 1987. Bernard Smith has suggested that in the shift from quasi-abstract art 'owing much to psychic automatism, to an art which is, among other things, an act of conscious choice' Nolan's reading of Søren Kierkegaarde may have been a catalyst; Smith 1967, p.78.

7. From Dimboola, late 1942. See Mayer 1973, pp.176ff. for discussion of these materials.

8. *Angry Penguins* 5, 1943.

9. *Ern Malley's Poems*, with an introduction by Max Harris, Melbourne, 1961, p.8: includes the McAuley-Stewart state-ment, critical commentaries and an account of the subse-quent court case in which Harris was charged with obscenity and found guilty of having sold, offered or distrib-uted certain indecent adver-tisements; convicted and fined £5. For a succint account of the affair and Nolan's response see Jan Minchin's essay 'The city and Ern Malley', in *Sidney Nolan: the city and the plain*, N.G.V., 1983, pp.60ff.

10. 14 July 1944. Years later, in 1961, Nolan said, 'It really came from the levels that we don't know much about. And that's why we have art'.

Politically committed members of the C.A.S. were not impressed with either of the versions of *Going to School* shown in the 'Anti-Fascist Exhibition'. Although Nolan was taking the role of the artist in wartime as laid down by Max Harris— 'record, accept, endure'[4]—these dawdling schoolgirls seemed to them just too much paint and not enough propaganda.

1. Letter to Jan Minchin, July 1983.
2. To Sunday Reed, 5 November 1942; quoted in Haese 1983, p.16.
3. 10 November 1942.
4. 'Art and Social Integration', *Australian Quarterly*, March 1943, p.32.

GOING TO SCHOOL 1942
Enamel on canvas
56 x 44.5 cm
Inscribed l.c.: 'GOING TO SCHOOL/ 8-11-42 NOLAN'
Private collection

More beautiful and soft than any moth
With burring furred antennae feeling its huge path
Through dusk, the air-liner with shut-off engines
Glides over suburbs and the sleeves set trailing tall
To point the wind. Gently, broadly, she falls
Scarcely disturbing charted currents of air...
- Stephen Spender, from 'The Landscape near an Aerodrome', *Poems*, 1933

'I still in those moments bump my head pretty solidly against Picasso, although there is not much trace of it except in the head of say something like "Going to School". Still the painting is out and it [is] that much more tangible to work on. The clearer your head is and workmanlike the better the painting, invariably. Mystic moments are as far as I can see a bloody nuisance.'
- To Sunday Reed, 5 November 1942

△
GOING TO SCHOOL [1942]
Ripolin enamel on steel sheet
46 x 66 cm
Inscribed l.c.: 'GOING TO SCHOOL'
National Gallery of Victoria
Presented by Sir Sidney and Lady Nolan 1983

Exhibitions: *C.A.S. Anti-Fascist Exhibition*, Athenaeum Gallery, Melbourne, December 1942, no.25: 'Going to School (2)—10gns'; David Jones' Gallery, Adelaide Festival, March 1970, no.4; Skinner Galleries, Perth, January 1971, no.4; *Sidney Nolan: the city and the plain*, N.G.V., 1983, no.12, illus.; *Nolan's Wimmera*, Horsham etc., October 1986–June 1987

'Yesterday yellow colored planes dived right down over us. Very close, the vibration making the stomach just about tickle. Not very funny at that either. Lovely in a way, the sudden patch of yellow in the sun and bright sky.'
- Nolan in Dimboola, c.October 1942

Fascinated by aircraft (although he had never flown), Nolan read Antoine de Saint-Exupery's *Night Flight* whilst stationed at Dimboola. He wrote repeatedly of the training planes 'flying around & around doing exercises' from the R.A.A.F. base at Nhill; 'quite at home above the trees' in the brilliant enamel-blue sky, seeming hardly to move as the landscape beneath appeared 'transitory and floating along'. Each morning, as he recalls, he could see school children passing the shop window where he painted—the front of a big garage where the Army food was stored. He grappled with the theme in a series of small paintings during October and November 1942: the war and the landscape as though seen through the eyes of a child. He was desperately short of materials. This painting is on a recycled sheet of metal; another, now in the National Gallery of Victoria, on a piece of corrugated cardboard.

The shallow space of the Dimboola townscape, with its overlapping planes of houses, churches and silos, is indebted to Cézanne. And the white bird-like form was probably a 'result of left-over cubism'.[1] The schoolgirl's head is largely painted out in this example. 'I get [the] feeling sometimes I could yell at it to make it come into shape. And when it goes dead I could kick a hole in it and hold my fist through from the back just to feel there was something real', he wrote.[2] And a few days later: 'Yesterday was bad for painting, things kept stumbling over themselves & I ended up feeling I had used a lot of paint & a lot of hard work doing it. It serves its purpose however, gets rid of a lot of junk thoughts and worked on much cleaner this afternoon. But it is a trial & error method.'[3]

By the time of Nolan's third one-man exhibition, in August 1943, his style was clearly representational. The exhibits fell into two quite distinct groups: lyrical Wimmera landscapes on the one hand and, on the other, a series of 'pathological' heads and portraits. This one was reproduced on the exhibition catalogue and on invitation cards for the opening. Nolan's initial response to the regimentation of army life, which he says, made him feel like a convict, was to cease creative work for the duration.[1] But as months passed by he could not refrain for long from painting.

Like Tucker, making documentary drawings of criminals and psychiatric patients at Heidelberg Military Hospital earlier in 1942, Nolan was much influenced by the Freudian theories of Dr Reginald Spencer Ellery. According to Max Harris, Ellery was a 'pervasive presence ... the pioneer Australian psycho-analyst'; whose recent book *Schizophrenia: the Cinderella of Psychiatry* (Australasian Medical Publishing Co., Sydney, 1941 and 1944) was owned by 'every painter of the Angry Penguin school'.[2] Ellery was preoccupied with the psychological traumas of wartime, conducive to aggression which resembled the derangement and loss of control symptomatic of schizophrenia.[3] This argument he presented in a new book, *The Psychiatric Aspects of Modern Warfare*, published by Reed & Harris, 1945— with, appropriately, Nolan's *Head of Soldier* on the cover. 'This book deals not with lunacy but with war', he wrote, 'The two subjects have more in common than their names suggest. They are almost exclusively human phenomena, and both are rooted in irrationality.'

Stylistically this painting relates to Picasso's double-faced Surrealist heads of 1938–39, in the comparable fixed stare and sharp indentation at the side of the face; also to the 'haptic types' of portrait heads illustrated in Viktor Löwenfeld's *The Nature of Creative Activity*, 1939. The 'portrait', with its lurid flesh colour, staring eyes, twisted face and lolling tongue, was by no means intended as a personal attack on Nolan's commanding officer with whom he got on reasonably well; it is, rather, a haptic expression of his feelings about the army and the war.

HEAD OF SOLDIER 1942
Enamel on cardboard
75.8 x 63.3 cm
Inscribed l.c.: 'HEAD/6.12.42 N'
Australian National Gallery
Purchased 1976

Provenance: Sunday and John Reed (M.O.M.A. 1958–65, no.58.087); Sweeney Reed 1976

Exhibitions: C.A.S. Studio, Melbourne, August 1943, probably no.3: 'Head', illus.; M.O.M.A., Melbourne, September–October 1958, no.87: 'Head of Soldier'; David Jones' Art Gallery, Sydney, February 1959, no.87; *Art and Social Commitment*, A.G.N.S.W. etc., December 1984–April 1985, p.145

'Certainly not a flattering or accurate— whatever that is—portrait of my captain in the army, Captain Bilby. It was used as the cover of Reg Ellery's book *Pyschiatric Aspects of Modern Warfare*.'

- Nolan, speaking to Elwyn Lynn, 21 April 1978

1. Letter from Joy Hester to Albert Tucker, 1942; quoted in Haese 1981, p.191.
2. Max Harris, 'Conflicts in Australian Intellectual Life', in *Literary Australia*, eds C. Semmler & D. Whitelock, Cheshire, Melbourne, 1966, p.19. The cover illustration of *Schizophrenia* was a drawing by a female schizophrenic patient, from a collection which Nolan had studied. For Tucker's wartime drawings, see Uhl 1969 and Mollison & Bonham 1982.
3. See Haese, loc.cit.; also discussed in Anderson 1967, pp.314f. and Gilchrist 1975.

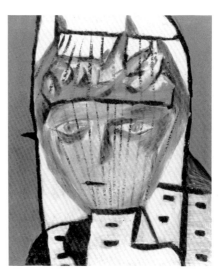

MORNING MASS 1943
Ripolin enamel on pulpboard
76 x 64 cm
Inscribed l.c.: 'Morning.Mass. /Feb.43./N.'
verso: painting inscribed l.c. 'Factory./ 4.12.42/N.' and '12/6/43....'
Heide Park and Art Gallery
Purchased 1980
For exhibition in Melbourne only

Provenance: The artist, to Sunday and John Reed (M.O.M.A. 1958–65) until 1980

Exhibitions: C.A.S. Studio, Melbourne, August 1943, no.4; M.O.M.A., Melbourne, September–October 1958, no.89; David Jones' Art Gallery, Sydney, February 1959, no.89; *Heide Park and Art Gallery*, November 1981, no.41

Painted at Ballarat in February 1943, this haunting image was part of Nolan's response to the local landscape. He had been struck, on his first visit to Ballarat the year before, by the colours 'where the mines have cut into the surface of the hill, leaving, with pink, blue, and white slag heaps, a very weird landscape in miniature'.[1]

Nolan remembers seeing women wearing veils on their way to church in Ballarat. Possibly his church-going subject, her mind filled with beautiful landscape, feels entrapped by her veil as by Blake's 'web of Religion'—an impediment to the creative imagination.

1. To Sunday Reed, 27 September 1942.

RAILWAY YARDS, DIMBOOLA 1943
Ripolin enamel on canvas
77 x 64 cm
Inscribed l.r.: 'N/17-3-43'
verso: 'Railway Station/Railway Yards,
Dimboola March 43 N'
National Gallery of Victoria
Presented by Sir Sidney and
Lady Nolan 1983

Exhibitions: *C.A.S.*, Sydney, June–July
1943, no.291: 'Railway Yards, Dimboola';
C.A.S., Melbourne, August–September
1943, no.140; *C.A.S.*, Adelaide, October–
November 1943, no.121; A.G.N.S.W. etc.,
1967, no.7; David Jones' Gallery, Ade-
laide Festival, March 1970, no.10; Skinner
Galleries, Perth, January 1971, no.10;
Stockholm, 1976, no.4; *Sidney Nolan: the
city and the plain*, N.G.V., 1983, no.17,
illus.; *Nolan's Wimmera*, Horsham etc.,
October 1986–June 1987

'I got up early the other morning & went
to the window to see what sort of a day it
was & I could smell all the wheat around.
Like being inside the silos...'
- Dimboola, summer of 1942–43

Part of Nolan's rejection of tired aca-
demic traditions was to employ deliber-
ately child-like composition, reminiscent
here of Vassilieff's Fitzroy paintings. He
sees the Dimboola railyards through the
eyes of the children on the bridge: *they*
see the steam train passing beneath
them and again puffing away into the
distance. He presents the whole scene
both in plan and elevation, as it were.
Viewed from a height, such as the top of
a wheat silo, he found the countryside
transformed: 'Must be like seeing down
from an aeroplane, the country cut up
into chocolate patches'.¹ Such playfully
sophisticated treatment of space owes
much to the example of Cézanne. 'Now I
don't doubt for a moment that I am not
great in the sense that Cézanne is', he
wrote to John Perceval, 'Far from it and if
I live to be 600 it is only a few facets of his
work that I can assess. That is because
only aspects of him are practicable to
me. What he does to me and that to a
large degree, is to provide a constant
impetus that is never far from me when I

am looking ... One is eager to find paral-
lels.'² But, he added, 'painting itself is
something else. One is rejecting with all
the force available all the influences that
do crowd in. I have a great desire to let
the past alone with painters.' As John
Reed wrote that year, he was 'drawing ...
on the real sources of the Australian
visual image'.³

1. c.May 1942.
2. Horsham, c.December 1943. Nolan knew
Cézanne's work both in reproduction and four
paintings in the *Herald* show of 1939; at least one
was now on display at the Melbourne Gallery;
see Haese 1984. On 18 May 1943 he wrote to
Sunday Reed, 'Thinking today with the shadows
from houses & trees just how much we are going
to need Cezanne's clearness to look at the
landscape'.
3. Catalogue sheet for *Exhibition of Paintings by
Sidney Nolan*, August 1943.

△
ICARUS 1943
Ripolin enamel on cheesecloth over
pulpboard
73.8 x 60.9 cm
Heide Park and Art Gallery
Purchased 1980
For exhibition in Melbourne only

Provenance: The artist, to Sunday and
John Reed, until 1980

Exhibitions: *Heide Park and Art Gallery*,
November 1981, no.40; *Selected Works*,
Heide, March–May 1982, no.40

Although related to the 'bathers' theme,
Icarus blends different levels of reality
and imagination, both more complex and
more personal. Nolan becomes Icarus
for one brief moment as he dives—like a
streak of lightning. In a compendium of
insistent images from his own adoles-
cence, he is also a sunbather on the
sand, a figure rolling down the green hill
at Elwood in the distance, and standing
on the shore. The technique—enamel
painted over fine linen cheesecloth laid
down on the board—gives the work an
almost dream-like quality.[1]
 Nolan had long been fascinated by
reproductions of the elder Brueghel's
mythic *Landscape with the Fall of Icarus*
(c.1558, Musée Royal, Brussels), which

shows that foolish youth plunging into the
ocean near a sailing ship, having flown
too close to the sun on his wings made of
feathers and wax.[2] The ship in his *Icarus*
relates indirectly to an unsuccessful
allied naval engagement with the Japa-
nese at Macassar which he read about in
February 1942. Burning galleons also
appear in his most disturbingly surreal
Bathers of 1943 (N.G.V.); where Richard
Haese has suggested they signify 'the
shipwreck of the young'.[3] This is one of
Nolan's few wartime paintings to convey
a sense of forboding and fear.[4]

1. Tucker seems to have been the first to paint on
muslin over pulpboard: a technique from Max
Doerner's *Materials of the Artist*, New York,
1934. Sunday Reed sent Nolan a number of
prepared boards from Melbourne in 1943.
2. 'You remember Brueghel's picture *Icare*. That
is what a man looks like falling into the sea', he
wrote on 29 March 1943; and in another letter,
'You can't say too much of Brueghel'. He had
already treated the theme of Icarus in his designs
for Serge Lifar's ballet of that name
in 1940.
3. Haese 1983, no.22; discussed pp.22f.
4. In a haunting portrait of roughly the same
date, now in a private collection, John Perceval
holds this picture along with a little model of a
ship made by Nolan and painted with
luminous enamel.

LATRINE SITTERS 1942 ▷
Ripolin enamel on pulpboard
63 x 76 cm
Inscribed l.r.: 'LATRINE SITTERS/
5.12.42.N.'
Private collection

'The sitter, as much as paintings come
from places, is from Hurstbridge, where
the latrines were on a golden hill with two
trees on it.'
- Nolan, from Dimboola, 9 December 1942

This is the second version of a painting
which Nolan submitted for the 'Anti-
Fascist Exhibition' in December 1942,
entitled *Dream of a Latrine Sitter*.[1] The
Communist and Social-Realist faction of
the C.A.S. severely criticized that first
version. To artists such as Vic O'Connor
or Noel Counihan, the daydreaming
private seated on a privy seemed to be a
complete abdication of political responsi-
bility. Nolan, they felt, was perversely
asserting the rights of the individual over
'collectivism'. He in turn conceded that
the first painting—with the 'dream' actu-
ally included on the left hand side—
was not an unqualified success. For one
thing, he admitted, the seated figure
looked 'more like a little girl than a sol-
dier'.
 'Dream of a latrine sitter was a long
shot', he wrote to Sunday Reed, 'but it
has come off enough. I don't think it can
ever really work out that way, though.
Not for a painting; maybe poetry. After
the exhibition, you had better cut the
dream part off. I had another try at it sans
dream' (Dimboola, 6 December 1942).
In this second version, 'without dream',
he placed the 'very aesthetic latrines'
of Hurstbridge training camp clearly
against the hillside. As he explained,
'Latrine sitters ... is something else again;
it's much different from the first one in
the show, has more to do with the golden
hill as it really was outside the tent, & the
other one after all looked like a little girl
& that's different from a hill'.[2]

1. Dated '4.12.42'; now in the Christensen Fund,
A.G.W.A. In the *Anti-Fascist Exhibition* catalogue,
it is no.26, called 'Dream' because of censorship;
as Nolan wrote to Sunday Reed, 'mention of a
latrine might have been more than enough for
Mr bloody Wilmot ... the one time I have a title to
a painting and it has to be cut out. That's tough' (9
December 1942). An interestingly comparable
subject is Tucker's *Philosopher*, reproduced in
Art in Australia 89, 1939; Uhl 1969, pl.14A.
2. Undated letter, December 1942. Although
Nolan was of the left, he was strongly anti-
Stalinist and utterly rejected Social-Realist
aesthetics. See Borlase 1968 and Haese 1983,
pp.66ff. and ch.5, on the growing ideological
and political division within the C.A.S. at
this time.

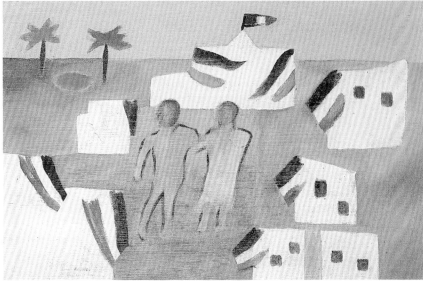

'One fine morning, in the country of a very gentle people, a superb man and woman were crying out in the public square: "My friends, I want her to be queen!" "I want to be queen!" She laughed and trembled. He spoke to friends of revelation, of a trial terminated. They swooned against each other.
In fact, they were monarchs for an entire morning, during which crimson hangings were raised again on the houses, and for the entire afternoon, during which they moved forward toward the gardens of palm trees.'
- Arthur Rimbaud, 'Royalty', from *Les Illuminations*

Not long after the 'Anti-Fascist Exhibition' in December 1942, Nolan wrote to Sunday Reed, 'I still have the idea to illustrate the poems as you translate them'.[1] She sent him a French dictionary so that he could also work on them himself. This was Nolan's only painted response at that time to the magical word-pictures of the young French poet. The Wimmera itself has been translated: into a North African landscape. A man and a woman wander arm in arm through a village of adobe dwellings swathed patriotically with the tricolour. Nolan's use of the more absorbent, rough textured side of the Masonite sheet lends an air of gentleness and mystery to the scene. Perhaps he was thinking not only of Rimbaud's '*Royauté*', but also the famous lines from the later prose poems *Une Saison en Enfer*: 'One must be absolutely modern ... Meanwhile this is the eve. Let us receive all influxes of vigour and of real tenderness. And at dawn, armed with an ardent patience, we shall enter the splendid cities'.

1. Some of her translations were published in *Angry Penguins* 4, 1942.

△
RIMBAUD ROYALTY 1942
Enamel on hardboard (reverse side)
59.5 x 90 cm
Inscribed l.l.: 'Rimbaud Royalty/Sunday Xmas 1942'
Heide Park and Art Gallery
Bequest of Sunday and John Reed 1982
For exhibition in Melbourne only
Provenance: The artist, to Sunday Reed
Exhibitions: C.A.S. Studio, Melbourne, August 1943, no.11: 'Royalty'; *1940-1945...*, M.O.M.A., Melbourne, October-November 1961, no.5: 'Rimbaud Royalty, 1942, Collection Sunday Reed'; *Selected Works*, Heide, March-May 1982, no.94

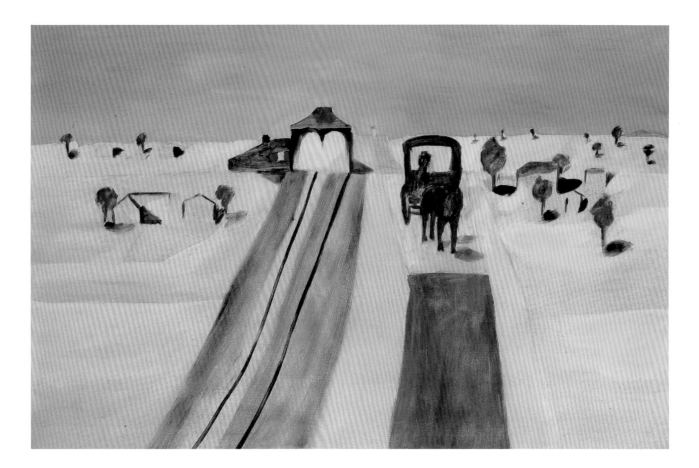

KIATA [1943]
Ripolin enamel on hardboard
61 x 91.5 cm
Australian National Gallery
Purchased 1974

Provenance: The artist, to John Sinclair
1947–1973; Sweeney Reed Gallery,
Fitzroy, March–April 1974

Exhibitions: *C.A.S.*, Sydney, June–July
1943, no.292: 'Kiata'; *C.A.S.*, Melbourne,
August–September 1943, no.141; *C.A.S.*,
Adelaide, October–November 1943,
no.122; *1940–1945...*, M.O.M.A., Mel-
bourne, October–November 1961, no.9:
'Kyata 1944 [*sic*] Lent by Mr John Sinclair';
Sweeney Reed Gallery, Fitzroy, 1974,
illus.

'The need to complete a picture [so] that
it has an all over tonal value is getting
greater. As long as it has that stillness
that comes from the picture standing
on its own, so much in the way of color,
architecture, etc. can go by the board.
Very little of modern art has it. Picasso,
Cézanne, very few of the others. It is the
one way you know a painting is finished,
and you know in just the same way as
when you look out of the window in the
morning you can tell what kind of a
day it is.'
- From Nhill, c.February 1943

The area around Kiata, just east of Nhill,
captured Nolan's imagination during the
summer of 1942–43. He wrote of the
township as 'something suspended at
high noon, & all the paintings have been
so much summer'.[1] This is one of his most
successful and satisfying Wimmera
landscapes: a 'floating scene', he said. It
is painted precisely and thinly as though,
to use Sunday Reed's metaphor, the
image had been peeled off like a transfer
in one unhesitating gesture.[2] Paul
Haefliger, art critic for *The Sydney
Morning Herald*, admired Nolan's use of
'large, simple spaces'; and wrote, '*Kiata*,
showing a railway line and a buggy in the
open country, with its almost brutal lines
cutting daringly across the picture, is one
of the most original abstracts conceived
by an Australian'.[3] After the war the
painting hung in Nolan's Parkville studio
until his departure from Melbourne
in 1947.

1. Nhill, 18 May 1943. He had painted *Kiata* at
Nhill, and sent it down to Melbourne by rail
early in February 1943.
2. Quoted in Haese 1983, p.20.
3. 29 June 1943. It must have made a striking
contrast with the preponderance of Social-
Realist war subjects in the same C.A.S. exhibi-
tion: for example, Herbert McClintock's
tendentious *I Was a Shift Worker in a Munition
Plant*. Arthur Boyd's entries included *The Kite
Flyers*; Perceval's the *Boy with a Cat*; and Tucker
submitted two early examples of his *Images of
Modern Evil*.

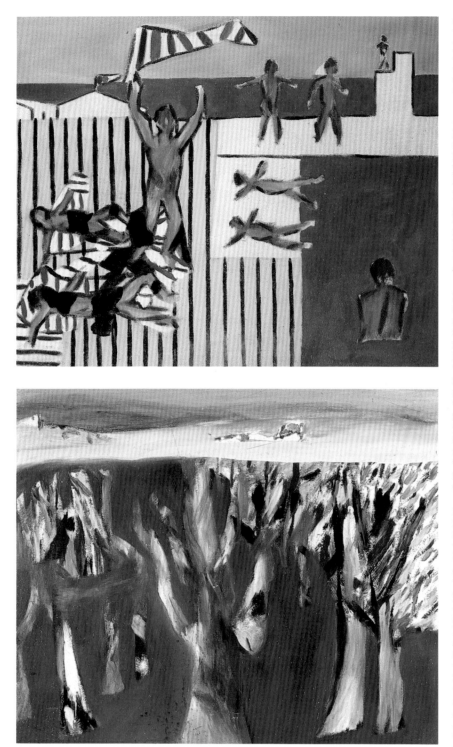

△
LAGOON, WIMMERA 1943
Ripolin enamel on pulpboard
63.5 x 75.9 cm
Inscribed l.c.: 'Lagoon/Oct 43/N'
verso: sketch of figure with hose
National Gallery of Victoria
Presented by Sir Sidney and
Lady Nolan 1983
Exhibitions: David Jones' Gallery, Ade-
laide Festival, March 1970, no.14; Skinner
Galleries, Perth, January 1971, no.14;
Sidney Nolan: the city and the plain,
N.G.V., 1983, no.26, illus.; *Nolan's Wim-
mera*, Horsham etc., October 1986–June
1987

'Too blasted hot. The landscape has
shimmered itself out of existence. The
lagoon has become almost mystic; that
is if one could think of such an involved
subject as mysticism ... The heat is inter-
esting visually but it needs the emotional
structure of Vincent [van Gogh] to deal
with it.'
- Nhill, 15 February 1943

Nolan eventually painted *Lagoon, Wim-
mera* more than eight months after
describing the scene in his letter to John
Reed: as a 'recollection in tranquillity'.
The brilliant colours, applied over a
white ground, in the patterning of

drowned tree trunks and the sweep of
yellow enamel distance show why he
was so particular about materials. He
had asked Sunday to send 'Dulux' if she
could not get 'Ripolin': 'Their three best
colors, strongest, brightest, are lemon
yellow, cobalt blue & the red ...'

◁ BATHERS 1943
Ripolin enamel on canvas
63.5 x 76.2 cm
Inscribed l.r.: 'Bathers./April.43./N.'
Heide Park and Art Gallery
Bequest of Sunday and John Reed 1982
Exhibitions: C.A.S. Studio, Melbourne,
August 1943, no.2, 8 or 9; M.O.M.A.,
Melbourne, September–October 1958,
no.90; David Jones' Art Gallery, Sydney,
February 1959, no.90; *Selected Works*,
Heide, March–May 1982, no.92;
Heide II—as it was, February–March
1983, no.24

Nolan's memories of St Kilda did not
desert him in the Wimmera. A similar,
although slightly less complex, view of
the men's swimming baths—'where I was
more or less reared', he says—is dated 6
December 1942 (N.G.V.).¹ In 1943, as he
wrote to the Reeds, he was painting so
many bathers that 'they appear to be
going on until one does walk on the
water'! On one level this is a celebration
of Australian sun and sea and untroubled
youth. As Nolan put it, 'Memory is I am
sure one of the main factors in my partic-
ular way of looking at things. In some
ways it seems to sharpen the magic in
a way that cannot be achieved by
direct means.'²

As a young man Nolan himself was
notorious for such daredevil athletic
feats as diving from the high tower
through a manhole in the boardwalk:
presumably his is the figure poised on
the diving tower here. But he is also the
solitary bather standing, back to the
viewer, in the dark blue water—a slightly
disturbing figure, alone despite such
lively company. This is haptic depiction
of temporally separated events. The
haptic treatment of space adds a faint
aura of disquiet to the scene: viewed
simultaneously from above (from the
tower perhaps) and more conventionally
from eye level (his own, in the pool) so
that normal perspective is eliminated. 'I
am sure about the bathers', he wrote, 'a
good feeling about the sea being blue
and standing up. Perhaps I'm thinking of
the Cézanne sea'.³ As in a child's
painting, all the figures appear to be the
same plane; and the wooden staging
seems to be in the same plane as the
water—despite an eight foot drop in
reality. This is what Nolan means when
he speaks of an uninhibited use of space
to obtain a stereoscopic feeling.⁴

In the library at 'Heide', Nolan once
noted an illustration of a comparable
composition by an Italian 'naive' artist,
The swimming pool at Gorla of 1934: 'St
Kilda baths and all', he wrote on his book
mark—although the painting is more
straightforwardly light-hearted in spirit
than his own work. Much closer in mood
is Carlo Carrà's *Bathers* of 1932, repro-
duced by Herbert Read in *Art Now*.⁵

Such possible starting points are nevertheless largely irrelevant to Nolan's final achievement. Pursuing the theme in 1943 he wrote, 'Painted another Bathers yesterday, will stick to them till they come clean in a different sense from the first one'.[6] With utmost simplicity of design and brilliant colour—more formal and schematic than the contemporary Wimmera landscapes—he made the St Kilda baths his own.

1. Reproduced in *Angry Penguins* 4, 1942, p.45. Haese 1983, no.16; see also Haese 1981, pp.186f. for discussion of the theme. Three *Bathers* were catalogued in Nolan's exhibition of August 1943. As recently as 1975 he produced a new series of 'bathers paintings' for exhibition at the Rudy Komon Gallery, Sydney, 1–26 May 1976; a number of which were purchased by the A.N.G.
2. Quoted by Anderson 1967, p.317.
3. To Sunday Reed, 18 May 1943.
4. Anderson, loc.cit.
5. Guido Piovene, *Cesare Breveglieri*, Edizioni del milione, Milan, 1943, pl.6; this book is now in the A.N.G. archives. Herbert Read, *Art Now*, Faber, London, 1933, pl. 22: the water 'tilted' to the high horizon, block-like form of the retaining wall and faceless bathers are notably comparable with Nolan's painting. In addition, he was 'very interested in the solid shadows falling on the bodies and the flatness the way Matisse would look at it'; interview, 21 April 1978, quoted by Lynn 1979, p.46.
6. To John Reed, Nhill, 20 May 1943.

FLOUR LUMPER, DIMBOOLA 1943 ▷
Ripolin enamel on pulpboard
76 x 63.5 cm
Inscribed l.r.: 'Flour Lumper/12/4/43...[illeg.]'
verso: 'Flour Lumper 12-4-1943 Dimboola Wimmera'
National Gallery of Victoria
Presented by Sir Sidney and Lady Nolan 1983

Exhibitions: C.A.S. Studio, Melbourne, August 1943, no.14; I.C.A., London, May 1962, no.11; A.G.N.S.W. etc., 1967, no.8; David Jones' Gallery, Adelaide Festival, March 1970, no.15; Skinner Galleries, Perth, January 1971, no.15; Stockholm, 1976, no.3; Paris, June–July 1978, no.3; *Sidney Nolan:the city and the plain*, N.G.V., 1983, no.18, illus.; *Nolan's Wimmera*, Horsham etc., October 1986–June 1987

SMALL 'FLOUR MAN' [1943]
Ripolin enamel on pulpboard
36.2 x 30 cm
Private collection

'*Flour Lumper* is an example of the part memory plays in creating an uninhibited use of perspective. Beside the railway track, to the left of the picture, is the figure of a man with a sack of flour on his back. Two significant details are distorted out of their normal relation and perceived size: the handkerchief, tied with two knots on the lumper's head, and the load he is carrying. The spectator can hardly avoid sharing the sensation of weight, from the size of the load of flour, since it is aggressively tilted against the picture plane. The sensation of oppressive heat is evoked by the large white handkerchief and the brilliant luminescent quality of the paint ... At the very end of the railway siding is a small figure, who at one time appears to be in the distance, and yet at another he could also be a Lilliputian standing on the lumper's head. Nolan is completely uninhibited in the way he plays with spatial ambiguities and the location of figures. Yet the whole order of the picture is controlled by an empathetic response. The distortions are in keeping with the way the lumper experiences the landscape.'
-Jaynie Anderson, September 1967

Nolan himself 'lumped' heavy bags of wheat whilst on transport duty loading stores. He was very pleased with this painting—'I think more about it & remember it better than most others'; and with the smaller 'Flour man' painted not long before.[1] The *Railway Guard* was, if anything, even more satisfying. It 'showed me what could happen with a perfect canvas & ripolin', he wrote, '& I suppose secretly I admire something about it'.[2] Both are executed with marvellous economy of means, with extensive use of the base support surface—brown pulpboard in one, white primed canvas in the other—as part of the composition. For Nolan, the starting point should always be visible in a finished work; as he told Perceval, paintings 'made correctly will not try to disguise the manner of their making'.[3]

1. Undated letter, late 1943 and one of 22 March 1943. A long discussion of this painting, in another letter to Sunday Reed, is quoted by Haese 1983, p.19. The small painting entitled 'Flour man' dated February 1943 in Sunday's diary, is presumably the 'sketch' version of *Flour Lumper* in this exhibition.
2. 25 March 1943; he had painted it ten days before. Both *Flour Lumper* and *Railway Guard* are memories of Dimboola, painted at Nhill (letter of July 1983).
3. Horsham, c.December 1943.

'You have probably given such a vivid impression of the landscape from Mt. Arapiles that the painting will have to work hard to live up to it. I will have to settle down to some continuous way of working to adequately cover that reiteration of similar objects that made the original feeling & landscape. Such factual items as setting up a new studio again keep me slow in actual canvases produced, but there has been some ferment inside of rejecting or accepting images as they come; & why did I not think of it before, it is the Chinese who can repeat practically the same image indefinitely in a painting without turning it to decoration & who also are so transparent.'
- To Sunday Reed, Dimboola, January 1944

Nolan was determined to work 'more & more' on landscape, 'particularly when surrounded by it, and ... to master that before using it to say other things which one knows have got to be said'.[1] As early as the 1860s, artists such as Eugen von Guérard and Nicolas Chevalier had sought romantically sublime subject matter in this area of the Grampians.[2]

In one sense *Wimmera (from Mount Arapiles)* celebrates the blue-and-gold tradition of Australian pastoral landscape art. But Nolan overturns the vision of Streeton, Heysen and all their conservative followers. There is no 'picturesque' recession. The only vestige of perspective is in the two small white wheat silos scarcely visible on the horizon. 'Sometimes the silos look so powerful here', he wrote in January that year, 'that seen from a distance standing up from the

trees you could imagine them as made by the Aztecs for no other reason than to worship the sun, which would not be out of order either, with the sun the dominant factor in this country'.[3] The repetitive scrubby trees, swiftly brushed and scumbled, seem almost to dance into the shimmering distance—over a 'landscape pitched in such a high key and so bright that it works in your stomach as well as your eyes'.[4]

1. From Ballarat, 24 October 1943.
2. Chevalier's dramatic view from *Mount Arapiles*, 1863, is now in the N.G.V.
3. 11 January 1943; quoted in Anderson 1967, p.318.
4. Dimboola, summer of 1942–43.

△

SELF PORTRAIT 1943
Ripolin enamel on hessian sacking, mounted on hardboard
59.5 x 55.5 cm
Inscribed l.l.: 'N/March 43'
verso: 'Nolan/March 1943'
Private collection

Exhibitions: C.A.S. Studio, Melbourne, August 1943, probably no.5: 'Head'; A.G.N.S.W. etc., 1967, no.6; David Jones' Gallery, Adelaide Festival, March 1970, no.9; Skinner Galleries, Perth, January 1971, no.9; Folkestone, 1979, no.19

'Being out in the open on top of the loaded trucks and the wind icy it seems to intensify looking at the fields. There is so little to break the vision and the whole landscape appears to surround you everywhere except the particular minute patch that is yourself.'
- Nolan in Dimboola, 24 May 1942

Nolan asked Sunday Reed to send him the boldest, rawest primary red, yellow and blue enamels when he was working in the Wimmera. (He could only find pastel colours in the local hardware shops.) This self portrait seems almost a conscious reversion to children's art.

There is an obsessive quality to the face: primitive, symbolic, possessed of some inner vision. But it is tempered by decorative lyricism. The little round trees and their shadows, painted in sketches upon the wall behind, are like musical notes in the golden landscape with which Nolan was then totally preoccupied. He had seen very similar mask-like heads with striped foreheads illustrating Viktor Löwenfeld's book, *The Nature of Creative Activity*. Löwenfeld distinguished 'visual' artists, who use colour fairly naturalistically; and 'haptic' types, who emphasize inner subjective experience through selective distortion, exaggeration and juxtapositions of expressive or symbolic colour.[1]

1. Four of the 'haptic' heads from Löwenfeld were later reproduced by Tucker in his article 'Exit Modernism', *Angry Penguins Broadsheet* 1, pp.9ff.; the originals were by visually handicapped children.

'he is also, on occasion, most original and certain of his passages are of rare subtlety'.[3] In some areas the rich pigments are blended and streaked with colours like mother-of-pearl—as were the wings of love and despair in the poem. (A few patches, where the thick paint surface has wrinkled, show why Nolan wished that his quick-drying enamel would dry even faster.) 'Ripolin is like quick-silver', he wrote to Sunday Reed—as though the paint itself possessed magical alchemic properties, 'I can see us cooking it over a fire or leaving it out under the rosemary all night to see what secrets can be found in it.'[4] Continuing his earlier theme of lovers and winged figures, this is one of the 'almost secret performance' paintings which Nolan felt kept him 'ready to deal with the Malleys that turn up. Or for that matter keep the illustrations to Rimbaud fresh & a reality.'[5]

1. Richard Haese suggests that the flying angel was also inspired by a watercolour 'by a Czechoslovakian peasant in a state of ecstasy' reproduced by Andrée Lhote in an article on 'The Unconscious in Art', *Transition, a quarterly review* 26, 1937, p.83. Nolan had also long admired 'Blake's rare portrayal of things that fly'.
2. To John Reed, Horsham, 1 December 1943.
3. 'The Contemporary Art Society Exhibition', *Angry Penguins*, December 1944, p.94.
4. Ballarat, 16 November 1943.
5. Undated letter, late 1943.

△
LE DESESPOIR A DES AILES (DESPAIR HAS WINGS) 1943
Ripolin enamel on pulpboard
75.5 x 63.5 cm
Inscribed l.l.: "Le désespoir a des ailes,
 L'amour a pour ailes nacré
 Le désespoir
 Les sociétés peuvent changer"
 Pierre Jean-Jouve
 N. 43.'
verso: 'SIDNEY NOLAN/360 COLLINS ST/MELB/"Dispair has Wings"/Jean Jouve'
Heide Park and Art Gallery
Bequest of Sunday and John Reed 1982
Provenance: The artist, to Sunday and John Reed (M.O.M.A. 1958–65) until 1982
Exhibitions: *C.A.S.*, Sydney, June–July 1944, no.308: '"Dispair Has Wings", Jean Jouve—25 gns'; M.O.M.A., Melbourne, September–October 1958, no.88; David Jones' Art Gallery, Sydney, February 1959, no.88; *Selected Works*, Heide, March–May 1982, no.93

'S. Nolan, whose creations are cast at random upon a flippant sea, has a most original sense of spacing and, withal, a lyrical charm which bursts forth in a splendid bouquet of spring colours. His derivations are many, his loyalties few, and unpredictable. He is the "enfant terrible" of Australian art.'
-Paul Haefliger, *The Sydney Morning Herald*, 28 June 1944

Pierre Jean-Jouve (b. 1887) was a French neo-Symbolist poet, whose colourful 'word pictures' followed in the tradition of Baudelaire and Rimbaud. His *L'Aile du désespoir* series of 1933–35, lines from which are inscribed on this painting, was presumably one of the many volumes in Nolan's portable wartime library.[1] This painting combines a near-abstract grid structure with lyrical Wimmera-like distance. 'Probably in the Jean Jouve I was attempting to bring together ... landscape [and] another order of emotional impact altogether', he explained, 'It is a different use of landscape which seems to involve a certain nostalgia, which sets up a search for an intensity of color'.[2]

 Haefliger objected to Nolan's use of the 'Picasso profile head which has, through constant recurrence, entirely lost its meaning. But', he conceded,

ARABIAN TREE 1943 ▷
Ripolin enamel on three-layer plywood
91.5 x 61 cm
Inscribed l.l.: 'Here the peacock blinks
 the eyes
 Of his multipennate tail.'
l.r.: 'I said to my love (who is living)
 Dear we shall never be that verb
 Perched on the sole Arabian Tree
 Ern Malley 1943'
verso: 'NOLAN/ARABIAN TREE'
Private collection, Melbourne

Provenance: The artist, to Sunday and
John Reed (M.O.M.A. 1958–65) until 1981;
private collection

Exhibitions: *C.A.S.*, Melbourne, Sept.
1944: 'Arabian Tree—N.F.S.'; M.O.M.A.,
Melbourne, September–October 1958,
no.84: 'Arabian Tree (Ern Malley) 1944';
David Jones' Art Gallery, Sydney, Feb-
ruary 1959, no.84; *Glimpses of the Forties*,
Heide, September–November 1982,
no.41

In the twenty-fifth year of my age
I find myself to be a dromedary
That has run short of water between
One oasis and the next mirage
And having despaired of ever
Making my obsessions intelligible
I am content at last to be
The sole clerk of my metamorphoses.
Begin here:

In the year 1943
I resigned to the living all collateral
 images
Reserving to myself a man's
Inalienable right to be sad
At his own funeral.
(Here the peacock blinks the eyes
of his multipennate tail.)
In the same year
I said to my love (who is living)
Dear we shall never be that verb
Perched on the sole Arabian Tree
Not having learnt in our green age to
 forget
The sins that flow between the hands and
 feet
(Here the Tree weeps gum tears
Which are also real: I tell you
These things are real)
So I forced a parting
Scrubbing my few dingy words to
 brightness...
- From 'Petit Testament' by Ern Malley

'Painted this afternoon, instead of swim-
ming, the Malley had started last week
on the panel of 3 ply. And now it is finished
looking different under the electric light.
Malley needs a small painting probably
and this is bigger than usual ..., but the
landscape he lived in was a strange one
when you think of it in color and practi-
cally everything is green with two red
rocks rising from it and
the Arabian Tree with the two figures
perched in it. Perched in a word like
trembling when read in a poem; as verbs
they have, as I wrote to John I think, an
explicit painterly instruction about them.
All of Rilke's images are the same...'
- To Sunday Reed, Horsham, December 1943

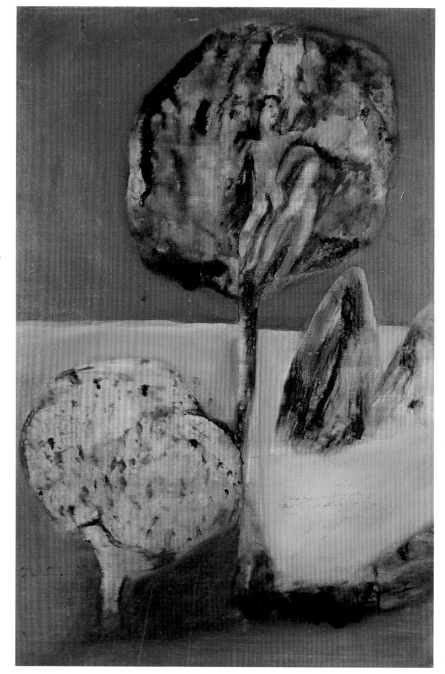

Ern Malley's embellished appropriation
of a line of poetry from Shakespeare
struck an immediate chord in Nolan's
imagination.[1] No doubt his lovers
'perched on the sole Arabian Tree'
referred to Sunday and himself. They
are also reminiscent of Chagall's floating
pair in *Lilac above the river*, 1931.[2] The
free-flowing, mingling colours—subtle
as a pastel by Odilon Redon—recall
Nolan's own experiments with inks on
absorbent tissue paper some five years
earlier. And yet the scene is plucked
straight from reality: a Wimmera land-
scape identified by that local geological
curiosity, the Mitre Rock near Mount
Arapiles.
 When the painting was reproduced
on the Ern Malley commemorative issue
of *Angry Penguins*, Autumn 1944, and

the hoax revealed, Nolan did not escape
media attack. Niall Brennan in *The Advo-
cate* called it 'a frightening example of
painter Sidney Nolan's excursions into
sublimity'. In the C.A.S. exhibition it was
dismissed by one journalist as 'an illustra-
tion ... of one of the non-existent poet's
meaningless lines'.[3] Even sympathetic
fellow artists evidently criticized the
other-worldly subject matter for Nolan
retaliated impatiently, 'It cannot be
expected to turn around & argue whether
Perceval has seen lovers in trees or not
...; does he think an age is green because
the grass is?' It was a segment of *his*
experience—'not a cubby hole for people
to fill up with their own imaginings', he
wrote: 'When will it be understood that a
painting is a thing one is able to make
after things—emotions, mental complex-

ities & what have you—are stabilized. A painting's last contacts are with the finger-nails if you like.'[4]

1. 'Let the bird of loudest lay,/On the sole Arabian tree,/Herald sad and trumpet be,/To whose sound chaste wings obey'; from 'The Phoenix and the Turtle', attributed to William Shakespeare, c.1601. See Nolan's letter to John Reed from Horsham, 1 December 1943.
2. Herbert Read, *Art Now*, Faber, London, 1933, pl.34; the Reeds' copy of this first edition is still in the 'Heide' library.
3. *The Advocate*, 5 July 1944 and *The Bulletin*, 29 September 1944; quoted in Minchin 1983, pp.61f., where Nolan's use of Ern Malley and Wimmera imagery in the 1970s is also discussed.
4. 9 January 1944. 'I am sorry the years have made this professional isolation', he added; and elsewhere, 'he is a hell of a good painter ... & yet who might as well be a bee keeper for all the similarity between us as painters' (letters of 16 and 17 August 1943).

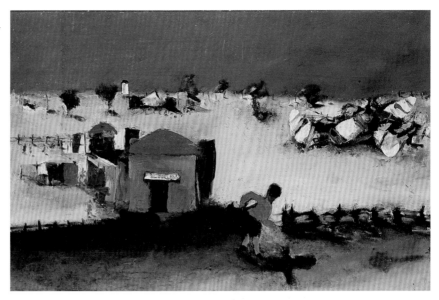

△
BOY WALKING TO SCHOOL 1944
Ripolin enamel on hardboard
62 x 90.3 cm
Inscribed l.r.: '12-11-44/N'
verso: 'NOLAN "Boy WALKING to School"/1944'
Private collection, Sydney

On 20 May 1943 at Nhill, Nolan wrote to the Reeds of 'a bad plane crash here last week killing the crew. Passing the paddock a couple of days later, in a truck, getting a load of wood, was certainly a shaking experience. It came down at Woorah about 7 miles out and the visible evidence was hardly what I anticipated. No piece, other than the engine, was bigger than two or three feet.' He had also witnessed a pilot parachuting to safety when an aircraft crashed in the Little Desert near Dimboola.[1] These memories coalesced in *Boy walking to School*, painted considerably later in his Parkville studio: one of the last works which can be said to belong to the 1940s Wimmera series.[2]

1. June 1942, recorded in numerous watercolour sketches; see *Sidney Nolan: works on paper retrospective*, 1980-81, catalogue nos 41-50, pp.20,27,50. On that occasion, Nolan's squad was given the job of collecting the wreckage; Haese 1983, p.16. On a similar theme, Tucker had also painted *Death of an Aviator* in 1942.
2. The dark blues and the central leaning figure relate to his crepuscule *Dimboola*, also late 1944 (N.G.V.) which shows himself with Sunday Reed in the Wimmera landscape. Nolan did not return to paint the area until 1966.

City of stars
mother superior,
telling of beads,
of visitations;
of journeys, of tears.

City of ashes,
bread and wine,
confessing softly
of gentle capitalism;
of hands, of hours.

City of rain
metropolitan,
stores in flower
seen in our eyes;
your eyes, your tears.

- Sidney Nolan, 'Melbourne', early 1940s

POST-WAR IN MELBOURNE

Nolan painted with his board flat on the floor of the sunny dining room at 'Heide'. It had bare scrubbed boards we all scrubbed, Sam Atyeo's *Organised Line* hanging over the fireplace (the first modern painter in Melbourne) and views away down to the river or into the herbaceous border. Ripolin poured down the sides of tins spread on newspaper and Nolan knelt over his board. Everyone walked through to the kitchen where Sun made perfections and revelations in rum babas or scones, hot with honey and saltless butter from Summer (the cow Nolan named), butter which melted alike on Sun's new grown peas, baby carrots or tansy omelette.

Everyone stepped over the paint—Max Harris, Peter Bellew, John Sinclair, Barry Reid, John Gooday, Jack and Molly Bellew, Douglas and Ann Cairns, Doc Evatt and Mary Alice, Minna and Dyason, Gordon and Kate Thomson, Moya Dyring and Minna with the Siamese blue eyes, caterwauling for her demon lover under the armchair, Bert Tucker, John Perceval and Mary Boyd, and Arthur, Joy Hester and Poltergeists, Florence and Mrs Lang's ghost which turned out to be an occasional draught from the septic tank, Angry Penguins and John himself (a naked Greek God said Florence) carrying orange juice and rare magnolias ... Vast bunches of white violets from the violet tunnel in your room, new Nolans for lunch every day, new rows to fight, 15 acres of trees to water and watch, right down to the river, the Contemporary Art Society born and fought for and Ern Malley's right to live—all this was background to these paintings.

- Neil Douglas, reminiscence of 'Heide', May 1962

'Heide' has been described as a haven, where patrons-with-a-difference John and Sunday Reed 'kept open house of table and mind'.[1] It was undoubtedly a refuge for Nolan, alias Robin Murray, when he left the army in July 1944. He had visited on leave whenever possible during the war; writing after one all too short stay: 'Each time the three of us are together things seem to go so deep that leaving feels like going for good, and there's so much that hasn't been said or done that it's almost unreal to accept leaving' (28 February 1943). Now he divided his time between 'The Loft' in Parkville and the happy security of Heidelberg. All the materials he needed were at hand; and he worked hard. Neil Douglas, who often helped in the gardens at 'Heide', remembers Nolan's boundless energy and enthusiasm whilst painting; Nolan saying 'simply a million times, "Look at this!"'—blue eyes, pink cheeks but dark hair—sleeves rolled up and Sun's apron on, those quiet pin-point eyes of smiling elation and fun! ... Any sequence that would race away of itself delighted him as he mixed paint, deftly trying to keep up with it.'[2] *Angry Penguins* had announced in 1944 that Nolan was henceforth a formal partner in the Reed & Harris publishing firm; and despite the battering they had taken over the Ern Malley affair, the next issue was more ambitious than ever—185 pages—with sections on music, film and jazz as well as sociology, art and literature.

Reed & Harris now moved to larger premises at 48 Queen Street; and added the popular monthly *Angry Penguins Broadsheet* to its publication list in January 1946. Nolan was also involved with John Sinclair in producing Jack Bellew's new *Tomorrow*—'a non-party monthly review of Australian and world progress compiled by leading journalists and artists'.[3] Max Harris has described the Angry Penguins circle as: 'a movement—a system of thought, aesthetic values and social attitudes—and its strength came from the fact that its whole existence depended on the communalism of creative life in a hostile and illiberal society... It was not a literary quarterly at all, but a common cultural workshop.'[4] Unfortunately, however, the 'common cultural workshop' was not always entirely harmonious; and it became increasingly vulnerable as various members developed their individual strengths and moved in new directions. Tucker felt that he was being shut out by the 'inner nucleus' of Nolan, Harris and the Reeds.[5] When John and Sunday Reed left for a holiday in Queensland late in 1946, Harris resigned from the firm and returned to Adelaide in their absence.[6]

Nolan wrote meanwhile to Reed in the far north, 'I can keep Heide whole until you come back to it & also build my own independence into some ripeness' (28 October). This was an important period of reflection and consolidation for him. He commenced his famous Ned Kelly paintings: the earliest dated example is inscribed 'March 14th 45'. In a series of St Kilda subjects he deliberately cultivated a 'primitive' painter's perceptual characteristics—doll-like figures and flat planes of bright colour—to evoke his own childhood experience and recollections. He was also painting the life of his immediate surroundings: the garden at 'Heide', the Yarra valley landscape, portraits of friends and associates. No longer an exile, he was, in the words of John Reed, 'a painter who paints what he sees about him, revealing to us with remarkable integration and a lovely clarity the essential heart of his experience'.[7]

1. Michael Keon, 'The Forties', in *Glimpses of the Forties*, Heide Park and Art Gallery, 1982.

2. MS of May 1962; Douglas was described in *Angry Penguins* as 'An expert milker and a specialist in the fantastic in nature. Executes incredibly meticulous drawings of flowers and animals of his own bizarre creating.'

3. Nine issues, March–November 1946; Jack Bellew was Peter Bellew's brother and an ex-chief of staff of the Sydney *Daily Telegraph*; Tucker also contributed to *Tomorrow*.

4. Harris 1963, p.8.

5. See Haese 1981, pp.122ff. He nevertheless shared a successful exhibition with Nolan and Boyd at Melbourne University in July 1946.

6. Harris resigned in October 1946. *Angry Penguins* ceased publication with the 1946 number; *Angry Penguins Broadsheet*, after ten issues, in December 1946.

7. *Exhibition of Paintings by Sidney Nolan*, C.A.S. Studio, August 1943.

LUBLIN 1944
Ripolin enamel on hardboard
60 x 91 cm
Inscribed l.r.: 'Lublin/3.9.44./N'
verso: composition entitled 'Tattooed Man',painted in the Wimmera in 1942
Art Gallery of South Australia
Gift of Sidney and Cynthia Nolan 1974

Exhibitions: *C.A.S.*, Melbourne, September 1944: 'Lublin—20gns'; *Festival Exhibitions*, A.G.S.A., 1974; *Aspects of Australian Surrealism*, Naracoorte Art Gallery, 15 August–10 September 1976; *Art Treasures from Adelaide*, A.G.N.S.W., January–February 1977; Perth Festival (*Ern Malley Collection*), February 1982, no.19; *Adelaide's Nolans*, A.G.S.A., 1983; *Sidney Nolan: the city and the plain*, N.G.V., 1983, no.35, illus.; *Art and Social Commitment*, A.G.N.S.W. etc., December 1984–April 1985, p.162

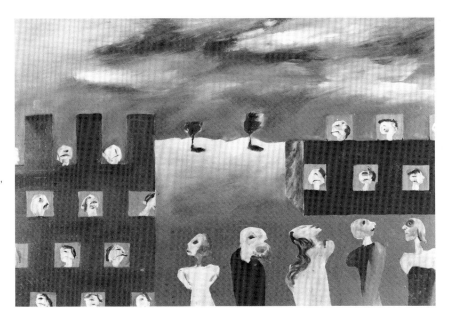

One of Nolan's very few paintings in response to specific wartime events, *Lublin* is a tribute to the first Polish city and concentration camp captured by Soviet forces. Lublin fell on 27 July 1944: just three weeks after his desertion from the army, when he was in considerable danger of imprisonment himself. The hideously masked, contorted figures in the foreground call to mind nightmare characters painted by the Belgian expressionist James Ensor (1860-1949).[1] Nolan's friend Yosl Bergner, an Austrian-born Jewish refugee who had come to Melbourne in 1937, was now exhibiting comparable subjects: a tragic *Funeral in the ghetto*, 1944, for example—depicting the Polish capital, Warsaw, where he had grown up and been educated.[2] The horrific grid of tenement cubicles in *Lublin* echoes the burnt-out skeleton buildings of Nolan's *Boy in township*, 1943, with its corpse of a dehydrated child killed by a bushfire in the Wimmera (A.G.N.S.W.). This memorable use of a dark rectangular 'window' form recurs, of course, as the famous black Ned Kelly helmet.

In recent years Nolan has linked *Lublin* with a line from the Ern Malley poem 'Baroque Exterior'—'the windowed eyes gleam with terror'; but this, he says, was not his intention in 1944.[3]

1. For Ensor's response to the first world war, see *20th Century Masters from the Metropolitan Museum of Art, New York*, A.N.G., 1986: entry on *The banquet of the starved*.
2. Yosl (Vladimir Jossif) Bergner, b.1920; see Jan Minchin, *Yosl Bergner—a retrospective exhibition*, N.G.V., 1985.
3. Conversation with the author, January 1987. The connection arose in his mind whilst reworking the 'Ern Malley' theme in 1973, and since then this work has been called 'Lublin, or Baroque Exterior'; he prefers now to revert to the original title.

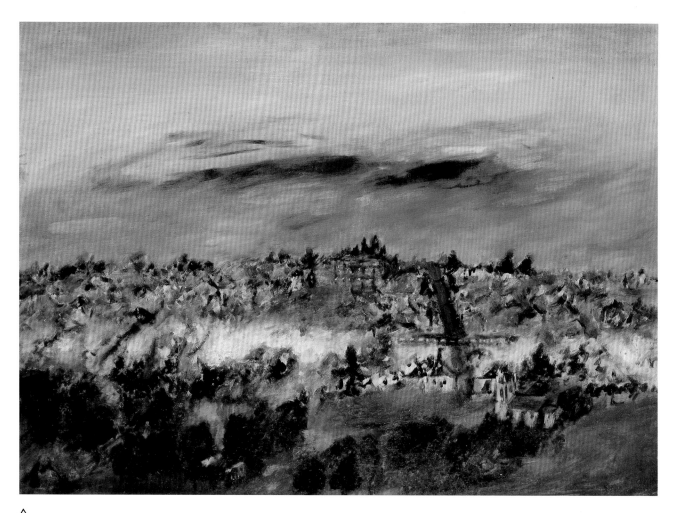

△

HEIDELBERG [1944]
Ripolin enamel on hardboard
91 x 121 cm
Heide Park and Art Gallery
Purchased 1980

Provenance: The artist, to Barrett Reid; to Sunday Reed—in exchange for *The Camp*, a Ned Kelly painting of 1946 now in the A.G.N.S.W.; until 1980

Exhibitions: *C.A.S.*, Melbourne, September 1944: 'Heidelberg—40gns'; *1940-1945...*, M.O.M.A., Melbourne, October–November 1961, no.11: 'Heidelberg 1944, Collection of Sunday Reed'; *Heide Park and Art Gallery*, November 1981, no.42, illus.; *Selected Works*, Heide, March–May 1982, no.42; *Glimpses of the Forties*, Heide, September–November 1982, no.44

The historic suburb of Heidelberg, about fourteen kilometres from Melbourne in the Yarra valley, has a long and important association with artists. In 1888 Arthur Streeton had discovered the old 'Eaglemont' homestead which became a focus for the so-called 'Australian impressionists' and their *plein-air* painting camps.[1] By the 1930s, when John and Sunday Reed moved to 'Heide', various artists' colonies were well established in the outer suburbs: the Boyd family were based at 'Open Country', Murrumbeena, for example, whilst Justus Jorgensen was erecting his 'Montsalvat' in Eltham.

When Howard Matthews saw this painting he told Nolan, 'Thank God you haven't gone any more modern'.[2] A relatively straightforward view, looking west up Burgundy Street from the gardens at 'Heide', it was reproduced in *Angry Penguins*, December 1944. A very similar painting remains in the artist's possession.

1. See Jane Clark & Bridget Whitelaw, *Golden Summers, Heidelberg and beyond*, I.C.C.A. and N.G.V., 1985.
2. Quoted in Lynn 1979, p.26.

ROSA MUTABILIS [1945] ↗
Ripolin enamel on hardboard
91.5 x 122 cm
Private collection, Melbourne

Provenance: The artist, to Sunday and John Reed until 1981

Exhibitions: *C.A.S.*, Melbourne, August 1945: no.135:'Rosa Mutabilis'; *Selected works*, Heide, March–May 1982, no.97; *Heide II—as it was*, February–March 1983, no.25

The spacious grounds of 'Heide', tended by Jim the gardener with assistance from Neil Douglas, were also most definitely Nolan's domain. When he had been up to his high-spirited tricks, Douglas recalls, 'scare-crows, stiff with propellors, stared from the tops of the almond and cherry trees or over the lavender; a wild painted hag with pretty ribbons and straw hair; pumpkins in the vast French vegetable garden overnight had purple pants and red eyes, and the Moonboy painting grew again on the roof ... Heide was heaven ...'[1]

The old-fashioned shrub rose *Rosa chinensis mutabilis*—whose flowers change colour, like magic, as they open—was planted by Sunday Reed. She was a keen and creative gardener. Nolan had painted her not long before enclosed by bushy wilderness at Heathmont.[2] Here she seems even more a natural extension of her physical environment: a domestic counterpart of the Greek nymph Daphne who was transformed by Zeus into a laurel bush. In the meadow beyond, young trees are fenced for protection from the 'Heide' cows—Rainbow, Orchid and Orchid's calf, Summer. Further up the hill is the farmhouse where the Reeds shared their lives with so many young artists for so long. Now known as 'Heide I', it still stands in Templestowe Road, Bulleen, adjacent to the Art Gallery which they built as 'Heide II' in 1968. And *Rosa mutabilis* still blooms in the garden every year.

1. Neil Douglas MS, 1962.
2. Illustrated in *Art and Australia*, June 1968, p.47; now in a private collection in Western Australia.

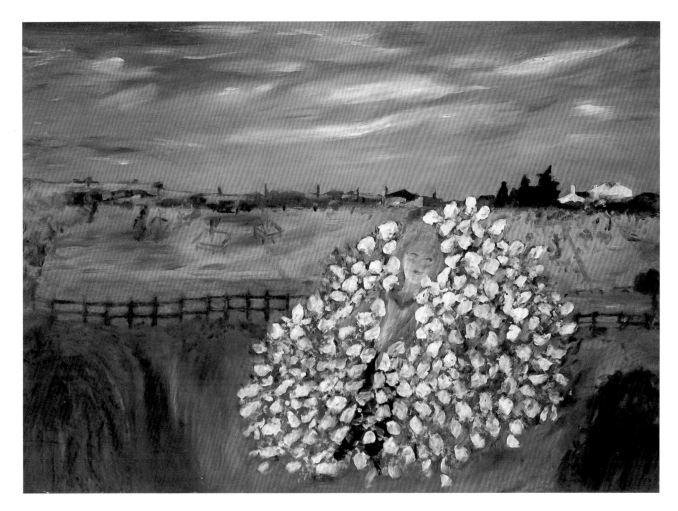

BOATS c.1945 ▷
Ripolin enamel and sand on hardboard
62.2 x 76 cm
Inscribed l.r.: 'N'
verso: previously a later painting,
'Dead banksia' dated 1953, separated
for sale in 1976
Private collection

Provenance: James O. Fairfax, Sydney,
1960s; until Christie's, Sydney, 22
October 1975, lot 429; Christie's Mel-
bourne, 28 April 1976, lot 515;
*Spring Exhibition 1977 Recent Acquisi-
tions*, Joseph Brown Gallery, Melbourne,
October–November 1977, no.74; private
collection, Melbourne

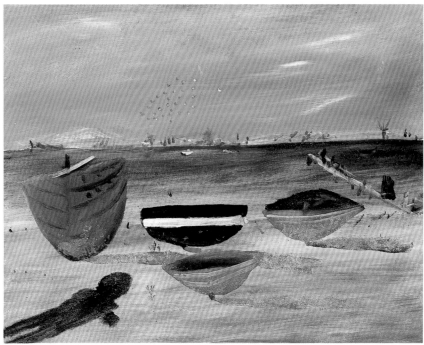

Nolan has always loved the beach. As a
boy in St Kilda, he says, he 'spent all day
and much of the night on the beach—it
was university, gymnasium, everything
combined'[1]; his father was a volunteer
lifesaver in those days. Later he lived at
Ocean Grove and often he stayed at the
Reeds' Sorrento holiday house. In this
delightful painting he plays optical games
with silhouettes and shadows as he had
in the earlier 'bathers' series; and as he
would so frequently in the Kelly works of
1946–47. The parallel shadows of the
boats are as blue on the yellow sand as
those of any self-respecting French
Impressionist—Monet, Renoir and the
like. The human shadow (his own?),
however, is curiously at odds
with reality. The beach sand applied in
patches to the wet paint surface is a witty
and deliberate touch of tangible reality.
But Nolan undoubtedly knew that sand
was a favourite 'painting medium' of
Surrealist artists in the 1920s, such as
Picasso, Dali and André Masson!

1. Sidney Nolan, 'Down Under on a visit', *Queen*,
London, 15 May 1962.

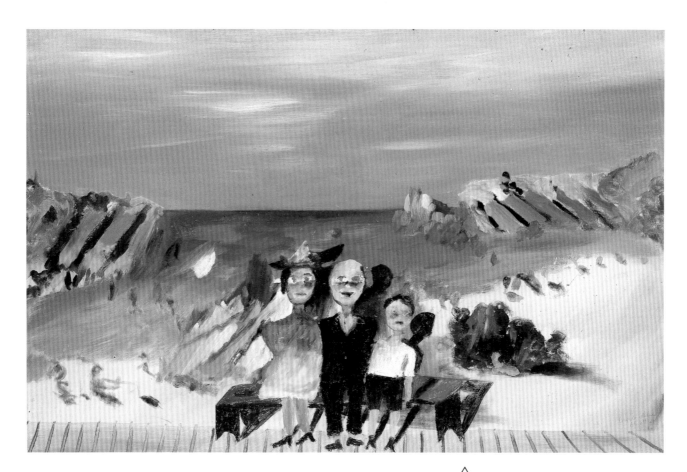

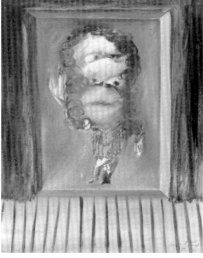

◁ GIGGLE-PALACE 1945
Ripolin enamel on canvas
76.2 x 63.5 cm
Inscribed l.r.: 'Giggle-Palace/
Jan 24th. 45./N.'
Art Gallery of South Australia
Gift of Sidney and Cynthia Nolan 1974
Exhibitions: I.C.A., London, May 1962,
no.28 (withdrawn from exhibition); *Festival
Exhibitions*, A.G.S.A., 1974; *Aspects of
Australian Surrealism*, Naracoorte Art
Gallery, August–September 1976; *Sidney
Nolan*, Naracoorte Art Gallery, April–
May 1977; *Adelaide's Nolans*, A.G.S.A.,
1983; *Sidney Nolan:
the city and the plain*, N.G.V., 1983,
no.44, illus.

'The presence of the amusement enter-
prises of the Phillips Brothers, on the St
Kilda beach foreshore has undoubtedly
drawn thousands of holiday makers to St
Kilda. The amusements they provide are
so varied that persons of every age are
able to be selective, and to enjoy them-
selves. Given a fine day, the visitor to the
Esplanade front will always find innocent
pleasure and amusements. One of the
early shows on the St Kilda beach was
the Hall of Laughter, owned by the
Princes Court Proprietary Company...'
- J.B. Cooper, *The History of St Kilda*, 1931

△
GIGGLE-PALACE 1945
Ripolin enamel on hardboard
61.5 x 91.2 cm
Inscribed l.r.: 'Giggle-Palace/
Feb. 1st 45/N.'
verso: 'FEB. 1st/1945'
Private collection
Exhibitions: I.C.A., London,
May 1962, no.29

The paintings of St Kilda—Nolan's 'kitsch
heaven as a boy'—are amongst the most
delightful of his works. This seaside
suburb is a unique part of Melbourne:
with promenades, esplanades and
ornamental gardens in the sunshine;
and cafés, dance halls and Luna Park
at night.
 'After I left the army', Nolan recalls,
'like a lot of others, I tried to recapture
things, to see things again, to re-experi-
ence them'.[1] In the larger *Giggle-Palace*
he is the small boy standing with Mr and
Mrs Nolan, senior, in front of a scenic
backdrop in a sideshow photographer's
studio at Luna Park—a painted beach at
the seaside! 'But the parents are real', he
says.[2] Here is a glimpse of his own care-
free childhood—and of anybody else's
too; not just a painted recollection, but
an evocation of the actual feeling of
being young.

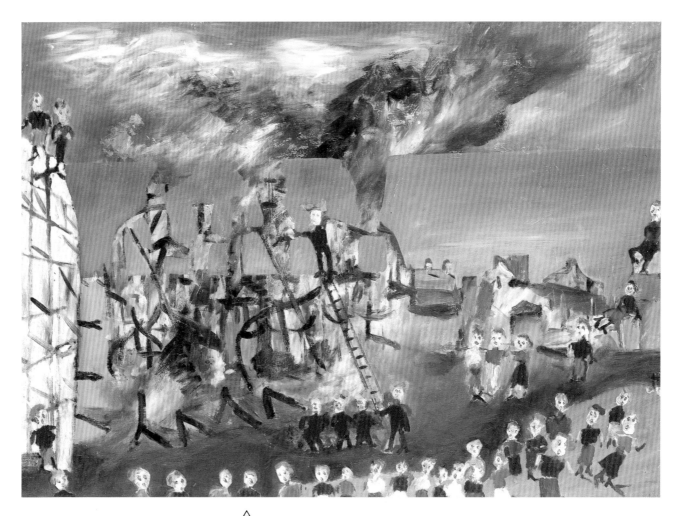

The mood of the smaller work is not so sunny: his own image in the Giggle-Palace hall of mirrors where patrons pay to see themselves successively elongated, squashed or swelled up like balloons. 'I guess it's about reorientation', he has since explained, 'and soldiers know how impossible it becomes: it's all distorted. So this mirror at Luna Park has a double, distorted image and double meaning. Maybe the world, when you try to look at it exactly, comes out disoriented.'[3]

1. Quoted in Lynn 1979, p.48.
2. *Queen*, 15 May 1962. Nolan produced a number of other 'Giggle-Palace' subjects at this time; including humorous renderings of faces (his own and friends) set on painted canvas bodies—of a hairy ape, a mermaid, a two-headed 'push-me-pull-you' creature, and Mary Magdalene.
3. Lynn, loc.cit.

△
FIRE. PALAIS DE DANSE, ST KILDA
1945
Ripolin enamel on hardboard
91.5 x 122 cm
Inscribed l.r.: 'Nolan/1945'
verso: 'Fire at Luna Park'
Private collection

Exhibitions: Newcastle etc., 1961, no.26; I.C.A., London, May 1962, no.16; Stockholm, 1976, no.10

'I can remember that the people climbed up on the white girders of the Luna Park fun-fair at the side to get a bird's-eye view of the fire, that the policemen on white horses nudged back the crowd with their horses' behinds and that the firemen were given free ice-cream. At the back, as always at St Kilda's beach, was the opalescent, uptilted plain of the sea.'
- Nolan's reminiscence, May 1962

The first St Kilda 'Palais de Danse' opened in 1913; became a cinema in 1915; and in 1926, whilst modern improvements to the facade were in course of erection, caught fire and burned to the ground. Nolan was nine years old at the time.

FERRIS WHEEL [1945] ▷
Ripolin enamel on three-layer plywood
89.9 x 119.4 cm
verso: formerly the Ned Kelly painting
The evening (now A.N.G.),
separated 1979
Heide Park and Art Gallery
Bequest of Sunday and John Reed 1982
For exhibition in Melbourne only

Provenance: The artist, to Sunday Reed

Exhibitions: *Selected Works*, Heide,
March–May 1982, no.95

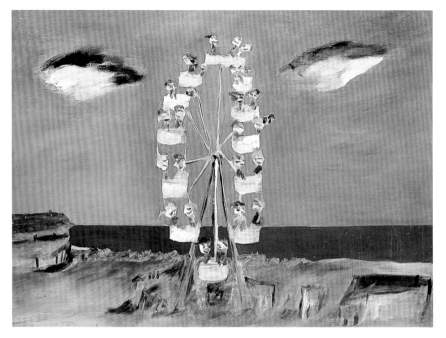

The school's long stream of time and
 tediousness
winds slowly on, through torpor, through
 dismay.
O loneliness, O time that creeps away ...
Then out at last: the streets ring loud and
 gay,
and in the big white squares the fountains
 play,
and in the parks the world seems mea-
 sureless.
And to pass through it all in children's
 dress,
with others, but quite otherwise than
 they:-
O wondrous time, O time that fleets
 away,
O loneliness.
And out into it all to gaze and gaze:
men, women, women, men in blacks and
 greys,
and children, brightly dressed, but
 differently;
and here a house, and there a dog,
 maybe...
And then with bat and ball and hoop to
 playing
in parks where the bright colours softly
 fade,
brushing against the grown-ups without
 staying...

- Rainer Maria Rilke, 'Childhood'

Nolan's pictorial meditations on his boy-
hood are part of that stream of modernism
which Richard Haese has termed 'sym-
bolist-expressionist-surrealist'.[1] Primitive
and *naïf* art was central to this tradition.
In Europe, the poet Charles Baudelaire
(1821–67) was amongst the first to praise
the intuition of children, saying, 'Genius
is nothing more than childhood rediscov-
ered'. Rilke was another. And Rimbaud
created a child's-eye world of colour
images of hallucinatory clarity in the
Illuminations, published 1886, which
Nolan has called a 'book of miracles'.

1. Haese 1981, pp.185ff.: an excellent discussion
of the 'Romantic' tradition of European mod-
ernism and its impact in Australia. A small
'sketch' version of *Ferris Wheel* is also in the
Heide collection.

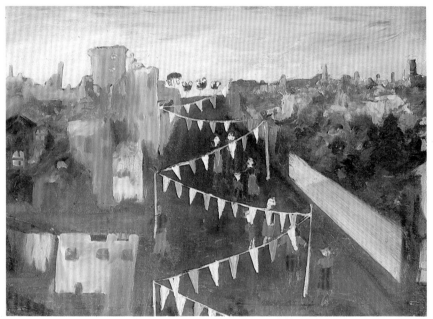

△
ROBE STREET, ST KILDA 1945
Ripolin enamel on hardboard
91.5 x 122 cm
Inscribed l.r.: 'Nolan 45/June 7[?]/
1945/Robe Street'
l.l.: 'Robe St/Robe St/June 18th. 45/N.'
verso: 'NOLAN/CARNIVAL ST KILDA.'
Private collection

Exhibitions: *C.A.S.*, Melbourne, August
1945, although not listed in catalogue;
Sydney catalogue unavailable

'The large, shiny pictures of Sidney
Nolan with their doll-like figures, naive to
the point of grotesque, are likely to pro-
vide the orthodox protestations—"My
little boy could do that, etc., etc."—from
those who go to scoff, nevertheless
anyone who has not a hidebound set of
prejudices should be able to derive
pleasure from them ... *Robe St., St Kilda* is

one of the outstanding works in the show;
there is a freshness and joy about it
which are very real. If we can't sense
them, perhaps it is because, as Traherne
said, musing on the lost visions of child-
hood, we have become corrupted by
"the dirty devices of the world".'
- Clive Turnbull, reviewing the C.A.S. exhibition,
The Herald, Melbourne, 20 August 1945

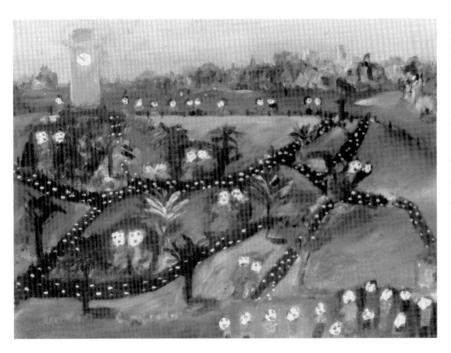

◁ ESPLANADE, ST KILDA 1946
Ripolin enamel on hardboard
91.5 x 122 cm
Inscribed l.r.: 'N 46'
verso: 'Esplanade St. Kilda 1946
Not for sale Nolan'
Private collection

Exhibitions: I.C.A., London, May 1962,
no.35; Folkestone, 1970, no.4; Stockholm,
1976, no.16

Esplanade, St Kilda, with its miriad flecks
and dots of light and the Catani memorial
clock tower on the evening horizon, is
comparable with children's paintings
reproduced in Löwenfeld's *Nature of
Creative Activity*, 1939.[1] Herbert Read
had praised the 'deliberate attempt to
reach back to the naivety and fresh
simplicity of the childlike outlook';
declaring in *Art Now* that painting had
nothing to do with 'polite culture or intel-
ligence'.[2] Likewise Tucker, in *Angry
Penguins* 7, December 1944, considered
that 'with the natural artist problems of
style and technique matter little, the
sustained intensity of his vision solves
them for him'.[3]

Nolan, of course, was no untrained
naif or amateur; but he cultivated the
primitive's perceptual characteristics for
deliberate effect. He presents the Catani
Gardens landscape as a map: of paths
for the loving couples whose faces shine
out of the darkness like lanterns. Such
memories of St Kilda are certainly very
different from the urban imagery of
protest in Perceval's fairground subjects,
Boyd's South Melbourne and Tucker's
Images of Modern Evil or 'Night Images'.

1. Plate 32, 'Town by Night' and pl.33, 'Accident
by Night'—by fourteen-year-olds with congenital
cataract of both eyes; Maggie Gilchrist sug-
gested this comparison (1975). The tower named
after Carlo Catani, the former Chief Engineer of
Public Works largely responsible for land-
scaping the St Kilda foreshore, was commis-
sioned when Nolan was thirteen: of forty-six
designs submitted in competition, the winner
was 'inspired by the Italian Campanile, and was
based on the best traditions of Italian Renais-
sance architecture'.
2. *Art Now*, London, 1933, pp.45f. Both *Art in
Australia* and *Angry Penguins* published illus-
trated articles on primitive, folk, Aboriginal
and medieval art, as well as children's work—
following the example of numerous European
art journals of the 1930s.
3. 'Paintings by H.D.: an unknown Australian
Primitive'—an article on Harold Deering or
'Professor Alfred Henry Tipper', the painter-
singer-cyclist whose naive canvases Tucker
had discovered in a Melbourne bicycle shop.

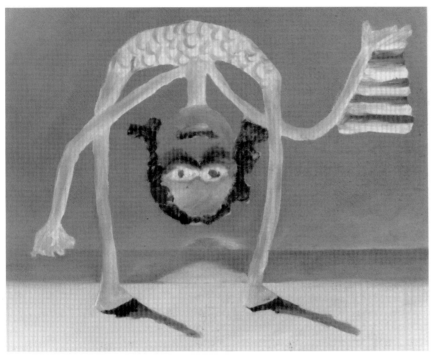

△
BATHER (AT SUNSET) 1945
Ripolin enamel on pulpboard
63.5 x 76 cm
Inscribed l.r.: 'Bather (at Sunset)/
May 29th 1945/N.'
verso: 'BATHER/1945/May 29th/
1945/May 29 1945'
Private collection

Exhibitions: Newcastle etc., 1961, no.20;
I.C.A., London, May 1962, no.22

'One was always rather reluctant to face
the fact that it was sunset—the girls
included—even though it meant that
night brought another kind of beach life.
Saying goodbye was put as gently, as
wittily as possible. But not everything
was painless—sometimes the blisters
on one's back were big as oranges.'
-Reminiscence in London, May 1962

This is one of approximately 280 early
works from 'Heide'—paintings, folios,
drawings—which were sent overseas to
Nolan late in 1958. Many were exhibited
four years later at the Institute of Contem-
porary Art in Dover Street, London,
when he said: 'Seeing these pictures
again is a bit like looking into a pool and
seeing your own reflection—memory
puts ripples across it. The people who
inspired some of the images, one no
longer sees, and so it's interesting to
remember them again from the images—
...Through the formal elements you
remember the emotional aspects of the
period even though the real emotions
have burnt themselves out since.'[1]

1. *Queen*, 15 May 1962.

ANGRY PENGUINS BROADSHEET

CROCODILE TEARS FOR GLASSOP

CHLOE
Grand Duchess of Ballyboo

THE TIN BULL AND THE RED RAG

EDITORS: MAX HARRIS, JAMES McGUIRE, SIDNEY NOLAN
No. 5 May, 1946

Photograph: National Gallery of Victoria

PAINTED BOWL c.1950
Earthenware decorated in polychrome
with abstract motifs, 'Arthur Merric
Boyd' Pottery
14 cm diameter
Inscribed on base: 'Lynda/
Uncle Sid/Nolan'
National Gallery of Victoria
Presented by Joseph Brown 1982
For exhibition in Melbourne only

Exhibitions: *The Painter as Potter*, N.G.V.,
December 1982–March 1983, no.38

'Apart from the marvellous feeling about
Murrumbeena and my particular friend-
ship with Arthur, being able to talk to
Merric and Doris Boyd was an important
factor in my art and an important example
to me. Their attitude to life indicated a
great respect for art and its importance
in the scheme of things.'
- Nolan, September 1981[1]

'Open Country' at 8 Wahroonga Cres-
cent, Murrumbeena, was built by Arthur
Boyd's father, Merric, in 1908; his original
pottery was added two years later. By
the 1940s, the 'commune' was a centre of
creative activity involving three genera-
tions: 'every room was used for sleeping
or working'. Arthur had built a studio for
himself in the garden in 1937, designed
by his architect cousin Robin Boyd.
'Arthur is probably the biggest enigma
in the community', wrote Nolan, 'in fact
he & his art are an almost indivisible
entity'.[2] His 'Arthur Merric Boyd' pottery
operated from 1944 in Neerim Road, with
Perceval (then married to Mary Boyd)
and Peter Herbst as founding partners;
joined by Neil Douglas a few years later.
Bergner, Joy Hester, Tucker, Tim and
Betty Burstall, Charles Blackman and the
Reeds were other welcome visitors at
Murrumbeena.

1. Interview quoted in *The Boxer Collection:
Modernism, Murrumbeena and Angry Penguins*,
exhibition catalogue, 'Lanyon', 1981, p.10.
2. 17 January 1944; and on another occasion (c.
December 1943), 'I give painters away lock
stock & barrel. All except Arthur Boyd. Rilke
will have to do as a soulmate & damned the
expense.'

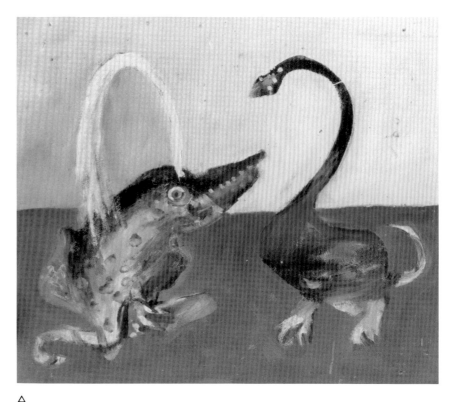

△
PAINTING [1945]
Ripolin enamel on hardboard
66 x 75.8 cm
Private collection

Exhibitions: I.C.A.,London, May 1962,
no.27: 'Painting 1945'

Nolan did *not* discover these prehistoric
bathing beauties cavorting at St Kilda
beach; but in a nineteenth-century book
with engraved illustrations, *The World
before the Deluge* by Louis Figuier. His
painting is a brightly coloured free trans-
lation of plate XV, 'Ideal scene of the Lias
with Ichthyosaurus and Plesiosaurus',
which he reproduced on the cover of
Angry Penguins Broadsheet the following
year. 'Some of the most fascinating art of
the 19th century is to be found in the steel
engravings which accompany all the
books of the period—poetry, novels,
treatises on anatomy, studies in evolution
and natural history', ran the accompa-
nying text, 'It was an era of rationalism,
but the romantic and gothic crept in by
the back door'. Figuier was a fanatical
opponent of the romantic and the marvel-
lous; 'But the illustrations to his book,
although they conform quite accurately
to the worlds he described therein,
reflect the gothic work of such people as
Henry Fuseli in particular, Samuel
Palmer, William Blake, and even Turner.
The book was published in 1865. In 1908
we see Rousseau's painting "Tiger
Attacking a Buffalo" possessed with the
same primitive atmosphere and glowing
exoticism.'[1]

1. *Angry Penguins Broadsheet* 5, May 1946, eds
Max Harris, James McGuire & Sidney Nolan;
three other plates were also reproduced, along
with Henri Rousseau's *Tiger attacking a buffalo*
of 1908. Figuier's opus, 'containing thirty-four
full page illustrations of exinct animals and ideal
landscapes of the ancient world designed by
Riou', was republished by Chapman & Hall,
London, 1867.

△
THE SISTERS [1946]
Enamel on hardboard
53 x 44 cm
Private collection, Melbourne

Provenance: Sunday and John Reed;
to Barrett Reid until June 1983; private
collection

Exhibitions: *Moderns Exhibition*, Lauraine
Diggins, North Caulfield,
June 1983, addenda list

Painted at 'Heide', these two little girls
are taken from a faded old photograph
of Nolan's own siblings, Marjorie and
Lorna, on the verandah of their childhood
home in Pakington Street, St Kilda.[1]

1. Reproduced in Adams 1987, p.7. Barrie Reid
wrote a poem called 'The Sisters' at the same
time in 1946.

△
ALBERT TUCKER 1947
Ripolin enamel on pulpboard
76.2 x 63.5 cm
Inscribed l.c.: 'Nolan/1947/Albert/
Tucker'
verso: 'Albert Tucker/1947/Nolan/
ADELAIDE'
Art Gallery of South Australia
Gift of Sidney and Cynthia Nolan 1974

Exhibitions: *Rebels and Precursors*,
N.G.V. and A.G.N.S.W., 1962, no.80;
Festival Exhibitions, A.G.S.A., 1974;
Adelaide's Nolans, A.G.S.A., 1983; *Sidney
Nolan: the city and the plain*, N.G.V.,
1983, no.58

Nolan first became friendly with Albert
Tucker (b.1914) at the time of the founda-
tion of the Contemporary Art Society in
1938. Tucker had attended classes at the
Victorian Artists' Society, 1933–39, and
briefly with George Bell; but was largely
self-taught as an artist. In 1937 Burdett
singled him out as 'a very young
painter of unusual promise ... a forceful,
wayward individual with a romantic,
turbulent outlook, but with a real com-
mand of medium and form'.[1] Like Nolan
and Arthur Boyd, he then endured the
brutal boredom and senseless discipline
of non-active army service. These three
were soon recognized as leaders of the
young generation of Melbourne artists.
Tucker wrote articles for *Angry Penguins*
and the *Broadsheet*; served
on the C.A.S. executive; and bore the
brunt of the Communist faction's attacks
on less politically committed members
of the Society.

Nolan became impatient with his
friend's strong sense of moral purpose—
asking, 'Why must painters be involved?
They only make pictures ... after all'.[2]
Tucker, however, found the atmosphere
at 'Heide' rather too rarified for a man of
his temperament. In 1947, they painted
portraits of one another—just before
Tucker set off overseas in February
reportedly declaring, 'I am a refugee
from Australian culture'.[3] As Nolan
recalls, 'I did a number of unflattering
portraits of people, including myself
at that time'.[4] Tucker called them
'courageous'.

This epic, told in unregenerate rhyme,
Deals with those artists streets ahead of
 Time,
Or streets above, or, maybe, streets
 below—
At all events, *outside* the vulgar flow
Of temporal things...
Around about the 'Angry Penguins' play,
Cheerfully woeful or morosely gay...
Where John Reed, dressed the profes-
 sional part,
Hears them their lessons in the school of
 art,
Where Sidney Nolan, like a looney don,
Shows them the canvases he's painted
 on.
Or—if his art must rightly be defined—
His blobs of paint with canvases behind;
Or, yet again, where Albert Tucker reels
Towards the blackboard of his high
 ideals...
*This Satire is directed at literary values
and is in no way intended to reflect on the
characters of persons mentioned.*
- Alister Kershaw, from 'The Denunciad' in *Angry
Penguins* 5, 1943

1. *The Herald*, 26 April 1937.
2. Letter of c.January 1944.
3. Hughes 1970, p.155. Nolan had entered an
earlier portrait of Tucker for the Archibald Prize
of 1945; also now in the A.G.S.A. For Tucker's
portrait of Nolan see Uhl 1969, no.5.27.
4. Lynn 1979, p.48.

△
NARCISSUS [1947]
Ripolin enamel on hardboard
122 x 91.5 cm
Art Gallery of South Australia
Gift of Sidney and Cynthia Nolan 1974

Exhibitions: *Rebels and Precursors*,
N.G.V. and A.G.N.S.W., 1962, no.72:
'Narcissus, 1947'; A.G.N.S.W. etc., 1967,
no.33; Folkestone, 1970, no.16; Dublin,
1973, no.19; *Festival Exhibitions*, A.G.S.A.,
1974; *Adelaide's Nolans*, A.G.S.A., 1983;
Sidney Nolan: the city and the plain,
N.G.V., 1983, no.60

Nolan first made a small 'sketch' of *Nar-
cissus* on 10 May 1945; and later that day
a larger painting, inscribed as a present
for Cynthia Reed who was then an occa-
sional visitor at 'Heide'.[1] In Ovid's *Meta-
morphoses* the beautiful demi-god
Narcissus is punished by death for the
vanity of falling in love with his own
reflection, seen in a clear pool
of water. He symbolizes the artist's self-
knowledge. Salvador Dali's *Metamor-
phosis of Narcissus*, 1937, is probably the
best known painted elaboration of the
theme.[2] Max Harris had identified himself
with the doomed youth in a
Surrealist poem of 1939.[3] Rilke's poem
beginning 'Over the spring there bent—
Ah, how silent—Narcissus' is, however,
closer in mood to Nolan's work.

In this self-portrait version of the story
Nolan's Narcissus has, ironically, found
a waterfall in which no reflection (or self-
knowledge) is ever possible—and is
looking at the outside world rather
than himself. Painted just before he left
'Heide', its cryptic mocking tone reflects
his own highly charged emotions at the
time. The landscape is both mythic and
quintessentially Australian—in the spirit
of Marcus Clarke's celebrated descrip-
tion written in 1880: 'In Australia alone is
to be found the Grotesque, the Weird,
the strange scribblings of nature learning
how to write.... But the dweller in the
wilderness acknowledges the subtle
charm of this fantastic land of monstrosi-
ties. He becomes familiar with the beauty
of loneliness. Whispered to by the myriad
tongues of the wilderness, he learns the
language of the barren and the uncouth,
and can read the hieroglyphs of haggard
gum trees blown into odd shapes, dis-
torted with fierce
hot winds...'.[4]

1. 37.2 x 24.8 cm, private collection, Victoria; 76
x 64.2 cm, private collection, Western Australia.
2. Now in the Tate Gallery, London; Dali also
wrote a poem called 'Narcissus' in 1937 (see
Ades 1982, p.133). A painting by Dali entitled
'*L'homme fleur*' was amongst the most controver-
sial items in *The Herald* modern art exhibition of
1939.
3. 'Narcissus', published in *Bohemia* 5, 1939, p.9.
4. Preface to *Poems of the Late Adam Lindsay
Gordon*, A.H. Massina & Co., London, 1880, p.v.

△

PORTRAIT OF BARRETT REID 1947
Ripolin enamel on pulpboard
74.5 x 62.5 cm
Inscribed l.l.: 'N/Jan. 47.'
Queensland Art Gallery
Purchased 1984

Provenance: Given by the artist to Barrett Reid, until 1983; Lauraine Diggins

Exhibitions: *Glimpses of the Forties*, Heide, September–November 1982, no.46; *Moderns Exhibition*, Lauraine Diggins, North Caulfield, June 1983, no.27

When John and Sunday Reed first met Barrie Reid in Brisbane in 1945, he was already—at the age of eighteen—a recognized poet. A small but vital group of artists and writers had coalesced around his bi-monthly magazine *Barjai: a meeting place for youth*, founded two years earlier as a forum for radicals under twenty-one. *Angry Penguins* had called him 'l'enfant Baudelaire'; but Nolan chose to portray him as a Young Rimbaud when he came to stay at 'Heide' for the summer of 1946–47.

Resemblances to the most famous portrait photograph of Rimbaud, taken by Carjat in 1871 and reproduced in many books, are unmistakable: from the cameo frame, stiff collar and jacket (young Reid's favourite American tweed), to hairline, facial structure and piercing eyes. He did not realize at first that Nolan was painting him. He thought he was watching fellow Queenslander, Laurence Hope, sitting for a portrait. When Nolan confessed to his trick, the latter was somewhat put out—having sat patiently to no purpose. The portrait which Nolan then quickly produced for Hope as compensation is now in the Art Gallery of South Australia.[1]

1. Reproduced in MacInnes et al. 1961, pl.9, but wrongly titled and dated.

FULLBACK 1946 ▷
Ripolin enamel on hardboard
121 x 90.3 cm
Inscribed l.r.: 'N'
verso: 'FULLBACK ST KILDA 24-8-46/ Sidney NOLAN/Private collection/to National Gallery Victoria/AUSTRALIA [1962]/Not to be sold'
Private collection

Exhibitions: *C.A.S.*, Melbourne, 1946, no.111:'Footballer—60gns'; *Rebels and Precursors*, N.G.V. and A.G.N.S.W., 1962, no.70; Stockholm, 1976, no.15; Chester, 1983, no.30, illus.

'I finished my painting of a footballer this morning & called Jim [the 'Heide' gardener] in to have a look at it. He said it looked quite real, almost as if you were there, so it at least passed the critical eye of a specialist.'
- 26 August 1946

Australian Rules football is an integral part of Melbourne life and the players are cast in a heroic mould. Nolan's footballer is not a portrait of any particular team member; this is an archetypal football star. (The redoubtable fullback of his own local side, Billy Mohr, would have worn the Saints' team colours of red, white and black.) By the time of the 1946 C.A.S. exhibitions, some critics felt that the younger Melbourne artists were beginning to appear 'more conservative'; 'and the most "advanced" painters there—Arthur Boyd, Sydney [*sic*] Nolan, Albert Tucker—show the greatest control over their medium'.[1] Here Nolan's *faux naïf* dislocation of scale and bright colours call up the roar of the crowd and the 'clear emotion', as Clive Turnbull wrote.[2]

Nolan tells an amusing story about his own performance on the field as a youth. During one match he made a spectacular run, dodging ahead, covering the whole length of the ground. 'I was very fit and no one could keep up with me'; until, intoxicated by his effort and still holding the ball, he ran smack into one of the goal posts! 'I was just full of myself. I didn't see anything else. People were widdling themselves, a woman was carried away in hysterics screaming, "It's not true, it's not true, make him do it again".'[3]

1. *The Sydney Morning Herald*, 12 November 1946.
2. *The Herald*, Melbourne, 18 February 1946. A closely comparable large frontal figure and diminutive audience appear in two of Löwenfeld's illustrations by visually handicapped teenagers: *The Nature of Creative Activity*, 1939, pls 55 and 56, entitled 'Orator'.
3. Quoted in Cynthia Nolan 1967, pp.72f.

GIPPSLAND INCIDENT 1945 ▷
Ripolin enamel on hardboard
91.5 x 122 cm
Inscribed l.c. (on tree trunk): '29.8.45'
Art Gallery of South Australia
Gift of Sidney and Cynthia Nolan 1974

Exhibitions: *Rebels and Precursors*,
N.G.V. and A.G.N.S.W., 1962, no.61;
A.G.N.S.W. etc., 1967, no.20; *Festival
Exhibitions*, A.G.S.A., 1974; Perth Fes-
tival, (*Ern Malley Collection*), February
1982, no.17; *Adelaide's Nolans*, A.G.S.A.,
1983; *Sidney Nolan: the city and the plain*,
N.G.V., 1983, no.50; *Aspects of Figurative
Painting 1942–1962: Dreams, Fears and
Desires*, S.H. Ervin Gallery, Biennale of
Sydney, 1984, no.25

'*Gippsland Incident* is based on a true
event. A man struck a tree with an axe
and he found embedded in it the figure-
head of a ship that had been wrecked on
the Gippsland coast. The figurehead had
floated up. But when he hit the tree, he
decapitated the woman. I inscribed the
tree with a heart, a rather menacing
arrow ... and the date of the painting. It
was a curious incident and I do not paint
such complete events as a rule.'
- Nolan, speaking to Elwyn Lynn, 21 April 1978

This is one of a number of partly narrative
'story pictures' which, through explora-
tion of Australian myth and history, led
on to Nolan's treatment of the Ned Kelly
saga. Other examples include *Tarred &
Feathered*, October 1945—depicting the
political agitator 'Riverina Dick' who was
thus besmirched in an old bush yarn;
and *Woman and tent*, July 1946, based on
a newspaper story about an elderly lady
camping out near Heidelberg.[1] The
protagonist of *Gippsland Incident* is
markedly similar in appearance to the
hanged miner in *Goldfields*, painted just
a few days later. It is a truly pathetic
episode. Even the tree weeps endless
'gum tears' for this man who has
destroyed the beautiful—albeit wooden—
object of his desire. And the scribbled
bush landscape is subdued with melan-
choly, for Nolan 'wanted some lyricism
mixed with the rather startling drama'.[2]

1. Both are now in the Nolan Gallery, 'Lanyon';
Gilchrist 1985, nos 5 and 18.
2. Quoted in Lynn 1979, p.52. In recent years
Nolan has related this work to a line of poetry,
'Here the tree weeps gum tears', from Ern
Malley's 'Petit Testament'—which also inspired
the *Arabian Tree* painting.

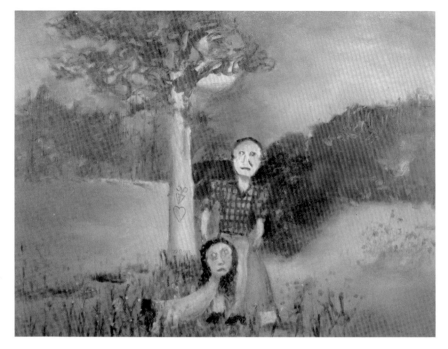

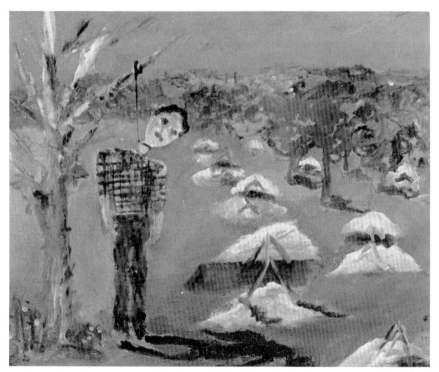

△
GOLDFIELDS 1945
Ripolin enamel on pulpboard
63 x 77 cm
Inscribed l.r.: '8-9-45/N'
verso: 'Goldfields/8-9-45/Nolan'
Tony Reichardt
Provenance: The artist, to Tony Reichardt,
of Marlborough Fine Art

Here is a sorry tale from Australian
history. During the 1850s goldrush many
an unsuccessful prospector took his own
life in this way. Nolan had seen illustra-
tions such as S.T. Gill's 'Unlucky digger
that never returned' in the *Victorian
Goldfields* sketchbook of 1852–53—
reduced to a skeleton in the bush. The
desperate figure in his own version of
the story is, however, a much more
shocking image.

NOLAN'S NED KELLY

A bushman of the last century described Australia as 'A queer country, so old that as you walk on and on, there's a feeling comes over you that you are gone back to Genesis'. It is this feeling that one lives in, wanders in, and, in the case of a painter, wishes to paint. I find that a desire to paint the landscape involves a wish to hear more of the stories that take place within the landscape. Stories which may not only be heard in country towns and read in the journals of the explorers, but which also persist in the memory, to find expression in such household sayings as 'Game as Ned Kelly'. From being interested in these stories it is a simple enough step to find that it is possible to combine two desires: to paint and to tell stories.

The history of Ned Kelly possesses many advantages from this point of view. Most of us have heard it, in one way or another, during our childhood, and it is still a topic of conversation in those parts of Victoria where the Kelly family lived. In its own way it can perhaps be called one of our Australian myths. It is a story arising out of the bush and ending in the bush.

Whether or not the painting of such a story demands any comment on good and evil I do not know. There are doubtless as many good policemen as there are good bushrangers.

- Sidney Nolan, in *The Australian Artist* I, 4, July 1948

When Nolan came out of the army he was, he says, 'more than interested in violence. We had been taught about arms and the use of the utmost violence.'[1] In addition, of course, he was—like Ned Kelly—a fugitive from the law. He was living at 'Heide', in a rarified atmosphere increasingly strained by personal tensions and his feeling of inescapable dependence. 'It seems strange, but when I painted the Kellys I thought of them as very angry, violent pictures, and so did everybody else. Today they look quite tranquil ... but still on target.'[2] On more than one recent occasion he has said that the now famous Kelly paintings of 1946–47 were really at least as much about himself as the nineteenth-century bushranger: 'You would be surprised if I told you. From 1945 to 1947 there were emotional and complicated events in my own life. It's an inner history of my own emotions but I am not going to tell you about them.'[3]

Nolan's urge to paint Australian landscape was nevertheless undiminished. Hitch-hiking with Max Harris through the Kelly country of north-eastern Victoria—a rough, scrubby landscape 'gone back to Genesis'—he felt that the bush was 'the most real aspect of life, because of the smell and the light and everything else'.[4] The Kelly story was thus 'a way of showing the Australian bush, a reason for painting the bush ... One is always trying to put something in *front* of the bush.' In *Township* and in the wonderful loosely scribbled landscapes behind *Steve Hart dressed as a girl* or *Death of Constable Scanlon*, the fluid qualities of Ripolin on hardboard in direct *alla prima* technique are exploited to the full.

By citing as his sources 'Rousseau and sunlight', however, Nolan has acknowledged a second visual facet of the series as a whole: the stylistic inspiration of unsophisticated traditions of imagery ranging from paintings by *Le douanier* himself, to folk art and American primitive works.[5] John Reed had given Nolan 'a little book with Rousseau's Tiger Hunt in it'—which he very much admired. The 'Heide' library contained a number of books on American and European primitive art; as well as the English *naïf* Christopher Wood (1901–30), who also used Ripolin; the Italian Cesare Breveglieri and various more obscure figures. In addition, a sojourn at Vassilieff's house, 'Stonygrad', in Warrandyte during the 'gestation period' of this Kelly series had also rekindled Nolan's interest in folk art traditions (and, no doubt, incredible stories of escape and adventure).[6] The deliberately schematic and decorative *faux naïf* elements are most evident in the indoor episodes of Nolan's Kelly story: *Constable Fitzpatrick and Kate Kelly*, *The defence of Aaron Sherritt* and *The trial*.

As subject matter, Ned Kelly was far from new. Nolan may have had the benefit of a grandfather who told first-hand tales of his days as a police officer chasing the Kelly

gang, but any young citizen could inspect the outlaw's celebrated suit of armour on public display at the Melbourne Aquarium. In July 1940, Sydney artist Donald Friend had produced designs in 'a vein of wayward, rollicking humour' for a ballet based on the Kelly story. 'I chose Ned Kelly', he said, 'because all Australians regard him as a popular figure, although he was a rogue.'[7] Clive Turnbull had published *Ned Kelly Being His Own Story of His Life and Crimes* illustrated by Adrian Feint, Hawthorn Press, Melbourne, 1942; and an exhaustive bibliography, *Kellyana*, Hawthorn Press, Melbourne, 1943. 'Ned Kelly is the best known folk hero', he wrote, 'the explorers, the administrators, the colonial politicians, are little more than names on the map. What sort of people they were the average citizen neither knows nor cares ... Kelly had a way with him.'[8] Writing in *The Herald* Turnbull admired an 'amusing *Bushranger*' by Cedric Flower at the Melbourne C.A.S. exhibition of August 1945. Above all, Douglas Stewart's verse drama *Ned Kelly* had had considerable impact in literary and artistic circles. James McAuley has noted the play's concern for 'courage, bravado, daring action, considered in themselves; the relation of the leader to those who are animated by his mind and will; the breaking of the dream against actuality; the contrast between the wild and the tame, the bush and the town, the natural and the artificial'.[9]

The figure of Kelly undoubtedly appealed to Nolan as 'one of our Australian myths'. In the words of fellow artist John Olsen 'he was absolutely poetically infected to an almost divine degree'.[10] He avidly read the primary historical documents: contemporary newspaper reports at the Public Library, the Royal Commission Report of 1881 and J.J. Kenneally's *Complete Inner History of the Kelly Gang and their Pursuers*. Barrie Reid remembers arriving at 'Heide' early in 1947:

> That first morning when I walked in, the hall was full of paintings. The dining-room was a studio with tins of ripolin, bottles of oil, a scrubbed long table and on the walls many charcoal drawings of bearded heads. I saw real painting, free and authentic, for the first time. I had arrived just as the Kellys were nearing completion; the large hardboard panels, the cardboard studies, the many drawings and watercolours, captured and controlled my eyes. For some time Nolan remained for me a reticent, quiet figure in the background of all this work.[11]

The stark black silhouette of Kelly's home-made armour became, in Nolan's hands, an unforgettable symbol, ranked by the London critic Robert Melville in that 'company of twentieth century personages which includes Picasso's minotaur, Chirico's mannequins, Ernst's birdman, Bacon's pope and Giacometti's walking men'. Abstract black squares had, as Nolan himself points out, 'been floating around in modern art for some time'.[12] 'All I did was put a neck on the square', he says; but it was an inspired combination of narrative and symbol unparalleled in Australian art.

Not all Nolan's paintings of Ned Kelly relate to specific historical events. Some episodes he painted more than once. They appeared unobtrusively at first, Alan McCulloch recalls, popping up in exhibitions 'here and there, modestly enough, but with great persistence. Ned Kelly's armour was a symbol we all recognised; a tragic symbol to some, a ridiculous symbol to others'.[13] Then in 1948, leaving 'Heide' to settle in Sydney, Nolan selected twenty-seven as the 'core' of his work on the Kelly theme up to that time—the back of each work inscribed with a title. They range in date from 1 March 1946 to 18 May 1947.

One of this 1946–47 series, the *Death of Sergeant Kennedy at Stringybark Creek*, he had already sold to Clive Turnbull; the others he left for Sunday Reed as a parting gift.[14] In April that year the group was exhibited for the first time at the Velasquez Gallery in Melbourne. The substantial catalogue was introduced by John Reed:

> Australia has not been an easy country to paint. A number of artists have sensed something of what it holds and one or two—the early Roberts and Streeton—have succeeded in giving us glimpses of it which were movingly true; but we have waited many years for a mature statement to cover both the landscape and man in relation to the landscape.
>
> In my opinion this has now been achieved by Sidney Nolan in the group of 27 paintings exhibited, and it is a remarkable achievement indeed, necessitating as it has the most sensitive and profound harmony between symbol, legend and visual impact...

Seeing the works *en masse* was a revelation to fellow artists—even to those closest friends who had watched their evolution at 'Heide'. The general public and local reviewers, however, displayed almost classic indifference. James MacDonald, former director of the National Gallery of Victoria and *The Age* critic at the time, declared, 'Nolan has a second-rate halloween or boogie-woogie notion of depiction—particularly in these Kelly daubs'. It was not until the end of the following year, when the same exhibition was shown in Paris to considerable acclaim, that Australian audiences felt able to agree with the Reeds' judgement. French and English critics were now quoted approvingly by daily newspapers in both Melbourne and Sydney—for example, Jean Cassou, head of the Musée national d'art moderne. Nolan's Ned Kelly paintings, in the words of Monsieur Cassou, were 'the work of a true poet and true painter' and a 'striking contribution to modern art'.[15]

1. 6 September 1984; interview quoted in Lynn 1985, p.7. Although Nolan had not seen active service himself, wartime society in general had been preoccupied with violence. His younger brother, Raymond, drowned in July 1945 in Cooktown, returning home —less than a month before the end of the war.

2. Interview with Janet Hawley, *The Age*, 14 February 1987.

3. Lynn, op.cit, p.9.

4. Barber 1964, p.90.

5. Henri Rousseau (1844–1910) was called '*Le douanier*' because he was a French Customs Officer as well as an amateur Sunday painter; in the twentieth century—'discovered' by Picasso—he became the symbol of sophisticated interest in the Primitive and pseudo-Primitive.

6. Felicity St John Moore, *Vassilieff and his art*, Oxford University Press, Melbourne, 1982, p.60; Nolan was intrigued by Vassilieff as a type— 'a natural and an adventurer in his wonderful house'.

7. *Daily Telegraph*, 27 July 1940, with illustration of two costume designs; *Sydney Morning Herald*, 27 July 1940; *Australia, National Journal*, September–November 1940, pp.34f., illus. He thereby won Colonel de Basil's £10 first prize for décor and costumes of a ballet with an Australian theme; the entries were judged in Melbourne (by Burdett) and Sydney.

8. Introduction to *Ned Kelly Being His Own Story of His Life and Crimes*, a reprint of Kelly's letter to Mr Donald Cameron MLA at the time of the Euroa robbery in 1878.

9. James McAuley, 'Douglas Stewart' in *The Literature of Australia*, ed. Geoffrey Dutton, Penguin, Ringwood, 1964, p.373. The play was first performed for an A.B.C. radio broadcast in 1942; published by Angus & Robertson, Sydney and London, 1943; Nolan would design stagecloths for the first stage production in 1956 (see catalogue). An article by Albert Tucker in *Angry Penguins*, 1943, discussed in a political context the relationship between 'art, myth and society'.

10. Quoted in Dutton 1986, p.190.

11. Reid 1967, pp.44f. Many of the charcoal bushranger heads are now in the A.N.G.; to be exhibited in 1988.

12. He has told Elwyn Lynn that he saw the abstract squares of Moholy-Nagy in fashion magazines and 'plonked the alien object, because it was part of Kelly's alienation, on the landscape'. He sometimes refers to Kasimir Malevich's levitated black square 'but that is just a matter of Irish convenience because, simply, he is better known'; Lynn 1985, p.10 (Malevich painted his famous white square c.1918). The abstracted red crescent mouth motif which recurs repeatedly in Tucker's *Images of Modern Evil* is a significant local precedent.

13. McCulloch 1961, p.464. Nolan showed Kelly paintings at the Rowden White Library in July 1946 and with the Melbourne C.A.S. that year. Donald Friend responded with a burlesque *Apotheosis of Ned Kelly* in 1946 and *Ned Kelly and family* in 1948.

14. Turnbull, now art critic of *The Herald*, reproduced the work in his *Art Here: Buvelot to Nolan*, The Hawthorn Press, Melbourne, 1947; it was purchased by the A.N.G. in 1972. In 1977 Sunday Reed presented twenty-five to the A.N.G. of which thirteen are in the present exhibition; *First-class marksman* left the Reeds' possession c.1959 and is now in a private collection.

15. *The Daily Telegraph*, Sydney, 15 December 1949, quoting Cassou's catalogue foreword.

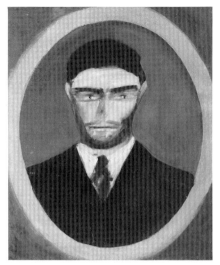

△

NED KELLY [1946]
Ripolin enamel on hardboard
74.5 x 61.5 cm
Australian National Gallery
Purchased 1970

Provenance: Sunday and John Reed;
Joseph Brown Gallery, Melbourne 1970

Exhibitions: *Autumn Exhibition 1970*,
Joseph Brown Gallery, Melbourne,
2–23 March 1970, no.26

'I am a widow's son outlawed and my
orders *must be obeyed*.'
- Kelly's 'Jerilderie Letter', 1878–79

Edward Kelly, son of John 'Red' Kelly—
an Irish ex-convict selector and cattle
thief—and his wife Ellen Quinn, was born
in 1854 at Beveridge, fifty kilometres
north of Melbourne. His father died in
1866; Ned was thus head of the family
at the age of eleven—with two younger
brothers and three sisters—and left
school. The widow and children now
moved to a selection of eighty-eight
acres in the King River valley, about half-
way between Greta and Glenrowan in
north-east Victoria. The land was bad
and the Kellys were poor. Four children
were born of Ellen's second marriage;
and local members of her own family,
the much intermarried Irish- Australian
Quinn-Lloyd clan, were in constant
trouble with the squattocracy and police.

Ned spent ten days in custody for
assault and robbery in 1869. In 1870 he
faced charges—later dismissed— of
aiding the bushranger Harry Power; in
October that year was sentenced to
three months' hard labour for assault and
indecent behaviour after a brawl; and in
April 1871 to three years in Pentridge
Prison for receiving a stolen horse. The
family was regularly involved in what he
later called 'wholesale and retail horse
and cattle dealing'.

This portrait is taken from the 'mug
shot' photograph at age eighteen on
Kelly's gaol record. As Bernard Smith
has observed, when Nolan embarked on
the first Kelly paintings he was satisfying
three distinct interests of the 'Angry
Penguins' group: the fascination with
expressive portrayals of criminals and
psychotic types, the interest in myth and

Ned Kelly's gaol record
Photograph by courtesy of the Public Record
Office, Melbourne

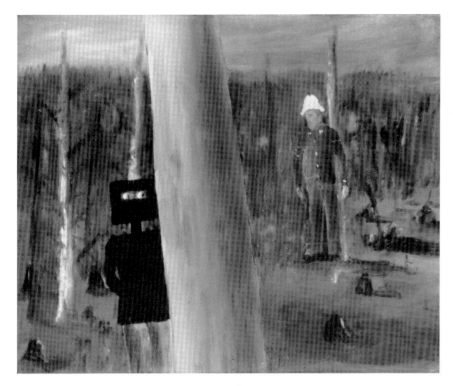

parcel of big ugly fat-necked wombat headed big bellied magpie legged narrow hipped splay-footed sons of Irish Bailiffs or english landlords which is better known as officers of Justice or Victorian Police who some calls honest gentlemen but I would like to know what business an honest man would have in the Police as it is an old saying it takes a rogue to catch a rogue'; whilst conceding that 'certainly their wives and children are to be pitied'.[2]

'The fact that one got on to Ned Kelly is not an accident', Nolan has explained, 'It was because of my preoccupation with, say, Flaubert and Balzac that I had the experience to look into my own society to see what was representative of it. It wasn't just that he wore a mask ... it was because I knew all those kinds of families up in that area of Victoria.'[3] Nolan also knew the soft, scrubby land-scape of the Goulburn valley from child-hood holidays. He discovered the Kelly country further east during the summer of 1945–46.

1. Quoted in Gilchrist 1985, p.5.
2. 'The Jerilderie Letter', written by Kelly some time between the Euroa bank robbery, 10 December 1878, and the hold-up at Jerilderie, 8–10 February 1879.
3. Gilchrist, loc.cit.

the desire for some kind of national identification.[2] A 'flash, ill-looking black-guard', according to police report, the young outlaw was in fact a handsome specimen of Australian manhood. He was a phenomenally good horseman and a champion fighter. And his eyes, described as 'hazel' in the records, are here as blue as Nolan's own.

1. Accounts of Kelly's character, appearance, and background are legion; and usually biased. Max Brown was writing his *Australian Son: the story of Ned Kelly* from 1945 (Melbourne, 1948). More recent examples are Bill Wannan, *Australian Bushranging, the stark story*, Rigby, Adelaide, 1978, pp.161ff., Harry Nunn, *Bush-rangers, a pictorial history*, Lansdowne, Sydney, 1980, and Keith Dunstan, *Saint Ned, the story of the near sanctification of an Australian outlaw*, Methuen, Sydney, 1980. A useful summary history of the Kelly gang by Bruce Semler is included in Lynn 1985, pp.13ff.
2. Smith 1962, p.27.

△
KELLY AND SERGEANT KENNEDY 1945
Ripolin enamel and collage on pulpboard
63.6 x 76.4 cm
Inscribed l.r.: 'March 14th 1945'
Nolan Gallery, 'Lanyon', Department of Territories
Presented by the artist 1974
For exhibition in Melbourne only

Provenance: Sunday and John Reed; reacquired by the artist through Sweeney Reed, Southern Cross Galleries and Alistair McAlpine, c.1973

Exhibitions: Newcastle etc., 1961, no.32; I.C.A., London, May 1962, no.33; A.G.N.S.W. etc., 1967, no.16; Dublin, 1973, no.5, illus.; Ilkley Manor House, April–May 1973; *Nolan at Lanyon*, 1975, no.3, illus.

The story of the Kelly gang, the culmina-tion of almost a century of bushranging in Australia, was already part history, part legend by 1945. As Nolan puts it, 'If you are remembered and if people paint you and write poems about you, and if the tribe latches on to it, then you have a myth'.[1] This is his earliest dated work on the theme in a public collection, painted whilst reading extensively in preparation for more detailed treatment.

The Irish Sergeant Michael Kennedy, aged thirty-six, father of five, had a reputation as a first class police officer according to reports of the time; he was shot and savagely mutilated at Stringy-bark Creek on 26 October 1878. Here Nolan has composed him from bits of paper—like a flimsy cut-out dummy; with a face from a newspaper photograph, perhaps as an ironic comment upon the truth and reliability of reported 'facts'. Ned Kelly himself objected strenuously to the 'brutal and cowardly conduct of a

Ripolin enamel on hardboard
91 x 121 cm
Inscribed l.r.: '12.12.46./N.'
verso: 'NOT FOR SALE PROPERTY OF
ARTIST/THE MARKSMAN NOT FOR
SALE/1946 NOLAN.'
Private collection

Provenance: The artist, to Sunday Reed
1948 (M.O.M.A. 1958); through Sweeney
Reed and Southern Cross Galleries and
Alistair McAlpine mid–1970s; private
collection

Exhibitions: Velasquez Gallery,
Melbourne, April 1948, no.6: 'First-class
marksman'; Unesco, Paris, December
1949, no.6; Rome, October 1950, no.6;
Gallery of Contemporary Art,
Melbourne, June 1956, no.6; M.O.M.A.,
Melbourne, September–October 1958,
no.96; David Jones' Art Gallery, Sydney,
February 1959, no.96: catalogued but not
exhibited; Stockholm, 1976, no.12; Paris,
June–July 1978, no.4; Chester, 1983,
no.3, illus.

Published as a screenprint in Marlbor-
ough Graphics' *Ned Kelly II* series,
1978–79, no.4

'While in the ranges they indulged in
rifle and revolver practice to such an
extent that all of the four mates were first-
class marksmen with any kind of fireman
[*sic*—firearm].'

This is said to be the only one of the 1946–
47 group which Nolan did not paint in the
dining room at 'Heide'. It dates from the
end of 1946 when he stayed for a couple
of months at 'Stonygrad', in Warrandyte,
whilst Vassilieff was away in Sydney.[1]
Nolan admired the 'exotic' Russian expa-
triate: 'I have a great respect for his
painting, perhaps as much for the way
he buried them when the Japs came, or
for the way he built himself a house &
painted the washhouse. Painting takes
a long time, it is a truism, but the one
valuable comment, you have to start to
live like a painter early. And not like
an intellectual.'[2]
 The scratchy disarray of scrub vege-
tation recalls Vassilieff's expressive,
anti-academic drawing with the brush.
The ranges rise in the distance like an
Australian translation of Cézanne's Mont
Sainte-Victoire.

1. Moore 1982, p.60.
2. Letter of 12 January 1944.

△
LANDSCAPE 1947
Ripolin enamel on hardboard
121.5 x 90.5 cm
Inscribed verso: 'LANDSCAPE, 31-1-47'
Australian National Gallery
Gift of Sunday Reed 1977

Provenance: The artist, to Sunday Reed
1948; (M.O.M.A. 1958–65) until 1977

Exhibitions: Velasquez Gallery,
Melbourne, April 1948, no.1; Unesco,
Paris, December 1949, no.1; Rome,
October 1950, no.1; Gallery of Contem-
porary Art, Melbourne, June 1956, no.1;
M.O.M.A., Melbourne, September–
October 1958, no.91; David Jones' Art
Gallery, Sydney, February 1959, no.91;
Georges' Art Gallery, Melbourne, June–
July 1963, no.1; Qantas Gallery, London,
June 1964, then Edinburgh, Paris,
Sydney, no.1; Tolarno Galleries, St Kilda,
November 1967, no.1; Auckland City Art
Gallery etc., 1968, no.1; Heide Park and
Art Gallery, November 1981–February
1982, no.1

Published as a screenprint in Marlbor-
ough Graphics' *Ned Kelly II* series, 1978–
79, no.1

'The "Kelly Country" is that portion of
north-eastern Victoria which extends
from Mansfield in the south to Yarra-
wonga in the north, and from Euroa
in the south-east to Tallangatta in the
north-west.'[1]

Within the Ned Kelly 'series' of 1946–47,
the inscribed dates of execution do not
necessarily correspond to the narrative
sequence. *Landscape* sets the scene.
The Royal Commission called this 'the
Kelly country' in 1881. Nolan has said
more recently, 'I put a fire or a setting
sun on the horizon ... I wanted a clear
ambiguity because this was the tranquil
scene for subsequent violence ... That
muddy, opaque quality of the dam is
very Australian; muddy under the
serene, clear blue sky'.[2]

1. Introductory quotations to the series of 1946–
47 were chosen by the artist for the first exhibi-
tion catalogue in 1948; they came from the
report of the Royal Commission into the police
force in 1881, newspapers and, in particular, J.J.
Kenneally's *The Inner History of the Kelly Gang*,
Melbourne, 1929.
2. 6 September 1984, quoted in Lynn 1985, p.13.

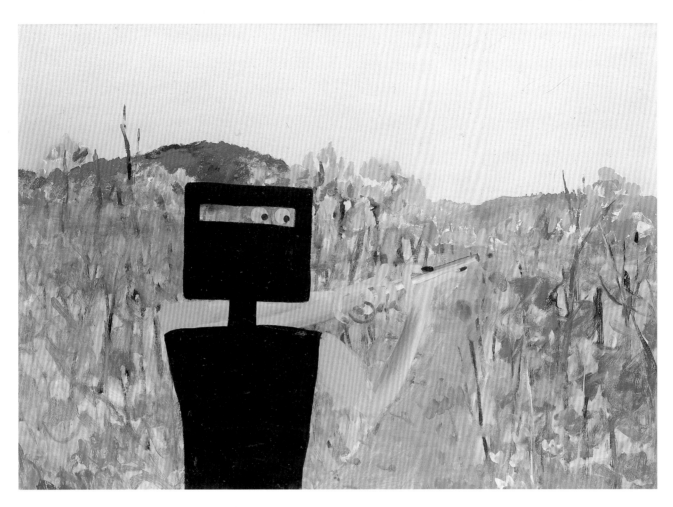

TOWNSHIP 1947 ▷
Ripolin enamel on hardboard
90.5 x 121.5 cm
Inscribed verso: 'TOWNSHIP, 6-2-47'
Australian National Gallery
Gift of Sunday Reed 1977

Provenance: The artist, to Sunday Reed 1948 (M.O.M.A. 1958–65) until 1977

Exhibitions: Velasquez Gallery, Melbourne, April 1948, no.7: 'Township'; Unesco, Paris, December 1949, no.7; Rome, October 1950, no.7; Gallery of Contemporary Art, Melbourne, June 1956, no.7; M.O.M.A., Melbourne, September–October 1958, no.97; David Jones' Art Gallery, Sydney, February 1959, no.97: Georges' Art Gallery, Melbourne, June–July 1963, no.6; Qantas Gallery, London, June 1964, then Edinburgh, Paris, Sydney, no.6; Tolarno Galleries, St Kilda, November 1967, no.6; Auckland City Art Gallery etc., 1968, no.6; Heide Park and Art Gallery, November 1981–February 1982, no.6

Published as a screenprint in Marlborough Graphics' *Ned Kelly II* series, 1978–79, no.5 as 'Mansfield'

'The peaceful town of Mansfield.'

'This is where they brought the dead policemen and I was intrigued by violence in peaceful settings', Nolan has explained.[1] It is a 'sleepy, hazy and dusty country town in the heat'—akin in feeling to early Riverina landscapes by Russell Drysdale, with their suggestion of an infinite horizon and their direct simplicity. Nolan would have seen Drysdale's *Sunday Evening* of 1941, for example, reproduced in *Art in Australia*.[2]

1. Lynn 1985, p.21.
2. In 1942; now in the A.G.N.S.W.; the paint quality is, of course, entirely different.

77

CONSTABLE FITZPATRICK AND KATE ▷
KELLY 1946
Ripolin enamel on hardboard
90.5 x 121.5 cm
Inscribed verso: 'SGT. FITZPATRICK
AND KATE KELLY/Oct 46'
Australian National Gallery
Gift of Sunday Reed 1977

Provenance: The artist, to Sunday Reed
1948 (M.O.M.A. 1958–65) until 1977

Exhibitions: Velasquez Gallery,
Melbourne, April 1948, no.4: 'Constable
Fitzpatrick and Kate Kelly'; Unesco,
Paris, December 1949, no.4; Rome,
October 1950, no.4; *Twelve Australian
Artists*, London etc., July 1953, no.28:
'—lent by John Reed, Esq.'; and Venice
Biennale 1954; Gallery of Contemporary
Art, Melbourne, June 1956, no.4;
M.O.M.A., Melbourne, September–
October 1958, no.94; David Jones' Art
Gallery, Sydney, February 1959, no.94;
Georges' Art Gallery, Melbourne, June–
July 1963, no.4; Qantas Gallery, London,
June 1964, then Edinburgh, Paris,
Sydney, no.4; Tolarno Galleries, St Kilda,
November 1967, no.4; Auckland City Art
Gallery etc., 1968, no.4; Heide Park and
Art Gallery, November 1981–February
1982, no.4

Published as a screenprint in
Marlborough Graphics' *Ned Kelly* series,
1971, no.2

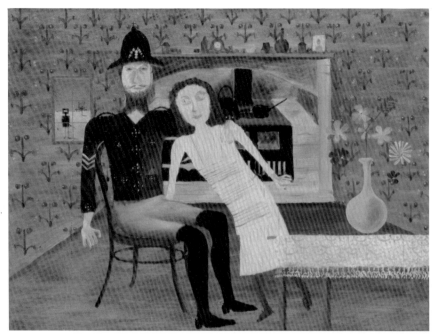

'Kate, in the exercise of her domestic
duties, was passing by Fitzpatrick when
the latter seized her and pulled her on
to his knee.'

The event which fired the Kelly gang's
'outbreak' took place on 15 April 1878.
Young Constable Fitzpatrick arrived,
without a warrant, to arrest Ned's brother
Dan. Shots were fired; Fitzpatrick
supposedly molested Ned's younger
sister and was somehow wounded in the
fray; the mother, brother-in-law and a
neighbour were arrested and gaoled.
Ned himself may or may not have been
present: he is certainly there, at least
in spirit, in Nolan's presentation of the
scene and undoubtedly he knew all
about the 'trying circumstances and
insults to my people'. The witnesses'
accounts varied and Fitzpatrick, never
a sergeant as suggested by the stripes
on his uniform, was later dismissed from
the force. 'It will pay Government to
give those people who are suffering
innocence, justice and liberty', Kelly
declared, 'if not I will be compelled to
show some colonial strategm [*sic*] which
will open the eyes of not only the Victoria
Police and inhabitants but also the whole
British army and now doubt they will
acknowledge their hounds were barking
at the wrong stump and that Fitzpatrick
will be the cause of greater slaughter to
the Union Jack than Saint Patrick was to
the snakes and toads in Ireland'.[1]

One of the most deliberately 'primi-
tivist' of the group, the episode seems
here less real even than a stage play. At
first glance the walls of the house appear
to create space by means of linear
perspective but it is arrested by the
pattern of the wallpaper which hovers
like a flat screen. The vase appears to
float upon a tabletop which is not there.
Kate herself is as weightless as one of
Chagall's brides. Nolan painted at least
two smaller, less resolved versions
of this episode.

1. 'Jerilderie Letter', 1878–79.

THE CHASE 1946 ▷
Ripolin enamel on hardboard
90.5 x 121.5 cm
Inscribed l.r.: 'Oct 2nd 1946/N'
verso: '26-9-1946 /THE CHASE'
Australian National Gallery
Gift of Sunday Reed 1977

Provenance: The artist, to Sunday Reed
1948 (M.O.M.A. 1958–65) until 1977

Exhibitions: Velasquez Gallery,
Melbourne, April 1948, no.15: 'The
chase'; Unesco, Paris, December 1949,
no.15; Rome, October 1950, no.15;
Gallery of Contemporary Art,
Melbourne, June 1956, no.15; M.O.M.A.,
Melbourne, September–October
1958, no.104; David Jones' Art Gallery,
Sydney, February 1959, no.104;
Georges' Art Gallery, Melbourne, June–
July 1963, no.13; Qantas Gallery, London,
June 1964, then Edinburgh, Paris,
Sydney, no.13; Tolarno Galleries, St
Kilda, November 1967, no.13; Auckland
City Art Gallery etc., 1968, no.13; ; *1940–
1965 The Heroic Years of Australian
Painting*, Melbourne Town Hall etc.,
April 1977–August 1978, no.43; Heide
Park and Art Gallery, November 1981–
February 1982, no.13

Published as a screenprint in Marlbor-
ough Graphics' *Ned Kelly* series, 1971,
no.8 as 'The Pursuit'

'I am sure the police would not ride them
down in a day; they would have to hunt
them down, but not ride them down—the
outlaws were well mounted.'

Nolan said recently of this work, 'Kelly
had been black but I put the stripes as
though he may have played Australian
Rules, you might think, but the same
stripes occur as wallpaper in the burning
Glenrowan Hotel. Events casting their
shadows before them? The policeman
goes the opposite way ... wisely.'[1] Kelly
has become a symbol: faceless within
the iron mask, limbless although holding
his gun.

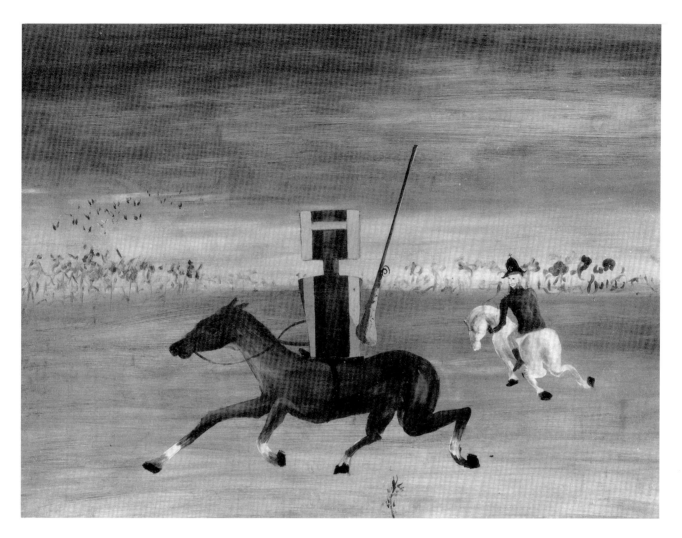

The sun-drenched landscape bears out Nolan's often quoted statement on these paintings that 'Kelly's own words, and Rousseau and sunlight are the ingredients of which they were made'.[2] Other interesting and adventurous sources are traceable, however. As Richard Haese points out, elements in *The chase* bear striking similarity to those in a fifteenth-century picture of Mars the Roman god of war in his chariot as reproduced in *Verve*, July–October 1939, a French art magazine which was in the 'Heide' library.[3] Kelly's armour and rifle echo the decorative armour worn by Mars and the shape of his flail; the white horse is also closely comparable. 'While a formal connection only', Haese concludes, 'it does link the story of Kelly with wider mythology'. When these Kelly paintings were exhibited overseas to great acclaim in 1964, London critic Edward Lucie-Smith wrote perceptively in *The Times*, 'What is most memorable about them is their insolence—the way in which an artist like Nolan treats the leaden certainty of historical fact as something as flexible and as malleable as mythological material once seemed to a painter like Boucher'.

1. Lynn 1985, p.32.
2. MacInnes et al. 1961, p.30.
3. Haese 1981, p.279.

STEVE HART DRESSED AS A GIRL 1947 ▷
Ripolin enamel on hardboard
90.5 x 121.5 cm
Inscribed verso: 'STEVE HART/
DRESSED AS A GIRL/18-2-47'
Australian National Gallery
Gift of Sunday Reed 1977

Provenance: The artist, to Sunday Reed 1948 (M.O.M.A. 1958–65) until 1977

Exhibitions: Velasquez Gallery, Melbourne, April 1948, no.8: 'Steve Hart dressed as a girl'; Unesco, Paris, December 1949, no.8; Rome, October 1950, no.8; Gallery of Contemporary Art, Melbourne, June 1956, no.8; M.O.M.A., Melbourne, September–October 1958, no.98; David Jones' Art Gallery, Sydney, February 1959, no.98; Georges' Art Gallery, Melbourne, June–July 1963, no.7; Qantas Gallery, London, June 1964, then Edinburgh, Paris, Sydney, no.7; Tolarno Galleries, St Kilda, November 1967, no.7; Auckland City Art Gallery etc., 1968, no.7; Heide Park and Art Gallery, November 1981–February 1982, no.7

Published as a screenprint in Marlborough Graphics' *Ned Kelly* series, 1971, no.3

'He appears to have been possessed of a considerable courage and resource, and during the period of his outlawry frequently rode about in feminine attire.'

'So successful was the attire', Kenneally continues, 'that he was taken to be one of the Kelly sisters and the police attributed many of his daring exploits to Kate Kelly. Steve Hart was never prominent as the Kelly brothers were, but he was at all times a faithful follower and a courageous ally.' He was mate of Dan Kelly from Wangaratta, five years younger than Ned, a snappy dresser (as a rule), a brilliant horseman, leader of the local Greta Mob of larrikins; and, according to the landlady at the Glenrowan Hotel, 'a very good boy'—despite a prior conviction for horse stealing. On one occasion, dressed as a girl and riding side-saddle, he won an event at the Greta races. He joined the brothers in the Wombat Ranges, rough country outside Mansfield, in 1878. The fourth member of the gang was twenty-one-year-old Joe Byrne.

QUILTING THE ARMOUR 1947 ▷
Ripolin enamel on hardboard
90.5 x 121.5 cm
Inscribed verso: 'QUILTING THE
ARMOUR, 28-4-47'
Australian National Gallery
Gift of Sunday Reed 1977

Provenance: The artist, to Sunday Reed
1948 (M.O.M.A. 1958–65) until 1977

Exhibitions: Velasquez Gallery,
Melbourne, April 1948, no.9: 'Quilting
the armour'; Unesco, Paris, December
1949, no.9; Rome, October 1950,
no.9; Gallery of Contemporary Art,
Melbourne, June 1956, no.9; M.O.M.A.,
Melbourne, September–October 1958,
no.99; David Jones' Art Gallery, Sydney,
February 1959, no.99; Georges' Art
Gallery, Melbourne, June–July 1963,
no.8; Qantas Gallery, London, June 1964,
then Edinburgh, Paris, Sydney, no.8;
Tolarno Galleries, St Kilda, November
1967, no.8; Auckland City Art Gallery
etc., 1968, no.8; Heide Park and Art
Gallery, November 1981–February
1982, no.8

Published as a screenprint in Marlbor-
ough Graphics' *Ned Kelly* series,
1971, no.1

'Mrs Skillion, who was Margaret Kelly,
sat out in the evenings sewing the soft
blue quilting into the headpiece of
the armour.'

Margaret was the Kelly boys' second-
eldest sister, married to William Skillion
who had been arrested, along with her
mother, by Constable Fitzpatrick in April
1878. The woman is working, as Nolan
points out, 'with tenderness and love,
while a peaceful world goes about its
life'.[1] In fact the famous armour, which
appears in all these Kelly paintings, was
worn only once—in the final siege at
Glenrowan. The gang had beaten flat a
number of stolen ploughshares to make
breast plates, shoulder guards and
the cylindrical helmet mask. The import
of young Mrs Skillion's task seems
horribly incongruous in this domestic
twilight scene.

1. Lynn 1985, p.23.

DEATH OF CONSTABLE SCANLON
1946
Ripolin enamel on hardboard
90.5 x 121.5 cm
Inscribed l.r.: 'April 25th 1946/... [illeg.]'
verso: 'STRINGYBARK CREEK/25-4-46'
Australian National Gallery
Gift of Sunday Reed 1977

Provenance: The artist, to Sunday Reed
1948 (M.O.M.A. 1958–65) until 1977

Exhibitions: Velasquez Gallery,
Melbourne, April 1948, no.10: 'Death of
Constable Scanlon'; Unesco, Paris,
December 1949, no.10; Rome, October
1950, no.10; Gallery of Contemporary
Art, Melbourne, June 1956, no.10;
M.O.M.A., Melbourne, September–
October 1958, no.100; David Jones' Art
Gallery, Sydney, February 1959, no.100;
Georges' Art Gallery, Melbourne, June–
July 1963, no.9; Qantas Gallery, London,
June 1964, then Edinburgh, Paris,
Sydney, no.9; Tolarno Galleries, St Kilda,

November 1967, no.9; Auckland City Art
Gallery etc., 1968, no.9; Heide Park and
Art Gallery, November 1981–February
1982, no.9

Published as a screenprint in Marlbor-
ough Graphics' *Ned Kelly* series,
1971, no.5

'He was in the act of firing again when
Ned Kelly fired, and Scanlon fell from
his horse and died almost immediately.'

Michael Scanlon was the second
policeman to die on the fateful day at
Stringybark Creek in October 1878—
after Constable Thomas Lonigan, against
whom Kelly had a particular grudge.
Here the wounded man is suspended
in space and time. 'In a sudden, violent
action time seems to stand still', says
Nolan, 'I have exaggerated; the bridle

must have been long, but that and the
levitated horse and constable increase
the unreality of violent events. Kelly
seems to be present only as a force of
destiny.'[1] As Kelly himself wrote, he
knew neither Scanlon nor Kennedy 'and
had nothing against them'; but 'Scanlon
who carried the rifle ... as quick as a
thought fired at me ... and was in the act
of firing again when I had to shoot him'.[2]

1. Lynn 1985, p.26.
2. 'Jerilderie Letter', 1878–79.

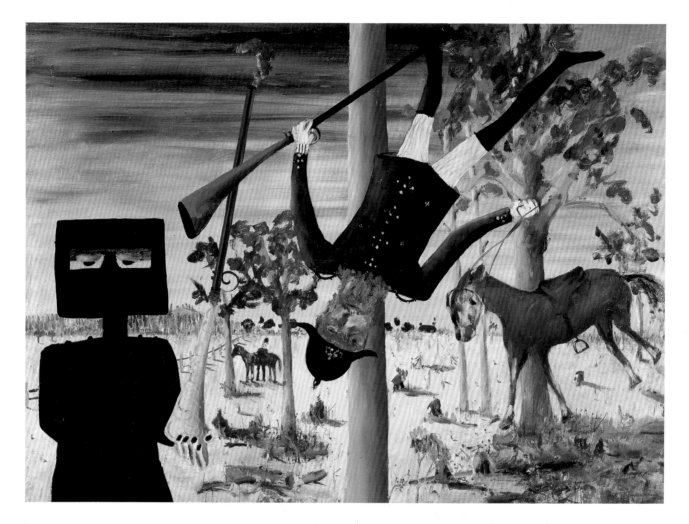

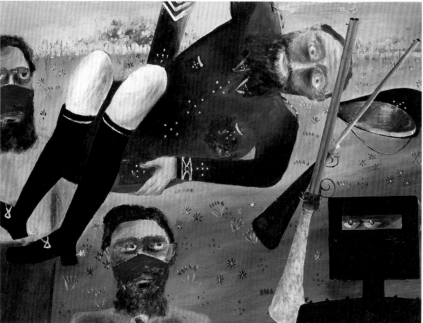

◁ STRINGYBARK CREEK 1947
Ripolin enamel on hardboard
90.5 x 121.5 cm
Inscribed verso: 'STRINGYBARK
CREEK/26-1-47'
Australian National Gallery
Gift of Sunday Reed 1977

Provenance: The artist, to Sunday Reed
1948 (M.O.M.A. 1958–65) until 1977

Exhibitions: Velasquez Gallery,
Melbourne, April 1948, no.11: 'Stringy-
bark Creek'; Unesco, Paris, December
1949, no.11; Rome, October 1950,
no.11; Gallery of Contemporary Art,
Melbourne, June 1956, no.11; M.O.M.A.,
Melbourne, September–October 1958,
no.101; David Jones' Art Gallery,
Sydney, February 1959, no.101;
Georges' Art Gallery, Melbourne, June–
July 1963, no.10; Qantas Gallery, London,
June 1964, then Edinburgh, Paris,
Sydney, no.10; Tolarno Galleries, St
Kilda, November 1967, no.10; Auckland
City Art Gallery etc., 1968, no.10; Heide
Park and Art Gallery, November 1981–
February 1982, no.10

Published as a screenprint in Marlbor-
ough Graphics' Ned Kelly series, 1971,
no.6 as 'Death of Sergeant Kennedy'

'If left alive Kennedy would, Kelly said,
be left to a slow torturing death at the
mercy of ants, flies, and the packs of
dingoes. Therefore he decided to put
an end to the sufferings of the wounded
sergeant, and, as the latter momentarily

turned his head, Kelly fired and shot him through the heart.'

Following the shooting of Scanlon, Sergeant Kennedy took cover by dropping off his horse and there ensued a running battle from tree to tree, with wild exchange of shots. 'I shot him in the armpit and he dropped his revolver and ran', Kelly wrote, 'I fired again with the gun as he slewed around to surrender. I did not know he had dropped his revolver, the bullet passed through the right side of his chest and he could not live.' Kelly denied accusations that the gang then handcuffed him to a tree or cut off his ears and, indeed, argued that his final shot was not 'wilful murder' but mercy. He added, in the classic style of the ill-used hero who knows no other truth than his own, that 'those men came into the bush with the intention of scattering pieces of me and my brother all over the bush and yet they know and acknowledge I have been wronged and my mother and four or five men lagged innocent and is my brothers and sisters and my mother not to be pitied also.'[1] The Royal Commission Interim Report, which was bitter enough about police mismanagement, passed savage judgement on Kelly over this affair: 'The cold-blooded despatch of the brave but ill-fated Kennedy when, wounded and hopeless of surviving he pleaded to be allowed to live to bid farewell to his wife and children, is one of the darkest stains upon the careers of the outlaws. It was cruel, wanton and inhuman, and should of itself, apart from other crimes, brand the name of his murderer, the leader of the gang, with infamy'.

Nolan flings the action at the viewer like a close-up in a film, filling the whole frame. He had always been fascinated by cinema and the visual effects possible in film as a medium; admiring earlier in a letter to Sunday Reed, for example, 'what Disney could paint & he isn't a painter ... Very strange you saying Disney would be proud of me'.[2] Ned and Dan Kelly, Steve Hart and Joe Byrne were now on the run. With the passing of the Felons Apprehension Act on 1 November 1878 they were officially outlaws and could be shot on sight.

1. 'Jerilderie Letter'.
2. December 1942.

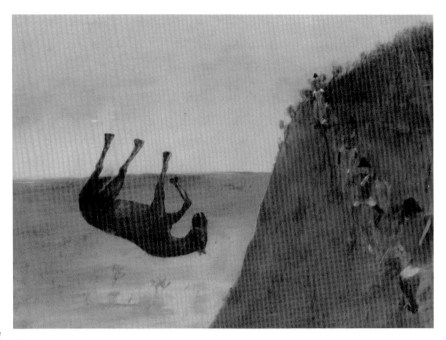

△
THE SLIP 1947
Ripolin enamel on hardboard
90.5 x 121.5 cm
Inscribed verso: 'THE SLIP/7-3-47'
Australian National Gallery
Gift of Sunday Reed 1977

Provenance: The artist, to Sunday Reed 1948 (M.O.M.A. 1958–65) until 1977

Exhibitions: Velasquez Gallery, Melbourne, April 1948, no.22: 'The slip'; Unesco, Paris, December 1949, no.22; Rome, October 1950, no.22; Gallery of Contemporary Art, Melbourne, June 1956, no.22; M.O.M.A., Melbourne, September–October 1958, no.111; David Jones' Art Gallery, Sydney, February 1959, no.111; Georges' Art Gallery, Melbourne, June–July 1963, no.20; Qantas Gallery, London, June 1964, then Edinburgh, Paris, Sydney, no.20; Tolarno Galleries, St Kilda, November 1967, no.20; Auckland City Art Gallery etc., 1968, no.20; Heide Park and Art Gallery, November 1981–February 1982, no.20

Published as a screenprint in Marlborough Graphics' Ned Kelly series, 1971, no.16

'The gully was exceedingly rough and precipitous. So much so that on one occasion as we were ascending in single file one of the packhorses lost its footing and fell.'

The advent of the first Kelly paintings, Alan McCulloch recalls, brought eloquence to the former 'emptiness' in Australian landscape painting.[1] Here the police are out in force. The melancholy evening light lends pathos to the grim drama. 'It is a dreadful descent and the horse will fall forever. I am nearing the climax of the tragedy', says Nolan.[2]

1. McCulloch 1961, p.464.
2. Quoted in Lynn 1985, p.42. He 'decided to put the horse upside down and give levitation another aspect'. Interestingly, in a slightly earlier work he painted an almost identical horse—suspended in water, drowning, rather than hanging in mid-air.

DEFENCE OF AARON SHERRITT 1946 ▷
Ripolin enamel on hardboard
121.5 x 90.5 cm
Inscribed verso: 'Nov 1946/DEFENCE OF AARON SHERRITT'
Australian National Gallery
Gift of Sunday Reed

Provenance: The artist, to Sunday Reed 1948 (M.O.M.A. 1958–65) until 1977

Exhibitions: Velasquez Gallery, Melbourne, April 1948, no.18: 'Defence of Aaron Sherritt'; Unesco, Paris, December 1949, no.18; Rome, October 1950, no.18; Gallery of Contemporary Art, Melbourne, June 1956, no.18; M.O.M.A., Melbourne, September–October 1958, no.107; David Jones' Art Gallery, Sydney, February 1959, no.107; Georges' Art Gallery, Melbourne, June–July 1963, no.16; Qantas Gallery, London, June 1964, then Edinburgh, Paris, Sydney, no.16; Tolarno Galleries, St Kilda, November 1967, no.16; Auckland City Art Gallery etc., 1968, no.16; 1940–1965 The Heroic Years of Australian Painting, Melbourne Town Hall etc. April 1977–August 1978, no.44; Heide Park and Art Gallery, November 1981–February 1982, no.16

Published as a screenprint in Marlborough Graphics' Ned Kelly series, 1971, no.10

1. *The Bulletin*, 7 October 1967, p.79. His own army uniform and rifle, wrapped carefully in newspaper and hessian bags, were hidden in the ceiling at 'Heide'. Douglas Cairns, who shared Nolan's Parkville studio at this time, gave him a handsome patchwork quilt made by patients at the Heidelberg hospital which inspired the one on Mr and Mrs Sherritt's bed. Lynn 1985, p.36.
2. Reproduced in Dr H.V. Evatt's *Rum Rebellion*, 1938, and plate 23 in Smith's own *Place, Taste and Tradition*, first published 1945.
3. In an article by Frank Medworth on ancient Greek art: the curious moustaches of Nolan's 'monster', the whimsical archaic smiles, the elbow-resting position, and the convergent bodies melting into a kind of tail, all find a source in the Greek sculpture.

'Mrs Sherritt: "They (the police) were in that position when Dan Kelly was in the room. I was put under the bed. Constable Dowling pulled me down, and then Armstrong caught hold of me, and the two of them shoved me under".'

Aaron Sherritt, a school friend of Joe Byrne and small selector, was only loosely associated with the gang. He often warned them of police movements but as the hunt intensified he became a double agent listed on the police pay sheet— a dangerous game. One night he was sitting by the fire in his hut near Sebastopol. Four police officers were posted there to protect him and to keep an eye on Byrne's mother who lived near by. When Byrne and Dan Kelly arrived and shot Aaron Sherritt through the chest at point-blank range, the policemen took his wife and mother-in-law as hostages and hid in the bedroom. When the outlaws rode away three hours later, the police thought their departure was a ruse; and didn't emerge until daybreak.

Nolan presents this episode as straightforwardly as a folk tale. Bernard Smith, however, has indicated the complex heritage of his apparently naive style in this work. Although the wall-paper and bright patchwork coverlet probably derive from specific personal memories, their treatment suggests the influence not of Rousseau so much as Matisse c.1910–11. The way in which the patchwork of the quilt is made to pass across the reclining policeman is certainly a Matisse-like device; plus a witty emphasis upon camouflage, so much a part of many an Australian artist's life during the war years.[1] The 'enchanting trio' under the bed, Smith suggests, have their pictorial origin in the somewhat ludicrous and frightened figure in a well-known colonial broad-sheet depicting 'The Arrest of Governor Bligh'.[2] And perhaps, he adds, there is also some memory of a 'charming triple-headed monster from the limestone pediment of the Old Hekatompedon on the Acropolis at Athens, ... published in *Art in Australia* in March 1942. It is not, of course, a deliberate borrowing but the vestige of a visual experience embodied and re-created in a new situation.'[3] Nolan was by no means a mere 'colonial boy'.

BURNING AT GLENROWAN 1946
Ripolin enamel on hardboard
121.5 x 90.5 cm
Inscribed verso: 'GLENROWAN/Oct 46'
Australian National Gallery
Gift of Sunday Reed 1977

Provenance: The artist, to Sunday Reed
1948 (M.O.M.A. 1958–65) until 1977

Exhibitions: Velasquez Gallery,
Melbourne, April 1948, no.25: 'Burning at
Glenrowan'; Unesco, Paris, December
1949, no.25; Rome, October 1950, no.25;
Gallery of Contemporary Art,
Melbourne, June 1956, no.25; M.O.M.A.,
Melbourne, September–October 1958,
no.114; David Jones' Art Gallery,
Sydney, February 1959, no.114;
Georges' Art Gallery, Melbourne, June–
July 1963, no.23; Qantas Gallery, London,
June 1964, then Edinburgh, Paris,
Sydney, no.23; Tolarno Galleries, St
Kilda, November 1967, no.23; Auckland
City Art Gallery etc., 1968, no.23; Heide
Park and Art Gallery, November 1981–
February 1982, no.23

Published as a screenprint in Marlbor-
ough Graphics' *Ned Kelly* series,
1971, no.13

'"I got no answer, of course, and I looked
in and found the bodies of Dan Kelly and
Steve Hart lying together. As far as I
could tell they were burnt from the waist
up".—Very Rev. Dean Gibney.'

'At about eight o'clock in the morning a
heart-rending wail of grief ascended
from the hotel. The voice was easily
distinguished as that of Mrs Jones, the
landlady. Mrs Jones was lamenting the
fate of her son, who had been shot in the
back by the police, as she supposed
fatally. She came out of the hotel crying
bitterly and wandered into the bush on
several occasions, etc.'

Following the terrible events at Stringy-
bark Creek, police reinforcements were
called in and Superintendent Nicholson
arrived at Benalla to take charge of the
hunt. By December 1878 some 220
troopers were in the North-eastern
District. The Kelly gang held out against
the strongest forces of the law for almost
another two years. Expert bushmen,
they secretly visited relations and
sympathizers. They held up a sheep
station; and the National Bank at Euroa.
On 8 February 1879 in Jerilderie, a small
town thirty miles north of the Murray
River in New South Wales, they comman-
deered the police station—as well as

uniforms and provisions—and bailed up
the local hotel. The New South Wales
government and banks now doubled the
reward offered by Victoria, to a total of
£8,000. Aboriginal 'black trackers' were
despatched from Queensland.

By June 1880, with Ned's mother and
numerous friends in prison as sympa-
thizers under the Felons Apprehension
Act, they laid plans for an all out attack
on the police at Glenrowan. The
'Jerilderie Letter' shows clearly that
Kelly believed he had a right to resist the
law—many officers were fellow Irishmen
whom he saw as traitors to the cause of
liberty. His stand at Glenrowan was
intended as a decisive blow and the
beginning of a popular revolt for reform
of the land acts and police practices.

The scheme went wrong largely
because of accidents of timing. The
outlaws failed in their attempt to derail
a special police train. They amassed
a total of sixty-two hostages—mainly
friendly—bailed up in Mrs Jones's
Glenrowan Hotel for two days; and
Byrne was shot in the groin as he stood

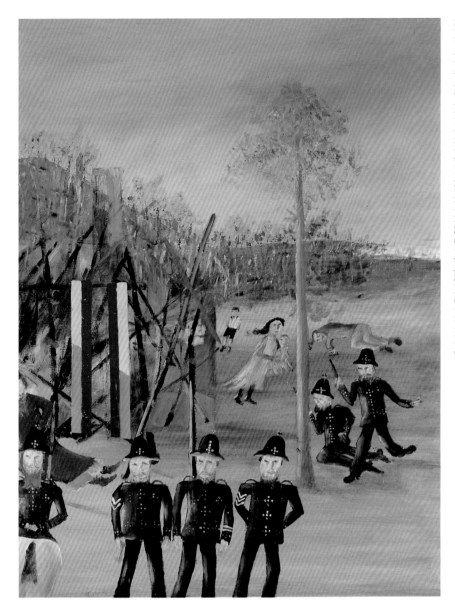

SIEGE AT GLENROWAN 1946
Ripolin enamel on hardboard
121.5 x 90.5 cm
Inscribed verso: 'GLENROWAN
/Nov. 46'
Australian National Gallery
Gift of Sunday Reed 1977

Provenance: The artist, to Sunday Reed
1948 (M.O.M.A. 1958-65) until 1977

Exhibitions: Velasquez Gallery,
Melbourne, April 1948, no.24: 'Siege at
Glenrowan'; Unesco, Paris, December
1949, no.24; Rome, October 1950,
no.24; Gallery of Contemporary Art,
Melbourne, June 1956, no.24; M.O.M.A.,
Melbourne, September–October 1958,
no.113; David Jones' Art Gallery,
Sydney, February 1959, no.113;
Georges' Art Gallery, Melbourne, June–
July 1963, no.22; Qantas Gallery, London,
June 1964, then Edinburgh, Paris,
Sydney, no.22; Tolarno Galleries, St
Kilda, November 1967, no.22; Auckland
City Art Gallery etc., 1968, no.22; Heide
Park and Art Gallery, November 1981–
February 1982, no.22

Published as a screenprint in Marlbor-
ough Graphics' *Ned Kelly* series,
1971, no.12

up to drink a toast 'to the bold Kelly
gang'. Some of the 'prisoners' escaped
under a hail of bullets, including Mrs
Reardon with babe in arms. Thirteen-
year-old Johnny Jones was shot. More
police arrived—standing about in rows
like Keystone Cops in Nolan's paintings.
Finally, amidst the confusion on Monday
28 June, the flimsy wooden hotel was set
on fire. Dan and Steve died in the blaze.
Ned confronted the police in a last stand,
in full armour and shouting, 'Fire away
you bloody dogs, you can't hurt me';
until, hit in the legs by shotgun blasts,
he collapsed and was led away.

Nolan tells a story that *Burning at
Glenrowan* and *Siege at Glenrowan* were
originally one picture: 'It was once six
feet by four, but late one night, Jack
Bellew, a journalist, said, "Look Sid, that
painting is too bloody big, cut it in two".'[1]
As two panels or one, together they
certainly make a powerful climax to
the story.

1. He continues, 'I told him to leave it alone, but
to prove it was not too big I would cut in in two.
You see I come from a long line of Irishmen.
So I cut it and looked at them separated and
together, and they looked better together.
Unfortunately I parted them forever'; quoted in
Lynn 1985, p.45, and Adams 1987, p.89. Nolan
has recently explained that he then made some
changes to each half—for example, repainting
the hotel roof in *Burning at Glenrowan*—so that
the two halves no longer fit together exactly;
conversation with the author, January 1987.

POLICEMAN IN WOMBAT HOLE [1946] ▷
Ripolin enamel on hardboard
91.8 x 122.3 cm
Inscribed l.r.: 'Nolan'
u.c. (on notepaper): '"Ned Kelly and
others/stuck us up today, when/we were
disarmed./Lonigan and Scanlon shot./I
am hiding in a wombat hole till dark. The
Lord/have mercy on me. Scanlon/tried
to get his gun out"'
Nolan Gallery, 'Lanyon', Department of
Territories
Presented by the artist 1974
For exhibition in Melbourne only

Provenance: Sunday and John Reed;
reacquired by the artist through
Sweeney Reed and Southern Cross
Galleries and Alistair McAlpine, c.1973

Exhibitions: *Nolan at Lanyon*, 1975,
no.15, illus.

Constable Thomas McIntyre was the
only one of four policemen to escape the
Kelly gang at Stringybark Creek on 25
October 1878. He fled on Sergeant
Kennedy's horse and hid in a large
wombat hole until dark. Nolan's
displaced wombat seems drolly diminu-
tive; and Constable McIntyre looks
somewhat like the proverbial ostrich
hiding its head in sand—as if to say, 'You
can't see me if I can't see you'. Only one
crooked little finger is poised for action
on the trigger of his gun; and he is
presumably unaware that a magpie
has perched itself upon the barrel! The
plaintive little message which Nolan has
transcribed was quoted in Kenneally's
*Complete Inner History of the Kelly Gang
and Their Pursuers*.

Amongst the Kelly drawings dated
1946, now in the collection of the Austra-
lian National Gallery, is an amusing
depiction of 'McIntyre riding, falling,
walking and hiding in wombat hole'—
successively on the one sheet, rather like
a nineteenth-century animal-locomotion
photograph by Muybridge; also
sketches of 'Constable McIntyre
shooting parrots', 'McIntyre escaping,
scarf flying behind' and 'McIntyre
hiding in wombat hole'.[1] This episode
was not included in the original
Melbourne *"Kelly" Paintings* exhibition
of 1948.

1. All presented by Sunday Reed in 1977. See
Lynn 1985, pp.50f.

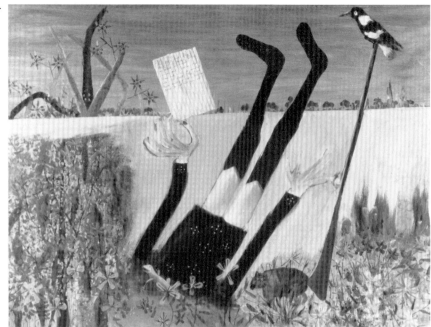

△
KELLY AT THE MINE c.1946-47
Ripolin enamel on hardboard
90 x 121.5 cm
Inscribed l.l.: 'N/Oct [?]'—very indistinct
Heide Park and Art Gallery
Purchased 1980
For exhibition in Melbourne only

Provenance: Sunday and John Reed,
until 1980

Exhibitions: *Heide Park and Art Gallery*,
November 1981, no.43; *Glimpses of the
Forties*, Heide, September–November
1982, no.45; *Another Summer*, Heide,
February–April 1987, no.10

This is one of several Kelly subjects
painted 1946–47 but not selected for
exhibition with the core group in 1948.[1]
The scene is the gang's hideout in 1878
in the Wombat Ranges, as described by
Ned himself: 'We had a house two miles
of fencing twenty acres of ground
cleared for the purposes of growing
mangle worsels and barley for the
purpose of distilling whisky. We were
also digging for gold we had tools and
sluice boxes and everything requisite for
the work.' Joe Byrne's father had been
a goldminer on the Woolshed diggings
near Beechworth, so presumably they
knew what they were about. Dan had
been 'quietly digging, neither molesting
or interfering with anyone', according to
his elder brother; 'he was making good

wages as the creek is very rich within half a mile from where I shot Kennedy'.[2] Nolan learned about the use of ventilated mineshafts like these from historical photographs and illustrations.[3] Kelly haunts the landscape like a sinister *genius loci*; the black silhouette of his armour painted thickly over the blue hills and soft pink distance.

1. Others on exactly this scale are in the Art Gallery of New South Wales and the RESI Statewide Collection. A group of slightly smaller works, mostly on pulpboard, include less resolved versions of various episodes. Some, as Nolan explained, were not intended as 'an incident in the sense that the other Kellys are' (letter to John Reed, 10 September 1946); for example the 'Kelly and horse' now at 'Lanyon', which he called his 'new Kelly on the red horse' and exhibited with the C.A.S. in 1946 as 'Ned Kelly N.F.S.'.
2. 'Jerilderie Letter', 1878–79.
3. Conversation with the author, January 1987. See, for instance, the painting by J. Roper, *Gold Diggers, Ararat* of 1854, reproduced by Smith in *Place, Taste and Tradition*, pl.29.

△
NED KELLY 'MONOTYPE' TRANSFER DRAWINGS c.1946–47
Nine red transfer drawings, one with enamel paint, on paper
each 23.5 x 30.5 cm
Private collection

Exhibitions: I.C.A., London, May 1962; *Rebels and Precursors*, N.G.V. and A.G.N.S.W., 1962, no.57; Chester, 1983, no.1

Most of Nolan's drawings on the Kelly theme, in pencil, crayon and wash, were made after the paintings were completed and should not be regarded as studies or preliminary works. A 'panel of nine Kelly heads' was included in the 1948 exhibition. These transfer drawings, similar in technique to his early semi-abstracts of 1939–40, are undated but seem also to have been produced after the painted series.[1] They are footnotes to the main narrative: colonial buildings, selectors' farm equipment, the bushrangers' horsemanship and weaponry.

1. Nolan gave one to artist Klaus Friedeberger who visited 'Heide' in the summer of 1946–47; Friedeberger himself had learned the technique, using printing ink and shoe polish on a glass plate, from Erwin Fabian in Sydney.

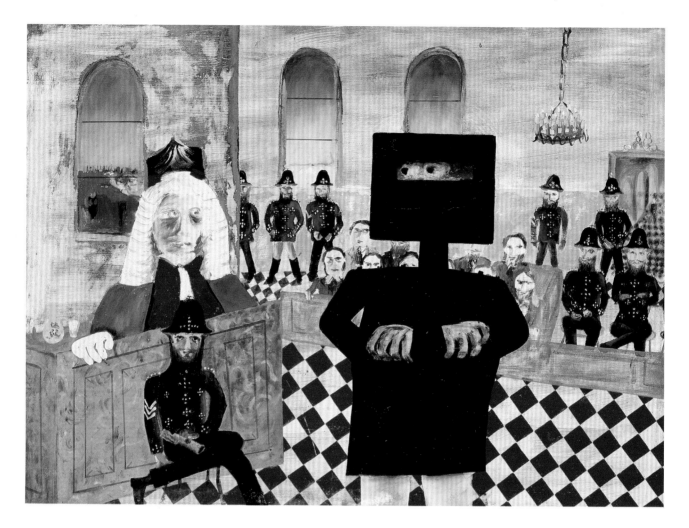

Children and governess, *anonymous watercolour of 1800–10; plate 46 in* American Folk Art, The art of the Common Man in America, *New York, 1932*
Photograph: State Library of Victoria

THE TRIAL 1947
Ripolin enamel on hardboard
90.5 x 121.5 cm
Inscribed verso: 'THE TRIAL/[?]0-1-47'
Australian National Gallery
Gift of Sunday Reed 1977

Provenance: The artist, to Sunday Reed 1948 (M.O.M.A. 1958–65) until 1977

Exhibitions: Velasquez Gallery, Melbourne, April 1948, no.27: 'The trial'; Unesco, Paris, December 1949, no.27; Rome, October 1950, no.27; Gallery of Contemporary Art, Melbourne, June 1956, no.27; M.O.M.A., Melbourne, September–October 1958, no.116; David Jones' Art Gallery, Sydney, February 1959, no.116; Georges' Art Gallery, Melbourne, June–July 1963, no.25; Qantas Gallery, London, June 1964, then Edinburgh, Paris, Sydney, no.25; Tolarno Galleries, St Kilda, November 1967, no.25; Auckland City Art Gallery etc., 1968, no.25; Heide Park and Art Gallery, November 1981–February 1982, no.25

Published as a screenprint in Marlborough Graphics' *Ned Kelly* series, 1971, no.15. Reproduced as a woven tapestry, one example of which is now in the Supreme Court of New South Wales.

'Judge Barry then passed sentence of death, and concluded with the usual formula: "May the Lord have mercy on your soul". Ned Kelly: "Yes, I will meet you there!"'

Edward Kelly, aged twenty-five, was remanded for trial at Beechworth. But with about two thousand sympathizers in the district, the Attorney-General switched the drama to the Melbourne City Court. He appeared before Judge Sir Redmond Barry on 28 and 29 October 1880, charged with the murder of Constable Lonigan. Nolan's depiction captures the irony of the heated exchange between larger-than-life protagonists, as reported word for word in *The Argus* of 30 October. 'A day will come at a bigger court than this when we shall see which is right and which is wrong', Ned cried during the long debate; and he replied to Sir Redmond's 'May the Lord have mercy on your Soul' with 'Yes, I will meet you there'. The whole business was conducted with almost indecent haste, for an important race meeting was about to begin; and, under the laws of the time, the prisoner was not allowed to give evidence on his own behalf. In spite of public meetings and a petition for reprieve with sixty thousand signatures, Kelly was hanged on 11 November. Judge Barry died less than a fortnight later.

TRAVELLING NORTH

The post-war period saw a steady slackening in Australia's cultural tempo—much lamented in the final issue of *Angry Penguins*. The Contemporary Art Society suspended operations in Victoria in 1947. Tucker left for Europe, via Japan; and Nolan felt a need to distance himself from the increasingly claustrophobic atmosphere of his life in Melbourne. Inspired by the Reeds' reports of Queensland and with the aim, initially, of investigating the circumstances of his brother's death, he departed from Essendon aerodrome early in July 1947. Despite 'watching & thinking about planes all these years', he had never flown before. 'Visually it is extraordinary', he wrote to the Reeds from Brisbane, 'In those first three minutes all my previous modes of seeing seemed to undergo real change'. And again: 'It was like being a bird. I can't explain further but it was probably the only kind of experience that is in the world that is pure enough to overcome me. Passing over the Kelly country, Wangaratta, Hume Weir was such an insight into the structure of it that it was almost a regret that Kelly had not been able to see his whole world in one moment.'[1]

He was met at Brisbane airport by Barrie Reid who took him home to stay at 'Chirnside'; introduced him to local artists; and to poets Charles Osborne—'a young actor & producer', Mary Christina St John, Judith Wright and her philosopher husband Jack McKinney.[2] Everyone was very friendly: 'stop & talk in the sun for as long as you like', he wrote. He sat in the botanical gardens—'the sun is making me a lotus-eater'. At the School of Arts in Ann Street he found 'everything from old paintings to snakes in bottles'; and working space upstairs in the attic owned by Pam Seeman. He read Captain Cook's *Voyages* at the John Oxley Library: 'Read a good deal about Cook & beginning to feel him connected with all the barrier reef visions & treasures ... Perhaps he isn't really, but there is something moving about his precise descriptions of how he found his way through all the coral.'[3] And then he discovered the history of Mrs Eliza Fraser as recounted in the *Shipwreck of the Stirling Castle*, London, 1838.

Unlike Cook, James Fraser did not make it through the reef. His 350-ton brig met her fate off the coast of Great Sandy Island—as the largest sand island in the world was then known. The unfortunate Scottish sea-captain was speared by hostile Aborigines, and his wife Eliza condemned to 'slavery'. Mrs Fraser's sole white companion was an escaped convict named David Bracefell. Eventually, Nolan read, this strangely matched pair fled together to the mainland: she promising to plead for his pardon if he would help her back to civilization. They spent months together in the jungle. Finally, however, just as they approached salvation, Mrs Fraser's Victorian scruples suddenly increased in proportion to the obvious reduction of her wardrobe. Bracefell was betrayed: although he did escape back into the bush. Eliza returned to England to exhibit herself and relate her 'dreadful unparalleled sufferings' to the public—at sixpence admission—in a tent in London's Hyde Park.

Nolan had first heard about Fraser Island from Tom Harrisson, a former British army major, sociologist, ornithologist, writer and visitor at 'Heide'.[5] Harrisson had trained parachute commandos there during the war; but it was the extraordinary landscape and the bird life which he spoke of afterwards. Soon Nolan was absolutely determined to explore the island himself. Cruising up the Queensland coast to Maryborough and Bundaberg in July, he viewed it from the decks of the *Bingera*. Eventually he obtained permission for himself and Reid to visit; and organized their passage on an ancient sea-going barge. 'Hired hands or paying passengers? I never knew', says Reid, 'Nolan had been, as usual, mysterious, laconic and efficient in his dealings with officialdom'.[6] They stayed several weeks. Most of the island was a Forestry Commission reserve and they were made very welcome by the timber gangers. Almost nothing had changed since the wreck of the *Stirling Castle* a century before. Thick stands of trees rose from the white sand. Clear freshwater streams flowed from the interior down to the sea and, in the south of the island, into large lakes which were bluer than the sky. Nolan sketched, 'painted a fair bit there & didn't write much', he says; and took notes and photographs of wildflowers and birds unlike anything he had seen before.

And everywhere in this landscape the historical actuality of Mrs Fraser—naked in the mangrove swamps, merging into the rainforest—became a living focus for his imagination.

1. Wednesday, 9 July 1947; 14 July 1947. At Mascot Airport *en route* he was met by Joy Hester and Gray Smith who had also left 'Heide' and were living in Sydney.

2. He was fascinated by Judith Wright; admiring especially 'the topical images that had such an impact' in her early poems—which were often read at 'Heide' (letter of 20 July 1947, Tamborine).

3. 17 July 1947, Brisbane. As an habitué of the Oxley Library, Reid had introduced Nolan to its rich holdings of historical Australiana—'a smaller version of Sydney's famous Mitchell'.

4. Nolan's principal sources for the true story and subsequent legend of Mrs Fraser were John Curtis, *Shipwreck of the Stirling Castle, containing a faithful narration of the dreadful sufferings of the crew, and the cruel murder of Captain Fraser by the savages. Also, the horrible barbarity of the cannibals inflicted upon the captain's widow, whose unparallelled sufferings are stated by herself, and corroborated by other survivors..., Embellished with engravings, portraits and scenes illustrative of the narrative*, George Virtue, London, 1838; Henry Stuart Russell, *Genesis of Queensland*, Sydney, 1888; and Robert Gibbings, *John Graham: Convict*, J.M. Dent & Sons, London, 1937. Captain Cook had named the land mass 'Sandy Cape' in 1802; Flinders showed it to be an island; *Stirling Castle* was wrecked on Swain Reef in May 1836.

5. Conversation with the author, June 1986. Thomas Harnett Harrisson, joint originator with Charles Madge of mass observation, had written several books including *Savage Civilisation* (Victor Gollancz, London, 1937) and contributed to *Angry Penguins*; he purchased one of Nolan's Wimmera paintings in 1943.

6. Reid, op.cit., p.447.

FRASER ISLAND [1947] ▷
Ripolin enamel on hardboard
77.4 x 105.4 cm
Inscribed l.r.: 'N'
Private collection

Provenance: Judith Wright, Queensland,
March 1948–c.1960; Johnstone Gallery,
Brisbane; Charles Osborne, London;
Bryan Robertson, London, until 1967;
Marlborough Fine Art, London;
private collection, London
Exhibitions: Moreton Galleries,
Brisbane, February 1948, no.8:
'Island—30 gns'

'I have modelled him on a timber cutter
I knew on the island: a man with a
wonderful beard, and strong spread-
ing toes that curled around things with
a grip like a flying fox's.'
- Nolan, interviewed in June 1957

The experience of Fraser Island worked
on two levels, as it were, in Nolan's
imagination. In his eyes the figure of a
Forestry Commission ganger emerging
from the tropical sea in 1947 was also that
of David Bracefell—free, for the moment,
of his striped convict garb and indeed all
the trappings of 'civilization'—as seen by
Eliza Fraser a century before. As Barrie
Reid recalls, 'Norm, the foreman, was
huge; his feet never used boots, he
walked like a cat ... Most days Nolan
went out with the foresters and most
nights yarned with Norm till the early
hours ... I wondered what Norm would
make of the paintings which were slowly
getting under way in the "studio". He
knew the island like no one else and
knew it with laconic but fierce posses-
siveness.'[1] When Norm saw the finished
pictures, Reid recalls, he and Nolan
became closer friends than ever.

Nolan had identified with fugitives
and 'outsiders' in the figures of Rimbaud
and Kelly. The story of Bracefell is also
in part, he says, one of betrayal: the
man betrayed by the woman and the
'founding' convict Australian who is
betrayed by the alien English. And it
has a wider significance—the tension
of being of European origin and
conquering or adapting to the
antipodean environment where that
origin becomes largely irrelevant.
'All this kind of thing comes into it',
Nolan has explained, 'I think all these
factors have played their part in the
Australian character'.[2]

Clive Turnbull wrote the catalogue
introduction for an exhibition of twelve
works in Brisbane the following
February.[3] Representatives of the
Queensland press were considerably
less enthusiastic. Elizabeth Webb of the
Courier-Mail, for example, objected to
'Mr Nolan's blatant extremism and what
appears to be deliberate maltreatment
of so much useful and hard-to-come-by
building material (all his "works" are
on masonite)'; and what she termed
'meandering in pictorial experiment'
(18 February 1948). Several readers,
however, replied in the artist's defence.
Among them was Judith Wright, who not
only deplored the journalistic 'provin-
cialism which is a disgrace to Brisbane's
standards of judgement', but also
purchased this painting herself.[4]

1. Reid, 1967, p.447.
2. Radio interview with Colin MacInnes, July 1957.
3. John Cooper, director of the Moreton Galleries,
thinking that Turnbull's catalogue foreword would
not arrive in time, had a second version printed: by
local painter Laurence Collinson, member of the
Miya Studio and founding co-editor of Barjai.
Collinson admired Nolan's fresh spontaneity, 'the
only technique to match his subjects: the primitive
bush land and the wild desolate sea that surrounds
it'; see Overland 26, April 1963, pp.32ff. I am grateful
to Michele Anderson, University of Queensland, for
this information.
4. Courier-Mail, 19 February 1948; and correspon-
dence with the author, December 1986.

MRS FRASER 1947 ▷
Ripolin enamel on hardboard
66.2 x 107 cm
Inscribed l.r.: 'Nolan/1947'
Private collection

Exhibitions: Moreton Galleries, Bris-
bane, February 1948, no.2: as 'Urang
Creek—n.f.s.'; Whitechapel Gallery,
London, June 1957, no.1: 'Mrs Fraser',
illus.; and Arts Council touring exhibi-
tion, no.1; Folkestone, 1970, no.18; Darm-
stadt, 1971, no.13, illus.; Dublin, June
1973, no.21, illus.; Zurich, October 1973,
no.2; Stockholm, 1976, no.17; Folkestone,
1979, no.26; Chester, 1983, no.29, illus.

Nolan's most memorable image of Eliza
Fraser—faceless in pain, or defaced by
cruelty?—is like a snapshot from some
sensational news story. 'There is some-
thing bizarre about a nude with white
skin in the lush darkness of a forest', he
says.[1] She is utterly vulnerable within the
unflinching focus of his oval painted
frame: as though seen through binocu-
lars or down the barrel of a gun. Stripped
of all defences she crouches like an
animal against a native Australian vege-
tation which is more beautiful than any
imaginary jungle painted by Rousseau.
As an image of humanity at its lowest
ebb, Mrs Fraser contrasts dramatically
with the powerful figure of her convict
rescuer in Fraser Island.

1. Vogue, London, June 1957.

LAKE WABBY 1947 ▷
Ripolin enamel on hardboard
77.3 x 106.3 cm
Inscribed l.l.: 'Lake Wabby/Oct.47./N/
Frazer Island./For Sun/Xmas
1947,['48,49/50,60/70' in another hand]/
Nolan'
Heide Park and Art Gallery
Bequest of Sunday and John Reed 1982

Provenance: The artist, to Sunday
Reed 1947

Exhibitions: Moreton Galleries, Bris-
bane, February 1948, no.12: 'Lake
Wabby—n.f.s.'; Selected Works, Heide,
March–May 1982, no.98; Heide II—as it
was, February–March 1983, no.26

'No wonder Harrisson was impressed ...
Ninety miles long and 30 miles wide at
its widest so it covers a lot of country.
Strange coast line, medium sized cliffs
covered in small thick scrub, but the
most impressive part is the way in which
great cliffs of sand make a pattern
against the scrub, particularly at the
top end ... The size of the island has
rather taken me back. You would need
a real expedition of a holiday to cover
it properly.'
- Letter of 30 July 1947

Nolan saw whales and thresher sharks
off the coast of Fraser Island; a coastline
often visible, as here, from the large blue
freshwater lakes which seem almost
suspended in the pristine landscape of
white sand. His Ripolin enamel was the
ideal medium for scrubby vegetation
and the translucent sky, he said; 'In
order to reproduce this light, this very
intense bright light which was flooding
over everything, one had to adopt a
different sort of palette from the conven-
tional oil palette'.[1]

1. Radio interview with Colin MacInnes, July
1957. Other examples of the untouched island
landscape, were included in the 1948 exhibition;
e.g. Platypus Bay and Hervey Bay, now in
private collections.

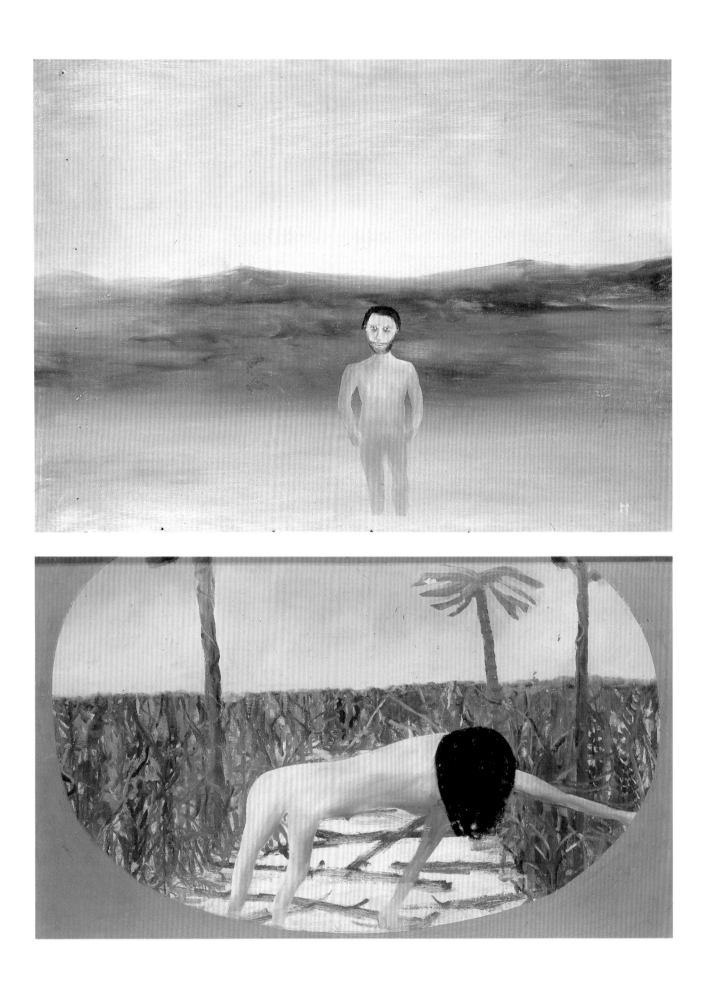

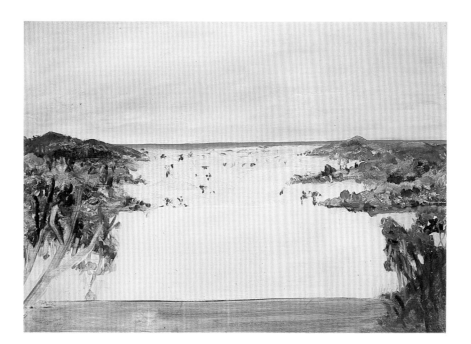

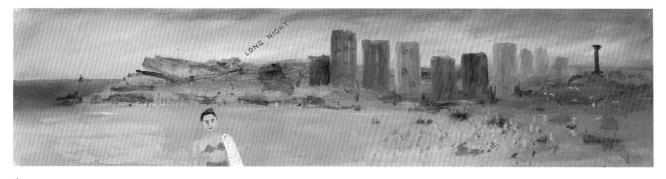

△
BONDI BEACH—'THE LONG NIGHT'
[1947–48]
Ripolin enamel on hardboard
30 x 120.6 cm
Inscribed l.r.: 'N'
u.c.: 'THE LONG NIGHT'
Private collection

Provenance: Gift of the artist to Alannah Coleman, Sydney, 1948; in London until February 1987; Lauraine Diggins, North Caulfield; private collection

This panel is a painterly play on the long horizontal format of Arthur Streeton's Sydney Harbour views of the 1890s.[1] Nolan evidently just cut a piece of his hardboard lengthwise to achieve the desired proportions—which are unique in his oeuvre. It was painted after a trip to Bondi with Joy Hester and Gray Smith on New Year's eve 1947.

Nolan was delighted by the sight of a sky advertisement for the film *The Long Night*—cut-out letters suspended from balloons—gradually sinking down into the sea.[2] The bikini-clad figure in the foreground may well be Joy Hester; or perhaps Cynthia Reed, with whom he had re-established contact on arrival from Queensland. Nolan was soon regarded as quite an extrovert by the local artistic fraternity: 'a real chatterbox when in the right company, with his attractive manners and quiet, pleasant, almost English voice, though he avoided talk about art theory'.[3] He was living not far from Kings Cross, using Alannah Coleman's studio in her absence.[4]

1. At that time Streeton had been camping out with Tom Roberts on the north shore, at Sirius Cove; often working on narrow wooden drapers' boards from inside bolts of cloth, which were the cheapest available painting surface in those depression years.
2. Nolan in conversation with Lauraine Diggins, February 1987; the film, starring Barbara Bel Geddes, Henry Fonda and Vincent Price, was made in 1947.
3. Harris 1960, p.12.
4. Alannah Coleman in conversation with the author, June 1986. The premises at 151 Dowling Street, Woolloomooloo had housed many artists over the years; see Daniel Thomas, *David Strachan 1919–1970*, A.G.N.S.W., Sydney, 1973, p.47.

'ORPHÉE'—DESIGN FOR A DROP
CURTAIN 1948
Collage, gouache, pencil, magazine
illustrations, transfer drawing
25.4 x 30.6 cm
Inscribed u.l.: '"Orphée"/Curtain';
and various dimensions
c.r.: 'Orphée hunts/Eurydice's/lost
life'—in reversed 'mirror' writing
verso: 'Sydney 1949 [*sic*]/SUDS produc-
tion/Sydney University (Sam Hughes)/
Sidney Nolan/1949 [*sic*]/Cynthia/
with love/xx/London/Nov. 56'
Australian National Gallery
Purchased 1987

Provenance: Gift of the artist to Cynthia
Nolan, 1956; Australian Galleries,
Collingwood, 1986

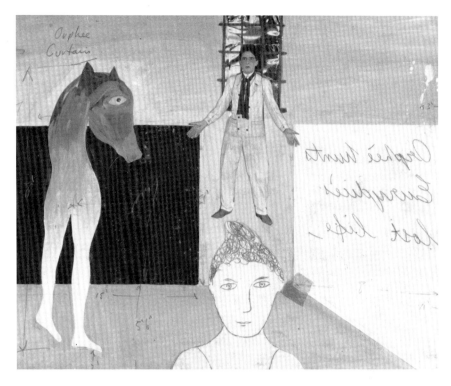

The Sydney University Dramatic Society
presented Jean Cocteau's '*Orphée—
A Tragedy in one Act and an Interval*',
together with Shakespeare's *Pericles,
Prince of Tyre*, in September 1948. The
producer was Sam Hughes; assisted by
Alannah Coleman, who also designed
Madame Death's costume. Jean Bellette
designed the scenery for *Pericles*. Nolan
designed *Orphée* and produced the
programme for both plays: an erudite
publication decorated with beautiful
transfer drawings and a series of illus-
trated advertisements.

Cocteau's Theatre of the Absurd—
of which *Orphée*, written in 1925, is a
masterpiece—combines a dash of Dada
with spoonfuls of Surrealism and Expres-
sionism, mixed liberally with Existen-
tialism. Based on the ancient Greek myth
of Orpheus and Eurydice, as explained
in the programme, it is 'a cerebral crea-
tion, a meditation upon death ... No
element of the theatre is forced into
unwarranted place of prominence or
obscurity. The scenery resumes its
active role. Naturalism goes by the
board: it is not a question of living on
the stage but of making the stage live ...
This reality of the theatre is the poetry of
the theatre and is truer than truth.'

The setting is 'Thrace—A room
in Orphée's villa'—at night in broad
daylight. Cocteau might have been
speaking for Nolan himself when he
said, 'My discipline consists in not letting
myself be enslaved by obsolete
formulae'. Unfortunately Nolan felt that
'the plays were not quite as good as they
should have been. "Orphée" came out
best, I think, with a genuine germ of
something. Played it more in mime
than Cocteau would have liked, but I
preferred it [that] way since there is little
hope here, with such players, of realizing
the brittle, witty & somewhat biting acting
that Cocteau would bring it.'[1] Even in
translation, it was a most ambitious
undertaking. Nolan's décor must have
gone a long way towards evoking a
surreal ambiance. As Cocteau asked—
quoted in the programme—'What is
style? For many people, a complicated
way of saying very simple things.
Whereas for us, a very simple way of
saying very complicated things.'

1. Letter to Barrie Reid, written on the back of
a transfer drawing of a robber, Wahroonga,
25 September 1948; Nolan continues: 'Waiting
for an Aussie one. If somebody does not come
forward I am going to write the "Miracle of the
Dog and Duck Hotel". Maybe!'

OUTBACK

Nolan's break with Melbourne was complete, as he explained to Tucker in April 1948: 'My life seems to have moved away from Melb. permanently. There has been a lot of upset ... I went down to Heide with Cynthia the day after we were married but came back the same day.'[1] In June that year he set off with his new family on a remarkable journey to some of the most remote parts of Australia. They travelled by road, rail, air and sea: inland across New South Wales to Adelaide, north through the 'dead heart' to Borrooloola and Darwin, then down the coast of Western Australia via Hall's Creek, Derby, Broome, Geraldton and Perth; and back to Sydney.

'This was the land of some of the most heroic explorers', Cynthia Nolan wrote in her notebook journal of the expedition, 'Of John Eyre who came here in 1840 expecting to find good pastureland, only to escape narrowly with his life; of Sturt whose eyesight failed through the privations of his several journeys'.[2] Flying low over the Musgrave Ranges, out to Ayer's Rock, 'Sidney gazed with his mouth open and his tongue pushed between his teeth, as he does when painting with the greatest intensity'. At Tennant Creek hawks swooped belligerently at him; 'he was both tremendously excited and repelled by the wind, desolation and phenomenal light'. All that he saw, noted and photographed was 'deeply absorbed and stored away to be thought about, to work within him', Cynthia wrote, 'until, enlivened by his own vision, paintings executed with fiery speed, savage scrubbing, tender delicacy and penetrating wit would eventually confront entranced or outraged spectators'.[3]

Some of the results of this outback trek, together with memories of his north Queensland odyssey the year before, were exhibited most successfully at the David Jones' Art Gallery, Sydney, in March 1949. Others appeared at Macquarie Galleries and with the Contemporary Art Society, or were entered in the Wynne Prize for landscape painting at the Art Gallery of New South Wales. Harry Tatlock Miller wrote a glowing report for *The Sun*:

> His first exhibition of Queensland outback paintings makes an amazing impact and leaves an indelible impression ... a sense of vast space—still, silent and everlasting. Time itself is arrested. A strange bird stands poised in the pink sky. A convict, escaping into desolation, pauses, listens. An old man sits in the sun.
>
> These pictures remain in the mind persistently flavouring the following hours, as a night's dream will haunt and colour the ordinary day ... *Mr Huggard* had a store. They dug the Pretty Polly Mine ... It was rough, ready and raw.[4]

There were deserted mines, old hotels, derelict farm machinery, swagmen 'on the wallaby track', birds and native flowers. In particular Nolan was exploring a theme of human presence in the Australian landscape: 'a continuity of experience from my own time back to the beginnings of settlement here. It is a thing I have struggled to see and perhaps for the first time have felt.'[5] As he wrote to Tucker, once 'our own tradition ... [is] fully exposed to the daylight ... we can reach out to find what are our real focal points'.[6]

Nolan's first exhibited painting of the explorers Burke and Wills is dated 1948.[7] He had researched his subject thoroughly—as usual—reading the explorers' own diaries and *Dig: a drama of Central Australia* by Frank Clune. He studied sepia photographs and engravings of Melbourne at the time; and portraits of the doomed explorers. The tragedy of Burke and Wills first formed in his mind as a series of images for paintings when he traversed the 'dead heart' of the outback himself. 'I doubt that I will ever forget my emotions when first flying over Central Australia', he says, 'and realizing how much we painters and poets owe to our predecessors the explorers, with their frail bodies and superb will-power'.[8] The resultant paintings are absolutely his own creation; not simple illustrations of past events but *imaginings* of historical reality.

Tatlock Miller observed considerable stylistic variety in Nolan's work: 'and at times one wants less haste, less "bigness" ... Perhaps for Nolan the vision would fade were it not so quickly noted'. And yet, he continued, 'Nolan tells us of Australia as no other artist has before him, and entirely after his own fashion'.[9] Sometimes the vegetation is

scribbled over bare Masonite which becomes the sunburnt earth—for example, in *Abandoned mine*. In other pictures, the reverse occurs: the background is thickly painted with Ripolin, with spaces left for trees, buildings and figures to be brushed in lightly upon the unprimed hardboard surface. Broad handling alternates with more concentrated and compressed notation. Certain of the stiffly posed and wiry-legged birds appear to be direct descendants of those specimens in early colonial ornithology by Gould or Watling—crossbred, of course, with Nolan's wit. He was working on 'a series of large paintings of imaginary birds' when Sir Kenneth Clark came to his studio; and later he assured Colin MacInnes that Australian birds 'fly, perversely, upside-down ... when the wind howls in the wastes they often find they have to'![10]

Nolan's local reputation was much enhanced by the reception of his Ned Kelly paintings in Paris in December 1949. The Art Gallery of New South Wales had recently purchased two of his outback landscapes. Critics noticed 'innumerable enormous exercises in the style of Sidney Nolan' at the C.A.S.—no longer 'a daemonical demonstration of revolutionary art'. And although Haefliger had warned in *The Sydney Morning Herald* that 'An Ecole Nolan leaves little for the follower', his counterpart at *The Sun* declared: 'Nolan may well prove himself indispensable to the art of this country'.[11]

1. Letter to Tucker, 19 April 1948; quoted in Haese 1981, p.294.

2. She worked her detailed notes into a book later in 1949, eventually published as *Outback* in 1962, p.22. Alan Moorehead's *Cooper's Creek* of 1963, the best account of the Burke and Wills expedition, also documents earlier forays by Charles Sturt, John McDouall Stuart and others; the book was written at Nolan's suggestion.

3. ibid., pp.31, 57.

4. *The Sun*, 8 March 1949; Tatlock Miller knew Nolan in Melbourne in the 1930s. The chairman of David Jones, amateur painter and collector Sir Charles Lloyd Jones, was one of Nolan's early patrons.

5. To John Reed, from Brisbane, 18 September 1947.

6. 19 January 1948, quoted in Haese 1981, p.270.

7. *Burke and Wills Expedition*, now in the Nolan Gallery at 'Lanyon'; Gilchrist 1985, pp.30,39. An interesting painting of two explorers and a camel in sunset-coloured desert, dated 1945, remains in the artist's possession; he also wrote poems about Cooper's Creek and the German explorer Ludwig Leichardt at about that time.

8. Letter to Geoffrey Dutton; quoted in Dutton 1967, p.459.

9. loc. cit.; he had also reviewed the C.A.S. exhibition in *The Sun*, 8 November 1948.

10. MacInnes et al. 1961, p.20. Although living in London, MacInnes had grown up in Australia—and should have known better. An early ornithological painting is reproduced in Smith 1945, pl.2.

11. *The Bulletin*, 19 October 1949; *The Sydney Morning Herald*, 6 November 1948 and 12 September 1949; Carl Plate's 'picture of the yellow wings of a white cockatoo above a yellow landscape' was singled out as particularly derivative. Tatlock Miller in *The Sun*, 8 March 1949.

◁ DESERT BIRD 1948
Ripolin enamel on hardboard
90.2 x 120.7 cm
Inscribed l.r.: '23-6-48/Nolan'
Private collection

Provenance: Purchased 1949 from Macquarie Galleries, Sydney, by the present owner's father

Exhibitions: *Christmas Exhibition*, Macquarie Galleries, Sydney, 1–24 December 1948, no.19: 'Desert Bird—35 gns'

'Sidney Nolan's taste for the spectacular is demonstrated at ... Sydney's Macquarie Galleries by his *Desert Bird*, a large painting of a blood-red sky, desert and swamp joining in blue, red and green, and a bird, a weird and wonderful and beautifully comic creature, leaping right across the picture, feet up and head thrown back like a broad-jumper, and wearing an expression of absurd solemnity.

 The picture is colorful, bizarre and humorous—all qualities of Nolan's usual work. It is a welcome relief to most of the other paintings in the exhibition, which have a distinct tendency towards the lugubrious, the thin and the commonplace.'
- *The Bulletin*, Sydney, 8 December 1948

◁ BIRD [1948]
Ripolin enamel on hardboard
122 x 91.5 cm
Inscribed verso: 'PROPERTY OF ARTIST/NOLAN'
The Lord McAlpine of West Green

Provenance: Dr David Sands, Sydney; Mrs E.C. Dyason, London; re-purchased by the artist from her estate; to Lord McAlpine, Broome

Exhibitions: *Queensland Outback Paintings*, David Jones' Art Gallery, Sydney, March 1949, no.8: 'Bird—lent by Dr David Sands'; Whitechapel Gallery, London, 1957, no.7; *Sidney Nolan—Paintings*, Broome Centenary, July–August 1983

'I can remember no other exhibition by a contemporary Australian which, with such seemingly disarming innocence of eye and hand, reveals so much individuality of vision... Creatures of the air, he gaily tells us, flew gaudily, unreal, over desert, swamp, rock and river ... a land which existed at the dawn of history.'
- Harry Tatlock Miller, *The Sun*, Sydney, 8 March 1949

FERN 1948 ▷
Ripolin on enamel on hardboard
121.5 x 91.5 cm
Inscribed l.r.: 'Nolan/48'
Sydney College of Advanced Education

Exhibitions: *Queensland Outback Paintings*, David Jones' Art Gallery, Sydney, March 1949, no.12: 'Fern—30 gns' (purchased by the Registrar, Sydney Teachers' College)

Nolan's curiosity embraced the smallest and most intimate details of the tropical northern landscape. He made many plant studies: photographs, detailed notes and, later, in the studio, paintings such as this herringbone fern (genus *Sticerus*). It may be only coincidental that Mrs Fraser reportedly survived her trials on a diet of 'a kind of Fern Root which we were obliged to procure ourselves in the swamps'.[1] The plant itself is dramatically enlarged in scale; painted sparingly, using the bare hardboard to remarkable effect, and set in a rich background of blue enamel.

1. Her own narrative, quoted in Gibbings, *John Graham: Convict*, London, 1937.

It would seem that the spirit of David Bracefell, roaming the bush in his convict uniform, followed Nolan from Fraser Island to the mainland; for here the great flowering 'kangaroo tail' wands of the blackboys (genus *Zanthorrhoea*) are boldly striped black and white. In *Carron Plains*, 1948 (A.G.N.S.W.), the trunks of the blackboy grass-trees are marked as well—like dreamtime Aboriginal warriors painted for a corroboree.[1] At the very end of 1947 Nolan joined a Royal Geographical Society expedition inland from Cooktown.[2] This was his first taste of the true outback—arid plains sparsely punctuated with windswept vegetation. His high horizon line of scraggy hills in *Blackboys* foreshadows Fred Williams's compositions of the 1960s.

1. Reproduced in Lynn 1979, p.82. See also the *Escaped convict* of 1948, in which the striped figure stands against a group of four matching grass-trees; MacInnes et al. 1961, pl.31. I am grateful to David Albrecht, National Herbarium, for botanical information.
2. Reid 1967, p.452. A painting from this period with comparable background vegetation is *Windy plain (Cape York Peninsula)* in the University of Western Australia collection.

△
BLACKBOYS [1948]
Ripolin enamel on hardboard
122.5 x 92 cm
Private collection

Provenance: Purchased from the David Jones' Art Gallery, 1950—46 guineas; private collection, Sydney

Exhibitions: *Collectors Exhibition*, Challerton Gallery, Castlereagh Street, Sydney, 16 March 1960, no.10: as 'Landscape—kindly lent'

'It takes courage to consider not only the grotesque ugliness and madness, almost always an ingredient in the Australian landscape; but also, what is even more trying, Nolan grappled with the frightening, useless, lost sweetness of the same wild bush, which produces such a tension—quaint and delicate living fossils posing baffling questions from incredibly remote ages of geology and bush silence. Between sweetness and ugliness is a new strangeness in Australia, new to Art, and poses questions never asked before in Art, symbolised by the aboriginal grass-trees' spooky remoteness.'
-Neil Douglas, May 1962

△
LITTLE DOG MINE 1948
Ripolin enamel on hardboard
91.5 x 122 cm
Inscribed l.r.: '1-12-48/Nolan'
The Robert Holmes à Court collection

Provenance: Sir Kenneth (later Lord) Clark, who took the painting to London in 1949; to his son; Marlborough Fine Art, London; to Mr and Mrs Robert Holmes à Court, January 1982

Exhibitions: *Queensland Outback Paintings*, David Jones' Art Gallery, Sydney, March 1949, no.18: 'Little Dog Mine—Lent by Sir Kenneth Clark'; Redfern Gallery, London, January 1951, no.14: 'Little Dog Mine—Lent Sir Kenneth Clark'; Clark loan collection, Arts Council of Great Britain, no.25; Whitechapel Gallery, London, 1957, no.9; and Arts Council touring exhibition, no.3; A.G.N.S.W. etc., 1967, no.46; Folkestone etc., 1970, no.21, illus.

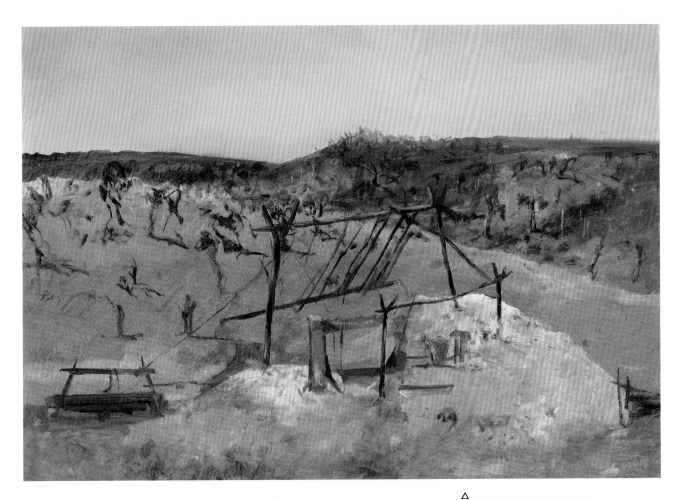

◁ PROSPECTOR 1948
Ripolin enamel on hardboard
91.5 x 122 cm
Inscribed l.r.: '6-7-48/NOLAN'
l.l.: 'NOLAN/48'
verso: 'Prospector 1948'
Private collection

Provenance: Mervyn Horton (founding editor of *Art and Australia*); until Christie's, Sydney, 24 September 1969, lot 77; Lord McAlpine, London; private collection

Exhibitions: *Third Annual Exhibition, Studio of Realist Art*, David Jones' Art Gallery, Sydney, 18–31 August 1948, no.28: 'Prospector—25 gns'; *Exhibition of Pictures by Australian Artists*, University Women's College Building Appeal, Tye's Gallery, Bourke Street, Melbourne, February–March 1949, no.37: 'Prospector—35 gns'; *The Mervyn Horton Collection*, M.O.M.A., Sydney, February 1960, no.20; A.G.N.S.W. etc., 1967, no.41; Stockholm, 1976, no.21; Paris, 1978, no.7; Chester, 1983, no.31

'Sidney Nolan's *Prospector* at the Studio of Realist Art's exhibition at David Jones' Gallery is a large free composition with sunbaked earth and a stretch of blue and sunny sky—something of a rarity at contemporary art shows and a pleasant relief...'
- *The Bulletin*, Sydney, 1 September 1948

Nolan deliberately broadened the public exposure of his work after moving to Sydney: exhibiting not only with the local Contemporary Art Society, but also at Macquarie Galleries and David Jones, with the neo-romantic Sydney Group (formed by Paul Haefliger in 1945) and the Studio of Realist Art. The latter, known as S.O.R.A., was founded after the war to foster figurative 'realist' and 'communal' art.[1] Although *The Bulletin* critic admired the sunbaked, hardboard landscape in Nolan's *Prospector*, he objected for some reason to the figure of the old gold-digger as 'not very Australian'. Certainly the style and overall mood of the work was radically different from earlier tendentious Socialist-realist mining subjects such as Noel Counihan's wartime series of coalminers at Wonthaggi.[2] Nolan felt, however, that his own outback Queensland subjects contained something close to the *origins* of authentic Australian experience.[3]

1. *Angry Penguins*, July 1946, p.1; see Haese 1981, pp. 170ff.
2. Counihan, who intended his work as a tribute to the war effort of the Miners' Union, spent a month with the underground workers at Wonthaggi late in 1944.
3. Letter to Tucker, 6 November 1947, quoted in Haese 1981, p.290.

△
ABANDONED MINE 1948
Ripolin enamel on hardboard
91.5 x 122 cm
Inscribed l.r.: 'Abandoned Mine/2.12.48/Nolan'
verso: 'Landscape/1948'
Private collection

Provenance: Christie's, Melbourne, 1 March 1973, lot 229; Lord McAlpine, London; private collection

Exhibitions: *Wynne Competition for 1948*, A.G.N.S.W., January–March 1949, no.12: 'Abandoned mine'

It was this painting, hanging in the Wynne Prize exhibition, which prompted Sir Kenneth Clark to seek an introduction to Nolan early in 1949. Visiting Sydney as Slade Professor from Oxford University, he was taken to the exhibition to see examples of 'contemporary Australian landscape paintings'; and, he later recalled, 'it was sad to see how the excellent ... painters of the late nineteenth century had exhausted the genre. As I was leaving ... I noticed, hung up high above the entrance stairs, a work of remarkable originality and painter-like qualities. I asked who it was by. "Oh, nobody." "But you must have his name in your catalogue." I said I would like to see some more of his work. "Well, he's not on the telephone." "But you must have his address." More angry scuffling finally

produced an address in a suburb of Sydney. I took a taxi there that afternoon, and found the painter dressed in khaki shorts, at work on a series of large paintings...'

Clark immediately purchased *Little Dog Mine* from the studio in Woniora Avenue, promised to assist if Nolan should ever come to England; and departed—'confident that I had stumbled on a genius'.[1] They remained close friends until Lord Clark's death in 1983.

1. Clark 1977; Clark had been Surveyor of the King's Pictures and director of the London National Gallery 1934–45.

Andrew Carnegie's Birthplace *by John Kane (1860–1934), plate 143 in* Masters of Popular Painting, Modern Primitives of Europe and America, *New York, 1938*
Photograph: State Library of Victoria

△
HUGGARD'S STORE 1948
Ripolin enamel on hardboard
91 x 122 cm
Inscribed l.r.: 'NOLAN/1948'
verso: 'HUGGARDS STORE/1-11-48/ Nolan' (twice)
Collection University of Western Australia
Tom Collins Memorial Fund 1953
Provenance: Purchased from the artist 1953

Exhibitions: *Queensland Outback Paintings*, David Jones' Art Gallery, Sydney, March 1949, no.25: 'Huggard's Store—50 gns'; Whitechapel Gallery, London, 1957, no.22; A.G.N.S.W. etc., 1967, no.43; *Sidney Nolan—Paintings*, Broome Centenary, July–August 1983

'Each Australian township has its hotel and each has its story. Some of the stories are of violence and struggle. One has known a bushranger, the other perhaps an abduction. Lives as well as timbers can be whiteanted and both slowly disintegrate.'
-Nolan, in *The Sunday Sun* colour supplement, 20 February 1949

Nolan's forlorn country hotels and general stores are set like flimsy cardboard cut-outs against blazing Ripolin skies, but they are also monuments to endurance.[1] He first visited remote northern townships like Injune, north of Roma, at the end of 1947; and travelled 'back of Bourke' and

further west with his family the following year. There he found a large part of Australia's 'energy'—a product of the clash between the memories of pioneering settlers and explorers and the impact of the new Australian scene.[2]

Various critics admired 'the stark and desolate reality' of works such as *Huggard's Store*. Comparison was made with Russell Drysdale's desert townships; *The Bulletin* finding 'more breadth and humor' in Nolan's treatments of the theme. As Harry Tatlock Miller put it, he knew how 'to play the basic frivolity of art'.[3] The rather curious format, with Mr H. Huggard's portrait inset like a stamp on an envelope, may well be a memory of an American primitive painting illustrated in a catalogue at 'Heide': a depiction of Andrew Carnegie's birthplace with its bearded proprietor similarly placed.[4]

1. *Agricultural Hotel* or 'The Licensee', *Going to work—Rising Sun Hotel* and *On the Murray*, all from 1948 and also in the Undercroft Gallery collection, University of Western Australia, unfortunately are not available for exhibition. Twelve paintings by Nolan were purchased by the University on the advice of Professor Allan Edwards in 1953; using the Tom Collins Memorial Fund established four years previously by the son of Joseph Furphy, author of *Such is Life*.
2. Letters to Tucker, 6 November 1947 and 19 January 1948; quoted in Haese 1981, p.290.
3. *The Sun*, Sydney, 8 March 1949; see also *The Bulletin*, 17 November 1948. Drysdale's *Cricketers* dates from 1948.

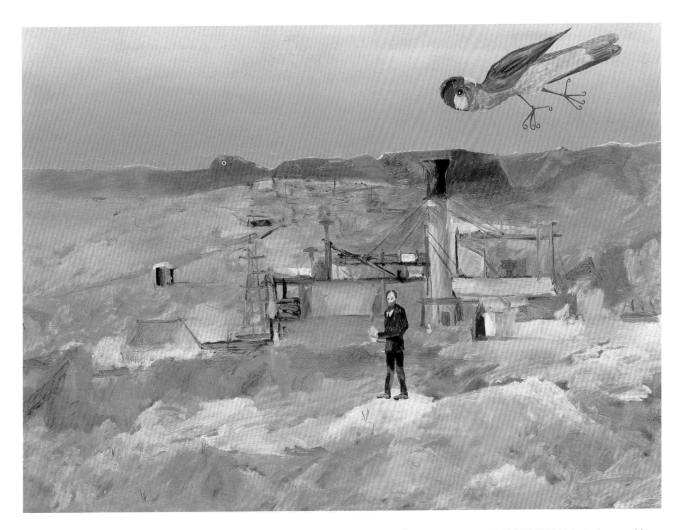

4.*Masters of Popular Painting, Modern Primitives of Europe and America*, Museum of Modern Art, New York, 1938, pl.143, painted by John Kane (1860–1934); this similarity was first noted by Maureen Gilchrist.

△
PRETTY POLLY MINE 1948
Ripolin enamel on hardboard
91 x 122.2 cm
Inscribed l.r.: '4.12.48/21/Nolan'
verso: 'Nolan'
Art Gallery of New South Wales
Purchased 1949

Exhibitions: *Queensland Outback Paintings*, David Jones' Art Gallery, March 1949, no.24: mistitled 'Pretty Molly Mine— 45 gns'; *Gallery Acquisitions for 1949*, A.G.N.S.W., December 1949; *A retrospective exhibition of Australian painting*, A.G.N.S.W., September–October 1953, no.146; Whitechapel Gallery, London, 1957, no.11; A.G.N.S.W. etc., 1967, no.49

In 1948 Tatlock Miller, writing for *The Sun*, had criticized the Sydney Gallery for not acquiring an outback subject by Nolan.[1] The following year when the director, Hal Missingham, spent part of his annual vote of £250 on *Pretty Polly Mine* and *Carron Plains*, the trustees were horrified. 'If I claimed them to be poetic portrayals of the Australian landscape I was sadly misinformed on the true use of the English language', he

discovered.[1] There was a vote of censure, and he was relieved of his power of purchase.

Nevertheless, this first acquisition of Nolan's work by any public gallery was welcomed warmly by most artists and critics. 'Sidney Nolan coaxes us into the spelbound [*sic*] world of his own imagination with such paintings as the delightful *Carron Plains* and *Pretty Polly Mine*. His is a completely personal idiom, as unique as that of le Douanier Rousseau', said James Gleeson.[3] 'Apart from his freshness of outlook, Nolan relies on a minimum of matter to give the maximum effect in the manner of a lyric poet', said *The Sydney Morning Herald* of 20 December 1949. He had actually met an eccentric mine manager at an old mining works near Mount Isa; but his 'poem' takes a decidedly comic twist with its outsized, stuffed-looking 'pretty Polly' floating in the sky. 'And surely more right to be there', as he told Missingham, 'than all those draperies and columns and thrones and over-developed figures in a lot of Italian painting of the Renaissance'.[4]

1. 8 November 1948.
2. *The Sun*, Sydney, 19 December 1949.
3. Quoted in Dutton 1986, p.119. Missingham worked out that when he was appointed, the trustees had a combined age of eight hundred years and a total of 294 years service; they were, of course, appointed for life.
4. Quoted in the introduction to *Sidney Nolan Retrospective Exhibition, Paintings from 1937 to*

1967, A.G.N.S.W., 1967. Nolan's six-year-old stepdaughter, Jinx, is called 'Polly' in Cynthia Nolan's various books on the family's travels, beginning with *Outback*. More recently Nolan has said that the Mt Isa mine manager 'liked feeding birds every morning. Everyone thought he was bonkers, but he fed the birds, rosellas and all'; Lynn 1979, p.78. A very similar figure appears in *Feeding the Birds*, 1948; MacInnes et al. 1961, pl.21.

BROOME—CONTINENTAL HOTEL 1949 ▷
Ripolin enamel and red ochre oil paint on
hardboard
92 x 122 cm
Inscribed l.r.: 'Broome, 1949/Nolan'
The Lord McAlpine of West Green

'We had sent a telegram reserving beds
at the Continental, which now proved to
be a shallow, whitewashed corrugated-
iron hotel built round a square of grass
and shrubs; seagulls perched on the roof
and a fresh wind blew in from the sea.
Our telegram had not arrived and
anyway there was no accommodation.'
-Cynthia Nolan, *Outback*, p.189

Nolan first visited Broome on the north
coast of Western Australia in August
1948. 'This gives me the key to all the
country we've seen', he told his wife,
sitting by the sea with his binoculars. He
has returned often; particularly in recent
years, since his friend Lord McAlpine
has been actively involved in redevelop-
ment of the historic town and its famous
pearl industry.

GOLDFIELDS 1949
Ink and Ripolin enamel on glass
25.4 x 30.5 cm
Inscribed l.l.: 'N/49'
National Gallery of Victoria
Purchased 1949
For exhibition in Melbourne only
Exhibitions: Macquarie Galleries,
Sydney, June 1949

'I did about sixty miniatures on the back
of glass on the Eureka Stockade in 1949. I
read Raffaelo Carboni's book on the
rebellion and I took what he said as
gospel. I did not try to do a large, histor-
ical summing up, but I did it as I read it in
the book. They are, so to speak, one-off
snapshots of each episode and of the
dramatis personae.'
- Nolan, to Elwyn Lynn, April 1978

THE BURNING OF BENTLEY'S HOTEL ▷
1949
Ink and Ripolin enamel on glass
51.3 x 83 cm
Inscribed l.l.: '-49.n.'
verso: 'THE FIRE [deleted]/The Burning
of Bentley's Hotel/30gns/(selected)/
SIDNEY NOLAN'
Mr Derek R. Gascoigne, Perth

Provenance: Mrs M.A. Evatt, Sydney; to
her daughter; sold through Jan Martin,
Castlemaine; Lauraine Diggins, North
Caulfield, August 1986; to The Lord
McAlpine of West Green; to Mr Derek R.
Gascoigne

Exhibitions: *C.A.S.*, Sydney, October–
November 1949, no.110: 'Burning of
Bentley's Hotel—40gns [deleted] N.F.S.';
A.G.N.S.W. etc., 1967, no.51

Nolan had painted on glass as a teenager,
whilst employed by a firm producing
illuminated signs; and on some small
panels at 'Heide'. For the series of 1949,
he worked first with Indian ink on the
reverse of the glass sheets. These draw-
ings—reminiscent of colonial engraved
illustrations—were then painted over in
enamel, again on the reverse, to create a
wonderfully translucent effect.
 Raffaelo Carboni's history of *The
Eureka Stockade*, 1855, had much of the
same attraction for Nolan as Kenneally's
book on the Kellys. It is an idiosyncratic
first-person narrative ranging from exu-
berant rhetoric to sarcasm to disarming
innocence. The red-headed Italian author
was arrested and brought to trial on a
charge of high treason for his part in the
goldminers' rebellion; acquitted and
allowed to leave Australia in 1856. Nolan
exhibited sixty-six small 'episodes' at
Macquarie Galleries in June 1949 and
two large panels at the C.A.S. in October.

◁EUREKA STOCKADE 1949
Ink and Ripolin enamel on glass
50.8 x 82.8 cm
Inscribed l.r.: '49.N'
verso: 'EUREKA STOCKADE/(sub-
mitted)/SABBATH MORNING. December
3rd 1854 [deleted]/40gns/66/SIDNEY
NOLAN'
Mr Derek R. Gascoigne, Perth

Provenance: Mrs M.A. Evatt, Sydney; to
her daughter; sold through Jan Martin,
Castlemaine; Lauraine Diggins, North
Caulfield, August 1986; to The Lord
McAlpine of West Green; to Mr Derek R.
Gascoigne

Exhibitions: *C.A.S.*, Sydney, October–
November 1949, no.109: 'Eureka
Stockade—40gns[deleted]N.F.S.';
A.G.N.S.W. etc., 1967, no.52

Paul Haefliger, writing in *The Sydney Morning Herald*, admired 'Nolan's light-hearted calligraphy casting its whimsical glance at history in *Eureka Stockade* (19 October 1949). These two large-scale panels depict the rebels, led by Peter Lalor, fighting under the 'Eureka Flag of Stars' near Ballarat on 3 December 1854 and the burning of Bentley's Hotel. They were purchased by Mary Alice Evatt, a painter herself and progressive trustee of the Art Gallery of New South Wales since 1943. Her husband, Herbert Vere Evatt, had written the introduction for the first reprint of Carboni's *Eureka Stockade* in 1942.[1] In 1965 the two paintings together provided the composition for Nolan's vast enamelled copper mural at the Reserve Bank, Melbourne.

1. *The Eureka Stockade: the consequence of some pirates wanting on quarterdeck a rebellion, by Carboni Raffaelo*, (Raffaelo Carboni 1817–75), printed for the author by J.P. Atkinson, Melbourne, 1855; republished by Sunnybrook Press, Sydney, 1942, edn of 150 copies; a second reprinted edition came out in 1947. The Evatts were among Nolan's important early patrons; see Dutton 1986 for their involvement with the arts in Sydney.

By the time Melbourne Punch published this ▷
cartoon, the Victorian Royal Society Exploration
Committee's expedition had been on the road
for eighty days: the most elaborate and best
equipped expedition ever set up in Australia.
Robert O'Hara Burke, a thirty-three year old
very Irish ex-policeman from Castlemaine, and
William John Wills, a surveyor aged twenty-five,
were leading a cavalcade of assorted personnel,
twenty-seven camels, twenty-three horses plus
wagons and drays into the 'ghastly blank' of
inland Australia. They aimed to cross the conti-
nent from south to north and plant their flag at
the Gulf of Carpentaria. Newspapers carried
copious reports; and arguments as to the suit-
ability or otherwise of camels for the purpose.
McDouall Stuart, leaving Adelaide around the
same time, favoured horses. Burke's ambitions
were doomed from the start: he was inexperi-
enced, with quarrelsome subordinates, travel-
ling at the worst time of year, overloaded with
the wrong provisions. At Cooper's Creek he
split the expedition and set off for the coast with
only three companions. John King was eventually
rescued—the sole survivor— in July 1861.

The final cost of this 'race' was almost £60,000
and at least six human lives. Even Stanley in
Africa, a mighty spender in that great age of
exploration, had not got through as much money.
And yet, as Alan Moorehead writes in his epic
Cooper's Creek, 'Despite its mismanagement
and its tragic result, the Burke and Wills expedi-
tion was one of those incidents that ... give colour
and movement to an age. It had the quality of a
myth, of a genuine and wholly Australian
legend.'

Painters who have treated the theme include
Dr Ludwig Becker (a member of the original
party), Nicolas Chevalier, S.T. Gill, William
Strutt, John Longstaff and George Lambert. Only
Nolan's images—evolving over more than forty
years—have become an integral part of Aus-
tralia's visual vocabulary: a continuing allegory
of twentieth-century attitudes to human
endeavour and self sacrifice.
Photograph: State Library of Victoria

THE GREAT AUSTRALIAN EXPLORATION RACE.

A race! a race! so great a one
 The world ne'er saw before ;
A race! a race! across this land,
 From south to northern shore!

A race between two colonies!
 Each has a stalwart band
Sent out beyond the settled bounds,
 Into the unknown land.

The one is captain'd by a man
 Already known to fame,
Who with Australian annals has
 For ever linked his name.

The other owns a leader, who
 Has all his bays to earn ;
Let's hope that he, a well-won wreath
 May claim on his return !

The horseman hails from Adelaide,
 The camel rider's ours :—
Now let the steed maintain his speed,
 Against the camel's powers.

No small concealments each from each,
 No shuffling knavish ways,
No petty jealousies and strifes,
 No paltry peddling traits,

Will find a place in such a race,
 But honor, virtue, worth,
And all that can ennoble man
 Will brilliantly shine forth.

A cheer then for each member, and
 A big one for the lot,
For it is known how all have shown
 These virtues.—*Have they not* ?

BURKE AND WILLS EXPEDITION, ▷
'GRAY SICK', 1949
Ripolin enamel and red ochre oil paint on
hardboard
92 x 120 cm
Inscribed l.r.: 'NOLAN/30-11-49'
The Lord McAlpine of West Green

Exhibitions: Redfern Gallery, London
1951, no.2: 'Burke and Wills Expedition,
"Gray Sick"—50gns'; S.H. Ervin Gallery,
Sydney, November 1985–January 1986,
no.2

Although the expedition was ostensibly a
team affair, the various members soon
found themselves voyaging very much
alone on their 'ships of the desert'. Wills
wrote in his journal near the end, 'Nothing
now but the greatest good luck can save
any of us. My pulse is at forty-eight, and
very weak, and my legs and arms are
nearly skin and bone. I can only look out,
like Mr Micawber, for "something to turn
up". I think to live about four or five days.
My spirits are excellent.'

Charles Gray, who had joined them at
Swan Hill, was one of the first to show
symptoms of fatal malnutrition—his 'legs
almost paralysed' with cramp. He was
caught stealing extra rations of flour to
make gruel. Both Burke and Wills
'thought him shamming' when he com-
plained of headaches and dysentery; but
he weakened steadily as they headed
back towards Cooper's Creek from the

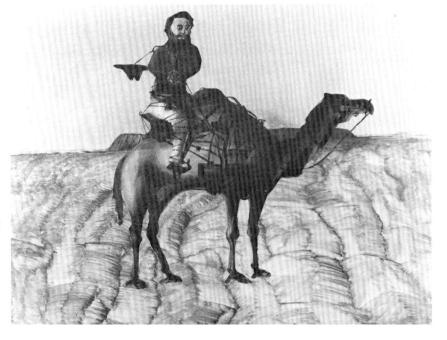

Gulf and finally had to be lashed to the
saddle of his camel. 'He had not spoken
a word distinctly since his first attack',
Wills recorded. He died about sunrise
on the morning of 17 April 1861.

Nolan has made Gray a slightly comic
figure; but poignant in his total isolation.
The landscape of oil-based red ochre,
scrubbed over the primed hardboard

surface with a dry brush, is less substan-
tial than the sheet of blue enamel sky. In
this arid country, the horizon glimmering
in the heat was a delusion and every
claypan reflected a sheen of water which
did not exist.

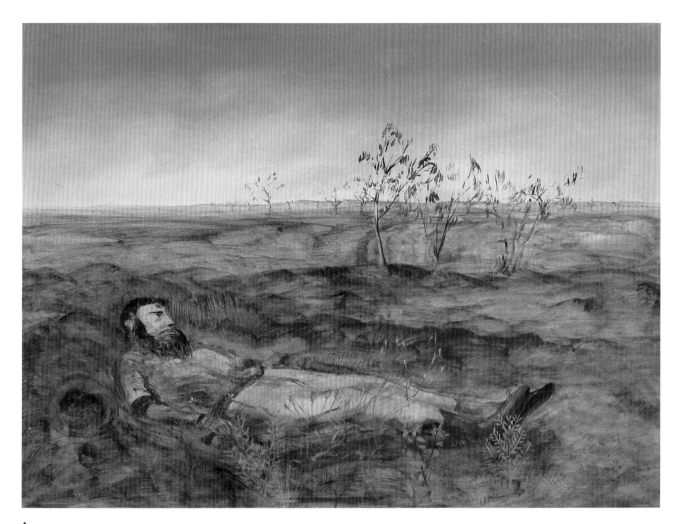

△
PERISHED 1949
Ripolin enamel and red ochre oil paint on
hardboard
91 x 122 cm
Inscribed l.l.: 'NOLAN/49'
l.r.: '31-12-49/Nolan'
verso: 'Perished 31/12/49/Nolan' (twice)
Collection University of Western Aus-
tralia
Tom Collins Memorial Fund 1953

Provenance: Purchased from the artist
1953

Exhibitions: *Sydney Art Today*, Macquarie
Galleries, Sydney, 28 February–10
March 1950, no.29: 'Perished'; *Central
Australian Landscapes*, David Jones' Art
Gallery, Sydney, March–April 1950,
no.14: 'Perished'; *The Australian Land-
scape*, Adelaide Festival of Arts,
A.G.S.A., March 1972, no.40 as 'The
Perish'; and subsequent tour 1972–73,
no.41; *Sir Sidney Nolan—Paintings*,
Broome Centenary, July–August 1983;
S.H. Ervin Gallery, Sydney, November
1985–January 1986, no.3

'I hope you will remain with me here till I
am quite dead—it is a comfort to know
that someone is by; but when I am dying,
it is my wish that you should place the
pistol in my right hand, and that you
leave me unburied as I lie.'
- Burke to John King, 29 June 1861

With the pistol clenched in his
 failing hand,
With the death mist spread o'er his
 fading eyes,
He saw the sun go down on the sand,
And he slept, and never saw it rise...
-Adam Lindsay Gordon (1833–70)

Leaving Cooper's Creek with Wills, King
and Gray on 16 December 1860, Burke
had told the remaining depot party that
he could be considered 'perished' if he
were not back within three months. They
were away more than four months;
returning to the base on 21 April 1861
only to find it deserted. Little did they
know that the others had departed only
nine hours earlier. They headed south-
west, hoping 'to recruit themselves and
the camels', Wills wrote, 'whilst saun-
tering slowly down the creek'. By the
end of June, however, they had eaten the
last of their camels and Burke's horse.
Wills died, leaving his watch and a letter
for his father.

Burke struggled to write some final
entries in his memoranda book: 'I hope
we shall be done justice to. We have
fulfilled our task, but we have been
abandoned. We have not been followed
up as we expected, and the depot party
abandoned their post. R. O'Hara Burke.
Cooper's Creek, June 26th ... King has
behaved nobly. He has stayed with me to
the last, and placed the pistol in my hand,

leaving me lying on the surface as I
wished. R. O'Hara Burke. Cooper's
Creek, June 28th.' As King recounted
later to his rescuers, 'That night he spoke
very little, and the following morning I
found him speechless, or nearly so; and
about eight o'clock he expired'.

Earth and man are Nolan's protago-
nists—'by no means simple antagonists',
as Geoffrey Dutton has observed. Robert
O'Hara Burke (1821–61) will soon be a
part of the landscape he sought to con-
quer. There is a greening on the distant
horizon; life endures in the stoic euca-
lyptus and springs anew in native flowers
already blooming on his lonely grave.

'Cooper's Creek'

As crystals descend
through the evening
so the camels descend
and men descend
in this extraordinary
continent.

As drought destroys
through the earth
so the throat destroys
and thirst destroys
in this extraordinary
continent.

As heat discards
through a heart
so the heart discards
and skin discards
in this extraordinary
continent.

As men vanish
through their eyes
so the bones vanish
transparent
in this extraordinary
continent.

- Unpublished poem by Nolan, mid-1940s

CAMELS, CENTRAL AUSTRALIA 1950 ▷
Ripolin enamel and red ochre oil paint on hardboard
122 x 152 cm
Inscribed l.r.: 'Nolan/1950'
Reserve Bank of Australia

Provenance: Purchased from the artist 1951

Exhibitions: Redfern Gallery, London, January 1951, no.8: 'Camels, Central Australia—125 gns'; A.G.N.S.W. etc., 1967, no.67: 'Camels in a landscape, 1950—Coll. Reserve Bank of Australia, Melbourne'; S.H. Ervin Gallery, Sydney, November 1985–January 1986, no.11

'Sidney became increasingly obsessed by the camels and spent hours watching them and planning big, delicate and detailed paintings... Camels are right, horses and cattle and trucks are anachronisms in this country.'
- Cynthia Nolan, *Outback*, p.152

'On saltbush-mulga country there was no other animal that thrived as well as the camel and none, with exception of kangaroos or emus, that suited the landscape so perfectly.'
- Herbert M. Barker, *Camels and the Outback*, 1964

Extraordinary creatures—alien fauna—able to carry two thousand pounds or pull five tons, camels are central to Nolan's 'Burke and Wills' paintings. Often the men appear superfluous, as though present by accident; sometimes they are not there at all. The camels quietly belong, like permanent rocky outcrops in the desert.

△
CAMELS IN THE DESERT 1951
Ripolin enamel and red ochre oil paint on hardboard
60 x 89 cm
Inscribed l.r.: 'Sidney Nolan 1951'
The Lord McAlpine of West Green

Provenance: Artarmon Public School, 1953–1986; Sotheby's, Melbourne, 30 July 1986, lot 84; Lord McAlpine

One-humped Arabian camels, or dromedaries, were first brought to Australia in 1846. George James Landells, appointed as Burke's second-in-command, imported twenty-four (with sepoys) from Peshawan in June 1860: duly welcomed by the Governor of Victoria at Railway Pier and marched up Swanston and Bourke Streets to Parliament House. Later arrivals were used on the construction of the Overland Telegraph Line, by the police and on Cobb and Co.'s outback mail run. Australia is now the only country in the world where they live wild; and hardy descendants of those early specimens are periodically rounded up for export to the Middle East. This painting was a present from the Nolans to the Artarmon primary school where Jinx was a pupil for two years until their departure to settle in Europe in 1953.

INLAND AUSTRALIA

Sidney Nolan's exhibition of Central Australian landscapes at David Jones' Art Gallery must be regarded as one of the most important events in the history of Australian painting. It is a superb and overwhelming experience, and it may not be too fanciful to imagine that future art historians will date the birth of a predominantly Australian idiom from this exhibition ... Nolan has been able to bring the vision of the poet and a respect for the objective facts of Nature into a single focus.

With the fluency and unerring precision of an artist who paints by instinct, and who has learned by experience to trust these instincts implicitly, he brushes into the pictures the majesty and fantasy of heat-tortured deserts. He makes us feel the oppressive fascination of these stark unpeopled immensities of wind-worn rock and bitter soil. And through them all runs the central theme of grinding heat. The earth is furnace-colored under dried-up skies.

- James Gleeson, 'Landscapes triumph for Aust. artist', *The Sun*, Sydney, 31 March 1950

Nolan had heard first-hand accounts of Central Australia at the age of fourteen from two painters at Prahran Technical College, who told him they had employed the Aboriginal watercolourist Albert Namatjira as a camel-driver.[1] In the early 1940s he saw Russell Drysdale's scorched landscapes littered with carcasses of perished livestock, inspired by the drought of 1940 in the Riverina district of New South Wales.[2] After the war, long distance travel became easier. Photographers such as Axel Poignant trekked the interior, publishing their work in *Walkabout* and similar magazines promulgating 'outbackery' to an urban populace. Flight gave Australians a sense of the vast scale of their island continent.

Inland Australia from the air was a whole new visual challenge for Nolan: 'Looking straight down from the plane gave me that questioning I felt on first seeing the flat Wimmera from the back of a motor truck. In that case the way to paint it was to put flat landscape vertically up the canvas. The position is exactly reversed from the plane. How to solve it I do not know as yet but modern painting has probably been too much in the hands of old-fashioned men ... [This] is vision without philosophy, distortion, primitiveness. [I] should have gone in an aeroplane a long time ago.'[3]

By 1950 he had logged a vast amount of outback travel. His exhibition of forty-seven Central Australian works, mostly 'aerial landscapes', at David Jones in April that year was both a popular and critical success. He called them 'composite impressions' of the country he had flown over.

'When you enter the gallery the blaze of reddish-brown hits you like a ton or two of real red earth', wrote Norman Bartlett in the *Daily Telegraph*: 'You have to take a deep breath and sort out the subtle harmonies of color and the superbly moulded shapes ... And how Sidney Nolan feels about Central Australia! He riots and revels among its fantastic landscapes in pictures which have the glow of heat in them, yet retains the bright clear light of his initial enthusiasm.'[4]

As Nolan has explained, Australian painters may live in cities (like most Australians) and 'might sit it out in other places, but their inner compulsions are towards exploring this place, because it isn't completely explored yet'.[5] Most critics welcomed the 'reality' of the works. 'The only grotesqueness in this show are those offered him by nature', said one. *Dry Jungle* was purchased by the Art Gallery of New South Wales. In Melbourne R.G. (later Lord) Casey declared, 'He may well be the man we have been hoping would arise—someone who is capable of expressing with size and vision what many Australians feel ... about this great and unusual country ... His effort and his intent will earn the gratitude of many devoted Australians.'[6] Others found them *too* real, simply 'documentary' and therefore 'facile': for example, John Bechervaise in a lengthy essay for *Meanjin* and, later, Max Harris in *Nation*.[7]

A number of inland landscapes were included early the following year in Nolan's first London one-man exhibition—at the Redfern Gallery, run by fellow Australian Harry Tatlock Miller.[8] The catalogue also lists explorer and Aboriginal subjects, out-

back townships and paintings on glass. Some English reviewers took him for an ingenuous colonial who held fast to local legends and a quasi-naive style because he simply could not encompass the Old World. As London critic John Russell remarked, for Nolan—an unknown Australian—to hold his own as a painter seemed as remarkable as for Joseph Conrad, a Pole, to write a decent English sentence.[9] His large panoramic *Inland Australia*—a cratered, almost lunar landscape—was nevertheless purchased for the Tate Gallery's permanent collection (although it had already been reserved by Kym Bonython). Drysdale had also recently exhibited outback paintings in London, at Leicester Galleries, as the prestigious art magazine *Apollo* noted in a rather condescending review of Nolan's work.[10] The 'old world' in general, and London in particular, was evidently ready to sit up and take notice of antipodean art.

1. MacInnes et al. 1961,p.38.

2. First exhibited at Macquarie Galleries, Sydney, in 1941. See Lou Klepac, *The Life and Work of Russell Drysdale*, Bay Books, Sydney and London, 1983; also *The Artist and the Desert*, by John Olsen and Sandra McGrath, Bay Books, Sydney and London, 1981.

3. 14 July 1947, from Brisbane; as a boy Nolan had been much impressed by the historic flights of Cobham, Amy Johnston, Kingsford-Smith and others.

4. 7 April 1950, p.8.

5. Radio interview, A.B.C., 22 March 1964.

6. 'Central Australian landscapes', catalogue foreword for Stanley Coe Galleries, Melbourne, July 1950.

7. Bechervaise, 'The Road to Nolan', *Meanjin*, Spring 1950, pp.179ff. Max Harris wrote, somewhat unfairly, 'They were extremely fashionable and sold freely. Nolan churned them out on some kind of aesthetic conveyor-belt' (2 July 1960). Alan McCulloch, also, has said 'it took me years to swallow this photographic pill'; *Meanjin*, December 1961, p.465.

8. The Redfern, in Cork Street, is London's oldest contemporary gallery; founded in 1923 by Rex Nankivell who asked Tatlock Miller to be its director after the war.

9. Introduction to *Sidney Nolan*, exhibition catalogue, Hatton Gallery etc., March 1961; Russell became a close friend when the Nolans settled in London.

10. 'Current shows and comments', *Apollo*, February 1951, p.33.

INLAND AUSTRALIA 1950 ▷
Ripolin enamel and red ochre oil paint on hardboard
121.5 x 152 cm
Inscribed l.r.: '23.3.50/Nolan'
The Trustees of the Tate Gallery, London
Purchased (Knapping Fund) 1951

Provenance: Kym Bonython; relinquished in favour of the Tate Gallery, 1951

Exhibitions: *Central Australian Landscapes*, David Jones' Art Gallery, Sydney, March–April 1950, no.38: 'Inland Australia—150 gns; Redfern Gallery, London, January 1951, no.7: 'Inland Landscape—125gns'; A.G.N.S.W. etc., 1967, no.61

Nolan's exhibition at David Jones in 1950 clearly demonstrated his capability for sustained and concentrated production. This painting, signed only days before the opening at the end of March, was singled out for praise by James Gleeson in *The Sun*.

For all its rocky substance, the forms in the landscape appear to be always moving under the changing light effects. It is not unlike the sea in its windswept immensity; relentless, dynamic and yet peaceful. As Mary Cecil Allen discovered, 'These violently-crumpled mountain faces loom up and disappear on every side. The whole landscape as

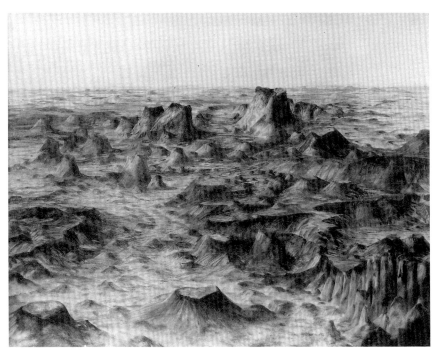

one travels through it has a calligraphic quality as if it were *written* in multi-coloured, two-dimensional shapes.'[1] For Australians, the desert interior seems to be another country. To Europeans, it is another world.

1. 'Notes on Central Australia', *Meanjin*, Spring 1950, p.192.

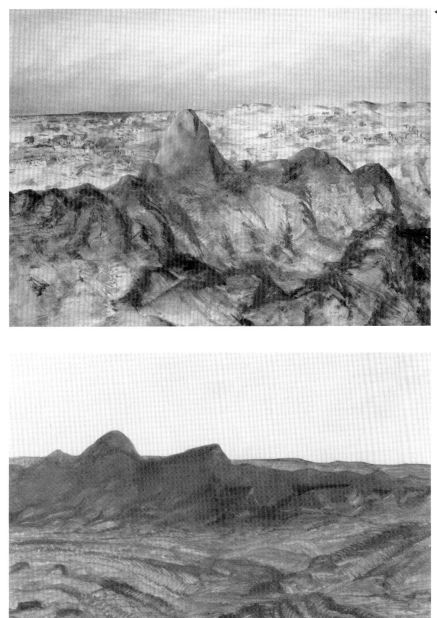

MACDONNELL RANGES 1949
Ripolin enamel and red ochre oil paint
on hardboard
90.1 x 120.3 cm
Inscribed l.l.: 'N'
l.r.: 'Nolan/14.11.49'
Art Gallery of South Australia
Purchased with South Australian
Government Grant 1952

Exhibitions: *Central Australian Land-scapes*, David Jones' Art Gallery, Sydney, March–April 1950, no.28: 'Macdonnell Ranges'; Royal South Australian Society of Arts, Adelaide, May 1952, no.1: 'Macdonnell Ranges—200gns'; *Twelve Australian Artists*, London etc., 1953, no.23 and Venice Biennale, 1954; A.G.N.S.W. etc., 1967, no.53; *Adelaide's Nolans*, A.G.S.A., 1983; S.H. Ervin Gallery, Sydney, November 1985–January 1986, no.5

'It is altogether too simplified a statement to call the Centre the Red Heart of Australia ... From an aeroplane the colours are like a rainbow beginning with bright cobalt blue at the horizon changing from purple to the most brilliant pink and at last to orange ... There are whites of every kind: green-whites, pink-whites and grey-whites. There are gaps in the Macdonnell Ranges where the sides of the cliffs and the huge fallen boulders are like palest malachite, coral and amethyst. Here is a world of deep space yet of two-dimensional forms ... Light is everywhere, reflecting from one shape to another so that the European ideas of solidity expressed in light and shade no longer hold good.'
- Mary Cecil Allen, 'Notes on Central Australia', *Meanjin*, Spring 1950

The Macdonnell Ranges, west of Alice Springs, were originally the southern part of a massive upfold fifteen million years ago and were then 3–4,500 metres high. Composed of sandstone shales, conglomerates and limestone, the whole area has been eroded by wind and dissected by rivers which flow strongly after the occasional rains. Only the most resistant rock remains.

MUSGRAVE RANGES 1949
Ripolin enamel and red ochre oil paint
on hardboard
76.8 x 121.9 cm
Inscribed l.r.: 'Nolan/49'
National Gallery of Victoria
Allan R. Henderson Bequest 1956

Provenance: Allan R. Henderson, Melbourne, 1950–56

Exhibitions: Possibly *Central Australian Landscapes*, David Jones' Art Gallery, Sydney, March–April 1950, no.3: 'Musgrave Ranges—40 gns'; Stanley Coe Galleries, Melbourne, July 1950, no.2: 'Musgrave Ranges—45 gns'; *Four Arts in Australia*, Malaysia etc., 1962: as 'The Musgrave Range'

Nolan's aerial perspective in this series gave the outback a sense of scale that no painter had attempted before. As exhibited in 1950, many of the pictures shared a common horizon line. They evoke the sensation, of which he had spoken in 1948, that the landscape was as old as Genesis; with its eroded bony mountains and peculiarly Australian confrontation with the sky. The apparently arbitrary termination of this space by the picture frame, due in part to the precedent of aerial photography, in fact enhances the feeling of infinite isolation. The hand of man is nowhere visible.

Artist John Brack has described Nolan's painting procedure in *Musgrave Ranges* as 'a curious inversion ... essentially that of a watercolourist'. The white priming under-coat shows through translucent thinly painted hills and valleys—worked with a semi-dry bristle brush and some finger-painting. 'The light blue implacable looking sky, on the other hand, in order to be tonally correct, has had to be painted opaquely'. Some overpainting has been done on the mountains, resulting in an odd effect of 'mist' which seems to detach itself from the higher peaks.[1]

1. Brack 1968, p.27.

MAGPIE 1950 ▷
Ripolin enamel and oil on hardboard
121.5 x 60 cm
Inscribed l.r.: 'Nolan/July 1950'
The Lord McAlpine of West Green

Provenance: Australian Galleries, Collingwood; L. Voss Smith, until April 1962; *Paintings from the famous Voss Smith collection of Melbourne and notable paintings from other sources, arranged by the Terry Clune Galleries, Kings Cross,* Geoff K. Gray, Sydney, 14–15 November 1962, lot 51: as 'Landscape with bird'; probably Leonard Joel, Melbourne, March 1964; to Dr John Kenny, Melbourne, until Leonard Joel, Melbourne, April 1985, lot 1370; Lord McAlpine

Exhibitions: 'Yamba', St Kilda, October 1965, no.53: as 'Landscape with magpie, 1950'; Brighton Historical Society, October 1967, no.35: 'Landscape with Magpie, 1950—loaned by John Kenny, Brighton'

△
ANGEL OVER ELY 1950
Ink and enamel on glass
29.3 x 24.2 cm
Inscribed l.r.: 'N/9.10.50'
Private collection
For exhibition in Melbourne only

Provenance: Purchased by the present owner's father in 1952—10 gns

Ely Cathedral is situated only a few miles from Cambridge, where Nolan spent the winter of 1950–51. A second version of this work remains in his family's possession.

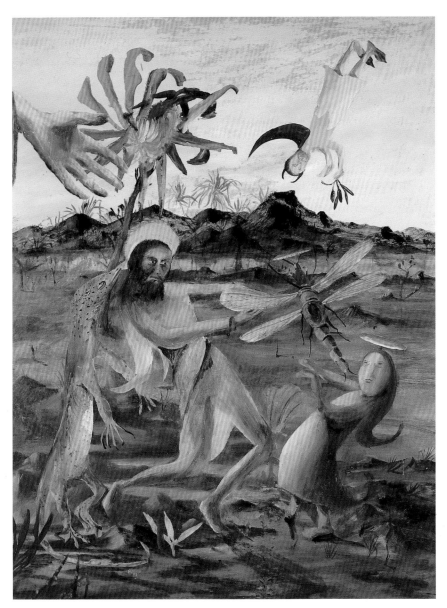

St Anthony of Egypt (Anthony the Great or Anthony Abbot, c.A.D.251–356) is generally regarded as the founder of monasticism. Born near Memphis in Upper Egypt, at the age of twenty he sold all his possessions and retired to a life of solitude in the desert. Despite—or perhaps because of—prolonged fasts, a hair shirt and severe penances, St Anthony suffered great temptations. The devil often put lewd thoughts into his mind by appearing as a beautiful woman. Devils disguised as savage beasts were also frequent visitors. Nolan's version of the Egyptian desert is curiously antipodean: a vast raw and archetypal 'wilderness' for the unfortunate hermit.[3] His devil flies like the parrot in *Pretty Polly Mine*; not only floating in the sky but upon the surface of the painting itself. Joining the saintly dance are a gigantic, menacing insect and goanna-lizard—both creatures reminiscent of motifs used by Boyd. The sustaining 'hand of God', reaching in from infinity on the left side of the picture-frame, also appears in Nolan's *Dream of Jacob*.[4]

1. As early as 1943, in the Wimmera, he had essayed as a 'secret performance' the Old Testament story of 'the angel wrestling and Jacob's foot disappearing out of the canvas and the world reflected in a stream' (*Genesis* ch.32), letter of December 1943; present whereabouts of that painting unknown. The 'Ern Malley' inscription on the reverse of *St Anthony* was added at the time of his renewed interest in the poems in the early 1970s.
2. Philipp 1968, cat.6.6, pl. XXII; see also *Renaissance References in Australian Art*, exhibition catalogue, University Gallery, The University of Melbourne, 1985. Albert Tucker, too, was studying the Bible and painting religious subjects in Italy in 1952.
3. Comparable backgrounds occur in his *St Francis receiving the Stigmata* and *The Flight into Egypt*, both of 1951, and *Annunciation*, c.1951.
4. MacInnes et al. 1961, pl.29 (incorrectly dated); at Christie's, Melbourne, April 1976, lot 529, illus., dated by the artist 1951 and 1953.

△
TEMPTATION OF ST ANTHONY 1952
Ripolin enamel on hardboard
122 x 96.5 cm
Inscribed l.l.: 'Nolan/52'
verso: 'Property/No 5 Mrs Edward Dyason/NOT FOR SALE London/Temptation/of St Anthony/Bought from/Estate/Cy...[illeg.]...an/1964/Young Prince EM/of Tyre/He the dark hero/Moistens his finger in iguana's/blood/1952 ADELAIDE'
Art Gallery of South Australia
Loaned anonymously

Provenance: Mrs E.C. Dyason, London; Mrs Cynthia Nolan

Exhibitions: *Macquarie Galleries Exhibition, Sydney Painting 1952*, Victorian Artists' Society, Melbourne, 11–21 June 1952, no.38: 'Temptation of St Anthony'; *Blake Religious Exhibition*, Mark Foys Gallery, Sydney, 9–30 April 1953, no.56; Whitechapel Gallery, London, 1957, no.46

'Nolan was certainly very conscious ... while in Italy, of the pagan-Christian duality of its culture (as indeed of all 'Christian' cultures); and tried, so to speak, to paint the spirit without denying the splendid validity of the flesh which the spirit must, in part at any rate, reject'.
- Colin MacInnes, 1961

After his first tour of Italy, Nolan painted several biblical and Christian subjects—linking his work decisively thereby with mainstream Western artistic tradition.[1] Probably the best known pictorial treatments of the 'Temptation of St Anthony' are those of Hieronymous Bosch and Matthias Grunëwald. It was a favourite theme of sixteenth-century mannerist painters; and, later, of expressionists such as James Ensor.[2] Amongst Nolan's contemporaries, Arthur Boyd and Perceval in particular produced religious paintings and made reference to Renaissance iconography. Boyd had painted a large suite of ceramic tiles with the 'Temptation of St Anthony' in 1951.[2]

△
ITALIAN STATUE c.1950–51
Ink and enamel on glass
30 x 25 cm
Inscribed l.r.: 'N'
The Lord McAlpine of West Green

Exhibitions: Probably Redfern Gallery, London, January 1951, one of nos 28–33: 'Antique Theme' I–VI

Nolan included a number of small glass paintings based on his Mediterranean travels in his first London exhibition.

CARCASS 1953 ▷
Ripolin enamel on hardboard
90.8 x 121.3 cm
Inscribed l.r.: 'NOLAN/1953'
Nolan Gallery, 'Lanyon',
Department of Territories
Gift of the artist 1974
For exhibition in Melbourne only

Exhibitions: *Drought Paintings*, Peter
Bray Gallery, Melbourne, June 1953,
no.29: 'Carcase'—100gns; David Jones'
Art Gallery, Sydney, July 1953, no.10:
'Carcass'; *Twelve Australian Artists*,
London etc., 1953, no.25 or 26: as
'Drought' and Venice Biennale, 1954;
Whitechapel Gallery, London, 1957,
no.47; A.G.N.S.W. etc., 1967, no.70; Darm-
stadt, 1971, no.21, illus.; Dublin, 1973,
no.29, illus.; Stockholm, 1976, no.26;
Nolan at Lanyon, 1975, no.23; *Aspects of
Australian Figurative Painting 1942–1962:
Dreams, Fears and Desires*, S.H. Ervin
Gallery, Sydney, 1984, no.58

'He sees miraculous harmonies in the
most unlikely places—in the disintegra-
tion of an animal's carcass, in the col-
lapsing architecture of their bones ...
He sees as though he were perennially
delivered from blindness and in the
intoxication of seeing for the first time
sees more deeply and more truly than the
rest of us, where eyes have been drugged
into insensitivity by constant use.'
- James Gleeson, 'Paintings of drought by Sidney
Nolan', *The Sun*, Sydney, 29 July 1953

By August 1952 an estimated 1,250,000
head of cattle had died in Queensland
and the Northern Territory after two
years without rain: the worst drought in
recorded history. Commissioned by the
Brisbane *Courier-Mail* to make drawings
of this devastation, Nolan lost count of
dried up corpses by the road—with
twisted bones, decaying ligaments and
hides stretched like drumskins in the
heat.[1] He followed the 'Murranji' cattle
track from the Victoria River country to
Newcastle Waters and then the Barkly
stock route eastward into Queensland.
Early in 1953 he travelled the 'Birdsville
Track'—from Maree, South Australia, to
Birdsville in Queensland. Besides making
drawings from memory of what he saw
on these journeys, Nolan took many
photographs of animal carcasses stilled
in their death throes like ghastly sculp-
tures. (He had also been moved by the
petrified bodies of dogs and human
beings in the museum at Pompeii.)
 Paintings on the theme were exhibited
in Melbourne and Sydney in 1953, dra-
matically dispelling any notion of the
artist as a charmer or facile decorator.
He made no attempt to soften the horror
by adding outback landscape back-
grounds. In this example, however, the
agonized cadaver seems already to be
merging with the earth; 'I wanted some

*Nolan's photographs show the macabre, corpse-
littered landscape he drove through in 1952: in
contrast the paintings are gentle and tender, in a
range of browns and soft hues of pinkish red.
Photograph: The artist*

indication that life might haunt the van-
ished bones', he explained. Although the
'canvas-crowding image' is thrust before
the eye without embellishment, the vio-
lence has receded long since 'and we
are left with the pathetic, mutely eloquent
remains'.[2] The paintings were exhibited
as though floating some inches away
from the wall—suspended from a beam
about four metres above the gallery
floor—so as to evoke a sense of space
and heighten the insubstantial, almost
weightless quality of their dessicated
subjects.[3]

1. In 1944 Drysdale had been commissioned by
The Sydney Morning Herald to record drought-
stricken western New South Wales. Other artists
moved by this dire symbol of the Australian
desert include Boyd, Clifton Pugh and Jon
Molvig.
2. Bryan Robertson, in MacInnes et al. 1961,
p.104. See also Lynn 1963, p.20; 1967, p.35;
1979, p.116.
3. A newspaper photograph of the installation
(*Sydney Morning Herald*, 30 July 1953) is repro-
duced in Adams 1987, p.125.

△
BURNT CARCASS 1952
Ink on paper
32.2 x 25 cm
Inscribed l.c.: 'N'
verso: 'No 12/BURNT CARCASS/
Sidney Nolan/52'
Private collection, Melbourne

Exhibitions: *Drought Paintings*, Peter
Bray Gallery, Melbourne, June 1953,
no.12: 'Burnt Carcass—6 gns'

EUROPE AND AMERICA

I've changed... The young-thing that one paints out of, when one's energy is
directed to altering and shaping the world around one, that has changed. Now I
know that in future the world around, life, experience, whatever it is, will shape
my paintings.

<div align="center">- Nolan in New York, 1958</div>

You are completely vulnerable before the things that the eyes see. Even with my
strong Australian background when I came to European scenes it was inevitable
that the pitch would be different.

<div align="center">- Nolan in London, September 1960</div>

Nolan has returned over and over again to the theme of Ned Kelly; and considers all
the paintings, 'small or large, early or late, indivisible like *Finnegan's Wake*'. Indeed
that 'stream-of-consciousness' by James Joyce (1882–1941) has had a pervasive effect
on Nolan's attitudes to art. Iconography and formal elements are constantly repeated,
combined and recombined, cross-referenced backward and forward in fresh juxta-
positions, with often ambiguous allusions, to create 'the same anew'. Like the poet
Robert Graves, he believes 'there is one story and one story only'.[1] In February 1949
he wrote in a letter to Barrett Reid: 'I can feel myself waiting until Mrs Fraser emerges
some more in me. Kelly by no means finished.'[2]

Living in Europe Nolan had a set of colour slides of his first Kelly paintings from
1946–47. That series was exhibited in Rome in December 1950 by the Reeds, who also
loaned three for the touring 'Twelve Australian Artists' exhibition of 1953–54. In 1954,
whilst in Italy for the Venice Biennale, he discussed with Albert Tucker various ideas
for a new series. Some of the 1950s Kelly paintings follow his original compositions
closely: *Kelly*, *The disguise*, and *Death of Constable Scanlon*, all dated 1955, for
example. The bright colours have gone, however; and much of the earlier *faux
naïveté*. Often now the Ripolin enamel is matt, used in subdued tones[3]: the Australian
landscape seen 'through a glass, darkly'—through memory and sheer physical dis-
tance. 'It may even be that he understands more about Australia when viewed from a
distance', said one writer in *The Studio*.[4] David Sylvester in *The Listener* considered
the 1940s works to 'have an irresistible charm, yet to be rather whimsical and anec-
dotal'. The recent works, on the other hand, 'have acquired breadth and luminousness
and complete conviction', he wrote, and 'should establish him among the half-dozen
best painters under forty in the world'.[5] Stylistic and technical innovations have simi-
larly transformed the imagery of Mrs Fraser and Bracefell, Burke, Wills and the
outback desert landscapes.

Marie Seton recalls her first sight of paintings by Nolan in May 1955:

Australia, which had been condensed for me into the lilting *Waltzing Matilda*
(improperly understood) suddenly, totally unexpectedly, became a place with
identity through the macabre fascination of Nolan's imagery. The geographical
heart—the central burning desert where the European had hoped to find an
inland sea but found it dried up a million years before discovery—was symbol-
ized by the twisted images of the bleached bones of cattle ... Nolan's paintings
blasted every vague idea I had of Australia. No national image could have aston-
ished me more than Nolan's figures of Ned Kelly...[6]

Some reviewers particularly admired his less 'story-telling' treatments of the Kelly
theme in this third exhibition at the Redfern Gallery; and again at the Whitechapel Art
Gallery in 1957. He was 'searching for and finding the ethos of his country in its past,
and elevating it through visual poetry to the level of myth', said the London *Daily
Telegraph*.[7] And Colin MacInnes declared:

The European series are, pictorially, incomparably finer ... The invented shapes
are intellectually more coherent and plastically more ingenious: the colours ...
luminous, rich and varied; while the presentation of the Kelly myth has gained a
new magic and imaginative power. Nolan has given the hero his metallic face

and body as he rides and strides through the enormous Bush, striking terror and constantly facing it. The mood of these pictures is sardonic, brutal, sad and tender. The story unfolds itself painfully and poetically in the successive episodes, and all the loss and sorrow of a rare young life thrown on to the scrap-heap are dignified, ennobled, and redeemed.[8]

Paintings were purchased by the Arts Council of Great Britain, Leicester County Council, the Walker Gallery, novelists C.P. Snow and his wife Pamela Hansford Johnson, Norman Parkinson and numerous other English collectors. At Durlachers Gallery on East Fifty-seventh Street, New York, the Kelly and the drought subjects were most admired by *The New Yorker*; and the Museum of Modern Art acquired *After Glenrowan Siege*.[9]

Across the world in Australia, popular attitudes towards Kelly were polarized at this time. Frank Clune had recently published *The Kelly Hunters: the authentic, impartial history of the life and times of Edward Kelly* (Angus & Robertson, Sydney, 1954). The playwright Douglas Stewart, whose *Ned Kelly* was revived in 1956 with stage cloths by Nolan, explained that 'The theme gave me a chance to set down a lot of thoughts I had been wanting to express about Australia, both the country and the national character: for Ned moved very close to his native earth—in many ways like an embodiment of it.'[10] This production—by John Sumner, with Leo McKern in the leading role—was not, however, staged in Melbourne as planned, because the Olympic Games organizers condemned its 'heroization' of the outlaw. A 'Melbourne Spy' in *Nation* attacked Nolan, Stewart, John Manifold, David Boyd and others for 'the deification of Kelly, Burke, Leichardt and the rest'; which, he said, 'seems to derive from the fact that Australians, hungry for a mythology in a country barren of legend, are prepared to confect one from any old ingredients'.[11]

Such virulent critics missed the point; at least in the case of Nolan. He has never merely illustrated 'legends'. As expatriate Charles Osborne wrote in his 'London letter' to *Ern Malley's Journal*, Nolan's treatment of Kelly was 'now perhaps less a vision than sophisticated comment. Ned 'has retreated a little' he said, 'he is not held up to our eyes with delight, we are asked to look at him through eyes more tired, less full of wonder'.[12] The subject is still Ned Kelly 'alone in the lonely bush, his eyes crimson with love'; but these 'wonderful paintings' are first and foremost works of art in their own right.

At Matthiesen's Gallery, London, in the summer of 1960 Nolan exhibited a total of seventy-five works on the ancient mythological theme of Leda and the swan and their watery surroundings: forty-four large panels painted in polyvinyl acetate dated 1958 and 1960 and thirty-one much smaller works in oil on paper from 1959–60. The exhibition was a 'huge and immediate success'.[13] John Douglas Pringle wrote: 'Sometimes the swan is flying, sometimes on the water, sometimes on the ground beside the pale body of the girl. Sometimes it seems to have exploded in the air so that all you can see is a twisted neck, a great beak or a wing like a cloud. The girl herself may be lying submissively on the sand or staring into the sky or wading in the water...'[14]

To critics who lamented Kelly's absence, Robert Hughes replied: 'To think of Australia as a *jardin exotique* is a fashionable way of missing the point, for to its painters it is not an exotic garden. It is the place where we live. One way of disliking Picasso is to prefer his blue period; one way of disliking Australian art is to feel cheated when the bushrangers do not appear.'[15] Quentin Bell objected to the scale of the 'quasi-baroque compositions which, if not empty, are certainly not replete [and] seem to me unworthy of his talents'.[16] Ultimately, however, Leda was 'the vehicle which brought him to the threshold of international recognition'. Max Harris points out that 'Nolan had the luck as well as talent to take to Europe a viable and spectacular new imagery at a time when Continental painting was uniformly abstract and austere'. Now he had proved himself 'as a European modern rather than a primitive phenomenon from the Antipodes'.[17] In the words of Alan McCulloch, 'After 150 years of vain effort to impinge itself on the consciousness of Europe, Australian art was "on the map", put there by virtually one man—Sidney Nolan'.[18]

1. Nolan had a copy of *A Skeleton Key to Finnegan's Wake* by J. Campbell & H.M. Robinson, New York, 1944; like Joyce, he seeks 'to discover the constants of experience'. Maureen Gilchrist points out similar emphasis on recurrent patterns in T.S. Eliot, Nietsche's 'eternal return'; and Spengler—'all things are chained and entwined together'; Gilchrist 1975, p.51.

2. Reid 1967, p.452.

3. Conversation with the author, January 1987; he also used enamel and oils together in some works at this time.

4. Zander 1955, p.84.

5. 12 May 1955, p.854.

6. Seton 1959, p.14.

7. 21 June 1957; the journalist extolled the 'primitive simplicity, stark realism and exotic symbolism' in this 'first large exhibition in England of an Australian artist'. *Art News and Review* VII, 8, 14 May 1955, had reported that Australian art had 'achieved an eminence distinct from and far ahead of other Dominions or perimeter groups'.

8. 'Sidney Nolan: The search for an Australian myth', introduction to the 1957 Whitechapel retrospective catalogue, p.13; and expanded in MacInnes et al. 1961, p.31.

9. *The New Yorker*, 7 April 1956. *After Glenrowan Siege*, 1955, is reproduced in MacInnes et al. 1961, pl.73; other works were purchased by private collectors.

10. 'Why Ned Kelly?', in the theatre programme for *Ned Kelly*, A.E.T.T., Sydney, 3 October 1956, p.13; Stewart's play was first presented on radio in 1942.

11. The 'spy' was Cyril Pearl, 8 November 1958; Nolan's original Kelly paintings were then on public exhibition in Melbourne. Tucker says that he began to produce Ned Kelly paintings in Italy in 1955 as a parody of Nolan's; but gradually his outlaws 'took on a life of their own'.

12. *Ern Malley's Journal*, May 1955, p.40; this short-lived periodical was edited by Barrie Reid, John Reed and Max Harris.

13. *The Sunday Times*, London, 19 June 1960. Nolan was interviewed on television; purchasers included the Queen, Agatha Christie, Rod Steiger and the Art Gallery of New South Wales; London's *Queen* magazine published a list of current status symbols with 'ownership of a Sidney Nolan' near the top.

14. The Australian journalist was quoted in *The Observer Weekend Review*, London, 12 June 1960.

15. Catalogue introduction, *Recent Australian Painting*, Whitechapel Art Gallery, London, 1961.

16. 'Sidney Nolan: Australian Painter', *The Listener*, 18 May 1961; he did admire 'a delicacy of invention' in the works on paper of both Leda and Mrs Fraser. Margaret Plant has criticized the large Leda paintings on similar grounds; 'Sidney or The Bush', *Dissent, a radical quarterly* 2, 2, May–June 1962, pp.22f. Various other adverse reactions to the Matthiesen exhibition are cited in Adams 1987, pp.146f.

17. *Nation*, 2 July 1960, p.13.

18. McCulloch 1961, p.465. George Johnston, in *Clean Straw for Nothing*, makes perceptive comments on the expatriate's need 'to prove something. To prove it to ourselves, I mean ... not to the place we have to get away from' (p.190; and see Kinnane 1986). Tucker and Boyd also held important exhibitions in London during 1960, at Waddington's and Zwemmer Gallery respectively.

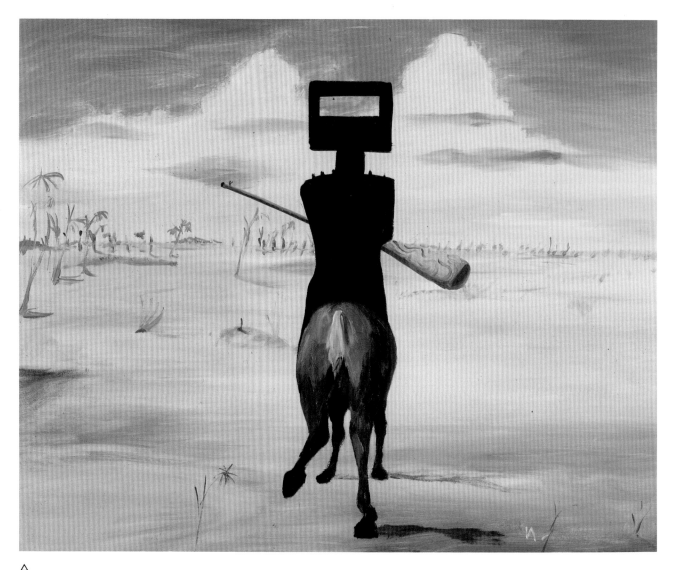

△
KELLY 1955
Ripolin enamel on hardboard
81.5 x 100 cm
Inscribed l.r.: 'N—'
verso: 'No 1 KELLY NOT FOR SALE/
LADY SNOW/KELLY/2/1/55/NOLAN'
Private collection, Canberra

Provenance: Sir Charles (later Lord) and
Lady Snow, 1957–81; by descent

Exhibitions: Redfern Gallery, London,
May 1955, no.2: 'Kelly'—125 gns; Durla-
cher Gallery, New York, March–April
1956, no.7; Whitechapel Gallery,
London, 1957, no.53; and Arts Council
touring exhibition, no.12; A.G.N.S.W.
etc., 1967, no.78, illus.

'Through all Nolan's painting has run the
heroic theme of the Australian bush-
ranger, Ned Kelly, an outlaw who in
popular myth may be compared with
Robin Hood, Rob Roy or the American,
Jesse James. In every country there is
such a figure: in Italy he is Pulcinello, in
Russia Petrouchka. He is the invincible
hero of the puppet show who defeats
everybody: the police, the clergy, even
death and the devil while he himself
remains immortal ... The head-guard
which he always wore was part of a
heavy piece of home-made armour
hammered out of plough shares. It has
become so identified with him as to have
become a symbol.'
-The Redfern Gallery presents Sidney Nolan,
London, May 1955

The lonely figure of Kelly 'riding in the
armour of self-containment across the
desolation of a wasteland' is probably
the best known image in Nolan's oeuvre.[1]
Man and horse are centaur-like in silhou-
ette by a trick of perspective. And as
Kelly invades the landscape, so the
landscape and the sky—pictorially and

metaphorically—invade him. In the
words of Elwyn Lynn, 'he resembles
those deities who can slip away and
leave their outward trappings to watch
and ward'.[2]

1. Harris 1960, p.12.
2. Lynn 1967, p.29.

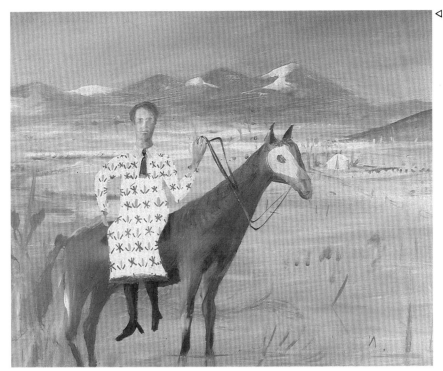

◁ THE DISGUISE 1955
Ripolin enamel on hardboard
64.8 x 80 cm
Inscribed l.r.: 'N'
verso: 'The Disguise/Nolan/Ned Kelly
Series/5/2/55'
Tony Reichardt

Provenance: Robert Melville, London; to
Tony Reichardt, Marlborough Fine Art

Exhibitions: Redfern Gallery, London,
May 1955, no.12: 'The Disguise'—75 gns

◁ GLENROWAN SIEGE 1955
Ripolin enamel on hardboard
91 x 71 cm
Inscribed l.r.: 'N.'
verso: '6/4/55'
ICI Australia Limited

Provenance: Russell Townend and John
McLeish, London, c.1955–60s; Mrs
Douglas Carnegie; to Southern Cross
Galleries, Melbourne, July 1975; to Lord
McAlpine; Joseph Brown Gallery, Mel-
bourne, April 1978; ICI Australia Limited

Exhibitions: Redfern Gallery, London,
May 1955, no.5: 'Glenrowan Siege'—95
gns; Whitechapel Gallery, London,
1957, no.64: 'The Glenrowan Siege,
1955—Collection: Russell Townend and
John McLeish, London', illus.; *Autumn
Exhibition, Recent Acquisitions*, Joseph
Brown Gallery, Melbourne, April 1978,
no.115, illus.

In the 1950s Kelly paintings a conflation
of images from earlier works both rein-
forces and extends their implications.
The *Glenrowan Siege* of 1955 is a quiet,
meditative painting by comparison with
Siege at Glenrowan and *Burning at
Glenrowan* from 1946. Here the shards of
wallpaper from Mrs Jones's Glenrowan
Hotel may also be emblems of renewal,
growing amid the ruins. The prostrate
bodies of the bushranger's companions
recall Nolan's drought-stricken car-
casses. Patches of bare white-primed
ground give the landscape an insubstan-
tial dream-like quality, as the blood-
stained figure of Kelly himself returns to
haunt the scene.

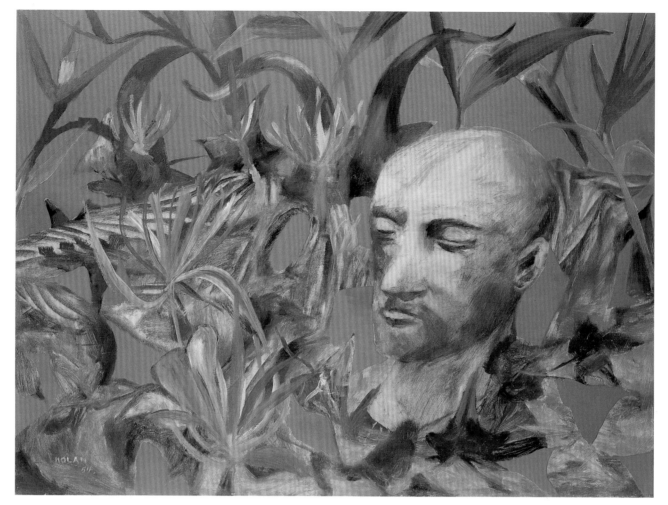

△
DEATH OF A POET 1954
Ripolin enamel on hardboard
91.5 x 122 cm
Inscribed l.l.: 'NOLAN/54'
verso: 'DEATH OF A POET/Sidney
Nolan/c/- British Council'; (also, in
another hand, 'DEATH OF AN
OUTLAW/NED KELLY')
The Walker Art Gallery, Liverpool
Presented by the Contemporary
Art Society

Provenance: Purchased from the White-
chapel retrospective by Eric Newton on
behalf of the C.A.S. in 1957

Exhibitions: Redfern Gallery, London,
May 1955, no.17: 'Death of an Outlaw';
Pittsburgh International, Carnegie Insti-
tute, October–December 1955, no.218:
'Death of a poet'; Durlacher Gallery,
New York, March–April 1956, no.6;
Whitechapel Gallery, London, 1957,
no.54; *Contemporary Art Society Recent
Acquisitions*, Tate Gallery, London, 25
February–26 March 1959, no.46; *Con-
temporary Art Society, 50th Anniversary
Exhibition*, London, 1960, no.52

'Nolan seeks to escape from the image
that is merely descriptive and the
symbol that is merely conventional. He
has discovered for himself painterly
ways of making his shapes and meanings
grow and realize themselves in a kind of
vegetational process of the imagination.'
- Bernard Smith, 'Nolan's Image', *The London
Magazine*, September 1962

Mortality is very rarely intimated in
Nolan's paintings of Ned Kelly. Several
works from the 1950s indentify the outlaw
unmistakably as a 'man of sorrows' with a
Christ-like face full of suffering and stoic
endurance, sometimes standing beneath
a crucifix. In *Death of a poet*, originally
exhibited as 'Death of an Outlaw', the
head is Kelly's plaster death mask.
Kelly's final appeal that his body be
handed over to relatives was refused by
the Governor of Victoria in November
1880. A cast was taken from his shaved
head after the execution; the skull
remained in the penal department and
his body went to an unmarked grave at
the Melbourne gaol.[1]

1. Kelly's death mask and his skull (until its theft
in December 1978) became great tourist attrac-
tions in Melbourne—like the stuffed skin of Phar
Lap and the nude painting of Chloe. Keith Dun-
stan, *Saint Ned*, Methuen, Sydney, 1980, p.79.

KELLY, SPRING 1956 ▷
Ripolin enamel on hardboard
121.9 x 91.4 cm
Inscribed l.r.: 'N—'
verso: 'November 10th 1956/
May 1956/N'
Arts Council of Great Britain
Purchased 1957

Exhibitions: Whitechapel Gallery,
London, 1957, no.66: 'Kelly, Spring';
The Arts Council as Patron, London,
April–May 1962; *British Painting '50–57*,

Arts Council of Great Britain touring
exhibition, June 1966–June 1967, illus.;
A.G.N.S.W. etc., 1967, no.83; *Recalling
the Fifties*, Serpentine Gallery, London,
February–March 1985

'This painting came after I had done
various paintings of Kelly as a bush-
ranger—it is a more universal applica-
tion of Kelly. This was one drawn with the
blossom as a kind of strong totem figure.
I tried to transfigure it into a kind of cele-
bration of Spring as if it is all suddenly
hushed for a minute. You hope to get
through to some sort of a sacramental
feeling. I came back into this picture to
see what happened to experience when
I put it into the old familiar mould. The
image of Kelly became the touchstone of
my progression as a painter.'
- Nolan, *The Studio*, London, October 1960

Kelly, Spring has been described as 'one
of the most robustly conceived and richly
painted' of the 1950s series, with its burst
of pink blossom, deep blues of aerial
distance and dreaming face.[1] It is dated
twice: May 1956, and again in November
when Nolan was much moved by the
abortive Hungarian uprising. Soviet
tanks entered Budapest early in the
morning of 4 November and savage
fighting broke out in the streets. People
tried to immobilize the advancing
armoured vehicles by smashing the
driving mirrors; for all they could see of
the driver was a face reflected in that

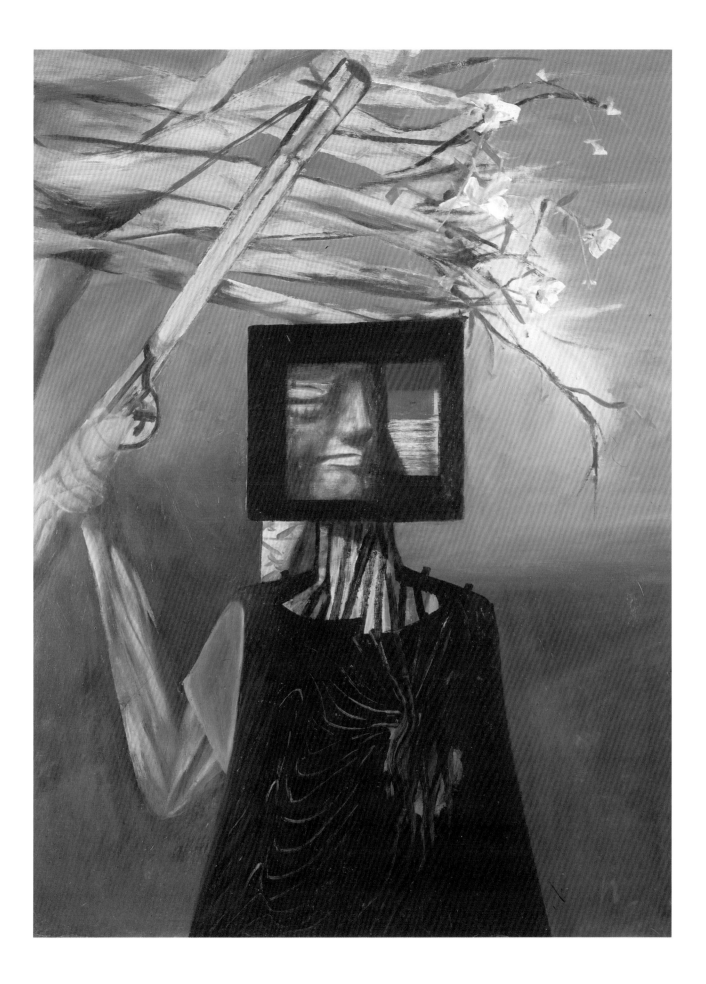

small frame. This description in a news item inevitably reminded Nolan of Kelly's features framed by armour.[2]

'History ... topicality of reference ... has overtaken Kelly, the dangerous man in the iron mask', observed a writer in *The Sunday Times*.[3] The Glenrowan wallpaper is barely visible behind his withered neck and real flowers are blooming in the aftermath of violence. The red heart is a pulsating sacred emblem of eternal life. Ned Kelly has become a metaphor of all humankind.

1. MacInnes et al. 1961, p.136.
2. The news report was quoted by Nolan in *Encounter*, January 1957; large-scale hostilities ceased within a fortnight, during which time Nolan produced three or four 'Kelly' paintings inspired by the event.
3. London, 16 June 1957.

△

'NED KELLY'—SET DESIGNS [1956]

'The Greek and Elizabethan playwrights had wicked Kings and Queens to analyse. Here in Australia, with royalty remote and constitutional we have to look about for a different kind of symbolic figure; and that is where Ned Kelly comes in. He is a symbolic, a national legend, because in his best aspects he typifies some of the virtues of our early colonial period—courage, dashing horsemanship, resistance to tyranny, a passion for freedom–and he is humanly interesting for his failings.'
- Douglas Stewart, 'Why Ned Kelly?', Sydney, 1956

'JERILDERIE' BACKCLOTH (ACT I)
Ripolin enamel on hardboard, squared for enlargement
31.5 x 44.5 cm
Inscribed l.r.: 'N.'
verso: 'Backcloth/JERILDERIE./for/ BANK/&/ROYAL HOTEL./SIDNEY NOLAN.'
Collection of Woolloomooloo Gallery

Provenance: Gift of the artist to John Sumner; given to Desmonde Downing, until her death in 1975; Woolloomooloo Gallery, Sydney

'BUSH' BACKCLOTH
Ripolin enamel on hardboard
31.7 x 44.5 cm
Inscribed verso: 'Backcloth./BUSH/for/ Kelly Camp/Sherritts Hut/Glenrowan Hotel'
Private collection, Melbourne
Provenance: Gift of the artist

This background was intended for Acts II and III, set in the bush around Glenrowan.

'KELLY'—SCRIM
Ripolin enamel and collage on hardboard
28 x 40.5 cm
Inscribed verso: 'SCRIM/Kelly'
Private collection, Melbourne
Provenance: Gift of the artist
Exhibitions: 'Yamba', St Kilda, October 1965, no.55

This is a design for one of the 'Special Cloths by Sidney Nolan', mentioned in the programme, which was actually used for the 1956 production. It was enlarged as a transparent scrim curtain with Kelly dramatically outlined against the land-scape. The now famous horseback sil-houette had first appeared in one of the Kelly paintings of 1947 (A.N.G.); and more recently in the *Kelly* painted in London in 1955 (q.v.); the design was also

reproduced, in monochrome, for the cover of the theatre programme.

Nolan had been commissioned by Hugh Hunt, Executive Secretary of the Australian Elizabethan Theatre Trust, when they met in London. It was John Sumner's third production for the A.E.T.T. Scenery and costumes were designed by Desmonde Downing; and the season opened at the Elizabethan Theatre in Newtown, Sydney, on 3 October 1956.[1]

1. For photographs of the production, see *The Australian Theatre Year Book*, ed. A.E.T.T., Cheshire, Melbourne, 1958.

'NED KELLY'—DESIGN FOR A PRO-GRAMME COVER [1956]
Mixed media on paper
30 x 25 cm (sight)
Private collection, Melbourne
For exhibition in Melbourne only

Provenance: Gift of the artist

Exhibitions: 'Yamba', St Kilda, October 1965, no.54

Nolan sent this design from London in 1956. Dominated by the outlaw's pow-erful brooding head and shoulders, the composition echoes that of *After Glenrowan Siege*, which the Museum of Modern Art, New York, had recently purchased. In the event, his 'Kelly on horseback' scrim design was adapted for the programme instead.

△
ITALIAN CRUCIFIX 1955
Ripolin enamel on hardboard
91 x 122 cm
Inscribed l.r.: 'N'
verso: 'Italian/Crucifix/1955/
Nolan/30/3/55'
Private collection

Exhibitions: Redfern Gallery, London,
May 1955, no.19: as 'Crucifix—Puglia [*sic*
Apulia]—150 gns'; Whitechapel Gallery,
London, 1957, no.60: 'Italian Crucifix,
1955—Collection: Cynthia Nolan', illus.;
and Arts Council touring exhibition,
no.15; A.G.N.S.W. etc., 1967, no.76, illus.;
*The Cynthia Nolan Collection of Paintings
by Sidney Nolan*, David Jones' Art Gal-
lery, Sydney, July 1975, no.13; Folkes-
tone, 1979, no.38, illus.

'Now he brings ... his eyes new to the old
Europe, which has nourished artists for
so many centuries. He is fascinated by
similarities in light and structure which
he detects in the landscapes of Southern
Italy and Australia. In Italy he feels at
home. After absorbing and digesting it,
pondering on its structure and its sym-
bolism, ... he understands its magic
instinctively. The architecture nourishes
his passion for symbols.'
- Alleyne Zander, *The Studio*, September 1955

No visitor to Italy can escape either the
eternal presence of the Classical, sug-
gested here by the background scene,
or the primal symbol of Christianity—the
Cross—superimposed upon a more

ancient foundation. Nolan's surreal
skeletal crucifix was inspired by way-
side shrines which he had seen and
photographed in Calabria. He also made
an artistic pilgrimage to northern Italy to
see the early Renaissance works of
Giotto and Masaccio, long familiar from
reproductions; and, in particular, to see
for himself the bomb-shattered ruins of
Andrea Mantegna's first great fresco
cycle at Padua.[1]

He painted several variations on this
theme of the primitive crucifix in a deso-
late 'architectural landscape'.[2] One
English reviewer considered that Nolan
might be likened to the Swedish film
director Ingmar Bergman, 'whose films
provoke discussion but elude open and
shut interpretation'.[3]

1. Painted 1454–57; the Ovetari Chapel in the
Eremitami Church was utterly destroyed by
American bombs on 11 March 1944. In George
Johnston's novel *Clean Straw for Nothing*, 1969,
the character of painter Tom Kiernan was
inspired by the author's friendship with Nolan:
Kiernan 'had an obsession once about doing a
painting of that moment when the bombs fell on
Padua ... He was going to call it *The New Renais-
sance*...' (p.299). Nolan still says he will one day
return to the theme; Kinnane 1986, p.152.
2. Examples at the Hamilton Art Gallery, Vic-
toria, and in a Melbourne private collection also
show influences of the simple Greek 'village-
scapes' of the brighter Aegean islands where
he lived in 1955–56.
3. Seton 1959, pp.14ff.

*Primitive crucifix in southern Italy
Photograph: The artist*

THE GALAXY 1957–58 ▷
Polyvinyl acetate on two canvases
mounted on hardboard
193 x 256 cm
Inscribed l.l.: 'N'
Art Gallery of New South Wales
Gift of Patrick White 1974

Provenance: The artist, to Patrick White

Exhibitions: *Transferences*, Zwemmer
Gallery, London, June–July 1958, thence
to Ireland and U.S.A., no.4: as 'Soldiers
shelled while bathing'; *Gifts from Patrick
White*, A.G.N.S.W., 1974, no.38

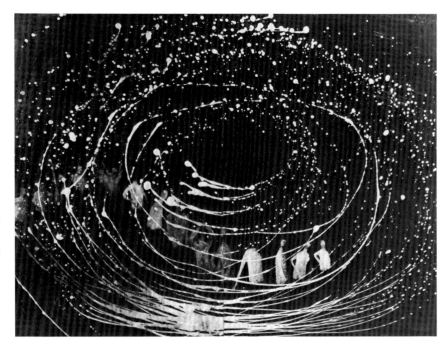

'Painting, to me, is a completely instinc-
tive thing. I think one applies paint as an
instinctive reaction', says Nolan, 'The
emotional force and the urge are the fuel
of energy that is necessary to approach
the paint with. The intellect is there for a
guidance system like a compass.'[1] In this
extraordinary work the subject evolved
through the very process of painting:
experimenting with a new medium—
polyvinyl—acetate—and 'compelled to
transmit emotions'. Working in post-war
Europe—at first in Greece, then Italy,
then in Paris late in 1957—he visualized
an image 'all whirling around like the
inside of an atom ... to symbolize a good
many things; not only Padua ... but
Dresden and Coventry and Monte Cas-
sino, and Hiroshima and Nagasaki'.[2] He
had visited the Gallipoli peninsula in
1956. He had also been reading Homer's
Iliad and wanted to paint the Trojan War,
he said, 'in the true brutality of its
images, within the impassive void of
cosmic indifference'.[3] Ancient Troy, the
Anzac story and comparatively recent
devastation fused in Nolan's mind.

The painting was called 'Soldiers
shelled while bathing' when first exhib-
ited in 1958. Later that year, however,
when the Nolans visited Patrick White
and Manoly Lascaris in America, White
said it looked 'more like the Milky Way'
than the inside of an atom: a macro-
cosm—rather than a microcosm—of the
human universe. They changed its title to
The Galaxy.[4]

This sweeping spiral of liquid P.V.A. may
recall Jackson Pollock's work but Nolan
never abandons completely the figurative
element in his art. By contrast, the 'Spirals'
of English painter Victor Pasmore are
completely abstract compositions even
when given such titles as 'The Fiery Sky'
or 'Snowstorm'.[5] Nolan's painting comes
closer to the spirit of contemporary
dance—in which he has always been
interested. Perhaps it is sheer coinci-
dence that Merce Cunningham, pio-
neering avant garde American
choreographer, had created his 'Galaxy'
ballet in 1956: a 'new theatre of motion'
with the element of chance as its keynote,
uniting human bodies, light and colour.[6]

Sidney Nolan with Patrick White, c.1963
Photograph: Axel Poignant, London

1. *The Studio*, October 1960, p.130.
2. Johnston 1969, p.300.
3. Johnston 1967, p.466.
4. Patrick White, in conversation with the author,
March 1987; (in *The Vivesector*, 1970, dedicated
to Cynthia and Sidney Nolan, White described
the Gallipoli campaign as 'a rustic picnic').
5. E.g. *Spiral Development—the Fiery Sky*, 1948,
Spiral Development—the Snowstorm, 1950–51
and *Spiral Motif*, c.1951; see Alan Bowness &
Luigi Lambertini, *Victor Pasmore, with a cata-
logue raisonné of the paintings, constructions
and graphics 1926–1979*, Thames & Hudson,
London, 1980.
6. First staged in Indiana, 18 May 1956; Cun-
ningham has worked closely with Robert Raus-
chenberg, Andy Warhol, Robert Morris and
Frank Stella. See Linda Doeser, *Ballet and
Dance, the world's major companies*, Marshall
Cavendish, London and New York 1977, pp.72ff.
and Anne Livet (ed.), *Contemporary Dance*,

Abbeville Press, New York, 1978. Alwin Niko-
lais, who says 'I resemble Pollock more than
Rubens', has also produced a ballet called
'Galaxy'—premiered 29 January 1960 in New
York. He writes: *Galaxy* centers on the idea of
orbit, the hanging together of things by their
affinities, their attractions, even their essential
repulsions ... Here were the affinities of light and
colors or shapes metaphorically and abstractly
representing the multitudinous unions which
create all forms, states, situations or identifica-
tions from microcosm to macrocosm.' Nolan's
painting was exhibited in America during 1958.

△
CONVICT AND MRS FRASER 1957
Polyvinyl acetate and oil on hardboard
122 x 153 cm
Inscribed l.l.: 'N 29-4-57'
verso: '29-4-57/Convict/& Mrs Fraser/
Sidney Nolan'
Private collection

Provenance: Dr Abrahams, London,
early 1960s; reacquired by the artist
through Marlborough Fine Art, London;
private collection

Exhibitions: Whitechapel Gallery,
London, 1957, no.88: as 'Figures and
lilypool', illus.; probably Durlacher
Gallery, New York, October–November
1958, no.15: as 'Bather and Lilypool';
Stockholm, 1976, no.29; *English Con-
trasts*, Artcurial, Paris, September–
November 1984; *Recalling the Fifties*,
Serpentine Gallery, London, February–
March 1985

Nolan produced thirty new paintings
based on the Eliza Fraser story for his
first full-scale retrospective in 1957.
These English works are, in the words of
poet Stephen Spender, 'the visible links
in the chain of an invisible narrative'
which lingered in his mind. Their 'dream
of trance-like atmosphere' might almost
make him seem a surrealist, Spender
continued: 'But he does not set out to
depict a stream of haphazard, acci-
dental, unexplained, disassociated
images, pouring from his unconscious
mind ... The characteristic of his method
which corresponds to the surrealists'
trust in lucky accidents, is his way of as it
were diving into the medium. Scrubbing
and sponging with his experimental
materials until the form begins to
emerge, which he elaborates. He allows
his figures to realise themselves within
the medium. Sometimes they seem to
linger on the threshold of appearances
and to haunt a landscape like gleam or
ghost, denying itself completeness of
emanation.'[1]

Nolan was working consistently on a
larger scale than ever before; and in a
new medium—polyvinyl acetate. Some
of the details in this example seem to
have been added in oil paint. As he
explained in 1957, this 'very fluent kind
of emulsion medium' was perfect for the
claustrophobic swampy landscapes that
he now wanted to depict. P.V.A. is a
relatively fast drying synthetic glue, into
which he mixed dry pigments.[2] It can be
used thickly, or thinned with water. A
medium for 'dark, still romanticism; it is
ideal for immediate effects, and its
shadows tend to shine rather than
retreat'. Bryan Robertson, then director
of the Whitechapel Gallery, described
the new series as seen *en masse*: 'The
complete gamut of colour ... is extraordi-
nary and of the liveliest invention,

ranging from dark olives, browns and
blacks constrasted with jewel-like col-
ours to a very sweet and fulsome orches-
tration of colour recalling Monet.'[3]

The mood has changed entirely since
his brightly-lit *Mrs Fraser* of 1947. As the
title suggests, this androgenous swamp
creature is the naked Mrs Fraser *and* the
stripe-garbed convict Bracefell. Nolan
seems fascinated by the possibilities of
camouflage, metamorphosis and trans-
formation by or for sexual experience.
The Queensland rainforest is now
painted by the light of his imagination.

Over the years, the process of
painting had taken over the story, he
explained at the time; 'the actual fact of
painting over a period changes one's
conception of it and this then becomes I
suppose part of the story ... It's become
increasingly gentler I think ... and the
effect is much more lyrical.'[4]

1. Catalogue introduction, Matthiesen Gallery,
London, June–July 1960.
2. Radio interview with Colin MacInnes, July
1957. Nolan learned of P.V.A. from Tucker when
they were both in Rome in 1954; Tucker having
recently been introduced to the new medium,
as the 'Vinavyl' brand, by an Italian painter
named Alberto Burri. See also Lynn 1967, p.37
and 1979, p.120.
3. MacInnes et al. 1961, p.150.
4. Interview with MacInnes, loc.cit.; in other
paintings from this 1950s series the figures
metamorphose variously into butterflies, lyre-
birds, fish and Aboriginal rock paintings. Arthur
Boyd, who arrived in London, November 1959,
pursued comparable themes of figures in
lagoons and lovers in mysterious dark land-
scapes in 1960–62; see Philipp 1968, e.g.
cat.10.2,10.9,10.25,10.47.

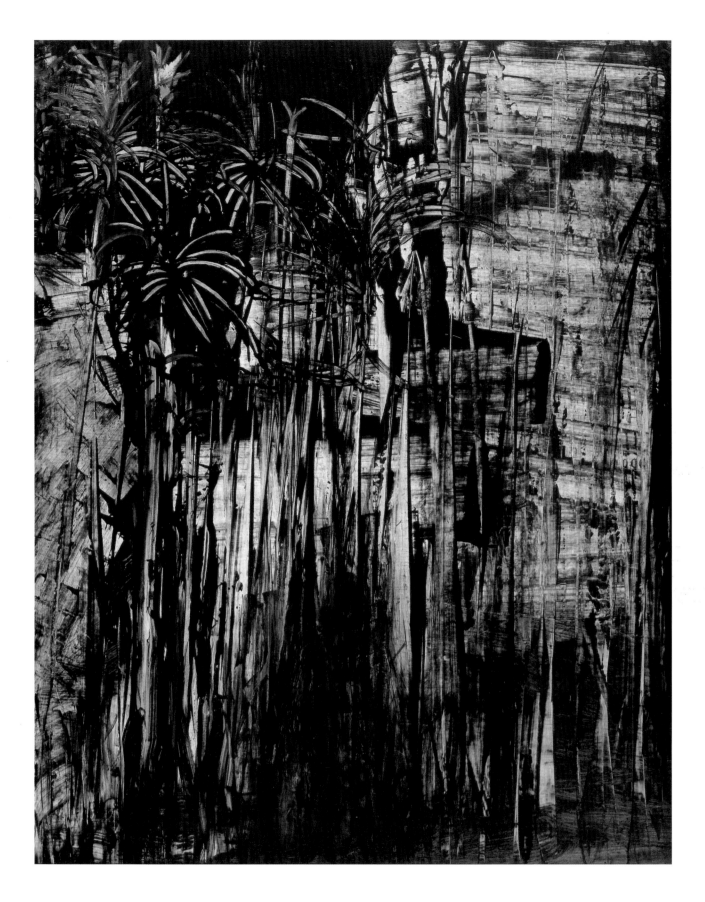

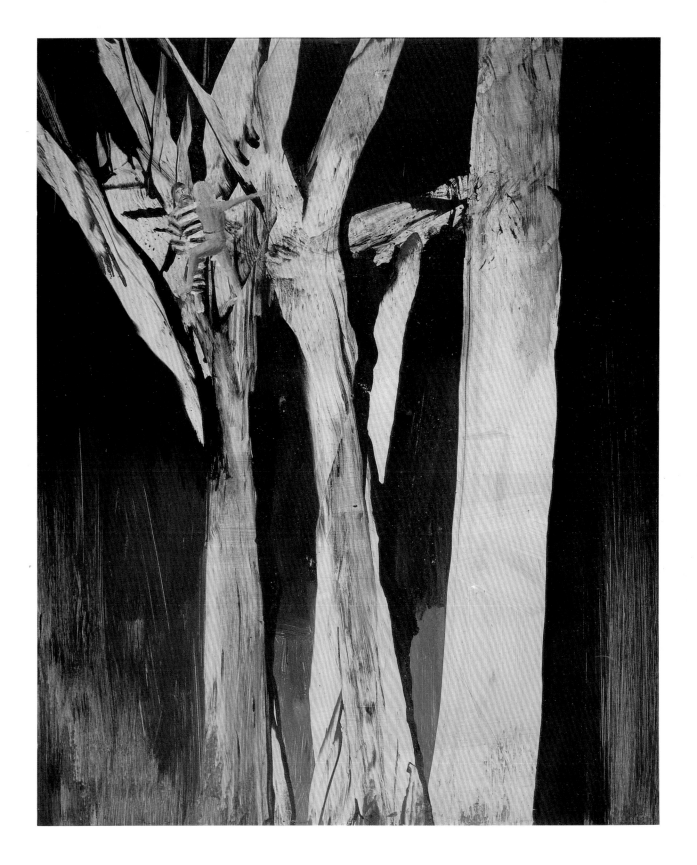

◁ RAIN FOREST 1957
Polyvinyl acetate on hardboard
152.9 x 122.3 cm
Inscribed verso: 'RAIN-FOREST/N/
DURLACHER/NEW YORK/14[?]-5-57'
National Gallery of Victoria
Purchased 1959

Provenance: The artist

Exhibitions: Whitechapel Gallery,
London, 1957, no.93: 'Rain forest'; and
Arts Council touring exhibition, no.22;
Durlacher Gallery, New York, October–
November 1958, no.3; *Australian
Painting: Colonial, Impressionist, Con-
temporary*, A.G.S.A. (Adelaide Festival),
March 1962, no.160; then Perth, London,
Ottawa and Vancouver until March 1963;
A.G.N.S.W. etc., 1967, no.89; on loan at
Queen's Hall, Parliament House, Mel-
bourne, September 1985–86

'As pictures they tend to be jagged,
uneven, and sometimes stunning; in mass
they are spectacular and disruptive as a
thunderstorm. Here is an attempt to
create an Australian art, almost as Rey-
nolds created an English art; ... art-histo-
rians should watch (and even step down
from their platforms to applaud) ... the
grand concert, the grand manner. It is a
cause in which gallons of English paint
have been spilt in vain ... For once, here
is a show literally fabulous.'
-David Piper, 'Round the London galleries', *The
Listener*, 27 June 1957

'It seems to have been that from here I
can see very clearly, perhaps even
more clearly what it is I felt about Aus-
tralia. It's kind of telescoped it and given
it a very precise imaginative thing, which
I hope makes the paintings even in a
strange sense more Australian.'
- Nolan, interviewed by Colin MacInnes, London,
July 1957

◁ FIGURES IN TREE 1957
Polyvinyl acetate on hardboard
152.9 x 122.3 cm
Inscribed l.c.: 'N. Nolan/6-5-57'
l.r.: 'Nolan'
verso: 'NOLAN 6-5-57'
The Lord McAlpine of West Green

Provenance: Sir Robert Adeane,
London, 1957–61; Mrs Douglas
Carnegie, Kildrummie, 1960s; Lord
McAlpine

Exhibitions: Whitechapel Gallery,
London, 1957, no.87: 'Figures in tree
1957—Lent by the artist', illus.; Australian
Galleries, Collingwood, October–
November 1961, no.14: 'Figures in tree,
1957'; A.G.N.S.W. etc., 1967, no.87: 'Fig-
ures in a tree 1957—Coll: Mrs Douglas
Carnegie'; *Paintings from the Collection
of Mr and Mrs Douglas Carnegie*, N.G.V.,
October–November 1966; *Sir Sidney
Nolan—Paintings*, Broome Centenary,
July–August 1983, lent by Lord McAlpine

The strangeness of these paintings is the
strangeness of real things. As Nolan told
Elwyn Lynn, this 'instantaneous, huge,
ghostly rearing-up of trees' is his

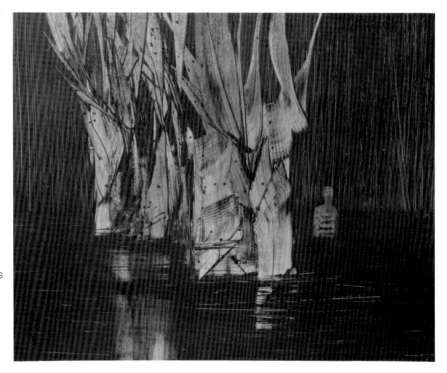

memory of a stand of enormous euca-
lypts seen in the glare of car headlights
near the Victorian-New South Wales
border about ten years earlier. 'Those
who have driven through the darkness of
the Australian bush know', says Lynn,
'how the visual imagination is alerted by
the momentary flash of forms uncannily
magnified and illuminated.'[1]
 In Nolan's hands the paint itself seems
vegetal. He invents his own conventions
of handling and imagery with vigorous
abandon—and perfect control. The
thick, coloured film of P.V.A. is scraped
back to leave areas of white-primed
hardboard almost bare: great tree trunks
which are crutches and erections for the
tiny, desperately vulnerable pair of
lovers. Geoffrey Dutton has admired the
'extraordinary combination of imme-
diacy and languor' that comes from the
speed with which Nolan's imagination
had to work using these materials: the
tropical swamp steams with a fecundity
that will never be shared by Mrs Fraser
and her convict.[2] Sir Kenneth Clark
hoped to acquire this painting from the
Whitechapel retrospective but it had
already been purchased by Sir Robert
Adeane.[3]

1. Lynn 1967, p.8.
2. Dutton 1986, p.144.
3. Information from the artist in conversation,
January 1987. Clark bought no.83, *Convict and
billabong*, instead; MacInnes et al. 1961, pl.87.

△
CONVICT AND SWAMP 1958
Polyvinyl acetate on hardboard
123.8 x 150.8 cm
Inscribed verso: 'CONVICT/& SWAMP/
1958/Nolan FOR/DURLACHERS/
NEW YORK'
Art Gallery of South Australia
Purchased, A.R. Ragless Bequest
Fund 1961

Provenance: The artist, through Bony-
thon Gallery, Adelaide

Exhibitions: Durlacher Gallery, New
York, October–November 1958, no.10:
'Convict and Swamp'; Bonython Art
Gallery, Adelaide, 11 September 1961;
Australian Galleries, Collingwood,
October–November 1961, no.8; *Austra-
lian Painting: Colonial, Impressionist,
Contemporary*, A.G.S.A. (Adelaide
Festival), March 1962, no.159; then Perth,
London, Ottawa and Vancouver until
March 1963; A.G.N.S.W. etc., 1967, no.85;
Adelaide's Nolans, A.G.S.A., 1983

Sometimes Nolan's Bracefell and Eliza
Fraser are like Adam and Eve in a latter
day and rather terrible Eden.[1] Here he
seems to give the legend of Orpheus and
Eurydice an ironic antipodean twist.
Whereas in Greek mythology Orpheus
descended to the underworld in a
doomed attempt to bring his lover back
to life on earth, in Nolan's version it is
Bracefell who is left behind in the shades.
Mrs Fraser does not look back—as
Orpheus found himself compelled to do.
 Roles are reversed; and themes of
freedom and bondage, love and sexual
betrayal are ambiguously intermingled.
Losing Eurydice made Orpheus despise
all women and, because of that, he was
torn to pieces by the frenzied Ciconian
Maenads. The convict David Bracefell
may be doomed to destruction in a
swampy Australian wilderness. But he is
also free.

1. MacInnes et al. 1961, p.22.

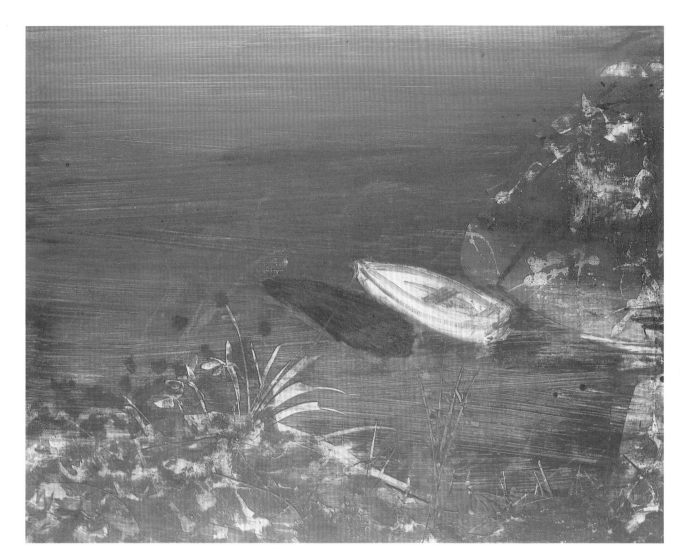

BOAT 1959
Polyvinyl acetate on hardboard
122.5 x 154 cm
Inscribed l.l.: 'N'
l.r.: 'Nolan'
verso: 'BOAT 1959/Feb 18th 1959/N./
No.7'
Private collection
Exhibitions: A.G.N.S.W. etc., 1967, no.97

'Do you remember that walk in Greece
when we set out early over the hills? You
walked behind me along the narrow
sheep track ... What a walk that was! You
always wanted to see what was round the
next hill, so we went on until we came to
the Aegean. That day we walked all day
and long after the sun went down.
Remember the bright moon lighting the
way home? ... I only need to go out and
look up at the sky, see the ocean flowing
or trees growing and I'm recharged.
Can't you do that?'
- The artist, quoted by Cynthia Nolan[1]

Cynthia Nolan remembered the months
spent on Hydra as the happiest of her
life—gardening, fishing with sponge
divers, bringing up their stores from the
village on donkey-back, visiting other
parts of Greece. The island was then
unspoilt by tourists. At first the Nolans
stayed with writers George Johnston and
Charmian Clift, expatriate friends known
in Sydney and London. Then they moved
into a beautiful, two hundred-year-old
fortress of a house, owned by the painter
Ghika (Nikos Hadjikiriakos). Nolan
painted the landscape; and he began to
work on the theme of ancient Troy. John-
ston remembers him 'obsessively
immersed in ... Homer's *Iliad* and Robert
Graves's *Greek Mythology*'.[2] And then,
on the neighbouring island of Spetsae, he
met Alan Moorehead who was writing his
book *Gallipoli* and had recently pub-
lished an article on the Anzac offensive
of April 1915—fought over the same
territory as the Trojan War.[3]
 As Johnston recalls, Nolan decided
that he, too, might tackle Gallipoli, 'as a
way of feeling into the bigger thing of
Troy': 'In the spring of 1956 the time
came for him to leave Hydra, but he
pursued his new obsession. Not from
books any longer—he now had to walk
on the actual plain of Troy, clamber the

mound of Hissarlik, trace where Sca-
mander flowed. Postcards came. From
Gallipoli, from the site of ancient Troy,
from Mudros and Lemnos, from Turkey,
the Black Sea. Cards bearing little
sketches— ... the scruff of wild thyme,
thorns on a ridge, rocks dropping into a
clear sea...' The Gallipoli theme
recurred in his work for years to come.

1. Cynthia Nolan 1967, pp.4f.; and see Ronald
McKie, 'A home that Homer would have
liked', *The Australian Women's Weekly*, 20
February 1957.
2. Johnston 1967, p.466. For detailed back-
ground to this Greek sojourn, see the excellent
biography of Johnston by Kinnane, 1986, pp.28,
40, 127, 152ff.
3. Alan Moorehead, 'Return to a Legend', *The
New Yorker*, April 1956; the author drew a
parallel between Gallipoli and Troy, first sug-
gested in *The Anzac Book* of poems, photo-
graphs etc. (ed. Sir W.R. Birdwood) in 1916.

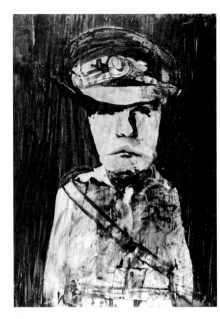

△
GALLIPOLI GENERAL c.1959
Polyvinyl acetate on hardboard
122 x 91 cm
Inscribed l.l.: 'N'
verso: 'Do Kelly white bank wallpaper'
The Lord McAlpine of West Green
Provenance: The artist

'The Trojan War, 1915'
We care not what old Homer tells
Of Trojan war and Helen's fame.
Upon the ancient Dardanelles
New peoples write—in blood—their
 name.

Those Grecian heroes long have fled,
No more the Plain of Troy they haunt;
Made sacred by our Southern dead,
Historic is the Hellespont.

Homeric wars are fought again
By men who like old Greeks can die;
Australian backblock heroes slain,
With Hector and Achilles lie.

No legend lured these men to roam;
They journeyed forth to save from harm
Some Mother-Helen sad at home,
Some obscure Helen on a farm.

And when one falls upon the hill—
Then by dark Styx's gloomy strand,
In honour to plain Private Bill
Great Agamemnon lifts his hand!
- J. Wareham, 1st Aust. Field Amb., *The Anzac
Book, Written and Illustrated in Gallipoli by the
Men of Anzac*, 1916

Every Australian knows the official
version of the Anzac story. The Austra-
lian and New Zealand Army Corps
under General Birdwood were
deployed, together with troops from
Britain and Canada, to storm the cliffs of
Gallipoli—only to be repulsed absolutely
by the Turks. After seven months they
were withdrawn, having suffered eleven
thousand deaths and twenty-four thou-
sand wounded. Ironically, the 25th of
April became a 'national day'—the day
Australia 'came of age'—although it was
a celebration of defeat.

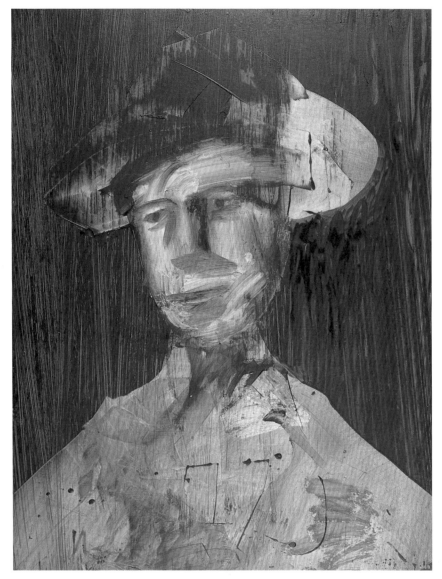

△
GALLIPOLI SOLDIER 1959
Polyvinyl acetate on hardboard
122 x 91 cm
Inscribed l.l.: 'N'
verso: 'NOLAN 13TH JAN. 1959/TO
LONDON'
The Lord McAlpine of West Green

Nolan has painted the human face of
Anzac in literally hundreds of works,
ranging in scale from slight sketches to
the horrific diptych of 1963.[1] 'It's some-
thing to do with my brother, I suppose,
dying so young', he says, 'I'm trying to
get an innocent look into the face'. His
conception of war as 'mass schizo-
phrenia', embodied in the *Head of Sol-
dier* of 1942, has changed with time.
Although he takes up some of the themes
made famous by artists such as George
Lambert—soldiers swimming, struggling
and dying—he makes no claim to 'docu-
ment' the first world war. It has been said
that Nolan's Gallipoli 'breaks over the
senses like a lamentation for lost souls'.[2]
Paintings spanning eight years were the
basis for a moving film, *Toehold in His-
tory*, made for Qantas in 1965.

1. Discussed later in this catalogue. Nolan pre-
sented 252 works to the Australian War Memo-
rial in 1977. For more detailed information on the
series, see Fry 1983 and Dutton 1985, pp. 124ff.
2. Nancy Borlase, *The Sydney Morning Herald*,
26 April 1980.

'He was using three magnificent blues;
first the paint glowed darkly, then a
young sad face would shine palely out.
He worked from 8 p.m. to 2.30 a.m., only
pausing, after the music had ceased, to
again switch back the needle. I heard that
particular Bach fugue forty-five times that
night, but now I could not say which one it
was. Sidney felt the Gallipoli situation,
war, the betrayal of youth, very deeply.'
- Cynthia Nolan: reminiscence of New York, 1958–
59, *Open Negative*, p.222

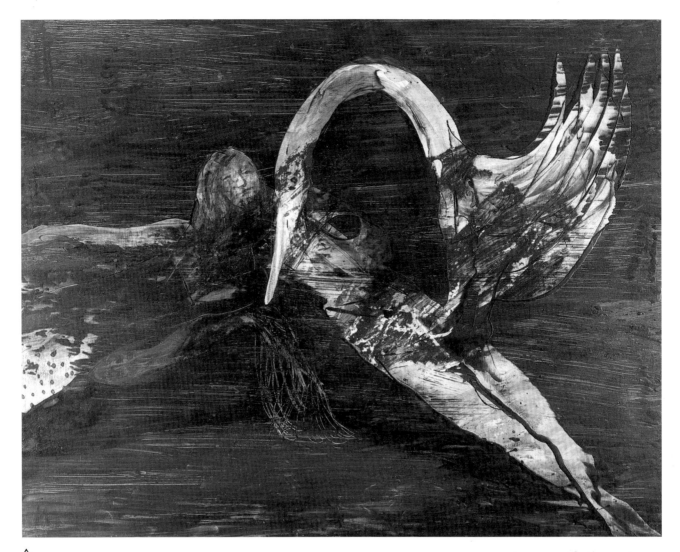

△
LEDA AND SWAN 1958
Polyvinyl acetate on hardboard
122 x 152.5 cm
Inscribed l.l.: 'N'
verso: '14th December 58/Nolan .../
Sold/Sydney'
Art Gallery of New South Wales
Purchased 1960

Provenance: The artist, through Mat-
tiesen Gallery, London

Exhibitions: Matthiesen Gallery, London,
June–July 1960, no.1: 'Leda and Swan
1958', illus.; A.G.N.S.W. etc., 1967, no.92

'During the day he painted on the floor,
first placing areas of colour on the pre-
pared board, next sweeping on poly-
vinyl acetate until the whole 4 x 5 feet
area was thick with paint, then seizing a
short-handled squeegee and slashing
and wiping, cornering and circling like a
skater, until another painting was com-
pleted. For the moment he had left the
Gallipoli theme. Now over and over
again, he was painting Leda and the
Swan. Sometimes the woman was
bloody, the swan very savage. Often the
figure was ambiguous, incidental, uni-
dentified, the swan was not. At night he
would usually continue on the large
boards, or work on paper, for he was
having a run.'
-Cynthia Nolan: reminiscence of New York, 1958,
Open Negative, p.224

GALLIPOLI SOLDIER c.1963 ▷
Oil on hardboard
122 x 91 cm
Inscribed l.r.: 'N'
The Lord McAlpine of West Green

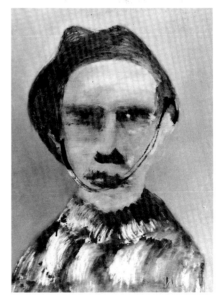

'To Australians Gallipoli is a rather spe-
cial subject, and though I like to jolt
people, I don't want to hurt or offend
anybody. A lot of Australians who fought
at Gallipoli are still alive and the paint-
ings must be acceptable to them. They
must have some kind of dignity. This was
the first great drama of modern Aus-
tralia—in which lads came out of the bush
and went to the other side of the world,
and found themselves faced with a kind
of cliff to climb. And it all folded up on
them—and it was all rather sad; it was
pretty tough. And I think these boys
returned with a feeling that they had a
new world and a new civilisation to be
built in Australia. All these people, all
these heroes, yes they all exist, but in a
kind of dream, larger than life, almost
unreal, in the way Achilles and Hector
exist for us. We still use them as symbols
for our dilemmas, don't we? ... So it
seems to me that I must throw it back as
much as possible, and treat it as a myth
or story that belongs to *all* the history of
Australia—and becomes a symbol of
what Australia has done and can do,
despite her rather grim beginning.'
- Nolan, interview with Noel Barber, 1964

LEDA AND SWAN 1960 ▷
Polyvinyl acetate on hardboard
120 x 90 cm
Inscribed l.r.: 'N'
verso: 'Leda and the Swan'
Mr and Mrs E. Zweig
Provenance: Barry Stern Gallery,
Sydney, c.1969–70; Mr and Mrs Zweig,
Sydney
Exhibitions: Matthiesen Gallery, London,
June–July 1960; probably Australian
Galleries, Collingwood, October–
November 1961, no.16

Whiles the proud Bird, ruffing his
 fethers wyde
And brushing his faire brest, did her
 invade,
She slept: yet twixt her eyelids closely
 spyde
How towards her he rusht, and smiled
 at his pryde.

-Edmund Spenser (1522?–99), *The Faerie Queene*,
III.ii.32

'Leda and the Swan'

A sudden blow; the great wings beating
 still
Above the staggering girl, her thighs
 caressed
By the dark webs, her nape caught in his
 bill,
He holds her helpless breast upon his
 breast.
How can those terrified vague fingers
 push
The feathered glory from her loosening
 thighs?
And how can body, laid in that white
 rush,
But feel the strange heart beating where
 it lies?
A shudder in the loins engenders there
The broken wall, the burning roof and
 tower
And Agamemnon dead.
 Being so caught up,
So mastered by the brute blood of the
 air,
Did she put on his knowledge with his
 power
Before the indifferent beak could let her
 drop?

-William Butler Yeats (1865–1935)

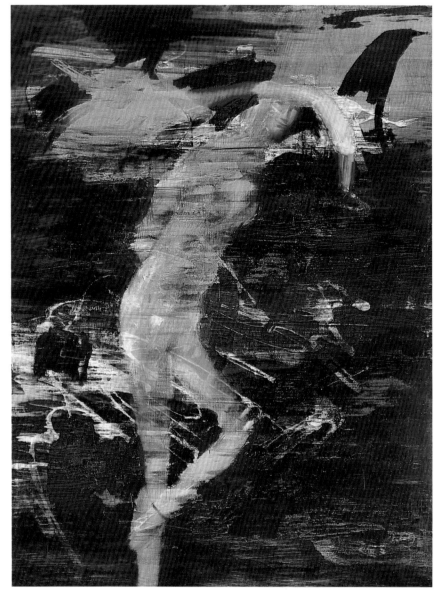

The ancient Greek myth of Leda and her swan exists in several versions. In its simplest form, the god Zeus transforms himself into a swan and couples with the Aetolian princess, wife of the King of Sparta. She subsequently lays an egg from which hatch Polydeuces and Helen of Troy.[1] The divine visitation—which culminated, of course, in the Trojan War—has been a powerful image through the ages. Nolan, however, was scarcely interested in the story; and owes nothing to versions by Leonardo, Michelangelo, Tintoretto, Correggio etc. Indeed his stimulus was essentially poetry rather than painted imagery.

Nolan was first inspired by the theme in 1945; perhaps after reading Rilke's *Leda*, which focuses more on the god's assumption of majestic new power than on the woman's response.[2] Edmund Spenser describes 'the proud Bird' in *The Faerie Queene*; and probably no one has made so memorable a symbol of Leda as the Irish poet Yeats. In 1958, when Nolan was living in New York, the trigger which fired his imagination was an unpublished poem by a little-known Australian, Alwyn Lee, ending

'...Until black Jupiter with snake-like
 head,
Has taken lubra Leda to her bed,
And everything, including tears, are
 shed.'

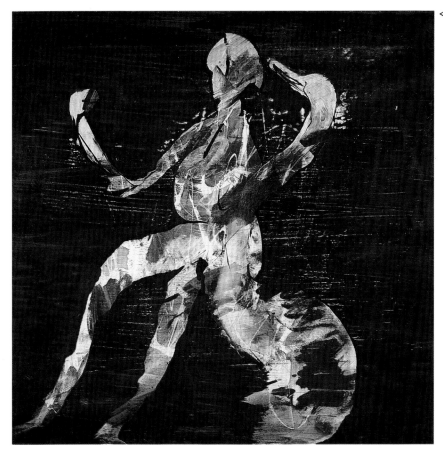

◁ LEDA AND SWAN 1960
Polyvinyl acetate on hardboard
121.5 x 121.5 cm
Inscribed verso: '15 MAY 1960/nolan'
The Sussan Corporation Collection
Provenance: Southern Cross Galleries,
Melbourne, c.1961
Exhibitions: Matthiesen Gallery, London,
June–July 1960, no.18

'Leda'

When the god in his necessity strode
 toward
The swan, he was arrested by its beauty;
Although amazed he vanished in the bird
Who was unconscious of his trickery

To use it for the deed, before he proved
The creature's feelings. But the fleeing
 One
Already knew who approached her in
 the swan
And instantly felt what he wished. He
 moved

Around her now, distracted to withstand
Or hide from him. He came under
And thrust his neck through her ever
 weakening hand.

In the beloved the god was lost.
There first he felt delight in every
 feather
And verily in her lap became the swan.

-Rainer Maria Rilke (1875-1926)

As he read these three lines, the myth came alive and he started to paint.[3]

'I found my mind full of images of necks and wings', he says. His memory mingled images of swans in London, coloured lights reflected on the River Thames at Putney; and the body of his stepdaughter swimming underwater; landscapes of Arizona; a decrepit poor-white village; the Pacific seabed. He had lived in modern Greece—a deserted theatre where once magnificent drama was enacted.[4] 'There is always an abstract feeling and one starts from this', he says; 'I incorporate visual data that is liable to come from any time or place ... One ends up with a landscape one has never seen before but it is presumably the landscape that you were feeling as you started the painting. Something arrives as visually equivalent to the first abstract sensation.'[5]

The encounters between bird and woman are often strangely asexual. Nolan was thinking mostly about the way in which objects can emerge from, merge with and return to an environment: in marked contrast to his earlier work with enamel paint where the technique imposes objects boldly upon the surface of a situation.[6] Nolan's Leda only vaguely suggests a legendary origin; she does not make her own myth as Ned Kelly had done.

1. Betty Radice, *Who's who in the ancient world*, Penguin, Harmondsworth, 1973, p.151.
2. *Leda and swan*, 1945, and a *Leda* of 1957, are reproduced in MacInnes et al. 1961, pls 6 and 99 respectively. Arthur Boyd tackled the Leda myth in 1943–44; Philipp 1968, cat.2.31 and 2.32.
3. Quoted in *The Observer Weekend Review*, London, 12 June 1960; Alwyn Lee was also living in New York.
4. Nolan in *The Studio*, October 1960, p.130; and Osborne 1967, p.460.
5. Nolan, loc.cit.; see also John Russell's catalogue introduction, Hatton Gallery, Newcastle-upon-Tyne 1961, and Nolan interviewed in Barber 1964, p.98.
6. Max Ernst used oils for very similar textural effects, by slashing and wiping back the pigments, in his American paintings of c.1960.

BURKE AND WILLS AT GULF [1961] ▷
Synthetic polymer paint on hardboard
122 x 152 cm
Inscribed l.l.: 'N'
National Gallery of Victoria
Presented: 'for Claire Pitblado, from
Sunday Reed' 1972

Provenance: Presented to the Museum
of Modern Art and Design of Australia
by Sunday Reed (Mrs Claire Pitblado
bequest) 25 June 1963; to the N.G.V.
July 1972

Exhibitions: Skinner Galleries, Perth,
November–December 1962, no.2:
'Bourke [sic] and Wills at Gulf'; S.H. Ervin
Gallery, Sydney, November 1985–
January 1986, no.14

'The camels are unforgettable, slightly
comic but also disquieting with their long
sinewy necks, ... their wobbly swaying
stance; and their riders perched precari-
ously on the steep rump seem to have
grown into the beasts, a kind of desert
centaur. Sitting well back they look
rather like figureheads on the wrong end
of the ship of the desert.'
-The Critic, Perth, 23 November 1962

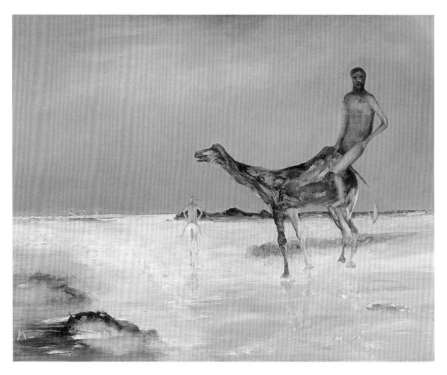

Man and beast are 'united, centaur-like,
for survival', says Nolan. But Burke and
Wills are doomed in their nakedness:
touchingly awkward, inept and defence-
less. Have they stripped off their clothing
as the last crazed act of men dying of
thirst? (According to the history books,
Wills's father alleged that his explorer son
died for want of clothes, 'so amply pro-
vided by himself [and] worn by others'.)
Have they really reached the Gulf of
Carpentaria? Or is this pale translucence
only yet another mirage of the desert?

In fact they never saw the ocean.
After struggling through mangrove
swamps, the camels often knee deep in
water, they camped for the night of 10
February 1861 by a creek which was
salt. 'At the conclusion of the report it
would be well to say that we reached the
sea', Burke wrote wistfully, 'but we could
not obtain a view of the open ocean,
although we made every effort to do so'.[1]
Coastal marshes blocked the way, the
rain streamed down and their provisions
were running out. As Alan Moorehead
says in Cooper's Creek, it seems sad,
even across this distance of time, 'that
Burke and Wills did not have their
Cortés-vision of that leaden sea that
washes along the Gulf of Carpentaria;
after so many hardships it would have
been for them a splendid thing.'[2]

In this new series on the theme of
Burke and Wills, the soft, matt paint and
its handling are strikingly different from
anything Nolan had done before: alto-
gether silkier, more delicate. 'Ravishing
is the only word for it', said Allan
Edwards when the paintings were first
shown in Perth: 'The skies are
immensely high, light, pearly, with a
flush of pink or burgundy coming
through the heavenly blue ... The sense
of immense space, empty, desolate, is
still hallucinatory ... [And his] character-
istic combination of inventiveness and
recapitulatory variation is prominent in
almost all the larger paintings in this
exhibition.'[3]

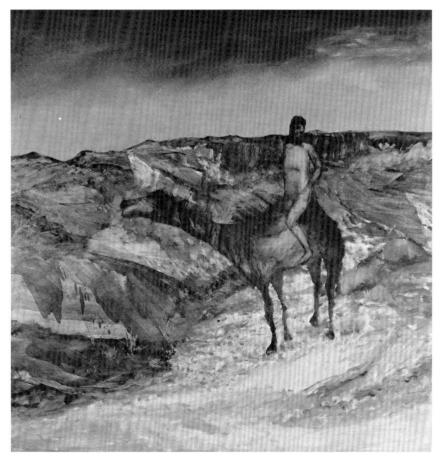

Moorehead could well have been
inspired by this very work when he
described the feelings of the search
party, sent out some eight months later:
'Sometimes strange double mirages
quivered on the plains around them and
trees hung upside down in the empty
sky. Where in all this dreaming, floating
space was Burke to be found?'[4]

1. Memorandum dated 28 March 1861, quoted in
Colwell 1971.
2. Moorehead 1963, p.80. Moorehead says, 'Mr
Sidney Nolan first suggested I should write this
book, and for this I most warmly thank him ... I
was able to complete the preliminary research
in Europe and in the autumn of 1962 I went to
Melbourne' (p.200).

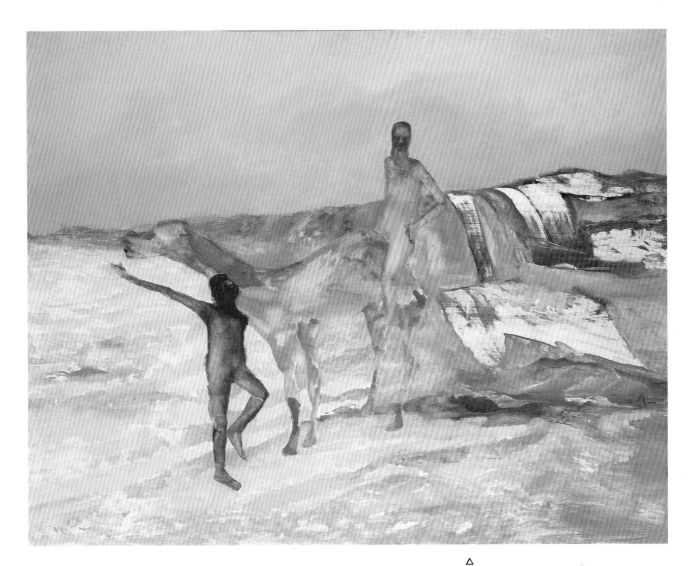

3. *The Critic* 3, 5, 23 November 1962, p.35.
Nolan's tools evidently included a windscreen
wiper blade (as first used when he was in
Greece) to achieve the scraped-back streaked
effects; the paint appears to be a water-based
P.V.A. medium, sometimes used with oil and/or
touches of enamel.
4. Moorehead, op.cit., p:131.

◁ CAMEL AND FIGURE [1962]
Synthetic polymer paint on hardboard
122 x 122 cm
Art Gallery of New South Wales
Gift of Godfrey Phillips International Pty
Ltd 1968

Provenance: The Viscount Collection,
Godfrey Phillips International Pty Ltd,
through Australian Galleries

Exhibitions: *Viscount Collection: 'The
Australian Scene'*, tour of state galleries
1963-64, no.3; World Conference on
Cultural Policies, Mexico City, July-
August 1982; S.H. Ervin Gallery, Sydney,
November 1985-January 1986, no.18

'They had seen the fantastic dawn colours
of the desert and had walked through
country where white salt pans ran through
scarlet sandhills with the cloudless sky
overhead—a landscape of red, white and
blue. And perhaps just as important as all
this they had learned how to come to terms
with the inevitable and the implacable—
with the certainty of death—and had not
found it too unbearable.'
-Alan Moorehead, 1965

For Nolan the key elements in the
explorers series of 1961-62 are 'the
actuality of the landscape, which for
Australians is intensified to the point of a
dream; [and] the strange conjunction of a
man on a camel, from which he surveys
the landscape as if he were walking on
giant stilts'.[1] He has said, somewhat
cryptically, of this painting in particular,
'the camels knew better'.[2] Quite true of
course; they knew how to survive in the
Australian outback (and still do). The
foolhardy, ill-equipped white explorers
did not.[3] There are plenty of edible
plants about (and can that be a rainbow
reflected on the camel's neck?)

 Although this work has been called
'Burke', Nolan prefers the generalized
title *'Camel and figure'*, suggesting a
universal emotion rather than incidental
details of history.[4]

1. Quoted in Moorehead 1967, p.459.
2. Lynn 1979, p.134.
3. An interesting modern 're-enactment' of the
journey is documented by Tom Bergin, *In the
Steps of Burke and Wills*, A.B.C., Sydney, 1981.
4. Conversation with the author, January 1987.

△
BURKE AND WILLS EXPEDITION [1962]
Synthetic polymer paint on hardboard
121.9 x 152.5 cm
Inscribed l.r.: 'N'
c.r.: 'Nolan'
verso: 'PERTH/1/BURKE/& WILLS/
EXPEDITION/Nolan/No1'
James O. Fairfax collection, Sydney

Provenance: The artist, through Skinner
Galleries, Perth 1962

Exhibitions: Skinner Galleries, Perth,
November-December 1962, no.1:
'Bourke [*sic*] and Wills Expedition', illus.;
A.G.N.S.W. etc., 1967, no.104; S.H. Ervin
Gallery, Sydney, November 1985-Jan-
uary 1986, no.15

'I went up the creek in search of the
natives ... They appeared to feel great
compassion for me when they under-
stood that I was alone on the creek, and
gave me plenty to eat. After being four
days with them I saw that they were
becoming tired of me, and they made
signs that they were going up the creek,
and that I had better go downwards; but I
pretended not to understand them. The
same day they shifted camp and I fol-
lowed them...'
-John King, Cooper's Creek, July 1861

As Alan Moorehead observes, King's
account of how he was cared for during

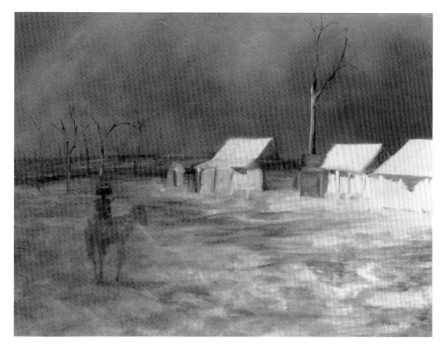

the two months before his rescue 'is one of the most moving tributes ever written to the kindness of the primitive people of Australia, and it makes perhaps the best epitaph for the now vanished blacks of Cooper's Creek. One must remember that they too, were hard pressed for enough to eat, and an extra man who was a semi-invalid was a great burden to them'.[1] Wills had also noted in his journal several instances of help from local Aboriginals on the outward journey.

1. Moorehead 1963, pp.140ff.

△
KELLY AND STORM 1962
Oil and enamel on hardboard
91 x 122 cm
Inscribed l.r.: 'NOLAN'
verso: 'Kelly & Storm/1962/22/..../8-1-1964/no.36/KYM—/NOT TO BE SOLD/OR EXHIBITED/PLEASE HOLD'
Dr von Clemm

Provenance: Gift of the artist to his daughter; sold through Lauraine Diggins 1986; Dr von Clemm, Massachusetts

Exhibitions: *Selected Australian Works of Art*, Lauraine Diggins, North Caulfield, June 1986, no.44, illus.

'Nolan at this time was moved by two influences, far apart in time but close in spirit; one was the loose, instantaneous, autonomous, swirling gestures of the abstract expressionists and the way of looking that De Kooning calls "the slipping glimpse". The other was Turner ... Nolan has more in common with Turner than stylistic devices: painting to both was a performance, a commitment to sudden moments of revelation ... Both are impressed with the maimed desolation of nature, with its boundlessness, with both its serenity and hostility, and both with human insignificance in the vastness...'
-Elwyn Lynn, *Sidney Nolan: Myth and Imagery*, 1967, p.43

'THE RITE OF SPRING'—DESIGNS FOR DECOR AND COSTUME 1962

COSTUME DESIGNS (NO.6) ▷
Aniline dyes, wax crayon and metallic paint on paper
52.2 x 63.5 cm
Inscribed l.l.: 'Rite of Spring/1962'
l.r.: 'Nolan'
Private collection
Exhibitions: Qantas Gallery, Sydney, September–October 1967, no.6; Chester, 1983, no.41, illus.

COSTUME DESIGNS (NO.8)
Aniline dyes, wax crayon and metallic paint on paper
63.5 x 52.2 cm
Private collection
Exhibitions: Qantas Gallery, Sydney, September–October 1967, no.8; Chester, 1983, no.42, illus.

DECOR—SCENE 2: BACKCLOTH AND DANCING FIGURES (NO.10)
Aniline dyes, wax crayon and metallic paint on paper
52.2 x 63.5 cm
Private collection
Exhibitions: Qantas Gallery, Sydney, September–October 1967, no.10; Chester, 1983, no.43

'I saw in my imagination a solemn pagan rite: sage elders seated in a circle watched a young girl dance herself to death. They were sacrificing her to propitiate the god of spring.'
-Igor Stravinsky (1882-1971)

'Lashed together, MacMillan and his designer, Sidney Nolan, have set out with rare unity of purpose to scale these heights. In Nolan's paint-smeared fleshings and MacMillan's joint-twisting choreography, the dancers take on the look, crude and bent, of primitive cave drawings.'
-*Plays and Players*, London, July 1962

This was Nolan's most ambitious design project for the stage to date: a new version of Vaslav Nijinsky's most controversial work, for the Royal Ballet at Covent Garden.[1] *Le Sacre du Printemps* or 'Rite of Spring' was first staged by Diaghilev's *Ballets Russes* in Paris in May 1913: booed by most of the audience throughout the premiere and performed only six times in all. The two-part ballet was set in the icy steppes of 'pagan Russia', with costumes based on authentic 'ancient folk tradition'.[2]

In London in 1962 both the choreography and the décor were dramatically original. Nolan and MacMillan together aimed to evoke an epitome of primitive ritual. Stravinsky's score is timeless. MacMillan's dancers appeared almost naked, with stencilled hands on their flame-coloured leotards and make-up, applied by Nolan, like Aboriginal body decoration. For the first tableau, 'The adoration of the earth', Nolan's backcloth, wings and floor *tapis* became a rugged gorge; the zig-zag rock formations of the cliff face echoing his original conception for Lifar's *Icare* in Sydney

twenty years earlier. In scene two, 'The sacrifice', a vast metallic version of his own *Boy and the Moon* painting of 1940 towered up behind the frenzied dancing, with Monica Mason in the role of the sacrificial 'Chosen One'. Clive Barnes wrote in *The Spectator*: 'Over this whole writhing mass of sub-humanity looms Nolan's terrifying ... totem symbol ... Whether it is meant to represent a phallic image or a tree of life we do not know. Certainly it looks forbiddingly like a mushroom cloud, question-marking the ambiguity of these strange aboriginal rites. Are they meant to be in the dim past of pre-history, or are they perhaps intended as an uncomfortable vision of the future?'

This production of *The Rite of Spring* has been revived several times and remains in the Royal Ballet's repertoire.[4] Despite their small scale, Nolan's designs have a powerful life of their own, rhythmic and erotic as the ballet in performance. His painted totemic figures—slightly 'out of focus'—seem to defy gravity with all the strength and vigour of dancers in motion.

1. The production at the Royal Opera House, Covent Garden, London opened 3 May 1962; with a successful season at the Metropolitan Opera House, New York, in 1963. Six of Nolan's designs are in the collection of the Museum of Modern Art, New York. MacMillan, one of Britain's leading choreographers, originally approached Jean Dubuffet with the commission. Nolan's most recent experience of theatre design was for Harvey Breit's play *The Guide* in 1961, with sets inspired by his travels in India; see *The Sunday Times*, London, 26 February 1961 and *Cambridge Review*, 4 March 1961—'It is nothing less than a masterpiece of theatrical design...' Arthur Boyd had produced designs for Stravinsky's *Le Renard* in 1961.
2. Illustrated in Mary Clarke & Clement Crisp, *Ballet, an illustrated history*, A. & C. Black, London, 1973, fig.112.
3. 'Vision of the Moonboy', 18 May 1962, p.651. The 'moonboy' backcloth was 11 by 18.3 metres. Other excellent reviews appeared in *The Daily Express*, *Dance and Dancers*, June 1962, *The Australian Women's Weekly*, 27 June 1962 and elsewhere.
4. His three-dimensional stage models are in the archives of the Royal Opera House, London.

◁ *MacMillan's choreography, like Nolan's costumes, seems influenced by Aboriginal art: reminiscent of the northern Australian 'Oenpelli Snake', in which dancers linked in single file bend and weave and wind incessantly in a day-long festival of spring. They had both studied Axel Poignant's photographs of Arnhem land Aboriginal dances.*
Photograph: Axel Poignant, London

△
Nolan was assisted on the 'Moonboy' backcloth by Clifford Bayliss, working in Covent Garden's model room (whom he met twenty-six years earlier at the Melbourne Gallery School). They clad the image with gold-coloured foil, crinkled and dulled to a range of subdued rainbow hues by burning off the foil's paper backing (Adams 1987, p.158).
Photograph: Axel Poignant, London

THE WORLD

Sidney Nolan is known, I suppose, as 'the Australian painter', a description which needs considerably qualifying if it suggests that we should put him in a special niche as an astonishing phenomenon, one of the two or three extremely original painters who have come out of Australia in the past decades ... By now he has made a great deal of the world his Australia ... It is not just that he travels widely and has a seemingly inexhaustible visual appetite for many countries, but that he also has a world consciousness, and, at times ... he expresses a world conscience.

- Stephen Spender, London, 1960

Art is a dialogue between the artist inside himself and the exterior world. On the other hand, art as a career is a public exposure. These two points of view must be synchronized. A public image is not to be received without circumspection.

- Nolan in Canberra, June 1965

By the 1960s Nolan had established the style of life that has remained his hallmark. Though based in England, his 'voyages of discovery' have made him perhaps the most widely-travelled artist of his generation. He visited China for the first time in 1965, when access was still very difficult for Western tourists. 'I have found that having looked at Chinese paintings a lot, it didn't really make sense to me until I had been there and seen and felt those misty voids', he says; '... and this whole idea of nature representing the fundamental philosophy of life'.[1] His work was now exhibited internationally by Marlborough Fine Art, the world's most powerful commercial gallery dealing in contemporary art. Major retrospectives in Australia and Ireland confirmed his stature. 'Nolan is a man of questing, nimble and impartial intelligence who might one day make a great P.R.A.', declared John Russell in the London *Sunday Times*.[2]

Perhaps inevitably, some Australians felt he had 'deserted' and 'betrayed his origins'. Robert Hughes admitted that Nolan was deceptively easy to 'knock' because of his popular success overseas. On the other hand, press reviews of the 'African Journey' and 'Antarctic' paintings quickly showed how fickle the British and American critics could be when confronted with what they perceived as an unwarranted change of style. One writer called him 'a civilization sampler'. 'Is he just an exotic pictorial journalist?' asked *The Sunday Telegraph*; and Hughes warned, 'As soon as people ask "What will Sid do next?", it is time to watch out'.[3] He was labelled 'eclectic'; which, of course, he has always unashamedly been. He was even taken to task for changes of media and technique; to which he replied that this was an integral aspect of his art:

I like to change the medium every now and again so that I can work against it, so that I am not proficient in it—because, in some way, I'm always worried by proficiency. It has so many dangers, especially as there is a certain kind of satisfaction in automatic response. But this could keep out more serious messages ... You do end up with certain kinds of mannerisms. You handle paint a certain way, you flick it this way and that way, and often this steals in unawares...

You see, even the muscles learn tricks ... Yes, you must fight against it because I suppose if a painting is worth anything it is supposed to come from some place inside yourself that you cannot get to through any other means.[4]

Nolan is no mere roving reporter. Certainly he takes notes, his 'own sort of short-hand for remembering'. He uses—and enjoys—photography.[5] But his memories are always stored; and then transformed by his extraordinarily inventive imagination. Long periods of observation and reflection are to him what preparatory sketches are to many other artists. When the moment comes for painting, however, he works very rapidly indeed; from time to time, as one English writer has put it, 'he gives off pictures like an electric charger'.[6]

Many of his most ambitious and original works from the 1960s and 1970s are too large or now too widely dispersed for exhibition. He has illustrated numerous books. The enamelled copper mural of *Eureka Stockade*, 1965, can be seen at the

Reserve Bank in Melbourne. (Nolan initially envisaged a huge 'Boy and the Moon' image for this commission, on a scale inspired by modern Mexican muralists such as Diego Rivera and José Clemente Orozco.)[7] Most of the *Paradise Garden* paintings are installed, in two parts, at the Victorian Arts Centre. The *'Little Shark'* mural hangs in the Sydney Opera House.[8]

1. Interview with Edmund Capon, Sydney, 1981. The first Chinese tour is the subject of Cynthia Nolan's *A Sight of China*, Macmillan, London, 1969, where she quotes him: 'A trip to China changes you. Something happens, a very quiet thing that's got to do with the future. It's a peculiar feeling to have been where we've been and come back again—like a dream in which you drown and fly at the same time.' Nolan has returned many times since.

2. May 1965; Nolan's sights were not in fact set on presidency of the Royal Academy!

3. *The Sunday Telegraph*, London, 2 May 1965. See Adams 1987, p.155.

4. Barber 1964, pp.98f.; and more recently, 'I changed my styles wilfully and consciously to keep interested' (*The Australian*, 22 April 1977).

5. Cynthia Nolan describes her husband's photographic arsenal in *One Traveller's Africa*: 'Sidney had all his cameras out: the Rolleiflex, the little Nikon with its huge tele-photo lens that when encased in its leather holster looked so exactly and unpleasantly like a gun, the Agfa with its monocular lens ... the tiny Mini, and the Cambinox which can also be used as binoculars. Some were loaded with colour, some with black and white, and some film was faster than the others. They lay in a jumble on the floor at our feet and he used one, then another [for] notes that will recall, like the taste of Proust's *madeleine*, what he has seen and experienced.' These days he is rarely without a polaroid camera and often uses a video.

6. David Piper, *The Listener*, 27 June 1957.

7. The commission came through Dr H.C. Coombs, as Governor of the Reserve Bank of Australia; the mural arrived from London in July 1965.

8. The three great multi-sectioned compositions of *Paradise Garden*, *Shark* and *Snake* together make up 'Oceania'—in conception although not in permanent physical disposition: all worked in multi-coloured crayon and fabric dyes on sheets of paper 30 by 25 cm. The 1,320 units of *Paradise Garden*, 1968–70, were inspired by the sight of Central Australia blooming after rain in 1967. *Snake* (1,644 units) comes from the Aboriginal dreamtime's 'rainbow serpent' stories. *'Little Shark'* is described by Daniel Thomas in 'Sydney Opera House: the works of art', *Art and Australia*, March 1974, p.262.

THAMES MORNING [1962] ▷
Polyvinyl acetate on hardboard
121.5 x 121.5 cm
Inscribed l.r.: 'Nolan'
verso: 'THAMES MORNING/Nolan'
Private collection

Exhibitions: Pieter Wenning Gallery, Johannesburg, April 1976, no.7: 'Thames morning', illus.

Nolan has very rarely painted England. In 1957 one of the 'round-the-world' subjects commissioned by Qantas was the River Thames at Tower Bridge.[1] Five years later he takes a wider and far more atmospheric view of the city shrouded in mist. 'Paint is the subject that gives rise to recognizable objects', as has been said of J.M.W. Turner. Nolan's London is majestically Turneresque and subtly Whistlerian at the same time.

1. Reproduced in Christie's Australia sale catalogue, 1 March 1973, pl.XI. He has said that to some extent the 'Leda' series, especially the works in predominantly green tones, are his paintings of England; also some of his most recent abstract compositions in greens, blues and greys (conversation with the author, June 1986). Tucker's 'Thames' series of 1957—dramatic collages of thickly paint-encrusted rags—make an interesting comparison; e.g. Uhl 1969, pl.24.

CONVICT [1962] ▷
Oil and enamel on hardboard
151 x 121 cm
Inscribed l.r.: 'N'
Private collection
Exhibitions: *British Painting in the Sixties*,
Tate Gallery, London, 1–30 June 1963,
no.84: as 'Man with Arms behind his
Head, 1962—Lent by Marlborough Fine
Art Ltd', illus.

△
MRS FRASER AND CONVICT [1962–64]
Oil and enamel on hardboard
151 x 121 cm
Inscribed l.r.: 'N'
verso: 'Mrs Fraser and Convict
1964 [*sic?*]'
Private collection

Exhibitions: *Australian Painting and
Sculpture in Europe Today*, Folkestone
and Frankfurt-am-Main, April–July 1963,
no.1: 'Convict and Mrs Fraser', illus.;
Arts Club of Chicago, December 1964–
January 1965, no.31, dated 1963; Darm-
stadt, 1971, no.26, dated 1962, illus.;
Dublin, June–July 1973, no.39, as 1962,
illus.; Marlborough Galerie, Zurich,
October–November 1973, no.7 as 1962;
Stockholm, 1976, no.44 as 1964; Folkes-
tone, 1979, no.61

In June 1964 plans were made for an
opera inspired by Nolan's Eliza Fraser
story: librettist Patrick White, composer
Peter Sculthorpe, designer Sidney Nolan.
A year later this team was disbanded
and White replaced by Alan Moorehead
and Roger Covell. The work, commis-
sioned by the Australian Elizabethan
Theatre Trust for the opening of the
Sydney Opera House (then projected
for 1969!), was never completed.[1] This
painting is a far gentler and more sympa-
thetic portrayal of Mrs Fraser and her
convict than most of Nolan's. It is repro-
duced on the cover of the *A Fringe of
Leaves*, White's historical novel of 1976
on the same theme. The film *Eliza Fraser*,
written by David Williamson, produced
and directed by Tim Burstall, was
released in 1976.[2]

1. See Michael Hannan, *Peter Sculthorpe, his
music and ideas 1929–1979*, University of Queens-
land Press, St Lucia, 1982; the idea evolved over
many years, culminating in Sculthorpe's *Rites of
Passage*—first staged at the Opera House in
September 1974.
2. Hexagon Productions Pty Ltd; starring
Susannah York, John Waters, Trevor Howard.
Kenneth Cook's *Eliza Fraser*, Sun Books,
Melbourne, 1976, is based on Williamson's
screen play.

GALLIPOLI 1963
Oil on hardboard—two panels
Each 156.5 x 239.5 cm
Each signed l.r.: 'NOLAN'
Australian War Memorial
Presented by the artist

Exhibitions: *British Painting in the Sixties*,
Tate Gallery, London, 1–30 June 1963
and tour, nos 85 and 86: as 'Painting,
1963—Lent by Marlborough Fine Art
Ltd'; *Pittsburgh International*, Carnegie
Institute, October 1964–January 1965,
no.7: 'Gallipoli II, 1963—Lent by Marlbor-
ough Fine Art'; Arts Club of Chicago,
December 1964–January 1965, no.27:
'Gallipoli, panel I' lent by Marlborough,
London; A.G.N.S.W. etc.,1967, no.121;
Nolan's Gallipoli, Australian War Memo-
rial, Canberra, April 1978 and tour,
no.98, a and b

'The Price'

Dead figures writhe and beckon in my
 dream;
 Wild eyes look into mine;
While I, bewildered, watch the bloody
 stream
 With misty eyes ashine.
It rends my heart, and I am nothing loath
 To have the murder cease.
Horror it is and carnage, yet are both
 Part of the price of peace.

- Corpl Comus, 2nd Bat., A.I.F., *The Anzac Book*, 1916

△
*Early sixteenth-century copy of Michelangelo
Buonarroti's cartoon for his* Battle of Cascina
*fresco in the Palazzo Vecchio, Florence (grisaille
on paper, collection of the Earl of Leicester,
Holkham Hall); as reproduced in many books on
High Renaissance art.*

By the mid-1960s, whilst Nolan was still painting his Gallipoli in London or America, a very different re-examination of the Anzac legend was taking place in Australia. Best exemplified, perhaps, in Alan Seymour's play *The One Day of the Year*, this amounted to wholesale rejection by the new generation of young Australians of any form of chauvinistic patriotism.[1]

Nolan's work is neither chauvinistic nor emotional, however. In this vast diptych flesh and blood soldiers, the real overlapping the mythical, the strong holding the weak, sink or swim towards inevitable destruction.[2] The staring face in the lower left corner is a tribute to the pointless death of his own soldier brother, drowned in 1945. He was also inspired by F.T. Prince's poem 'Soldiers Bathing', written in 1954:

The sea at evening moves across the sand,
And under a sunset sky I watch the freedom of a band
Of soldiers who belong to me: stripped bare
For bathing in the sea, they shout and run in the warm air.
Their flesh, worn by the trade of war, revives
And watching them, my mind towards the meaning of it strives.

All's pathos now. The body that was gross,
Rank, ravening, disgusting in the act and in respose,
All fever, filth and sweat, all bestial strength
And bestial decay, by pain and labour grows at length
Fragile and luminous. 'Poor bare forked animal'...

He plays with death and animality,
And reading in the shadows of his pallid flesh, I see
The idea of Michelangelo's cartoon
Of soldiers bathing, breaking off before they were half done
At some sortie of the enemy, an episode
Of the Pisan wars with Florence...[3]

The composition derives in part from 'Michelangelo's cartoon of soldiers bathing' — *The Battle of Cascina*, 1504–06 — perished long ago but well-known to posterity through copies. Nolan selected *Gallipoli* as his 'best or most characteristic work of the sixties' for exhibition at the Tate Gallery in 1963.[4]

1. *The One Day of the Year* was first staged in 1960; first published 1962.
2. Nancy Borlase, *The Sydney Morning Herald*, 26 April 1980.
3. Extract from poem by Frank Templeton Prince, printed in full in *The Penguin Book of Contemporary Verse 1918–60*, ed. Kenneth Allott, Harmondsworth, 1962, pp.249ff.
4. *British Painting in the Sixties*, Tate Gallery and tour, catalogue introduction.

ZEBRA [1963] ▷
Oil on hardboard
152 x 121 cm
Inscribed l.l.: 'N—'
Private collection

Exhibitions: *African Journey*, Marlborough Fine Art, London, May 1963, although not included in the catalogue; A.G.N.S.W. etc., 1967, no.116

'The main thing that struck me, the first time I saw the animals in their free state, is that they look like new works of art— shining as if they'd just been painted by someone whose name I didn't know. Then I realised that they were beautiful, and marked in the way they are, so that they can look at each other; and for the first time I understood that they must have an aesthetic sense too, and that in painting them I merely hope to partici pate in this thing between them ... The fascination of going to see a zebra or a gazelle is the fascination of discovering a perfected shape.'
- 'Nolan in Africa', *Queen*, 24 April 1963

Visiting Kenya in the autumn of 1962, Nolan spent ten days in the Serengeti National Park.[1] Great herds of animals in migration were like the prehistoric cave paintings of Lascaux come alive, he said. The series of animal paintings which he produced during the following year are worked in washes of oil paint on primed hardboard, scuffed and polished with a cloth (e.g. a piece of nylon stocking) to define the main shapes. Details are touched in with strokes from a more heavily loaded brush. 'These animals have a message for us in that they are unique', he said at the time, '—the message will become fossilized as the species die out'.[2] Both this feeling of ephemeral wonder and the sense of animals in motion are evoked by the technique itself: 'a fuzz of colour, a dyed streaky ground, texture achieved through the pigment, finally a deft stroke ... to mark out the essential characteristic hiero-glyph'.[3] As observed in *The Arts Review*, 'Seldom, perhaps has the fugitive nature of the wild creature been so excellently conveyed, nor so much essential feeling extracted from the confrontation of man and beast'.[4]

1. See Adams 1987 for a detailed account of this journey. I am most grateful to Mrs Doria Block, with whom the Nolans often stayed in Nairobi, for additional information.
2. Quoted in *Queen*, 24 April 1963, pp.85f. He explained his technique in *Time*, 26 April 1963.
3. *The Observer*, London, 12 May 1963; the reviewer added that in a few examples Nolan ran 'an ever-present risk of the wrist outrunning the heart and mind'.
4. Anthony Retallack, 'Sidney Nolan', *The Arts Review*, 4–18 May 1963.

△
ELEPHANT AND MOUNTAIN [1963]
Oil on hardboard
152 x 121 cm
Inscribed l.l.: 'N'
verso: 'Nolan/Elephant/& Mountain'
Private collection

Exhibitions: *African Journey*, Marlborough Fine Art, London, May–June 1963, no.21: 'Elephant and Mountain', illus.; *Australian Painting Today*, for exhibition in Australia and Europe, September 1963–December 1965, no.52—n.f.s.; A.G.N.S.W. etc., 1967, no.115; Folkestone etc., 1970, no.40; Dublin, 1973, no.4; Stockholm, 1976, no.43; Paris, 1978, no.13; Folkestone, 1979, no.50; 'Lanyon', 1986–87, no.5, illus.

'Certain things hit me each day, and I write them down in my diary. Quite simple things. One finds that an ele-phant's skin looks like raw silk. This might not mean anything to anyone else, but it has the effect of taking me back to that moment, that second when I saw that particular elephant—always; even in twenty years' time it will take me back. But I don't do a drawing of it at all—I just use this kind of memory aid.'
- Nolan, interviewed by Noel Barber, London, 1964

Nolan has always been fascinated by elephants. They appear in several 'African Journey' oil paintings and works on paper: huge, gentle silhouettes which can move so quietly. Nolan's creatures are camouflaged in their landscape; dissolved and integrated into the whole surface of the painting.

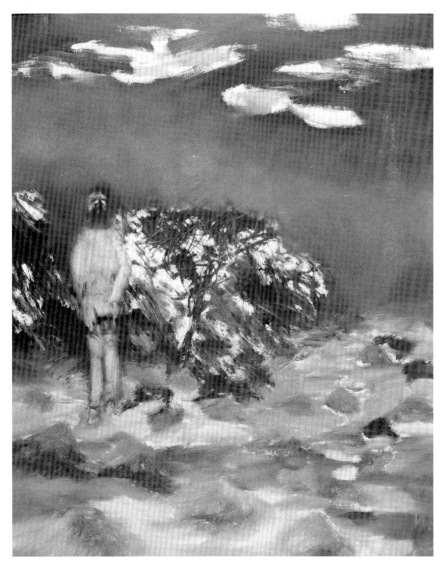

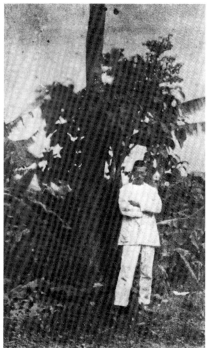

Arthur Rimbaud at Harar
Photograph: State Library of Victoria

△
RIMBAUD AT HARAR 1963
Oil on hardboard
153 x 122 cm
Inscribed l.r.: 'N'
verso: '16 Feb 63/Nolan/No. 3'
Private collection

Exhibitions: *African Journey*, Marlborough Fine Art, London, May–June 1963; *Nieu Realisten*, Gemeentmuseum, The Hague, 1964; *Pop Art, Nouveau Realisme...*, Palais des Beaux Arts, Brussels, 1965; A.G.N.S.W. etc., 1967, no.109; Stockholm, 1976, no.35; Paris, 1978, no.12; 'Lanyon', 1986–87, no.4

'The common denominator of all of us Australian painters is a concern with the figure in the landscape. It seems a peculiarly Australian trait, and I think it gives a poignancy to all our work.'
-Nolan, in *Time Magazine*, 26 April 1963

Nolan visited Dar Es Salaam, travelled north to Lake Rudolf near the Ethiopian border; and then on to Harar—in the footsteps of Arthur Rimbaud who had settled there in 1880 and remained in Africa for eleven years. This painting was admired by a number of critics when first exhibited in London in 1963. 'The flare of tattered clouds and brilliant hummocks in a vision of Rimbaud is an example which finds correspondences in that poet's *Une Saison en Enfer*', said *The Spectator* (24 May). Nolan's 'headlong impulsiveness' was praised (not unlike Rimbaud's own, perhaps). Comparison was made with 'the atmosphere of hallucination and terror' in works by Francis Bacon.[1]

In 1942 Nolan had described the poet as bearing 'the birthmark of an angel, naked and possessed'.[2] As he now explained in *Time*, the theme of 'man in an extreme environment' is paramount in his art. His painting, with its brutal *mélange* of acid colours, far transcends the famous photograph of Rimbaud's alcoholic self-exile in poverty stricken Harar—'cut off from all intelligent society'. Paul Verlaine presumed his former lover was already dead; and published *Les Illuminations* in Paris in 1886.

1. Edward Lucie-Smith, *The Listener*, 23 May 1963; some of the apes and a screaming gorilla are notably comparable; see Lorenza Trucchi, *Francis Bacon*, Thames & Hudson, London, 1976 and Michel Leiris, *Francis Bacon*, Phaidon, London, 1983.
2. *Angry Penguins* 4, p.44.

△
A meteorologist in Sir Douglas Mawson's Australasian Antarctic expedition 1911–14 Photograph by Frank Hurley: The Mawson Institute for Antarctic Research, University of Adelaide Il trovatore at the Sydney Opera House, 1983 Photograph by courtesy of The Australian Opera

CAMP 1964 ▷
Oil on hardboard
122 x 122 cm
Inscribed l.l.: 'N'
l.r.: '9 Sept 1964/Nolan'
Private collection

Exhibitions: Marlborough-Gerson Gallery, New York, January 1965, no.5: 'Camp', illus.; Australian Galleries, Collingwood, September–October 1965, no.11: 'Camp'; Stockholm, 1976, no.46; 'Lanyon', 1986, no.15, illus.

'We shall march on the depot with or without our effects, and die in our tracks.
 24 March 1912 ...
Since the 21st we have had a continuous gale; ... outside the door of our tent it remains a scene of whirling drift. I do not think we can hope for any better things now. We shall stick it out to the end but we are getting weaker, of course, and the end cannot be far. It seems a pity but I do not think I can write more.
 R. Scott
For God's sake look after our people.'
- Last diary entries of 'Scott of the Antarctic',
 March 1912

'Nothing decays in this pure icy air, nothing rusts. You can walk into Scott's hut and find after half a century his tobacco pouch with the tobacco still smokable, his boxes of biscuits and preserved meats still fresh and his writing materials lying as he left them on his table.'
- Alan Moorehead, January 1965

The human history of the Antarctic is very short: first sighting probably 1820, first confirmed landing only in 1895. Historical drama mingles in these paintings with the excitement of Nolan's entirely new visual experience. He had seen photographs of the British expedition of 1907–09 under Ernest Shackleton. He knew the story of Captain Robert Falcon Scott, reaching the south geographical pole only to find the Norwegian flag already flying; and of Oates, walking into the blizzard to die alone rather than hold back his companions. Documentary photographs of the first Australasian polar expedition show Douglas Mawson and his men with their beards and woollen balaclavas fused into helmets of ice, their faces covered by a solid mask of frozen breath.[1]

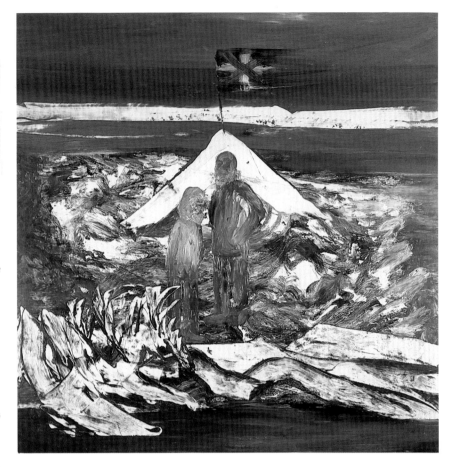

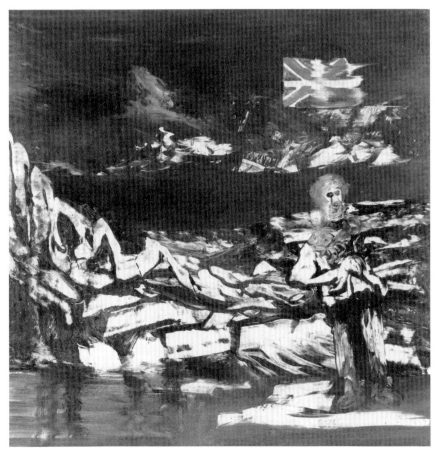

1. See Frank Hurley, *Shackleton's Argonauts*, McGraw-Hill, Sydney, 1979; Elspeth Huxley, *Scott of the Antarctic*, Weidenfeld & Nicolson, London, 1977; Sir Douglas Mawson, *The Home of the Blizzard: being the story of the Australasian Antarctic expedition 1911–14*, Rigby, Adelaide, 1969; Colin Heath, *Australians in Antarctica*, Methuen, Sydney, 1984.

146

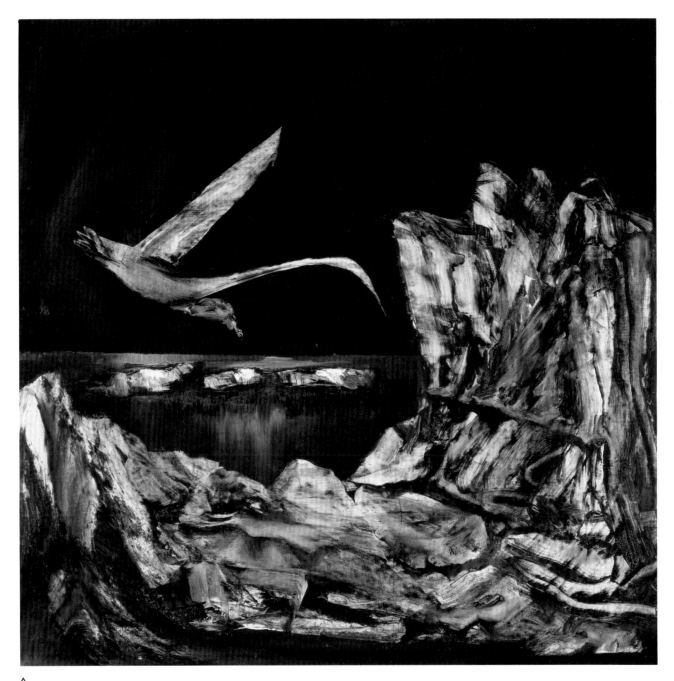

△
BIRD 1964
Oil on hardboard
122 x 122 cm
Inscribed l.l.: '14 Sept 1964/Nolan'
Private collection

Provenance: The artist, through Australian Galleries, November 1965; private collection, Melbourne

Exhibitions: Australian Galleries, Collingwood, September–October 1965, no.9: 'Bird'

'It is black, ochre, dark green and blue, with an oyster-coloured sky and an indigo sea. The colours appear as if under intense moonlight.'
- Nolan, describing the Antarctic landscape in *The Australian Women's Weekly*, 15 September 1965

◁ANTARCTIC CAMP 1964
Oil on hardboard
122 x 122 cm
Inscribed l.l.: '9 Sept 1964/Nolan'
verso: 'Antarctic Camp/Nolan/1964'
Private collection

Provenance: Lister Gallery, Perth; private collection, Perth

Exhibitions: Marlborough Fine Art, London, May 1965, no.16: 'Antarctic Camp', illus.

'These grim themes could easily be oppressive, and it seems to me to be something of an achievement that Nolan reveals that they are not really so. After all, the explorer came to these wastes in pursuit of a vision—himself where no one had ever been before—and what he saw was wonderful. It was not necessary to conquer. To see was enough—to see and to comprehend that both ice and desert were larger than man and that they

possessed a rhythm and a poetry of their own. If it was Nolan's object to put you in the explorer's eye and give you a part at least of his vision then I think he has succeeded admirably.'
- Alan Moorehead, January 1965

Eight days in Antarctica fuelled Nolan's imagination for some months of painting later in 1964. He and Alan Moorehead went as guests of Rear Admiral J.R. Reedy, Commander of the U.S. Navy Antarctic Support Force; flying from Christchurch, New Zealand, to the American base on McMurdo Sound in mid-January. Nolan took a box of watercolours and two hundred blank postcards to record his impressions during the helicopter tour of several research stations including the South Pole. The finished paintings are worked in oil mixed with an alkyd gel medium, instead of the usual linseed oil and turpentine.[2] Sometimes

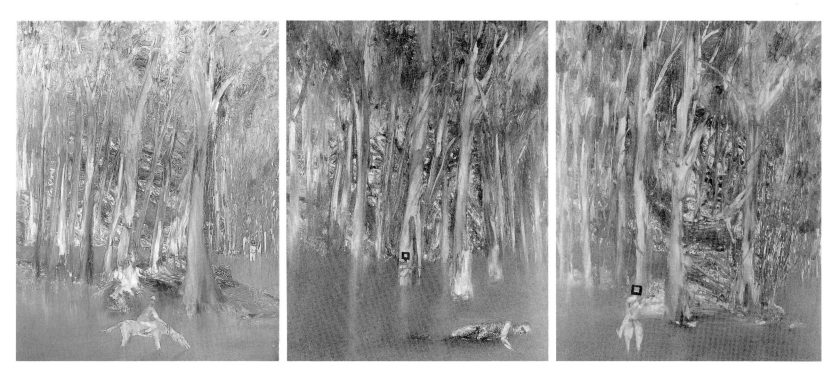

Nolan employed the scraping back technique used previously with P.V.A. In other passages the paint is as thick and ragged as the savage glacial land scape itself: repellent and absolutely inimical to man.

Nolan remembers arriving with a 'cliché idea' of the landscape as 'rather a flat enormous paddock across which dogs would run'; haunted by the spirits of Shackleton, Scott, Bird and Mawson, of whom he had read as a boy. He found instead 'a majestic kind of great conti-nent': the coldest, highest, driest and windiest on earth, covering some four-teen million square kilometres (almost twice the size of Australia). 'And the fearful nature of the continent which one had imagined didn't come across as fear', he says: 'This instantaneous fear at the first glimpse of it, that it would annihi-late one ... was overcome straight away by the sense of wonder at it. You know it was so remote, so big, and in a way so beautiful that this swept over any fear you had, and there was a kind of feeling at the back of my mind that if one had to die there, in one way it wouldn't be so bad. It represented a reality stronger than oneself'.[3]

Nothing green grows in the Antarctic; Mount Erebus looms menacing against the dark sky. Nolan is still fascinated by the paradox of inseparable dread and wonder engendered by this icy land.[4]

1. Moorehead was preparing a series of articles for *The New Yorker* and planning his book *The Fatal Impact, an Account of the Invasion of the South Pacific 1767–1840* (Hamish Hamilton, London, 1966); he proposed the Antarctic venture to Nolan in 1963 when they were both at the Adelaide Festival.
2. Letter to Daniel Thomas, from New York, 10 January 1966. Some fifty paintings are dated over a period of eighteen months from about April 1964.
3. A.B.C. radio broadcast, 23 March 1964. Moorehead described his response to the landscape in very similar terms (1965, p.5).
4. Conversation with the author, June 1986. His interest was especially rekindled by the Air New Zealand disaster when a tourist plane crashed into Mount Erebus in November 1979, killing all 257 passengers and crew.

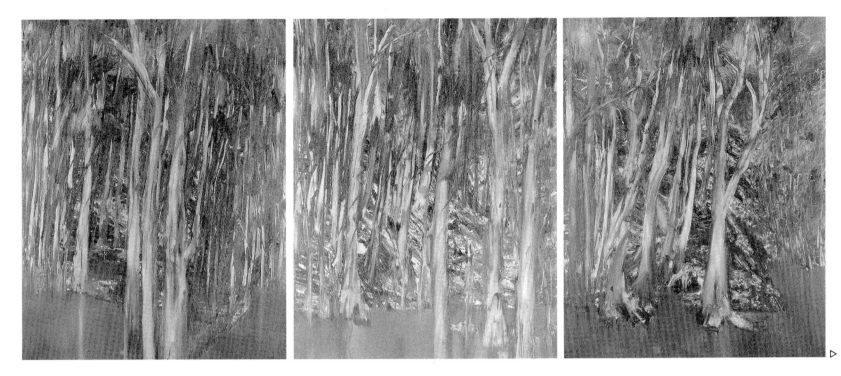

'THE DISPLAY'—DESIGN FOR
STAGECLOTH [1964]
Wax crayon and paint on paper
mounted on cardboard
50.3 x 63.3 cm
Inscribed l.r.: 'Nolan'
verso: 'Nolan/(Canberra)' and staging
instructions in another hand
Private collection
For exhibition in Melbourne only
Provenance: Gift of the artist

Nolan has called the ballet 'a ritual
description of our civilization'.[1] *The
Display* was his first design project for
an Australian work—choreographed by
Sir Robert Helpmann and composed by
Malcolm Williamson for The Australian
Ballet. Kathleen Gorham, Garth Welch
and Bryan Lawrence were the leading
dancers for its Adelaide Festival pre-
miere in 1964.[2] Several critics considered
Nolan's sets and costumes, designed in
London in December the previous year,
to be the most impressive aspect of the
whole production: his inventive use of
gauzes, with lighting by William Akers,
transformed the stage into a mysterious
deep green rain forest. There were
twenty curtain calls on opening night.

Nolan himself was so pleased with
the total effect that he executed a number
of small paintings of the production. *The
Display* subsequently toured to Mel-
bourne (October 1964), Canberra,
London, Liverpool, Glasgow and else-
where overseas. Plans are afoot for its
inclusion in The Australian Ballet's bi-
centenary season in 1988.[3]

1. *Time Magazine*, 16 April 1965.
2. This coincided with his 'African Journey'
exhibition at the Bonython Gallery, exhibitions
by Boyd and Drysdale, and Patrick White's new
play *Night on Bald Mountain*. See *Airways
Magazine* 30, 9, September 1964; *The Illustrated
London News*, 25 September 1965. Boyd had
designed *Elektra* for Helpmann in 1963, using
painted bodysuits reminiscent of Nolan's *Rite of
Spring* costumes.
3. I am indebted to Bill Akers for information.

△
RIVERBEND 1964–65
Oil on hardboard—nine panels
Each 153 x 122 cm
Inscribed chronologically l.l.: '27 Dec
1964/Nolan' and l.r.: 'N'; l.l.: 'N—/28 Dec
1964/Nolan'; l.l.: 'N—/28 Dec 1964/
Nolan'; l.l.: 'N—/29 Dec 1964/Nolan'; l.l.:
'N—29 Dec 1964/Nolan'; l.l.: '10 Jan
1965/Nolan'; l.l.: '12 Jan 1965/Nolan'; l.l.:
'12 Jan 1965/Nolan'; l.r.: '14 Jan 1965/
Nolan'
Australian National University
Acquired with assistance of donations
from John Fairfax Ltd, Dalgety Australia
Ltd, Associated Securities Ltd, Carlton
and United Breweries Ltd, The British
Petroleum Company of Australia Ltd,
Darling and Company Ltd, Peddle Thorp
and Walker, Consolidated Gold Fields of
Australia Ltd 1967–68

Exhibitions: *Recent Paintings (1964–65)*,
A.N.U. and Department of the Interior,
Canberra, August–September 1965, nos
1–9; David Jones' Art Gallery, Sydney,
May 1965, nos 5–13; Shepparton Art
Gallery, February 1966; A.G.N.S.W. etc.,
1967, no.137; Blaxland Gallery, Sydney,
March 1973; A.G.N.S.W., March–May
1981

A second version of *Riverbend*, painted
a year later, was reproduced as a series
of nine limited edition photo-lithographic
prints in January 1982

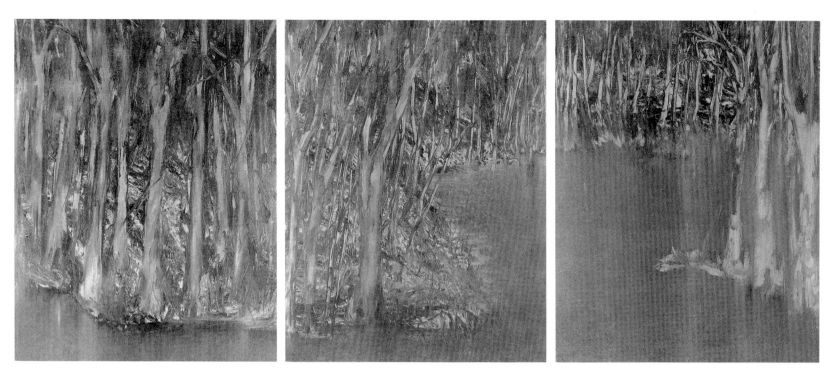

'The painting is a combination (in my mind) of the Goulburn River, at Shepparton where I spent my boyhood holidays, and the Murray. It is very much my father's country ...'

'I can still evoke in myself, in my studio on the Thames, the river that I saw as a boy. A big long river, with the sun coming through the leaves, the vertical leaves of the gum trees. I've never seen it anywhere else ...'
- Nolan, interviewed in London, *The Listener*, 13 November 1969

'Nine panels ..., it engulfs one in its own world, just as Monet's waterlilies in Paris do. It is a compelling image of extension, the flat endlessness of Australian landscape which contains only one long, slow river, give or take a tributary.

Since a stately river ... is such an uncommon feature of Australian experience, it is a proper starting point for myth. Among the relentless giant march of purple, crackled tree trunks along its banks dart tiny, spotted, insect intruders, in and out of the water: Kelly and the police, antagonists fulfilling their necessary roles as nature spirits enmeshed in this tree and water barrier.'
- Daniel Thomas, *The Sydney Morning Herald*, 8 March 1973

Nolan produced about twenty-five Ned Kelly paintings in preparation for this nine-panel *tour de force*—almost eleven metres in total length.[1] *Riverbend* was the first of his series of great polyptyches of the mid-1960s. Kelly and his policeman are now insubstantial, wraith-like figures; subordinated to the colours and textures of the bush. The air is uncannily still. Their drama unfolds like a slow motion dream sequence. Kelly's helmet, immediately recognizable and now familiar in almost any language, is just a tiny black square—a pictorial punctuation mark. 'One reads such long horizontals', says Daniel Thomas, 'one cannot grasp them as a visual unity, and in this they resemble oriental hand scrolls, in which writing and painting are not firmly differentiated as art forms'.[2]

Nolan has never been afraid to use story to shape and influence the direction of his art. Anecdotal elaboration is here reduced to a minimum. Nevertheless, his whole conception deliberately ignores the pictorial intellectualism of its 'period'. In 1965, as Lynn points out, contemporary painting was in the midst of a wave of abstraction of simple structures, uniform colour and Pop and Op art that relied on commercial art's meticulous means.[3] John Henshaw agreed, when *Riverbend* was seen in Nolan's Australian retrospective in 1967, that such 'lush romanticism' was an aesthetic refuge for viewers 'from the boredom of hard edge'.[4] Nolan places all his faith in his own imagaination. Henshaw observed that the diminutive protagonists seem almost 'absorbed' by nature. And yet, he continued: 'Allusion, suggestion, ever-present fantasy conjured up long after the visual experience has passed, in no way affect Nolan's astonishing ability to convince the spectator that what he presents is real.'

1. Lynn 1979, p.130. Nolan explains that these paintings, same size and media as the panels of *Riverbend*, formed 'a prolonged search of how to get a stereoscopic effect of the bush against a mottled background'; he was assisted by Cézanne's solution in *Dans le parc du château* in the London National Gallery. His second version of *Riverbend*, in oil on canvas, is dated 30 December 1965–3 January 1966, painted in New York; still in the artist's own collection, it has been shown in numerous international exhibitions.
2. *The Sydney Morning Herald*, 9 September 1967; see also Lynn 1967, p.28.
3. Lynn, op.cit., p.46.
4. *The Australian*, 16 September 1967. The nine panel polyptyches *Inferno* (q.v.) and *Glenrowan*, 1966 (now at the Carnegie Institute, Pittsburgh) were also included in that exhibition.

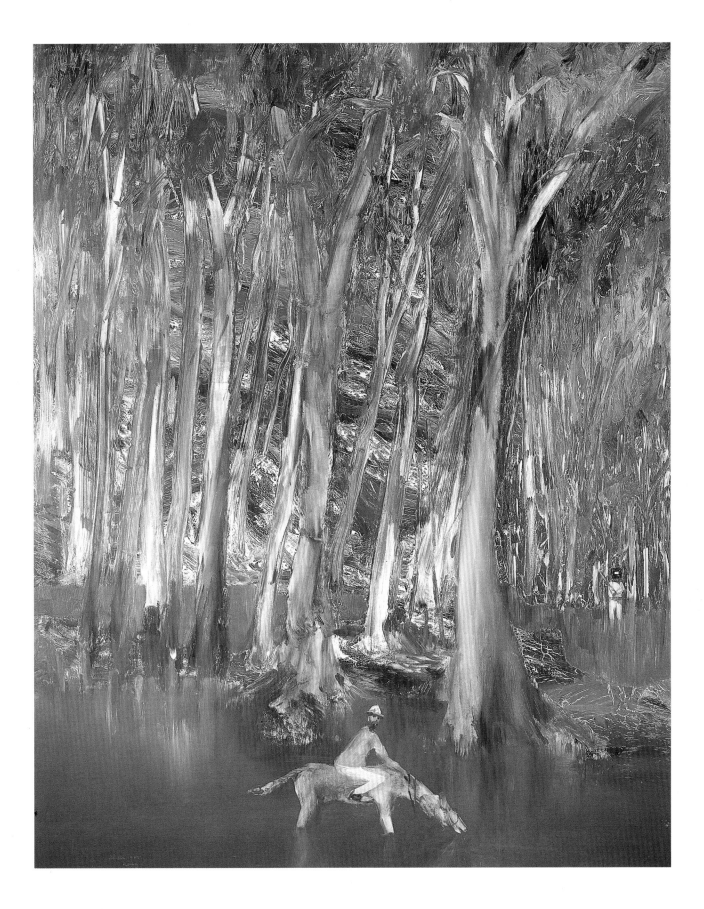

(detail)

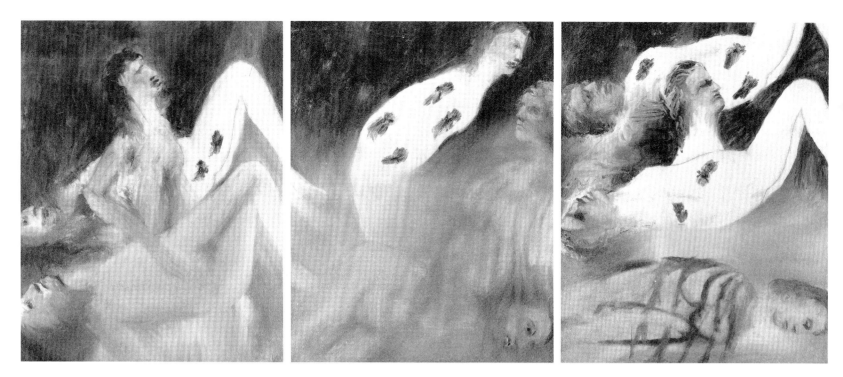

INFERNO 1966
Oil on canvas—nine panels
Each 153 x 122 cm
Inscribed chronologically on four of the
panels—l.r.: '10 March/1966 Nolan'; l.c.:
'13 March 1966/N'; l.l.: '14 March 1966/
Nolan'; l.l.: '16 March 1966 Nolan'
Art Gallery of South Australia
Loaned anonymously

Exhibitions: San Antonio, Texas, January–
February 1967, nos 39–47: 'Inferno';
A.G.N.S.W. etc., 1967, no.138, illus.;
Marlborough Fine Art, London, May
1968, no.2, illus.; Folkestone etc., 1970,
no.52; Darmstadt, 1971, no.40; Dublin,
1973, no.56; *Festival Exhibitions*, A.G.S.A.,
1974; Perth Festival (*Ern Malley Collec-
tion*), February 1982, no.20; *Adelaide's
Nolans*, A.G.S.A., 1983; *Sidney Nolan: the
city and the plain*, N.G.V., 1983, no.68

Published as a set of nine screenprints
by Marlborough Graphics, London,
in 1967

'I did this panel from Lowell's version of
"The Trojan Women", in which he says
that the women were stacked in the
streets like firewood; but even though
you have such thoughts as these, you
are making a painting and it can't be too
terrible. The women, instead of
remaining stacked like firewood, started
to float and in the end I felt they were like
Dante's souls in hell, all wheeling round
like birds, so I changed the title to
Inferno.'
-The artist, 1967

'There is a reluctance to own up to the
deepening sense of the tragic that informs
later Nolan ... What taste finds hard to
assimilate is the frequent, apparently
wilful, withdrawal of that lyrical gift and
the substitution of a harsher, more
abrasive language ... Nolan's vision
changes as drastically as his style. This
Nolan is far from the lovable and lyrical
early master.'
- Patrick McCaughey on *Inferno*, in *The Age*,
Melbourne, 17 November 1983

Living and working at the Chelsea Hotel,
New York, in the first half of 1966, Nolan
was fired with an intense burst of creative
energy.[1] He became a close friend of
Robert Lowell—by general critical con-
sensus, the best American poet of his
generation. Lowell's poetry, like Nolan's
painting, 'draws habitually from the
inexhaustible theatre of many mytholo-
gies ... as well as modern life'.[2] The two
men met frequently, preparing illustrated
editions of the poet's work. Many paint-
ings came of this fruitful collaboration,
described in *Time* as 'an oratorio
streaked with images of visceral inten-
sity'. Patrick McCaughey has recently
admired 'the chilling sexual acrobatics'
of *The Vanity of Human Wishes*, a triptych
of canvases inspired by Lowell's *Satires
of Juvenal* and now in the Art Gallery of
South Australia.[3]

The nine panels of *Inferno* began as
Nolan's response to the *Oresteia* trilogy
of Aeschylus as translated by Lowell.
The imagery transformed itself in the
making, however. Nolan had long been
fascinated by 'The Inferno', from Dante's
fourteenth-century poem *The Divine
Comedy*. Thirty-six watercolour illustra-
tions by William Blake were acquired by
the National Gallery of Victoria in 1941.
Dante tells of his journey to the nine
circles of the underworld in which sin-
ners, both historical and mythological,
are meted out punishments to fit their
earthly transgressions. The imagery for

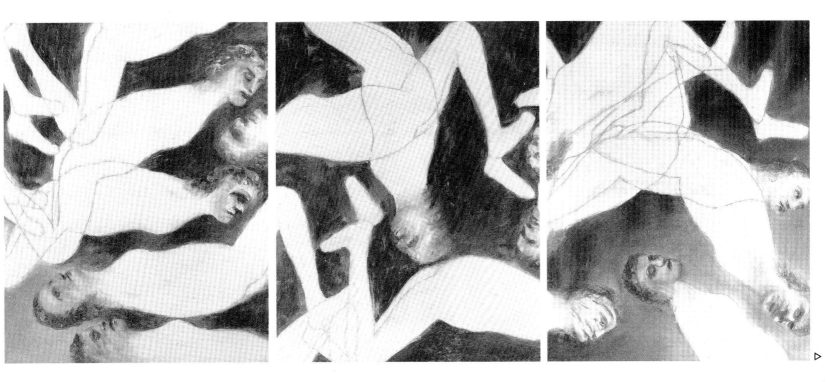

Nolan's polyptych comes from the second circle: the floating figures embody the tale of the lovers Francesca da Rimini and her handsome brother-in-law, Paolo, slain by her vengeful husband. Their souls were assigned to an eternal torment of unrealizable passion; an infinite underworld without gravity, buffeted by hot winds—a hell of their own making.

Dante's imagery is tantalizing, graphic, even pictorial yet his vast and abstract conception of Hell defies precise visualization. Specific tortures—rivers of boiling blood and so forth—have been painted by artists over the centuries: Nardo di Cione in the church of Santa Maria Novella, Sandro Botticelli, Henry Fuseli and Eugène Delacroix are examples. Nolan comes closest in spirit to Auguste Rodin, working on the great bronze relief 'Gates of Hell' from 1880 until his death in 1917; although Nolan's condemned souls are flat and weightless as paper cut-outs by contrast with Rodin's fully rounded forms.[4] *Inferno* has been compared with the Hiroshima panels by Iri Maruki and Toshiko Akamatsu, widely exhibited in the 1950s, which gave the world a new perspective on nuclear catastrophe.[5] By the 1960s, Vietnam was of more immediate concern. And, with figurative 'neo-expressionism' at the forefront of painting in the 1980s, Nolan's parable of human pride and torment speaks with renewed power and relevance.[6]

1. Guests at the Chelsea Hotel, at 222 West Twenty-third Street, have included composers Virgil Thomson and George Kleinsinger, playwright Arthur Miller, poets Dylan Thomas and Edgar Lee Masters and artist John Sloan. Nolan rented one of its penthouses and a large space for a studio on the ground floor.
2. *Time Magazine*, New York, 2 June 1967, pp.35ff.; a critical biography of the poet.
3. *The Age*, 17 November 1983; a number of related paintings remain in the artist's possession.
4. Five posthumous casts now exist of Rodin's *Porte de l'Enfer*. Nolan would have known well the sculpted doors' imagery of bodies in ever-changing perspective, appearing out of an amorphous mass of undefined matter; the overlapping figures standing, kneeling and supine; the barren vine of thorns arising from the figures of female lovers.
5. Reviewed by Robert Hughes in *The Observer*, Sydney, 26 July 1958. The comparison with *Inferno* was made by Hal Missingham in 1967.
6. In 1982 he exhibited a new series of thirty drawings inspired by Dante's 'Inferno'.

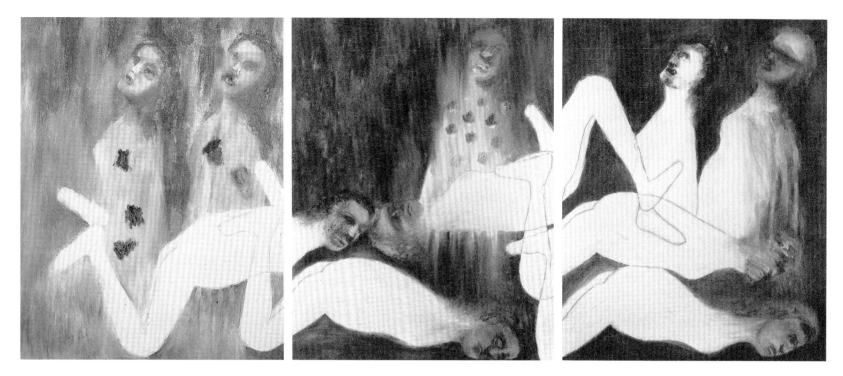

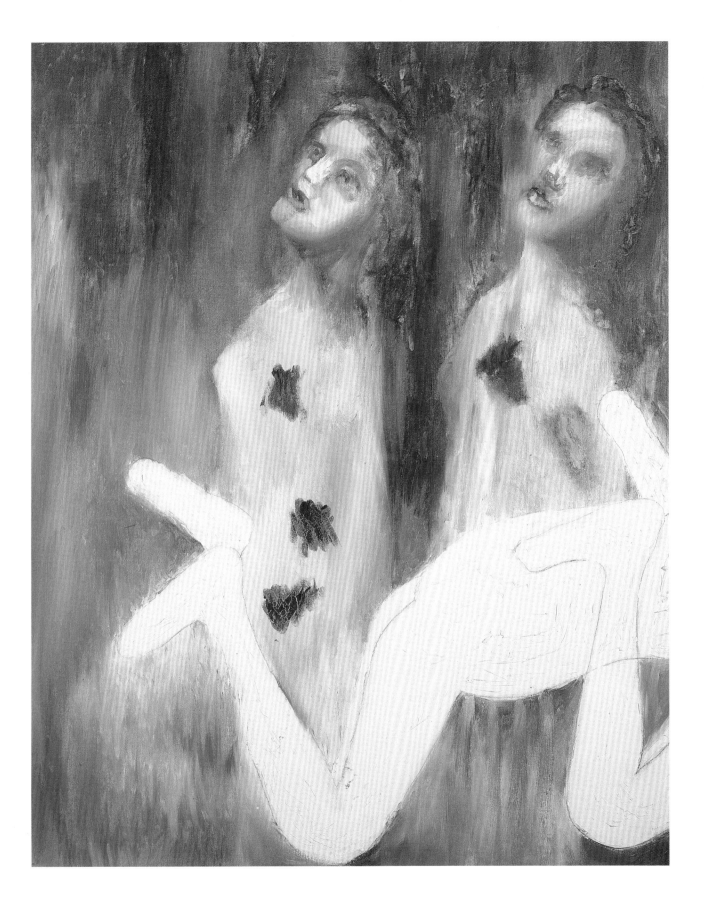

(detail)

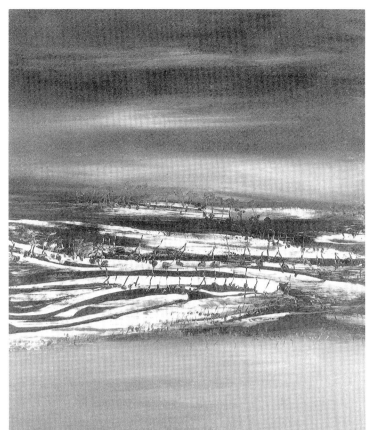
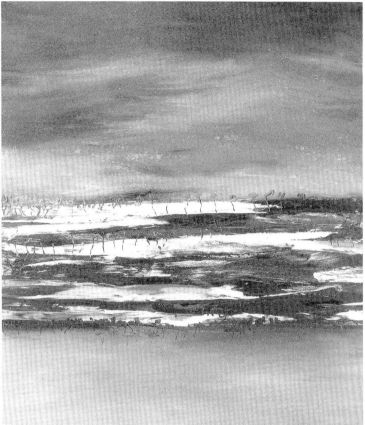

△
LANDSCAPE (SALT LAKE) 1966
Oil on hardboard—four panels
Each 152 x 122 cm
Inscribed (each panel, left to right)—
verso: '① 24 August 1966/Nolan/FOR
PERTH/LANDSCAPE/Set of 4'; (2) verso:
'FOR PERTH/LANDSCAPE/Nolan (Set
of 4) No②/24 August 1966/Nolan'; (3) l.r.:
'N—' and verso: '③ 24 August 1966/
Nolan/FOR PERTH/LANDSCAPE/
(Set of 4)/No ③'
Alcoa of Australia Limited
Purchased 1971

Fourth panel inscribed, l.r.: '24 Aug 1966
Nolan' and verso: 'FOR PERTH/LAND-
SCAPE/No ④/(Set of 4)/24 August 1966/
Nolan/④'
The Robert Holmes à Court
collection, Perth

Exhibitions: Skinner Galleries, Perth,
January 1971, nos 24–27: 'Landscape
(Salt Lake) 1–4'; *The Cairnmiller Institute
Exhibition of Contemporary Art by Aus-
tralian Painters and Sculptors, sponsored
by Alcoa of Australia Ltd*, Georges Gal-
lery, Melbourne, 7–11 August 1973:
panels 1–3; Lauraine Diggins, North
Caulfield, 28 October–7 November 1980,
no.32: panel 4 as 'Storm over the
Kimberleys'

'The panels show great areas of space,
without beginning, middle or end, punctu-
ated but not enclosed by groups of dead
trees and fallen logs, by river-shallows
and flats, by flood, and the wreckage of
forests. The unity ... comes from within
and not from without. The motif is form-
less, chaotic: the paintings create order
out of this formlessness.'
- Catalogue introduction, *Sidney Nolan 40–70*,
Skinner Galleries, Perth, 1971

DROUGHT 1966 ▷
Oil on hardboard–three panels
Each 152 x 122 cm
Inscribed verso: DROUGHT/Drought
Triptych/12/Sep/1966/Nolan/ERN
MALLEY/ 'It seemed we had substituted
The abattoirs for the guillotine'/Perspec-
tive Love Song'
Art Gallery of South Australia
Loaned anonymously

Exhibitions: *Pittsburgh International*,
Carnegie Institute, 1967–68, no.6:
'Drought 1967 [*sic*]—Courtesy of Marlbor-
ough Fine Art Ltd, London', illus.; Skinner
Galleries, Perth, January 1971, no.31:
'Drought 1,2,3'

Screwed up by the sun, held together by
maggots, dehorned and castrated
anyway it stands like a rotting ship struck
by lightning.

The eye is a window to unmoving space,
the brain inside defrauded. Any birth-
marks are made by a whip.

And yet nothing is forever, this universal
victim will not be knocked, it was not
mummified in the belief that God is a
drover.

- Sidney Nolan, 'Carcass', 1971

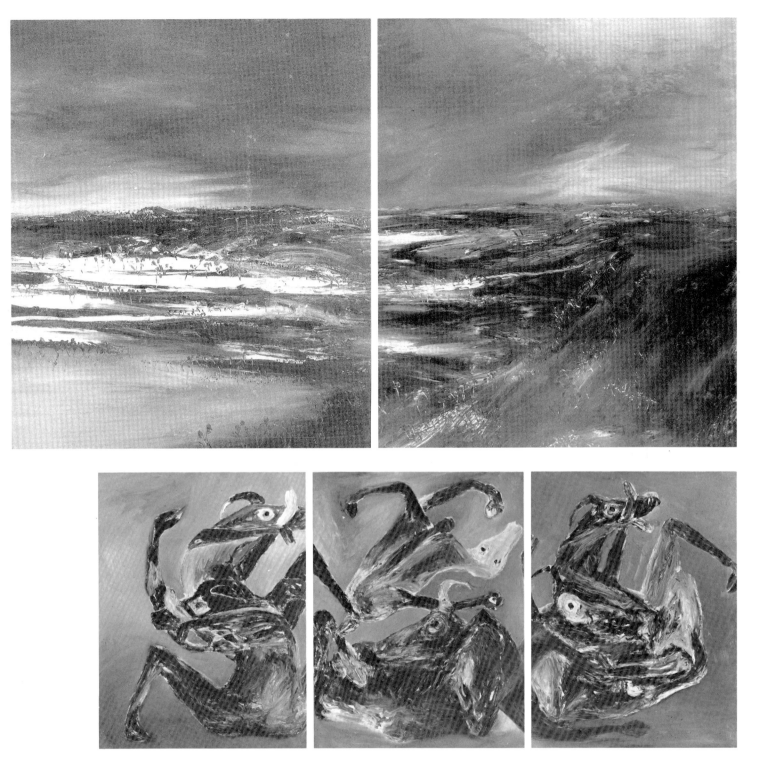

The theme of drought-dessicated car-casses, which has inspired a number of artists, first appeared in Nolan's Austra-lian outback paintings in the early 1950s. In 1971 he wrote several 'notes for poems' associated in his mind with his *'Dust'* series of etchings.[1] In 1973–74, whilst working on a new series of 'Ern Malley' subjects for exhibition at the Adelaide Festival, he re-examined many paintings still in his possession ranging in date from the 1940s to the 1960s. This 'infernal' triptych immediately recalled imagery from the Malley poem 'Perspective Lovesong':

It seems we had substituted
The abattoirs for the guillotine.[2]

1. 'Carcass' is quoted in Lynn 1979, p.188.
2. Interestingly, in his own copy of the Ern Malley poems, the preceding couplet is also marked—noted as recalling *Inferno*. The com-plete text of this first verse runs: 'It was a night when the planets/Were wreathed in dying garlands./It seemed we had substituted/The abattoirs for the guillotine./I shall not forget how you invented/Then, the conventions of faithfulness.'

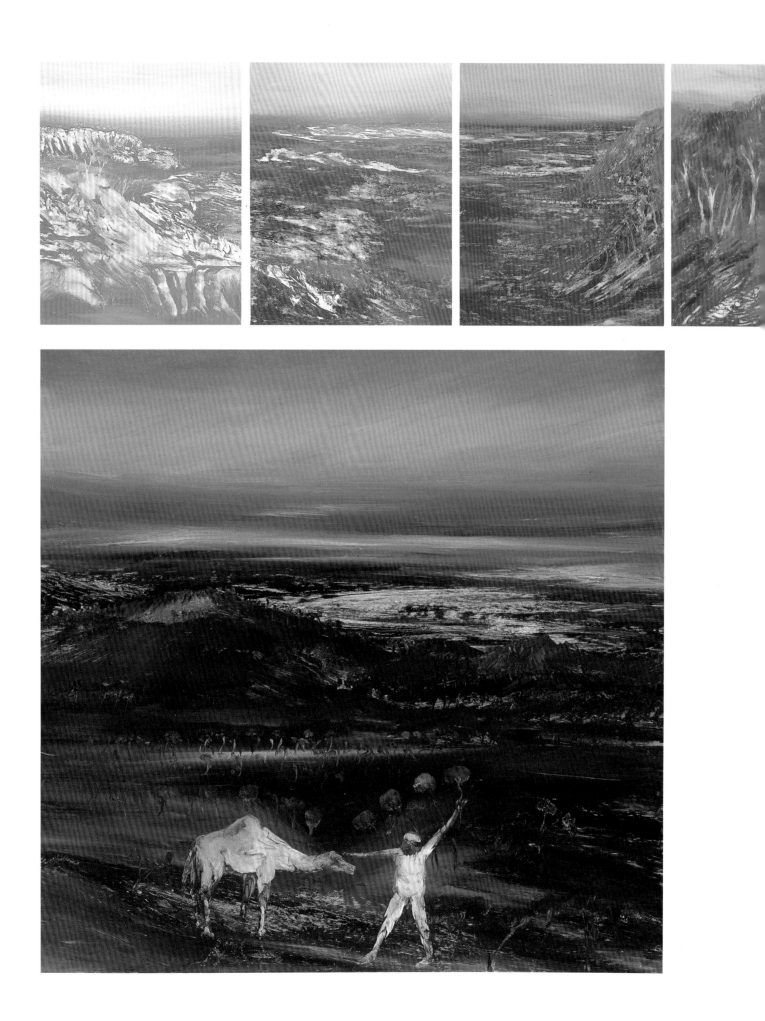

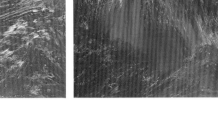

◁ CAMEL AND FIGURE 1966
Oil on hardboard
121 x 121.9 cm
Inscribed l.r.: 'NOLAN/1966'
verso: '20 Sept/1966/Nolan'
The Trustees of the Tate Gallery, London
Presented by The Lord McAlpine of
West Green 1983

Provenance: Lord McAlpine, purchased
from the artist c.1980

Exhibitions: A.G.N.S.W. etc., 1967, no.143;
Folkestone etc., 1970, no.50; Darmstadt,
1971, no.38, illus.; Dublin, 1973, no.54,
illus.; Marlborough Galerie, Zurich, 1973,
no.9, illus.; Stockholm, 1976, no.56; Paris,
1978, no.28; Folkestone, 1979, no.67

This is
Leichardt country,
from the fall of the
Meteor and Dawson;
this is the man
they hated, the earth hated
right up to this mountain,
the trees his name, carved
in the name of Paradise, Purgatory.

Here he watched, with
the white cloud and
stars, calling himself
lover, eater of dingoes.

- Sidney Nolan, unpublished 'Explorer poem', 1940s

Returning to the 'explorers' theme in
1966, Nolan first thought of this naked
figure as Burke (more flamboyant and
more manic than Wills, as he told Ronald
Alley).[1] In fact this is an archetypal
explorer, evoking the absurdity and the
heroism of his ambition at one and the
same time; that persistent and compelling
human longing for 'some wilderness plot,
inviolated by man' which sent Rimbaud
to Africa, Scott to the Antarctic and put
Coleridge on the road to Xanadu.[2]

The white iridescent area in the dis-
tance is a salt lake: actually Lake Frome
north of Adelaide, says Nolan, which was
not on the route taken by Burke and Wills
in 1860. The trees are perhaps reminis-
cent of Mallee scrub around Dimboola.
This desert, its fantastic immensity
brought into being by the paint itself,
seems almost to have turned to mud.

Man and beast are insubstantial, ghostly
figures. They are not painted; but
scraped out of the landscape itself—with
scarcely more than a swish and a dab
from the artist's thumb.

1. Mr Alley, formerly Keeper of Modern Pictures
at the Tate Gallery, is currently working towards
a book on Nolan's painting. His entries on Nolan
for the Tate catalogue are forthcoming; I am
grateful to the Gallery for supplying copies of
their text.
2. Robert Melville, 'The Poetry of Painting',
catalogue foreword, Sidney Nolan, New York,
1965, p.2.

△
DESERT STORM 1966
Oil on hardboard—seven panels
Each 152.3 x 122 cm
Inscribed chronologically—l.r.: 'N/1 Aug
1966/Nolan' and verso: 'PERTH.NO.①/
THE NORTH-WEST [crossed out]/IN
MEMORY OF S.H.N. [the artist's father]';
l.r: '6 Aug 1966/Nolan' and verso: 'FOR
PERTH/NO②/THE NORTH-WEST'; l.r.:
'6 Aug 1966/Nolan' and verso: 'FOR
PERTH NO③/THE NORTH-WEST'; l.r.:
'6 Aug 1966/Nolan' and verso: 'Nolan/
FOR PERTH NO④/THE NORTH-WEST';
l.r.: '8 Aug 1966/Nolan' and verso: 'FOR
PERTH NO⑤/THE NORTH-WEST/8th
Aug./Nolan [signed twice]'; l.r.: '8 Aug
1966/Nolan' and 'NO⑥ FOR PERTH/
THE NORTH-WEST/8th Aug/1966/
Nolan [twice]'; l.r.: '8 Aug 1966/Nolan'
and verso: 'FOR NO⑦/PERTH/THE
NORTH-WEST/8th Aug/1966/Nolan
[twice]'
Collection: Art Gallery of
Western Australia
Purchased 1970

Provenance: The artist, through
Skinner Galleries

Exhibitions: Skinner Galleries, Perth,
February 1970, no.1: 'Desert storm',
illus.; Australian Paintings, A.G.W.A.
south-west touring exhibition, Western
Australia, 1971

'Nolan's great Desert storm does for the
dry, rocky interior of Australia what
Riverbend did for her muddy rivers and
their swampy banks. Paint becomes the
presence of sand, stone outcrop and
scrub. Not the scale simply, but the
texture, the light and the haunting space,
involve the specator totally in the work
in front of him.

The theme of Desert storm is space
and light—and a sudden, suffocating,
red dark. The seductive blue of an end-
less distance draws us on, though it
offers only repetition after repetition of
what we can already see. This blue
space is threatened by the dust-storm
which blows up on the three right-hand
panels. The idyllic desert, beautiful even
when it is baleful, can become an inferno
of grit...

Nolan says that Riverbend "marks the
point at which I decided I couldn't be a
European", and the Desert storm is for
him a proper, an Antipodean, emblem:
it expresses both place, and a situation
of soul...'

- Patrick Aelfred Hutchings, catalogue introduction,
Sidney Nolan recent paintings, Skinner Galleries,
Perth, 1970

A LIVING LEGEND?

Not long ago, Nolan was asked by an Australian customs officer, 'You going to keep doing it till you drop?' He said 'yes' then, that he would always go on painting. In his seventieth year he gives no sign of stopping or dropping; and he is not only painting pictures but writing poetry, making prints, involved with films, designing for the stage, still reading omnivorously, etc. etc. He is something rather rare and unexpected in modern art. As Elwyn Lynn observes, 'he is a supreme entertainer; a new Nolan exhibition is a new performance'.[1]

Style is not the key to Nolan; he has been called 'a one man dictionary of styles'. The moods of his art are equally encyclopaedic, for his is an extremely complicated mind and it is an intensely private art—although so often popularly accessible. As Max Harris points out, 'It's the quality of the performance that counts. Secrecy is an element that can't be discarded in the life of a creative person.'[2]

Nolan has the mind of a poet as defined by T.S. Eliot—'a receptacle for seizing and storing up numberless feelings, phrases, images, which remain there until all the particles which can unite to form a new compound are present together'. Sometimes, it seems, he responds to literature through a deep kinship with the imagination of the writer. On other occasions he simply seizes isolated images which happen to take his fancy. He treats mythology as his own personal property. The same applies to history—ancient and modern. 'When I use a word', said Humpty Dumpty in *Alice through the Looking-Glass*, 'it means just what I choose it to mean'. Ever cautious Alice replied, 'The question is whether you *can* make words mean so many different things'. Sir Sidney Nolan undoubtedly can make *images* mean exactly what he pleases.

Nolan has often been criticized for being too prolific, particularly during the last two decades. In 1982, for example, Peter Fuller of *The Sydney Morning Herald* spoke of 'weak and flippant crayon drawings' and a 'frightening falling away of Nolan's powers'.[3] Terence Maloon wrote more realistically:

> Nolan isn't like the legendary King Midas, but then neither was Picasso. Both Picasso and Nolan have produced huge quantities of slight, hasty, facile paintings and drawings, which have their moments, but tend to crowd-out the erratic masterpieces, and distract from the relatively short bursts of activity when their work really was hot ...
>
> When there's a strong identification with the imagery ... Nolan makes the full force of his sensibility felt, and some wonderful paintings result.[4]

As Mary Eagle has remarked (*The Age*, 12 January 1980), many people who love Nolan's work don't *want* to see the stardust settle or his career soberly laid out. He is 'a leprechaun spinning magical moonshine' and much of the writing on his art has been in the nature of dazzling camouflage.

Nolan is the first to admit that not all he touches turns to gold:

> I must get steamed up with what I'm thinking about as content before I start trying to find forms. The message, if that is not too pompous a word, is the necessary trigger for me ... Finally, I've got to start working—without any forms visible in front of me, with nothing really worked out. One gradually trusts oneself to find them, you know. It's a gamble ... It's a private kind of thing, and the public production and statement is only designed to reach other people's inner ideas. Of course, this means you must be prepared to suffer defeat after defeat as they crop up ... I am never in the position of feeling that I can do anything at will ... This studio has been littered with paintings I've thrown away, destroyed, hidden. But, of course, out of this comes something that one hopes is successful—to oneself. And finally there comes your exhibition, which I like to think of as being the sum of those paintings that I feel haven't defeated me.[5]

Elsewhere he has stated quite categorically that he is 'compelled' to transmit emotions. 'I care for that process so much that I'm prepared to belt the paint across the canvas much faster than it should be belted. I don't care as long as I get that emotional communication.'[6] An attitude which relies so heavily on impulse and chance is doubtless part of Nolan's Irish (and Irish-Australian) heritage. 'Painting is only worthwhile if you don't know the outcome', he has explained, 'When you start painting you must

never know what the end product is going to be. You should end up with something looking at you which you have never seen before.'[7] If people do not like his work, he says, that's *their* bad luck; and one of his mottoes has always been 'Fly with Icarus!' Lord Clark—among the the first to call him a genius—also considered that 'when time has weeded out his colossal output and the didactic snobbery of abstract art has declined, he will be of even greater renown'.[8]

Nolan's greatest strengths may also be his weakness: infinite curiosity, a constant, urgent quest for artistic invention and a passionate love of the actual painting process. Perhaps he tries to do too much. He has always felt that painting and film-making could be thoroughly compatible activities. 'The temptations are only too obvious', he wrote as long ago as 1942, 'Not bounded by four straight lines, color that moves while you watch it, & music at your elbow into the bargain. What could be better?'[9] Some forty-five years later he is also fascinated by computers:

> I read a book on the making of Mad Max III which explains how a kind of laser computer technique provided all the complex structural angles for the models in the Sydney holocaust sequence. It's amazing. I've been working with a souped-up graphic computer to solve problems concerning sets I'm doing for Covent Garden. It gives an infinite number of transformations of images you feed in and you can draw at the same time to alter the images. You can turn them green, red, black, get them rolling and turn them inside out.[10]

He is using this computerized Quantel 'paintbox' for an ambitious suite of prints, to be produced with Alecto Editions for Australia's bi-centenary in 1988. Somewhat ironically, he often speaks these days of 'old painters gaining a sort of serenity'!

In recent years Nolan has been an extraordinarily generous cultural benefactor. 'I'm absolutely determined to spread my appreciation of the enjoyment of art for everyone to understand', he once wrote. Gifts and loans to public institutions are documented throughout this catalogue: to universities, opera companies, performing arts establishments and elsewhere, as well as to museums and galleries. He has presented works to the Australian people through the National Gallery of Victoria, the Art Gallery of South Australia, the Nolan Gallery at 'Lanyon' and the Australian War Memorial. He has donated paintings to Ireland; and envisages regular music festivals at 'The Rodd' in Herefordshire. He and Arthur Boyd plan to bequeath to Australia their property on the Shoalhaven River at Nowra, New South Wales[11]: substantial acreage of that Australian landscape within which his 'legends' have acquired identity and substance—wherever he has lived in fifty years of painting.

According to Robert Hughes, no other Australian artist has so far 'achieved that triumphant integration of allegory, dream and image'. Tucker has called him, 'at his best, one of the finest visual talents in the world today'.[12] Unquestionably, he is a citizen of the world. Yet, despite a high public profile, Nolan remains an enigma. 'What I'm hoping is that I can, having painted quite differently over the last twelve months, start my next decade on a new basis', he says, 'so I don't mind what happens, because I'm already somewhere else'.[13] In the final analysis, there is *no* final analysis; at least not yet—not in 1987—while he strides on so purposefully and unpredictably ahead of all admirers, detractors and humble art historians.

1. Lynn 1967, p.49.
2. 'The Three Faces of Nolan', *The Weekend Australian*, 10 November 1979.
3. 31 July 1982; see also Max Harris in *The Weekend Australian*, 28 February 1982.
4. *The Sydney Morning Herald*, 8 January 1983.
5. Quoted in Barber 1964, pp.94f.; he said much the same in an interview for *The Australian Women's Weekly*, 8 June 1977.

6. Quoted in Adams 1978, p.26.
7. Barber, loc.cit.
8. Clark 1977, p.195.
9. Letter to Sunday Reed from Dimboola, December 1942. Not long afterwards he wrote that he had been studying photographs of electron microscopy at the Y.M.C.A. and colonial art at the Ballarat Gallery, as well as painting and reading (and performing army duties).

10. Interview with Stephen Hope, *Vogue Australia*, April 1986, p.192.
11. Interviews with Liz Hickson, *Woman's Day*, 8 August 1983, p.6 and Janet Hawley, *The Age*, 14 February 1987; and see Adams 1987, pp.242 and 256ff.
12. Conversation with the author, November 1986.
13. Quoted by Robin Hill, *The Sydney Morning Herald*, 31 January 1987.

MINER 1972 ▷
Oil on hardboard
122 x 122 cm
Inscribed l.c.: 'Nolan'
verso: 'MINER/1972/Nolan'
Art Gallery of South Australia
Gift of Sidney and Cynthia Nolan 1974

Exhibitions: Marlborough Fine Art,
London, December 1972, no.32: 'Miner
1972', illus.; David Jones' Art Gallery,
Sydney, November 1973; Ilkley Manor
House, April 1973

'The portraits of men and women at the
iron-ore workings and the glimpse of
the inferno of heat and dust they inhabit
introduces us to the aborigines of a new
Australian outback, harsher and uglier
than Nature could ever invent. They live
in a squalor of work, drink and copulation.
Their tribal markings are formed by
sweat and purple dust. Here and there a
Christian emblem is a souvenir of another
way of life. They look like the damned
who passed through the bodies of medi-
eval devils and emerged as a kind of
excrement. Yet they are individuals to a
man and they have congregated in hell
for the high pay, and Nolan's portraits
of them give him the right to echo some
lines from Robert Lowell's translation of
Dante's "Inferno", Canto XV: "I fixed my
eyes with such intensity on his crusted
face that its disfigurement could not
prevent my recognizing who he was".'
- Robert Melville, London, November 1972

Nolan's miners—at the iron workings
of Mount Tom Price, in the Hamersley
Ranges of north-western Australia—
seem indeed to inhabit an inferno.
(They are also helmeted 'outsiders', like
Ned Kelly.) Such outback workers have
been described by Australian poet (and
erstwhile Ern Malley hoaxer)
James McAuley:

A futile heart within a fair periphery;
The people are hard-eyed, kindly, with
 nothing inside them,
The men are independent but you could
 not call them free.

With Nolan, a ruthless pounce on the
image is all; there are few side issues;
his pigments swirl as violently as molten
ore. These 'crusted faces' have been
described as the most moving of Nolan's
works: 'the ultimate expression of the
stoic defiance of a cruel and miserable
existence that men and animals share'.[1]

1. Lynn 1979, p.162; one of the series was pur-
chased by Dame Joan Sutherland. They are
reminiscent of some of Oskar Kokoschka's
portrait heads; cf. also Drysdale's outback
characters; and Jon Molvig's, 'hooked on the
very edge of existence'.

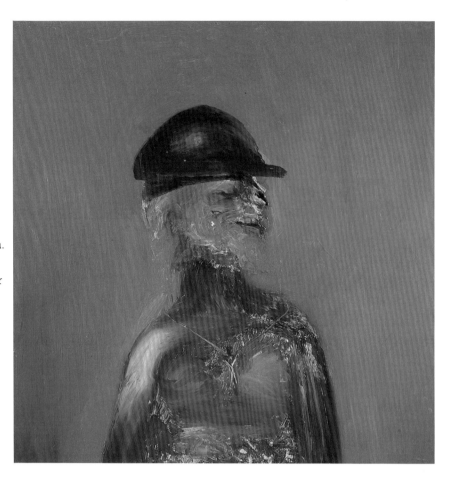

△
SYDNEY HARBOUR 1978
Oil and enamel on hardboard
92 x 122 cm
Inscribed l.l.: 'Nolan 78'
Label verso: '20.4.78'
The News Corporation Collection
Provenance: Rudy Komon Gallery

'Despite the clustering of modern build-
ings in the foreground, Nolan's *Sydney
Harbour* evokes an ancient image. Even
the Opera House, a central image in the
picture, has been transformed into an
exotic pyramid, which might well exist
on the shores of an imagined inland sea,
salty and remote.'
- Sandra McGrath, *Sydney Harbour paintings from
1794*, Sydney, 1979

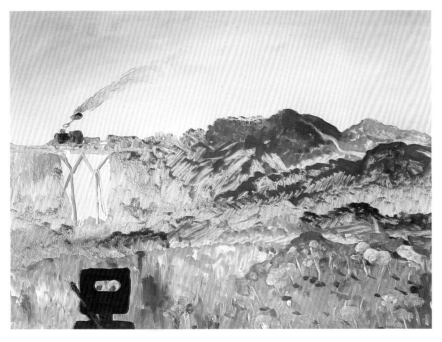

One of the comparatively few city paintings by Nolan, this tourist's-eye-view depicts Sydney Harbour as seen from a deluxe hotel suite at the Sheraton Wentworth Hotel. Its loose, spontaneous brushwork (and probably finger and cloth work) is characteristic of his painting style at this time. The city appears almost ephemeral against the Australian elements of land, sky and bright blue water.

◁ KELLY AND HORSE 1980
Enamel on hardboard
91 x 121.5 cm
Inscribed l.l.: 'Nolan'
verso: 'Kelly & Horse/Nolan/1980'
The News Corporation Collection
Provenance: Rudy Komon Art Gallery
Exhibitions: Rudy Komon Art Gallery, Sydney, March–April 1981, no.12

▽ KELLY AND BRIDGE 1980
Enamel on hardboard
91 x 121.5 cm
Inscribed verso: 'Kelly & Bridge/ Nolan/1980'
Private collection
Provenance: The artist, through Rudy Komon Art Gallery; private collection, Sydney
Exhibitions: Rudy Komon Art Gallery, Sydney, March–April 1981, no.8

The popular purification or 'sanctification' of Ned Kelly began very soon after his execution in November 1880. A Royal Commission into the Victorian Police Force the following year revealed, in Nolan's words, that 'there are doubtless as many good policemen as good bush-rangers'. Ned's gang was resurrected almost immediately at the Melbourne Waxworks. Films were made of the Kelly legend: the first in 1907 and the most recent, starring the Rolling Stones' Mick Jagger, in 1970. 'Mr Kelly appears stronger than ever after surviving a kiss of death that would have proved lethal to lesser men—his cinematic representation by an English pop singer', said the Melbourne *Herald* of 28 July 1970.

In the 1980s, Kelly's role in Nolan's art is still changing; adapting to suit the artist's own experiences and moods. It is certainly not historical documentation. He has been a hero, a fool, a man who armoured himself against Australia, who faced it, didn't face it, conquered it, lost it—'ambiguity personified'.[1] In *Kelly and bridge* the mountains and somewhat rickety railway bridge have a curiously Chinese flavour. The landscape of *Kelly and horse* looks rather 'Wild West': perhaps it is a film set.

1. *The Bulletin*, 29 December 1962. His paintings exhibited at Komon's in March 1980 mingled the death of Christ with that of the hitherto imperishable bushranger, in sour or garish colours suggesting bitter defeatism. The 1981 exhibition was a much more cheerful affair: with Kelly 'the awkward intruder in beautifully immediate landscapes'. *Kelly and bridge* was reproduced in *Australasian Art News*, May 1981.

ERN MALLEY 1973 ▷
Oil on hardboard
122 x 122 cm
Inscribed l.r.: '11 Sept 73/Nolan'
Art Gallery of South Australia
Gift of Sidney and Cynthia Nolan 1974

Exhibitions: *Festival Exhibitions*, A.G.S.A.,
1974, no.35; *Sidney Nolan*, Naracoorte
Art Gallery, April–May 1977; Perth
Festival (*Ern Malley Collection*), February
1982, no.9; *Adelaide's Nolans*, A.G.S.A.,
1983; *Sidney Nolan: the city and the plain*,
N.G.V., 1983, no.69, illus.

'Boult to Marina'
Only a part of me shall triumph in this
(I am not Pericles)
Though I have your silken eyes to kiss
And maiden-knees
Part of me remains, wench, Boult-upright
The rest of me drops off into the night.
What would you have me do?
　　　Go to the wars?
There's damned deceit
In these wounds, thrusts, shell-holes, of
　　　the cause
And I'm no cheat.
So blowing this lily as trumpet with my
　　　lips
I assert my original glory in the dark
　　　eclipse...

- Ernest Lalor Malley, 1943

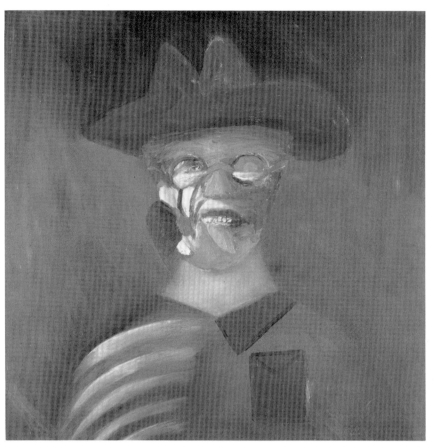

Nolan returned to the notorious sixteen
'Ern Malley' poems in a series of paint-
ings and large drawings for exhibition at
the Adelaide Festival of 1974. What still
appealed to him, thirty years after the
hoax, was 'the imaginative release occa-
sioned by the self-sufficiency and finality
of single images, though the poems might
remain eternally obscure'.[1]

This 'portrait' is not stylistically part
of the series proper. Ernest Lalor Malley
(purportedly 1918–43, actually b.1943–
d.1944) is clearly shown to be a direct
descendant of Nolan's *Head of Soldier*
of 1942; and a victim of what Dr Ellery
called then *The Psychiatric Aspects of
Modern Warfare*.[2] He is a soldier poet—
like the hoaxers, Corporal Harold Stewart
and Lieutenant James McAuley, who
brought him into being on a 'pretty idle
afternoon in Victoria Barracks'. As Jan
Minchin explains: 'The rivetting power of
the portrait comes from Nolan's subjec-
tive vision. Without a living model, he
conjured up the figure out of his intimate
knowledge of the Ern Malley affair, his
own part in it, and his understanding of
how a notorious-poet came to symbolize a
rebellious creative spirit. By deliberately
painting Malley as a rude, macabre
figure—an anti-hero—Nolan pokes fun at
those philistines who would censure art.'[3]

The erotic, which Nolan felt had not
'so far been very conspicuous' in Austra-
lian culture, comes aggressively to the
fore in his 1970s Ern Malley works. On
his copy of the Ern Malley poems he
noted that this painting relates to a line
from 'Boult to Marina': 'What would you
have me do? Go to the wars?' The original
Boult was certainly 'not Pericles' (the
Prince of Tyre in Shakespeare's drama).

He was a brothel-keeper's servant,
despatched to purchase prostitutes from
pirates; and offered money by one of the
prospective acquisitions—namely
Marina—to find her some alternative
employment. That passage of harsh, yet
richly amusing Shakespearean satire is
an apposite progenitor for Ern Malley as
portrayed by Nolan.

1. Elwyn Lynn, catalogue introduction, *Sir
Sidney Nolan*, Festival of Perth, 1982. The Ade-
laide Festival exhibition was reviewed at length
by Frances Kelly in *The National Times*, 4 March
1974 and Max Harris in *The Australian*,
9 March 1974.
2. See *Head of Soldier*, 1942, in this catalogue;
the glazed expression, contorted features and
lolling tongue ultimately owe something to the
heads illustrated in Löwenfeld's *Nature of
Creative Activity*, 1939.
3. Minchin 1983, p.67; where some works from
the Ern Malley series (now A.G.S.A.) are illus-
trated. Nolan himself was also a 'soldier-poet'
of course; the photograph of Malley as a child,
published along with the poems by Reed &
Harris, was actually a very youthful John Sinclair.

'SAMSON ET DALILA'—DESIGNS FOR
DECOR 1981
'DESERT LANDSCAPE: THE MOUN-
TAINS OF SOREK'—gauze (no.9) for act II
Crayon and inks on paper
61.3 x 76 cm
Private collection

'RAM IN THICKET'—cloth for act III, ▷
scene 1
Crayon and inks on paper
61.3 x 76.4 cm
Private collection

Reproduced in a set of four lithographs
published by the Royal Opera House
Development Appeal in 1982 (edition of
100 with ten artist's proofs)

'I found the proposal for me to design
this opera a strange one at first, but when
I realized that it was to be set in North
Africa, a place with which I identify,
I became drawn to it.'
- Sir Sidney Nolan, London, September 1981

'French opera requires clarity and
colour. I thought that it would be very
interesting to combine the painterly view
with a spectacular grand opera, which is
dramatic and rather poetic ... My choice
was a straight response to his paintings,
which strike a chord in me ... As a painter
he uses myth and a very strong expres-
sion of sexual conflict. This was the first
opera expressing the idea of destructive
woman.'
- Elijah Moshinsky, producer, London 1981

The story of Samson and his betrayal by
Delilah comes from the Book of Judges,
chapters 14–16. The Israelites, enslaved
by the Philistines of Gaza, are roused to
revolt by their leader Samson. The High
Priest of Dagon enlists the support of
Delilah, a Philistine woman once loved
by Samson but deserted by him in the
interests of his divine mission. The High
Priest's attempt to bribe Delilah to dis-
cover the secret of Samson's strength is
rejected: she is eager to aid him for
motives of personal and national revenge.
With an adroit mixture of cajolery and
mocking contempt, she seduces Samson
and learns his secret. He is captured by
the Philistines. His hair is shorn, his eyes
torn out, he is put to turning a mill. Sum-
moned to take part in a celebratory
sacrifice to Dagon and humiliated by his
captors, he prays to Jehovah to restore
his strength for one brief instant. The
prayer is answered.[1]

◁ PETER GRIMES 1977
Enamel on hardboard
91.5 x 122 cm
Inscribed verso: 'Aldeburgh/Britten/
Peter Grimes/Nolan/27 March 77'
Private collection

Exhibitions: *Sidney Nolan—an artist's
response to the music of Benjamin Britten*,
30th Aldeburgh Festival, June 1977

'A great work with a terrific impact. You
can see it going back to *Zauberflöte* and
Fidelio but there it is in front of you too,
a tortured, gentle anxious music, and a
modern character in Grimes that is a
masterpiece of creation. *Grimes* is such
stuff as dreams are made on, and is
acted and sung with a terrifying and
beautiful reality by Peter Pears; he left
me shattered.'
- Charles Osborne reviewing Britten's *Peter Grimes*
at Covent Garden, 'London Letter', *Ern Malley's
Journal*, November 1954

'I was electrified the first time I heard
one of his works. From the 1950s I went to
the Aldeburgh Festival every year.'
- Sir Sidney Nolan

Nolan was introduced to the composer
Benjamin Britten by Sir Kenneth Clark,
at Aldeburgh in 1951. Since 1964 he has
contributed exhibitions to several of the
Festivals: including the 'Shakespeare
Sonnets' series in that year and '*Paradise
Garden*' works in 1968.[1] This picture was
painted for the Thirtieth Festival, when
his exhibition was subtitled 'An artist's
response to the music of Benjamin
Britten'. The opera *Peter Grimes* (1945) is
based on George Crabbe's poem 'The
Borough' of 1810, describing life and
character as seen by the poet in Alde-
burgh. Grimes is a villainous fellow who
'fish'd by water and filch'd by land' and
kills his apprentices by ill-treatment.
At length he is suspected. Forbidden
to keep apprentices and living alone,
he is driven insane with guilt and even
tually dies.[2]

Britten, like Nolan, was inspired by
Rimbaud's poetry. In 1970 they travelled
together in Central Australia; and subse-
quently worked for some time on a ballet
based on Australian Aboriginal boys'
initiation rites and the 'Rainbow Serpent'
theme, until Britten's death in 1976.[3]

1. One of the few 'Shakespeare Sonnet' paintings
in a public collection is at the A.G.N.S.W. The
annual music Festival, founded by Britten and
Sir Peter Pears at their home at Aldeburgh on
the Suffolk coast in 1948, is one of the continuing
pleasures of living in England for Nolan and
his wife.
2. Another of the *Peter Grimes* paintings is now
in the Tate Gallery; Nolan also painted subjects
from *Billy Budd* and other Britten compositions.
3. Nolan's manuscript is still in his possession; by
no means abandoned. His first experience of
music by Britten was the song cycle from Rim-
baud's *Les Illuminations*—in Melbourne in 1947;
Adams 1987, p.175.

This was Nolan's first design commis-
sion for opera: and the first production
of *Samson et Dalila* at Covent Garden for
thirty-five years. 'We work very closely
together and have become a kind of
double-act', says Australian-born pro-
ducer Moshinsky.[2] Drop-curtains and
a series of vast painted gauzes, lit to
varying degrees of translucency, were
used successively and in combination.[3]
The whole opera was rose-coloured;
sometimes dimmed to purple shades,
or dramatically to aubergine. For the
two hundred costumes, as Moshinsky
explains, Nolan did not use a costume-
plate drawing method: 'We talk to the
wardrobe department, build a prototype
and work on that. Lots of the materials
are screen-printed and hand-painted,

but the line is very simple. They look like
clothes...' He took five curtain calls on
the opening night.[4]

1. Resumé adapted from The Royal Opera
House programme, London, 1981: Delilah was
played by Shirley Verrett and Samson by Jon
Vickers; choreography by David Bintley.
The opera by Camille Saint-Saëns (1835–1921)
was first performed at the Weimar Hoftheater
in 1877.
2. *The Observer*, London, 27 September 1981.
3. The cloths (each about 16.5 x 10.2 m) were
produced by scene painters at Harkers under
Nolan's supervision; lighting was by Nick
Chelton. Nolan was commissioned in January
1981, began work in May; the season opened
on 18 September.
4. Alannah Coleman, 'Opera: London triumph
for Nolan', *The Bulletin*, Sydney, 3 November
1981, p.72; see also *The New Standard*, London,
18 September 1981; *Vogue*, September 1981,
p.240.

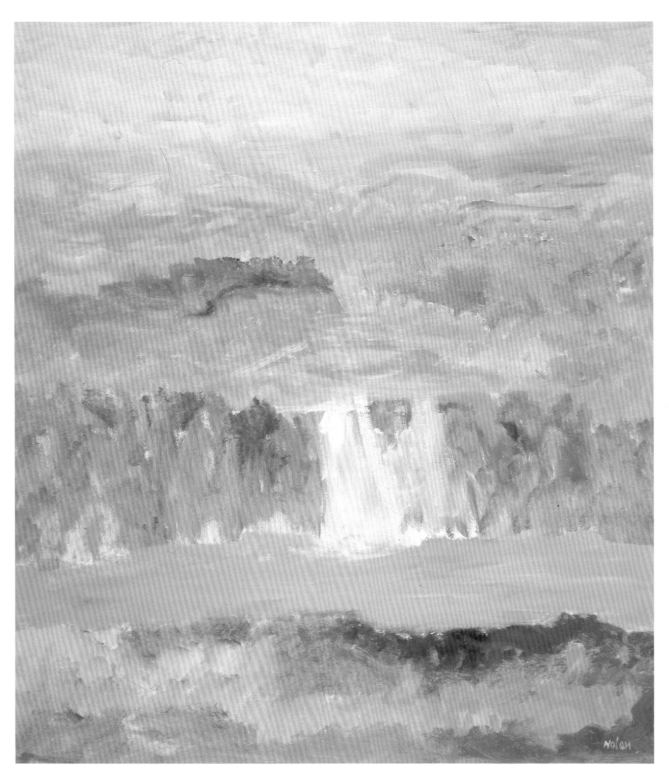

△
KIMBERLEY LANDSCAPE—
PRINCE REGENT RIVER 1983
Enamel on canvas
183 x 160 cm
Inscribed l.r.: 'NOLAN'
verso: 'Nolan 26 Oct 1983'
The Lord McAlpine of West Green
Provenance: The artist

SUN CINEMA, BROOME 1983 ▷
Enamel on canvas
183 x 160 cm
Inscribed l.l.: 'Nolan'
verso: 'NOLAN 12 AUG '83 SUN
CINEMA BROOME'
The Lord McAlpine of West Green
Provenance: The artist

Exhibitions: Holdsworth Galleries,
Sydney, October–November 1983,
no.85: 'Sun Cinema, Broome—$25,000';
Spirits and Effigies, 'Lanyon', March–
May 1984, no.21

'The emotional process has to take a
certain amount of time, you have to physi-
cally go to the place, you have to look at it,
you must then feel it in your stomach and
you must go away and keep on feeling it
and remembering it. But at some point it
then turns into a mental construction
which also has to mature and at a certain
point you have your image.'
- Sir Sidney Nolan, to Edmund Capon,
A.G.N.S.W., 1981

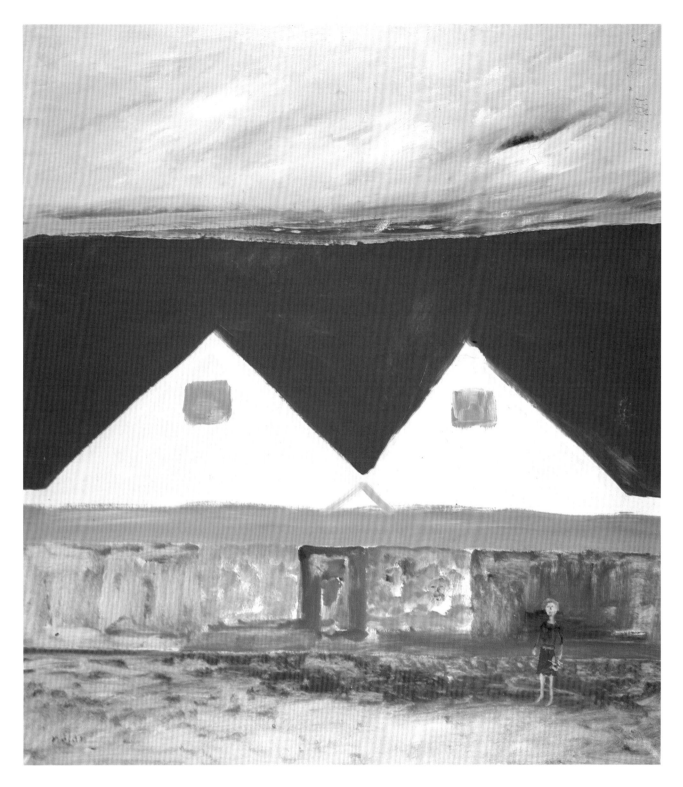

Nolan has travelled extensively in north-western Australia, especially since his friend The Lord McAlpine of West Green has lived for part of each year in Broome.[1] It is a landscape of extremes: inspiring on the one hand Nolan's brutal 'portraits' of miners and Aboriginal vagrants and, on the other, these large liquescent paintings. Pigment is pushed, pulled and scumbled vigorously on to the canvas very directly. There is no reworking; each stroke expresses the spirit of the subject.

The *Kimberley landscape* is a majestic panoptic outback vista. Although inspired by a particular geographical location, it has what George Johnston once described as 'the sense of a recessed opening from reality, through which one might walk right into the world of [the artist's] imagination, and go on and on, for ever finding one's own journey and new views and vistas and remarkable things to be examined'.[2] *Sun Cinema* is more intimate, despite its considerable scale. Much of the old pearl-diving township of Broome remains, situated on the coast at the southern tip of the Kimberley region. This corrugated iron open-air cinema, built in 1916, still operates in Carnarvon Street after sunset (as Lord McAlpine's private jet roars overhead through the night sky).

1. Some further information about Lord McAlpine can be found in *The Alistair McAlpine Gift*, Tate Gallery, London, 1971 and *Times on Sunday*, 8 March 1987; his Pearl Coast Wildlife Park opened in Broome on 12 August 1984. Nolan had included a number of north-west subjects in his

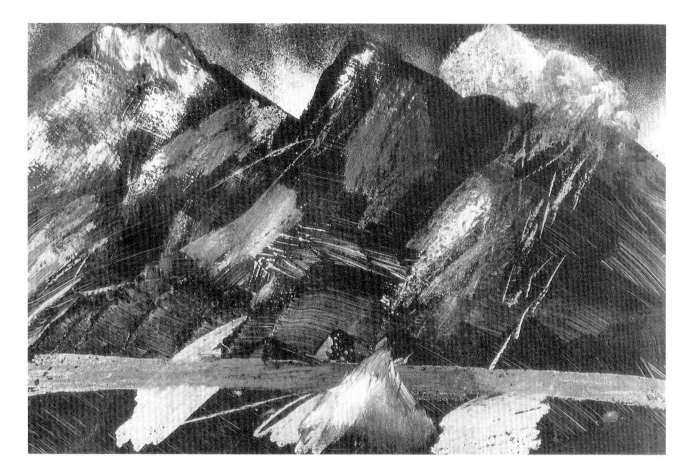

'Central Australia' exhibition at David Jones in 1950: e.g. Kimberley landscapes, the Fitzroy River, etc.
2. Johnston 1969, p.302; he continued, 'There are journeys of the spirit as well as the bodily ones, and I am beginning to think that the former are the more important'. Nolan's *Bungle Bungle* landscape, also a Kimberleys subject, is painted in a similar dramatically loose style; one of five large outback paintings commissioned for the Victorian Arts Centre, actually executed at Boyd's Shoalhaven property in October 1984 (now in a Perth private collection and unfortunately unavailable for exhibition).

△

IL TROVATORE—THREE DESIGNS 1983
'HIGH MOUNTAINS'—original design for front stagecloth, used for programme cover (illustrated)
Wax crayon, inks and spray paint on paper
57.2 x 72.3 cm

'MOUNTAIN LANDSCAPE'—
first show cloth
Wax crayon, inks and spray paint on paper
58.5 x 73.5 cm

'TWO HEADS'—second show cloth
Wax crayon, inks and spray paint on paper
49.5 x 73.5 cm

On loan from the Australian Opera
Presented by Sir Sidney Nolan 1983
Exhibitions: Rex Irwin, Woollahra, July 1983; the two show cloth designs also at New South Wales House, London, October–December 1983

'I like opera. You can have all the passions with absolutely none of the pain. The most wonderful thing is—after a really hard day of painting—to go to sleep at the opera and wake up in an impassioned moment and not know where you are for a moment. To be aware only of the music—that is wonderful... This production took a lot of finessing. It was essential to find the central images of the opera—because those images are vital. The plot is not cogent.'
- Sir Sidney Nolan, Sydney, July 1983

The complicated story of Giuseppe Verdi's *Il trovatore* (first performed, Rome, 1853) revolves around its two female characters. Azucena is the daughter of a gypsy who was accused of cursing the young son of a nobleman and burned as a witch, fifteen years before. In revenge she abducted the baby to throw into the embers of the same fire but, in her distress, threw in her own baby. She has brought up the other child as her own. Leonora is a lady-in-waiting at court and loved by two men, the Count di Luna and Manrico, the troubadour and leader of rebel forces engaged in civil war against the Count. Di Luna is the elder son of the nobleman who had Azucena's mother burned.[1]

This production by The Australian Opera continued Nolan's collaboration with Elijah Moshinsky. Dame Joan Sutherland played Leonora in 1983, with Lauris Elms as Azucena, Kenneth Collins as Manrico and Jonathan Summers as di Luna.[2] Luciana Arrighi designed the costumes; and Nick Chelton the lighting. Nolan oversaw the painting of some

eighteen backdrops and gauzes at the Australian Opera's workshops in Surry Hills, Sydney. Darkness lashed by fire is the key image; the setting a Spanish Gothic cathedral at night. 'Designing an opera requires fitting into a mosaic of story-telling, and the producer's intellectual analysis of that story', he says, 'I'm very fond of opera. And I'm always interested in finding a relationship between painting and music.'[3]

1. The Australian Opera's programme, Sydney, 1983; see also Paul England, *Fifty Favourite Operas*, Bonanza Books, New York, 1985, pp.252ff.
2. First performed at the Sydney Opera House, 25 June 1983; revived in Melbourne and Sydney, 1985 (with Joan Carden as Leonora); Sydney and Brisbane, 1986.
3. Interview with Christine Hogan, *The Australian Women's Weekly*, July 1983, p.12; reviews of the opera's most recent season appeared in *The Australian* and *The Herald*, 15 January 1986. Nolan has also been working with Moshinsky towards a new production of Wagner's 'Ring' cycle at Covent Garden.

 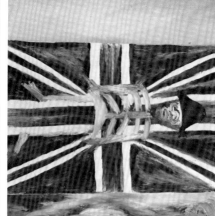 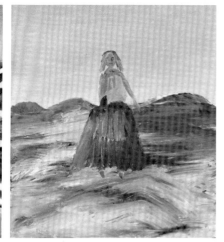

△
BURIAL OF BURKE—TRIPTYCH 1985
Oil on canvas—three panels
Each 183 x 160 cm
Inscribed (1) l.l.: 'N'
(2) and (3) l.r.: 'N'
Each numbered and inscribed verso:
'BURIAL OF BURKE 20 AUG 1985 Nolan/
Burial of Burke/20 Aug 1985/Nolan'
Private collection

Exhibitions: S.H. Ervin Gallery,
November 1985–January 1986, no.28:
'Burial of Burke',illus.; 'Lanyon', Feb-
ruary–April 1986; *Jack Manton Prize*,Q.A.G
February–March 1987

'The name of Robert O'Hara Burke is
henceforth to be a precious possession ...
The glory of his deed, and the sorrow of
his death, will render that name mem
orable in the annals of our country. And
well may Victoria be proud of this, her
first hero. The story of his great achieve-
ment, if it is the saddest, is also one of
the highest in the history of manhood.
No fiction was ever half so romantic—
no hero more valiant, bold or loyal ... No
conqueror dying on the field of battle
could earn a fame more glorious.'
- *The Argus*, Melbourne, November 1862

In 1984 Nolan was invited to join the
Hoyts-Edgley film crew on location for
the making of Graeme Clifford's *Burke
and Wills* at Cooper's Creek. His experi-
ence resulted in a fresh response to the
'explorers' theme: a series of five trip-
tychs, completed in England (whilst
listening to Mozart) during August 1985.
Having been involved with a number of
films in the past (mainly about his own
work), he was interested in the film-
making process itself; and the director,
cameramen, sound crew and various
pieces of equipment appear in some of
the paintings. He was overwhelmed by
the beauty of the landscape: 'The sand-
hills were covered in daisies. But nothing
had changed out there in a million years.
Nothing was different to when Burke and
Wills were there. It was a drama as if it
were really happening all over again. I
felt like Prometheus when he stole the
fire. Not guilty, but a bit uneasy, almost
as if I shouldn't have been there.'[1]

The *Burial of Burke* triptych makes
some new comments on his old theme of
Australian exploration history. The
striped man in the left panel has as much
in common with his *Escaped convict* of
1962 (A.G.N.S.W.)—bounding into out-
back freedom—as it has with any pre-
vious explorer figure. Burke's bones,
superimposed on the British Union Jack,
make a telling metaphor for the values of
a society which urged the race to be the
first white man to cross Australia.[2] As
Alan Moorehead wrote in *Cooper's
Creek*: 'Death on the field of glory, one
felt, might be a very fine thing, and death
in bed very bearable. But this was just
death, stark, despairing and meaning-
less, the monster in the dark.' There is,
however, nothing like failure on a grand
scale for capturing public imagination.

The woman in the third panel is pre-
sumably Miss Julia Matthews, a light
operatic prima donna who had toured
the goldfields when Burke was still a
policeman at Beechworth and with whom
he had evidently fallen in love.[3] Perhaps
she was 'with him in spirit' on the Cooper
(as Laura Trevelyan was with Leichardt
in Patrick White's *Voss*). Certainly she
was among the first to approach the
editor of *The Argus* to rouse public
demands for a search party. And she
gave Howitt a rather sad letter for the
lost explorer:
Dear Sir
 It is with fear I now address you but I
hope my fear will soon be allayed by
hearing of you safe and sound ... I dare
say you almost forget me but if you scrape
your various reminiscences of the past
you may well recollect the laughing
joyous 'C. Cupid.'
My sincere regards to you; all the citizens
in and around Melbourne join in love to
you, bless your little heart.

With polaroid and video cameras, note-
book and formidable visual memory,
Nolan captured certain key images in
the re-enacted drama. Miss Matthews's
role on film was considerably larger
than that allotted in the common run of
history books.

1. Interview with Keith Dunstan, *The Sun*, Mel-
bourne, 3 November 1984; see also *The Austra-
lian*, 7 November 1985. Burke was played by
Jack Thompson, Wills by Nigel Havers, John
King by Matthew Fargher and Julia Matthews
by Greta Scacchi.
2. Burke's remains (and Wills's) were brought
back to Melbourne by Alfred William Howitt
and buried on 21 January 1863. The best-known
painted rendition of the scene is probably
William Strutt's *Burial of Burke*, 1911 (now in the
State Library of Victoria). Interestingly, Albert
Tucker painted a triptych format *Arrival at
Cooper's Creek* in 1958.
3. See Moorehead 1963, pp.126, 191; and Colwell
1971, p.15 for further biographical data.

△
SELF PORTRAIT IN YOUTH 1986
Spray paint (Marabu Satin) on canvas
183 x 160.6 cm
Inscribed l.l.: 'NOLAN'
Private collection

Many years ago now, Nolan reportedly said, 'I used to think I was a rebel, but I'm an experimenter and synthesizer'.[1] In fact, he has always been all three: a quiet rebel, a constant experimenter and a synthesizer of reality and imagination. In this portrait he presents himself on a scale to match the most challenging late twentieth-century modes of perception. The contrast with earlier, domestically-scaled works, such as the Wimmera *Self portrait* of 1943, is dramatic.

Is the subject young or aging?—shrouded in its mist of paint. Nolan has called the portrait his 'tonal homage to Hugh Ramsay' (another Australian expatriate artist—who, tragically, died in 1906 at the age of only twenty-eight).[2] It is nevertheless absolutely contemporary in spirit.

Painted on 18 April 1986—just four days before Nolan's sixty-ninth birthday—the medium is a modern German-made spraycan enamel in

170

What an artist really wants to say is something which, one day, out of contemporary contexts, will mean something important, will be sure of survival. This is quite different from momentary success or fulfilling current demands.
- Sir Sidney Nolan, Covent Garden, 1981

Sir Sidney Nolan stands in front of one of a pair of large paintings commissioned by the Hong Kong Group for the lobby of Exchange Square, Hong Kong; unveiled in January 1987.
Photograph by courtesy of Brian Adams

which, he finds, the wet colours blend almost magically together on the canvas as his Ripolin did in the early 1940s. Free from 'take' in ten minutes and dry in half an hour, this new medium allows Nolan to paint faster and larger than ever before.[3] He is theatrical—but never histrionic. He manipulates the spray with speed and extraordinary precision; working at constantly varying distances from the canvas to create veils of pigment, layer upon airy layer. Nolan's most recent pictures are alchemy in paint.

1. Cynthia Nolan 1967, p.93.
2. Conversations with the author, June 1986; alternative comparisons ranged from a late Rembrandt self-portrait to an anonymous Irish larrikin in a dark alley! (Ramsay was one of the earlier Australian painters admired and discussed by the 'Heide' circle; cf. Nolan's letter comparing Ramsay and McCubbin, written at Nhill, 22 March 1943).
3. His two Chinese landscapes for the new Hong Kong Land Group building, installed January 1987, are worked in a similar technique and measure some 4.5 by 3 metres. He had first used spray paints in his advertising and display jobs in the 1930s; now he achieves remarkable

effects by spraying the still wet paint with fixative or mixing his pigments with Winton gel; sometimes using a kind of stencilling and often working the paint with bundled rags or fingers.

SELECTED BIBLIOGRAPHY

Many newspapers and magazines have been selectively read for art criticism and articles on the historic context of Nolan's work; specific references are cited in footnotes.

Advertiser (Adelaide)
Age (Melbourne)
Angry Penguins (Adelaide, 1940–42; Melbourne 1943–46)
Angry Penguins Broadsheet (Melbourne, 1945–46)
Argus (Melbourne)
Art and Australia (Sydney)
Art in Australia (Sydney, 1922–42)
Australian (Sydney)
Australian Artist (Melbourne, 1947–49)
Bulletin (Sydney)
Daily Telegraph (Sydney)
Ern Malley's Journal (Melbourne, 1952–55)
Herald (Melbourne)
London Magazine
Meanjin (Brisbane, 1940–44; Melbourne, 1945–)
Nation (Sydney)
Observer (London)
Queen (London)
Studio (London)
Sun (Melbourne)
Sun (Sydney)
Sydney Morning Herald
Time Magazine
Times (London)
Tomorrow (Melbourne, 1946)
Walkabout (Melbourne, 1934–)

All one-man and group exhibition catalogues traced by the author are included chronologically in the biographical outline.

BOOKS AND ARTICLES

Adams, Brian. 'Nolan at 60'. *Airways*, March–April, 1978.

Adams, Brian. *Sidney Nolan: such is life, a biography*. Hutchinson of Australia, Melbourne; 1987.

Adams, Brian. 'Sidney Nolan versus Australia'. *Good Weekend*, 16–18 April 1987.

Ades, Dawn. *Dada and Surrealism reviewed*. Arts Council of Great Britain, London, 1978.

Anderson, Jaynie. 'The early work of Sidney Nolan 1939–49'. *Meanjin* 3, 1967.

Barber, Noel. *Conversations with Painters*. Collins, London, 1964.

Baverstock, Felicity. *Fraser Island, sands of time*. Australian Broadcasting Commission, Sydney, 1985.

Birdwood, Sir W.R. et al. *The Anzac Book, Written and Illustrated in Gallipoli by the Men of Anzac*. Cassell & Co. Ltd, London and Melbourne, 1916.

Bonython, Kym (ed.). *Modern Australian Painting and Sculpture 1950–1960*. Rigby, Adelaide, 1960.

Bonython, Kym (ed.). *Modern Australian Painting 1960–1970*. Rigby, Adelaide, 1970.

Borlase, Nancy. 'Three decades of the Contemporary Art Society'. *Art and Australia*, June 1968.

Brack, John. *Four Contemporary Australian Landscape Painters*. National Gallery of Victoria, Melbourne, 1968.

Brown, Max. *Australian Son: the Story of Ned Kelly, including the 'Jerilderie Letter', a recently discovered statement of 8,300 words made by Ned Kelly*. Georgian House, Melbourne, 1948.

Clark, Kenneth. *The Other Half, a self portrait*. John Murray, London, 1977.

Clune, Frank. *Dig: a drama of Central Australia*. Angus & Robertson, Sydney, 1937, 1944 etc.; republished 1976 as *Dig: the tragic story of the Burke and Wills expedition*.

Colwell, Max. *The Journey of Burke and Wills*. Paul Hamlyn, Sydney, 1971.

Doerner, Max. *The Materials of the Artist and their Use in Painting, with notes on the techniques of the Old Masters*. Rupert Hart-Davies, London, 1969 (first published in German 1921; English edn 1934).

Dutton, Geoffrey. 'Sidney Nolan's Burke and Wills series'. *Art and Australia*, September 1967.

Dutton, Geoffrey. *Sun, Sea, Surf and Sand— the myth of the Beach*. Oxford University Press, Melbourne, 1985.

Dutton, Geoffrey. *The Innovators—the Sydney alternatives in the rise of modern art, literature and ideas*. Macmillan Australia, Melbourne, 1986.

Fowlie, Wallace. *Rimbaud*. University of Chicago Press, Chicago, 1965.

Friend, Donald. *Painter's Journal*. Ure Smith, Sydney, 1946.

Fry, Gavin. *Nolan's Gallipoli*. Rigby, Adelaide, 1983.

Gilchrist, Maureen. 'The art of Sidney Nolan: the first decade 1939–1947'. Unpublished B.A. Hons thesis, University of Melbourne, 1975.

Gilchrist, Maureen. *Nolan at Lanyon*. 3rd edn. Australian Government Publishing Service, Canberra, 1985.

Gleeson, James. *Modern Painters 1931–70*. Australian Art Library Series, Lansdowne, Melbourne, 1971.

Gregory, Clive (ed.). 'Sir Sidney Nolan'. In *The Great Artists, their lives, works and inspiration*. vol.4, part 90. Marshall Cavendish, London, 1986.

Gunn, Grazia. *Arthur Boyd: seven persistent images*. Australian National Gallery, Canberra, 1985.

Haese, Richard. *Rebels and Precursors: the Revolutionary Years of Australian Art*. Allen Lane, Melbourne, 1981.

Haese, Richard. 'The Wimmera paintings of Sidney Nolan'. In *Sidney Nolan: the city and the plain*. National Gallery of Victoria, Melbourne, 1983.

Haese, Richard. 'The lost Wimmera years of Sidney Nolan 1942–44'. *Art Bulletin of Victoria* 24, 1984.

Harris, Max. 'The Young Master: Sidney Nolan's conquest of two worlds'. *Nation*, Sydney, 2 July 1960.

Harris, Max. 'The making of Nolan'. *Nation*, Sydney, 23 September 1961.

Harris, Max. *Ern Malley's Poems*. Lansdowne, Melbourne, 1961.

Harris, Max. 'Angry Penguins and after'. *Quadrant* VII, 1, 1963.

Harris, Max. 'Nolan at St Kilda'. *Art and Australia*, September 1967.

Harris, Max. 'Apotheosis of the Wheatlands'. Introduction to *Wimmera Paintings of Sidney Nolan*. Adelaide Festival of Arts Exhibition, David Jones' Art Gallery, Adelaide, 1970.

Hetherington, John. *Australian Painters, Forty Profiles*. Cheshire, Melbourne, 1963.

Horton, Mervyn (ed.). *Painters of the 70s*. Ure Smith, Sydney, 1975.

Hughes, Robert. 'Melbourne's Forties'. *Nation*, Sydney, 11 August 1962.

Hughes, Robert. 'Rebels and Percursors'. *Meanjin*, XXI,3, September 1962.

Hughes, Robert. 'Nolan and Boyd'. *Nation*, Sydney, 4 April 1964.

Hughes, Robert. *The Art of Australia*. Penguin Books, Harmondsworth, 1970.

Ingram, Terry. *A Matter of Taste, investing in Australian art*. Collins, Sydney, 1976.

Johnston, George. 'Gallipoli paintings'. *Art and Australia*, September 1967.

Johnston, George. *Clean Straw for Nothing, a novel*. Collins, London, 1969.

Kinnane, Gary. *George Johnston—A Biography*. Nelson, Melbourne, 1986.

Lea, Shelton & Harris, Robert (eds). *A Flash of Life*. Anthology to mark Barrett Reid's sixtieth birthday. Privately published by Christine Webb, Mountain View, Victoria, 8 December 1986.

Löwenfeld, Viktor. *The Nature of Creative Activity. Experimental and Comparative Studies of Visual and Non-visual Sources of Drawing, Painting and Sculpture, by means of the Artistic Products of Weak Sighted and Blind Subjects and Art of Different Epochs and Cultures*. Kegan Paul, Trench, Trubner & Co., London, 1939.

Lucie-Smith, Edward. *Movements in Art since 1945*. Thames & Hudson, London, 1969.

Lynn, Elwyn. 'Sidney Nolan: myth-maker of Australian painting'. *Hemisphere* 7, 10, October 1963.

Lynn, Elwyn. 'Australian Painting'. *Current Affairs Bulletin*, University of Sydney, November 1965.

Lynn, Elwyn. 'Nolan, a vision of the Australian landscape'. *Vogue Australia*, September 1967.

Lynn, Elwyn. *Sidney Nolan: Myth and Imagery*. Macmillan, London, 1967.

Lynn, Elwyn. 'Assessing Sidney Nolan'. *Quadrant*, March–April 1973; reprinted in *Art International*, October 1973.

Lynn, Elwyn. *Sidney Nolan—Australia*. Bay Books, Sydney, 1979.

Lynn, Elwyn (introd.). *The Darkening Ecliptic*. R. Alistair McAlpine Publishing, London, 1974.

Lynn, Elwyn, & Semler, Bruce. *Sidney Nolan's Ned Kelly*. Australian National Gallery, Canberra, 1985.

McCulloch, Alan. 'The Sidney Nolan book'. *Meanjin*, December 1961.

McCulloch, Alan. *Encyclopaedia of Australian Art*. 2 vols. Hutchinson, Melbourne, 1984.

MacInnes, Colin. 'Sidney Nolan and the Kelly myth'. *Encounter*, London, December 1955.

MacInnes, Colin, Kenneth Clark & Bryan Robertson. *Sidney Nolan*. Thames & Hudson, London, 1961; includes reprint of MacInnes's 'Search for an Australian Myth', introduction to *Sidney Nolan: catalogue of an exhibition of paintings from 1947 to 1957*, Whitechapel Art Gallery, London, 1957, also in his *England, Half English*, MacGibbon & Kee, London, 1961.

McQueen, Humphrey. *The Black Swan of Trespass, the emergence of modernist painting in Australia to 1944*. Alternative Publishing Co-op Ltd, Sydney, 1979.

Mayer, Ralph. *The Artist's Handbook of Materials and Techniques*. ed. Edwin Smith. 3rd edn rev. Faber & Faber, London, 1973 (first published 1940).

Melville, Robert. *Ned Kelly: 27 Paintings by Sidney Nolan*. Thames & Hudson, London, 1964.

Melville, Robert (introd.). *Paradise Garden*. R. Alistair McAlpine Publishing, London, 1971.

Minchin, Jan. 'The city and Ern Malley'. In *Sidney Nolan: the city and the plain*. National Gallery of Victoria, Melbourne, 1983.

Minchin, Jan. 'The violent vision of the 1940s'. *Art Bulletin of Victoria* 26, 1986.

Missingham, Hal. 'Recent Australian Painting'. *The Studio*, London, February 1957.

Missingham, Hal. 'Sidney Nolan'. *Art Gallery of New South Wales Quarterly*, October 1967.

Mollison, James & Bonham, Nicholas. *Albert Tucker*. Macmillan Australia & Australian National Gallery, Canberra, 1982.

Moore, Felicity St John. *Vassilieff and his art*. Oxford University Press, Melbourne, 1982.

Moorehead, Alan. *Gallipoli*. Hamish Hamilton, London, 1956; and new illustrated edn, Macmillan Australia, Melbourne, 1975.

Moorehead, Alan. 'Artist from the Outback'. *Horizon*, New York, September 1962.

Moorehead, Alan. *Cooper's Creek*. Hamish Hamilton, London, 1963; and later edns.

Moorehead, Alan (introd.). *Sidney Nolan*. Marlborough-Gerson Gallery, New York, 1965.

Nolan, Cynthia. *Outback*. Methuen, London, 1962.

Nolan, Cynthia. *One Traveller's Africa*. Methuen, London, 1965.

Nolan, Cynthia. *Open Negative—an American memoir*. Macmillan, London, 1967.

Nolan, Cynthia. *A Sight of China*. Macmillan, London, 1969.

Nolan, Cynthia. *Paradise, and Yet*. Macmillan, London, 1971.

Nunn, Harry. *Bushrangers, a pictorial history*. Lansdowne Press, Sydney, Auckland, London, New York, 1980.

Osborne, Charles. 'Leda and the Swan'. *Art and Australia*, September 1967.

Osborne, Charles. *Masterpieces of Nolan*. Thames & Hudson, London, 1975.

Philipp, Franz. *Arthur Boyd*. Thames & Hudson, London, 1967.

Plant, Margaret. *John Perceval*. Australian Art Library Series, Lansdowne Press, Melbourne, 1971.

Read, Herbert. *Art Now*. Faber & Faber, London, 1933.

Read, Herbert. *Art and Society*. Heinemann, London & Toronto, 1937.

Reed, John. 'Nolan's Ned Kelly Paintings'. *Art and Australia*, September 1967.

Reid, Barrett. 'Nolan in Queensland; some biographical notes on the 1947-48 paintings'. *Art and Australia*, September 1967.

Rilke, Rainer Maria. *Duino Elegies*. trs J.B. Leishman & Stephen Spender. Hogarth Press, London, 1939.

Rilke, Rainer Maria. *Selected Poems*. tr. J.B. Leishman. The New Hogarth Library, vol.III, Hogarth Press, London, 1941.

Rimbaud, Arthur. *'A Season in Hell' and 'Illuminations'*. tr. Enid Rhodes Peschel. Oxford University Press, London, 1973.

Robertson, Bryan & Lord Snowdon. *Private View: the Lively World of British Art*. Nelson, London, 1965.

Rothenstein, John. *Modern English Painters*. 3 vols. Cassell, London, 1962-74.

Rubin, William S. *Dada and Surrealist Art*. Thames & Hudson, London, 1969.

Serle, Geoffrey. *From Deserts the Prophets Come, the Creative Spirit in Australia, 1788-1972*. Heinemann Australia, Melbourne, 1973.

Seton, Marie. 'Sidney Nolan—an artist of the Antipodes'. *The Painter and the Sculptor* 2, 2, Summer 1959.

Sinclair, John. 'His Student Years'. *Art and Australia*, September 1967.

Smith, Bernard. *Place, Taste and Tradition, A Study of Australian Art since 1788*. 2nd edn. Oxford University Press, Melbourne, 1971 (first published 1945).

Smith, Bernard. *Australian Painting Today*. The John Murtagh Macrossan Lecture, Brisbane, 1961. University of Queensland Press, St Lucia, 1962.

Smith, Bernard. 'Image and Meaning in Recent Australian Painting'. *The Listener*, London, 19 July 1962.

Smith, Bernard. 'Nolan's Image'. *The London Magazine*. London, September 1962.

Smith, Bernard. 'Nolan as Mythmaker'. *The Bulletin*, Sydney, 7 October 1967.

Smith, Bernard. *Australian Painting 1788-1970*. Oxford University Press, Melbourne, 1971.

Tregenza, John M. *Australian Little Magazines 1923-1954: Their Role in Forming and Reflecting Literary Trends*. Libraries Board of South Australia, Adelaide, 1964.

Turnbull, Clive. *Art Here: Buvelot to Nolan*. The Hawthorn Press, Melbourne, 1947.

Uhl, Christopher. *Albert Tucker*. Australian Art Library Series, Lansdowne Press, Melbourne, 1969.

Wilenski, R.H. *The Modern Movement in Art*. rev.edn. Faber & Faber, London, 1935 (first published 1927).

Wilenski, R.H. *Modern French Painters*. 4th edn. Faber & Faber, London, 1963 (first published 1940).

Zander, Alleyne. 'Sidney Nolan', *The Studio*, London, September 1955.

PUBLISHED INTERVIEWS

'The search for an Australian myth', radio interview with Colin MacInnes, London, broadcast 11 and 12 July 1957, typescript in Whitechapel Art Gallery archives.

'Sidney Nolan, Q. and A.', *The Studio*, London, October 1960.

The Sun, Melbourne, 21 December 1961.

Harper's Bazaar, April 1962.

'Artist in armour', interview with Patricia Rolfe, *The Bulletin*, Sydney, 22 December 1962.

The Sunday Mirror, Sydney, 1 March 1964.

'Guest of Honour', A.B.C. radio 2FC, Sydney, 22 March 1964.

Sunday Telegraph, Sydney, 29 March 1964.

Conversations with Painters, by Noel Barber, Collins, London, 1964.

'Painting a myth', radio interview with George Bruce, broadcast on Scottish Home Service, *The Listener*, London, 8 October 1964.

'Speaking with Sidney Nolan. The Australian Heroic Dream', interview with Charles S. Spencer, *The Studio*, London, November 1964.

The Australian, 13 March 1965 (Gallipoli paintings).

'The Pain and the Glory', interview with Hugh Curnow, *The Bulletin*, Sydney, 20 March 1965.

'Bewitched by the environment—the Australian painter Sidney Nolan talks to A. Alvarez', (B.B.C. 1), *The Listener*, London, 13 November 1969.

'The quiet scene-stealer', interview with Amanda Lazar, *The Age*, Melbourne, 7 May 1977.

'Flower power', with Sandra McGrath, *The Australian*, 4 April 1978.

The Australian Weekend Magazine, 7-8 March 1981.

Sidney Nolan in China (exhibition catalogue), interview with Edmund Capon, Director of the Art Gallery of New South Wales, March 1981.

'Sir Sidney rides the waves imperturbably', with Philippa Hawker, *The Age*, Melbourne, 9 March 1982.

'The artist and two authors', with Gary Kinnane, *The Age*, Melbourne, 10 April 1982.

'Why Sidney Nolan brushed off Patrick White', with Liz Hickson, *Woman's Day*, 8 August 1983.

'Sir Sid's game—a singing Ned', with Don Bennetts, *The Herald*, Melbourne, 10 September 1984.

'Controversy is no worry for the master', with Keith Dunstan, *The Sun*, Melbourne, 3 November 1984.

'Sir Sidney Nolan', with Duncan Fallowell in *Good Weekend*, 11 May 1985.

'Sir Sidney Nolan', with Stephen Hope, *Vogue Australia*, April 1986.

'Nolan, secrets of a painter's life', with Janet Hawley, *The Age*, 14 February 1987.

'Nolan at 70—still dazzling and puzzling the public', with Rosemary Neill, *The Bulletin*, 21 April 1987.

INDEX OF WORKS

Abandoned mine 1948, 101
Abstract monotypes [1940], 36
Angel over Ely 1950, 112
Antarctic camp 1964, 147
Arabian tree 1943, 56
Bather (at sunset) 1945, 65
Bathers 1943, 51
Bird 1948, 97
Bird 1964 (Antarctic), 147
Blackboys [1948], 99
Boat 1959, 129
Boats c.1945, 61
Bondi Beach—'The Long Night' [1947–48], 93
Bowl, painted ceramic c.1950, 66
Boy and the moon [1940], 39
Boy walking to school 1944, 57
Broome—Continental Hotel 1949, 104
Burial of Burke (triptych) 1985, 169
Burke and Wills at Gulf [1961], 134
Burke and Wills expedition [1962], 135
Burke and Wills expedition, 'Gray sick' 1949, 106
Burke, Burial of (triptych) 1985, 169
Burning at Glenrowan 1946, 84
Burning of Bentley's Hotel, The 1949, 104
Burnt carcass 1952, 114
Camel and figure [1962], 134–35
Camel and figure 1966, 158
Camels, Central Australia 1950, 108
Camels in the desert 1951, 108
Camp 1964, 146
Carcass 1953, 114
Chase, The 1946, 78
Collage of engravings 1938, 33
Constable Fitzpatrick and Kate Kelly 1946, 78
Convict [1962], 141
Convict and Mrs Fraser 1957, 125
Convict and swamp 1958, 128
Death of a poet 1954, 120
Death of Constable Scanlon 1946, 80
Defence of Aaron Sherritt 1946, 82–3
Desert bird 1948, 97
Desert storm 1966, 158–59
Despair has wings 1943, 55
Disguise, The 1955, 119
Display, The—ballet décor [1964], 149
Drought 1966 (triptych), 156
Elephant and mountain [1963], 144
Ern Malley 1973, 164
Esplanade, St Kilda 1946, 65
Eureka Stockade 1949, 105
Fern 1948, 98
Ferris wheel [1945], 64

Figures in tree 1957, 127–28
Fire in palais de danse, St Kilda 1945, 63
First-class marksman 1946, 76
Flour lumper, Dimboola 1943, 52
Fraser Island [1947], 91–2
Fullback 1946, 68
Galaxy, The [1957–58], 124
Gallipoli (diptych) 1963, 142–43
Gallipoli General c.1959, 130
Gallipoli soldier 1959, 130
Gallipoli soldier c.1963, 131
Giggle-palace 1945, 62
Girl and horse [1941], 37
Glenrowan siege 1955, 119
Going to school 1942, 45
Goldfields 1945, 70
Goldfields 1949, 104
Head of Rimbaud [1938–39], 38
Head of soldier 1942, 46
Heidelberg [1944], 60
Huggard's store 1948, 102
'Icare'—stage designs 1939–40, 34
Icarus 1943, 48
'Il trovatore'—stage designs 1983, 168
Inferno 1966, 152–55
Inland Australia 1950, 110
Italian crucifix 1955, 123
Italian statue c.1950–51, 113
Kelly 1955, 118
Kelly and bridge 1980, 163
Kelly and horse 1980, 163
Kelly and Sergeant Kennedy 1945, 75
Kelly and storm 1962, 136
Kelly at the mine c.1946–47, 86
Kelly, spring 1956, 120–22
Kiata [1943], 50
Kiewa valley 1936–37, 33
Kiewa valley landscape 1936–37, 33
Kimberley landscape—Prince Regent River 1983, 166
Lagoon, Wimmera 1943, 51
Lake Wabby 1947, 91,93
Landscape 1947, 76
Landscape (salt lake) 1966, 156–57
Latrine sitters 1942, 48
Le désespoir a des ailes 1943, 55
Leda and swan 1958, 131
Leda and swan 1960, 132,133
Little Dog Mine 1948, 100
Lublin 1944, 59
Luna Park 1941, 37
'Luna Park' transfer drawings, 35
Macdonnell Ranges 1949, 111

Magpie 1950, 112
Miner 1972, 162
'Moonboy' (Boy and the moon) [1940], 39
Morning mass 1943, 46
Mrs Fraser 1947, 91–2
Mrs Fraser and convict [1962–64], 140
Musgrave Ranges 1949, 111
Narcissus [1947], 67
Ned Kelly [1946], 74
'Ned Kelly'—stage designs [1956], 122
'Ned Kelly' transfer drawings c.1946–47, 87
'Orphée'—stage design [1948], 94
Painting ('mythological creatures') [1945], 66
Perished 1949, 107
Peter Grimes 1977, 165
Policeman in wombat hole [1946], 86
Portrait of Albert Tucker 1947, 67
Portrait of Barrett Reid 1947, 68
Pretty Polly Mine 1948, 103
Prospector 1948, 100
Quilting the armour 1947, 80
Railway guard, Dimboola 1943, 53
Railway yards, Dimboola 1943, 47
Rain forest 1957, 126,128
Reid, Portrait of Barrett 1947, 68
Rimbaud at Harar 1963, 145
Rimbaud, Head of [1938–39], 38
Rimbaud Royalty 1942, 49
'Rite of Spring'—stage designs 1962, 136–37
Riverbend 1964–65, 148–51
Robe Street, St Kilda 1945, 64
Rosa mutabilis [1945], 60
'Samson et Dalila'—stage designs 1981, 164
Self portrait 1943, 54
Self portrait in youth 1986, 170
Siege at Glenrowan 1946, 85
Sisters, The [1946], 66
Slates, painted 1941–42, 40
Slip, The 1947, 82
Steve Hart dressed as a girl 1947, 79–80
Stringybark Creek 1947, 81
Sun Cinema, Broome 1983, 167
Sydney Harbour 1978, 162
Temptation of St Anthony 1952, 113
Thames morning [1962], 139
Township 1947, 77
Trial, The 1947, 88
Tucker, Portrait of Albert 1947, 67
Untitled transfer drawings c.1940, 35
Wimmera (from Mount Arapiles) 1943, 53
Window: girl and flowers 1942, 41
Woman and tree 1941, 36
Zebra [1963], 144